GEORGE N. BARNARD

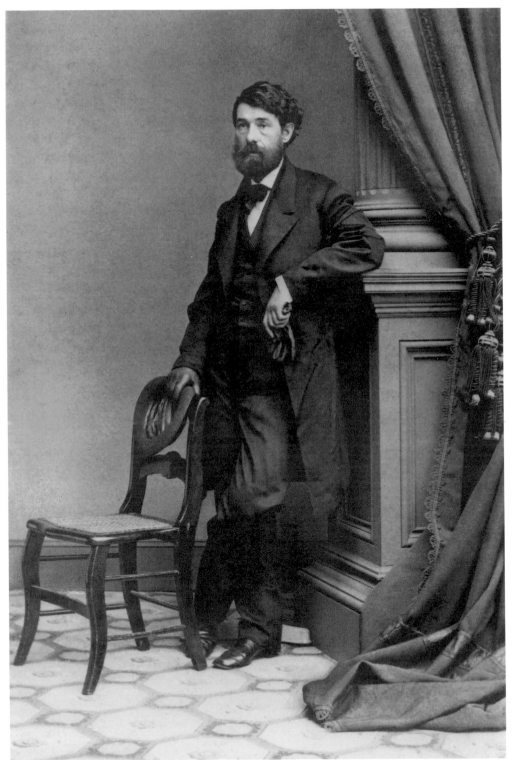

Brady Studio: *Portrait of George N. Barnard*, ca. 1865; carte-de-visite; Larry J. West,
New York

GEORGE N. BARNARD

PHOTOGRAPHER OF SHERMAN'S CAMPAIGN

KEITH F. DAVIS

HALLMARK CARDS, INC.

KANSAS CITY, MISSOURI

This publication is one of a series from the Hallmark Photographic Collection celebrating the history and art of photography. Previous titles include *Todd Webb: Photographs of New York and Paris, 1945-1960* (1986), and *Harry Callahan: New Color, Photographs 1978-1987* (1988). The Hallmark Photographic Collection is a project of Hallmark Cards, Inc., and reflects the company's larger dedication to public service and the creative support of the arts.

Research for this book was supported in part by the National Endowment for the Humanities.

Designed by John Muller + Company, Kansas City, Missouri

Distributed by the University of New Mexico Press, Albuquerque, New Mexico

ISBN: 0-87529-627-0 (cloth)
 0-87529-628-9 (paper)

Cover: *Destruction of Hood's Ordnance Train*, 1864

Printed in the United States of America

CONTENTS

Unless otherwise noted, all photographs reproduced in this book are by George N. Barnard. When Barnard's authorship is probable, but not definitively proven, works are indicated as "attributed to Barnard." Collaborative works ("Barnard and Bostwick," "Barnard and Gibson," etc.) are also noted. Precise titles are printed in italic. Titles given by this author appear in square brackets. Simple descriptions of untitled works are given in roman (non-italic) type. We are very grateful to the individuals and institutions that kindly granted permission to reproduce these works.

Within quotes from nineteenth-century sources eccentric spellings and punctuation have been retained without comment to preserve the flavor of the original text. Various spellings of daguerrean ("daguerreian") and the title of Barnard's photograph *Woodsawyer, Nooning* ("Woodsawyer's Nooning") also appear unchanged within quotes.

ACKNOWLEDGMENTS

Research for this book began more than a decade ago. In the intervening years many individuals and institutions have provided invaluable advice and research assistance. For their example, encouragement and support, special thanks are extended to Beaumont Newhall, John Szarkowski, David Travis, Elizabeth Hadas, Thomas Southall, George R. Rinhart, David Strout, Mrs. James E. Coleman, Joel and Ruth Ann C. Davis, and Trish Davis.

The following individuals and institutions were particularly helpful in the course of this work: Suzanne Etherington, Judy Haven, and Robert McLaughlin of the Onondaga Historical Association, Syracuse, NY; Mrs. Marie T. Capps and Judith Sibley, Special Collections, U.S. Military Academy at West Point, West Point, NY; Michael Winey and Richard J. Sommers, U.S. Army Military History Institute, Carlisle Barracks, PA; the staffs of the Prints and Photographs, and Manuscript Divisions of the Library of Congress, Washington, DC; and Robert Sobieszek, David Wooters, and Rachel Stuhlman, George Eastman House, Rochester, NY.

Deep thanks are extended to Larry A. Viskochil and the staff of the Chicago Historical Society for research assistance over the years, and for their collaboration on the 1990-91 touring exhibition accompanying this book.

Valuable assistance has also been provided by Brita Mack, Huntington Library, San Marino, CA; William Stapp, National Portrait Gallery, Washington, DC; Charles Lamb and Dr. Wendy C. Schlereth, University of Notre Dame Archives, Notre Dame, IN; Peter Galassi and Tony Troncale, Museum of Modern Art, New York, NY; Julia Van Haaften, New York Public Library, New York, NY; Terry Prior, Oswego County Historical Society, Oswego, NY; Dr. Judith Wellman, State University of New York at Oswego; Lois Gauch, Archives, Eastman Kodak Company, Rochester, NY; John Grabowski, Western Reserve Historical Society, Cleveland, OH; Carl Engel, Lake County Historical Society, Mentor, OH; Sharon Bennett, Charleston Museum, Charleston, SC; Paul Figueroa, Gibbes Art Museum, Charleston, SC; Gail McCoy, Archives and Records Division, City of Charleston, SC; Lois Stein, Kenosha County Historical Society, Kenosha, WI; David Harris, Canadian Centre for Architecture, Montreal; James Borcoman, National Gallery of Canada, Ottawa; and the staffs of Special Collections, University of California-Los Angeles; J. Paul Getty Museum, Malibu, CA; Connecticut State Archives, Hartford; Atlanta Historical Society, Atlanta, GA; Georgia State Archives, Atlanta; Georgia Historical Society, Savannah; Burnham Library, Chicago Art Institute, Chicago, IL; Spencer Museum of Art, Lawrence, KS; Historic New Orleans Collection, New Orleans, LA; Kansas City Public Library, Kansas City, MO; New York State Archives, Albany, NY; Metropolitan Museum of Art, New York, NY; The New-York Historical Society, New York, NY; Onondaga County Public Library, Syracuse, NY; Oneida County Historical Society, Utica, NY; Charleston Library Society, Charleston, SC; South Carolina Historical Society, Charleston, SC; South Caroliniana Library, Columbia, SC; and the Tennessee State Archives, Nashville, TN.

Deep thanks also go to individuals who have helped in a great variety of ways: A. Verner Conover, W.E. Erquitt, William Frassanito, Robert H. Gilbert, Harlan M. Greene, Mark Haworth-Booth, Rick and Mary Hock, Donald Hoffman, Charles Isaacs, Rebecca Kanan, James M. Livingood, Grant Romer, David Ruth, Martha A. Sandweiss, Anthony Slosek, Richard W. Stephenson, Tex Treadwell, Theodore Turak, Susan Walker, and Larry J. West.

I am profoundly grateful to the National Endowment for the Humanities, Washington, DC, for a fellowship granted in 1986 assisting research on this project.

Thanks to John Muller and James Dettner of Muller + Co., Kansas City, MO, for their careful design of this volume, and to Annasue Wilson and Professor Herman Hattaway for editorial advice.

I am grateful for the assistance and professionalism of fellow Hallmarkers Jaye Miller, Sharon Pritchett, Gene Schmitz, Mike Pastor, Susan Hubbard, Rich Vaughn, Tracy Shrader, Pat Fundom and Sally Hopkins. For William A. Hall's invaluable guidance I am particularly grateful. Finally, projects such as this reflect a larger company commitment to scholarship and the arts. That philosophy, and the twenty-five year history of the Hallmark Photographic Collection itself, directly reflect the vision of Chairman of the Board, Donald J. Hall.

Keith F. Davis
Curator, Fine Art Collections
Hallmark Cards, Inc.

INTRODUCTION

George N. Barnard was one of the most important and respected photographers in nineteenth-century America. In addition to his brilliance as a picture-maker, Barnard's long career provides a nearly unparalleled case study of the photographic profession's first half-century in America. Barnard's life deserves close attention both for the quality and complexity of his pictures and for the unique breadth of his experiences.

Barnard's stature in the history of photography has been widely acknowledged. However, few attempts have been made either to document the facts of his life or to discuss his photographs within a larger cultural and artistic context. Barnard's biography has been a misleading tangle of fact, supposition, and often-repeated error. The scope of his photographic work has also remained unclear. Until relatively recently, many of Barnard's photographs (and, indeed, too many Civil War images in general) were generically credited to Mathew Brady. While the "Brady Studio" deserves full credit for its share of this massive production, it is possible that Brady himself made *no* field photographs during the war. These blanket attributions have always been incorrect; they are now indefensible. Similarly, when used as mere adjuncts to history texts, Barnard's photographs have often been poorly reproduced and carelessly cropped. An exclusive emphasis on the content of these images has masked the complexity and integrity of Barnard's vision.

It is ironic, however, that in other instances Barnard's reputation in photographic history has resulted in an overly generous attribution of images to his hand. It has been too easily presumed, for example, that because Barnard worked in Chattanooga or Nashville during the war that all unidentified images from those areas are probably his work. In some instances these attributions may be justified. In other cases, however, such presumptions only serve to obscure the contributions of lesser-known photographers. Much work remains in sorting out the complex issues of authorship and sponsorship for the entire genre of Civil War photography.[1]

These dilemmas arise in large part from our still fragmentary knowledge of nineteenth-century photography as a whole and, in particular, the hitherto limited information available on Barnard. He left only a handful of published statements and even fewer personal papers. Barnard attracted no undue attention through colorful eccentricities or public scandals, and he died in quiet obscurity decades after the completion of his most important work.

Despite this paucity of first-hand data, a surprising number of references to Barnard are contained in newspapers, photographic journals, and census, tax, and real estate records of the period. Friends and associates often made note of him or preserved his correspondence. Barnard also belonged to several professional organizations that published summaries of their meetings. From such sources a skeleton of empirical fact may be established. This structure is then given definition and meaning through a judicious — and inevitably subjective — use of deduction and interpretation.

The goal of this study is two-fold: to present the facts of Barnard's life and to suggest the meaning of his work. These ambitions — one essentially archaeological and the other interpretive — are individually challenging and often difficult to reconcile. The most persistent research results in a chronological record still riddled with frustrating gaps and ambiguities. (These gaps are indicated all too clearly by phrases such as "it is likely that..." or "one suspects that...") While the significance — or even occurrence — of many events can only be surmised, such deductions are essential to the creation of a coherent narrative. On another level of inquiry, the life of one's immediate subject, to be most richly understood, must be perceived within a larger matrix of historical incident and cultural values. This requires an even wider range of judgments on the issues, ideas, and motivations germane to a life, a body of work, and a cultural epoch. Barnard's significance as a photographer cannot, ultimately, be separated from the values, personalities, and historical events of his time. The meanings of his life and work are to be found squarely in the context of his era. Conversely, the unique facts of Barnard's life illustrate the contingencies that shape any career, and give specificity to otherwise vague cultural and historical generalizations.

This biography draws on previous research on Barnard and his contemporaries while extending significantly the depth and scope of that work. This study is founded on the belief that an awareness of the basic events of Barnard's life must precede larger speculations on the meaning of his work. At the same time, an attempt has been made to locate these facts in a cultural context generated from study in a wide range of related disciplines. It is hoped that this combination of micro- and macroscopic viewpoints provides an original document of Barnard's life and times, and a valuable foundation for future research.

Would Barnard himself have recognized this narrative as his life? Without question, he would have seen it as uneven and incomplete. He would have perceived only sporadic correspondence between the quantity of surviving information on various aspects of his career and the relative importance of those events. Innumerable details of his life went unrecorded, and much of what he understood as common knowledge has left no historic trace. He might feel that such important factors as his religious faith or love of family were insufficiently stressed. Barnard might also have been amused by speculations on the meaning of some of his images and puzzled by late twentieth-century attitudes toward photographic history in general.

What sort of person was George N. Barnard? The evidence suggests that he was intelligent, kind, modest, generous, and somewhat idealistic. In his professional life, Barnard was dependable, reserved, serious, and well-liked. He was a conservative man of high moral character, religious faith, and social propriety who typically held himself apart from the controversies and causes of the moment. Like many of his period, Barnard had a high regard for the concepts of taste, refinement, and progress. He had a particular interest in music and probably read fairly widely in the field of visual arts. He was financially astute, practical, hard-working, and mechanically inclined. Although not himself a rich man, Barnard led a middle- to upper middle-class existence and had relatives who were quite wealthy. He was also a devoted family man, and lived with or near relatives most of his life.

This quiet, respected professional was a complex man of technology, art, and commerce who held simultaneously a faith in cultural progress and a nostalgia for a simpler, pre-industrial way of life. Barnard's interests and motivations reflect some of the most important ideological currents of nineteenth-century America. In an age of national transition from a society of farmers and independent artisans to one of high technology and industrial organization, Barnard's photographs explore such important themes as war, the American landscape, and the status of newly freed blacks. Barnard was not a conscious propagandist or activist. However, in addition to their acknowledged documentary importance, Barnard's photographs reveal much about his own values and ideas, and those of his culture.

During Barnard's life America underwent a dramatic process of growth and change. This period witnessed a revolution in transportation and communication, unprecedented geographical expansion, vast population shifts, the traumas of the Civil War and Reconstruction, and the birth of the modern industrial state. American society experienced a fundamental transformation that continues to shape the culture of the late twentieth century.[2]

Before the Louisiana Purchase of 1803, the United States had been a relatively insignificant power with a population the size of Ireland's. In the early decades of the nineteenth century this population was both rapidly growing and highly mobile. From the relatively dense older states such as Connecticut, for example, a steady migration of families took place to northern New England, central New York, Pennsylvania, Ohio, and points farther west. This physical expansion was paralleled by radical changes in the technology of transportation. The introduction of the steamboat and the construction of canals and railroads dramatically increased the speed and economy of travel. This rapidly developing transportation system, combined with new technologies of mass production, greatly altered the manufacture and distribution of goods. Barnard's life coincided with a basic change in American society from a world of handmade things to one of machine-made goods. The regimen and economic organization of the industrial workplace profoundly changed the nature of American labor and the character of its cities.

These changes in the production, distribution, and consumption of goods were reflected in an expanding, if inconsistent, economy. In the early 1820s the American economy began for the first time to expand at a faster rate than the nation's population. However, the fastest growth of the pre-war period, in the 1830s and 1850s, was punctuated by the lingering recession of 1837-43 and the shorter downturn of 1857-58. Years of modest prosperity followed the economic stimulation of the Civil War. The Panic of 1873 led to another depression, which lasted until about 1878. While the overall trend of these decades was toward rising wages and prices, a number of factors — including more efficient means of production and transportation — combined to exert a downward pressure on the price of many goods. The 1840s and the years 1873-96, for example, saw prolonged price declines throughout the American economy. These periods created concern and belt-tightening among many small businessmen as profit margins shrank and competition increased.

Varying attitudes toward the nation's evolving economic and social structure were expressed in the political sphere. The Whig (and later Republican) Party generally attracted those — like Barnard — who benefited from the new competitive market economy: upwardly mobile, white-collar professionals and skilled laborers, Protestants, and farmers near urban areas or major transportation lines. The Democratic Party, on the other hand, tended to draw its support from those who felt disenfranchised by the system, or at the bottom of the status ladder: wage-earning laborers, Catholics, immigrants, and rural farmers.

The most animated political debates of the pre-war years centered on the issues of territorial expansion, states' rights, and slavery. Domestic tensions over the abolition issue increased dramatically in the 1840s and 1850s. The Fugitive Slave Law of 1850, requiring northern authorities to surrender escaped slaves to their owners, was violently controversial. The Kansas-Nebraska Act of 1854, an attempted compromise on the issue, further polarized the country and led to the establishment of the resolutely abolitionist Republican Party. The Dred Scott decision of 1857, in which the Supreme Court ruled that slaves were the property of their owners even in free states, inflamed abolitionists. John Brown's ill-conceived raid on the Federal arsenal at Harper's Ferry, in 1859, frightened Southerners with visions of social anarchy, and prompted an increasingly unyielding response to Northern demands. By the time of Lincoln's election in late 1860, there were no more compromises to be made.

The Civil War remains the central episode in American history. Practically every family in the nation had a member or relative in uniform between 1861 and 1865, and many grieved the death of loved ones. The war resulted in horrendous losses:

over 623,000 deaths and a total of a million casualties from a national population of 32 million. The financial costs of the war were also astronomical: in early 1863 the North alone was spending $2,500,000 each *day* to pursue the conflict. By 1865 the war had consumed no less than five billion dollars in direct military expenses. These huge expenditures resulted in a dramatic expansion of the Northern economy while bankrupting the South.

These outlays funded a war of unprecedented scale and technological sophistication. It seems only a slight exaggeration to suggest that, from a purely military perspective, the Civil War began in the eighteenth century and ended in the twentieth. Romantic notions of chivalry and individual valor were early casualties in the first sustained application of industrial technology to warfare. Rifled muskets, machine guns, iron-clad vessels, the railroad, and telegraph all changed the existing rules of combat. The extensive use of entrenchments in the last half of the conflict anticipated the static bloodbaths of World War I a half-century later. The concept of "total war" — the use of military force against not only enemy troops but the morale and resources of civilian populations — also came into its own, with horrific consequences in the twentieth century.

Four bitter years of war settled the issue of slavery (if not that of racial inequality) and preserved the Union. They also determined the future course of the country's development. Union victory ensured the economic dominance of the North's brand of free-market capitalism, as well as the role of a powerful central government. During the war the power of the various states had shifted, by necessity, to the capital cities of Richmond and Washington. It is profoundly ironic that Confederate leaders found the creation of a relatively powerful central government essential to their struggle for states' rights. These trends were irreversible and after 1865 the "United States" was clearly understood as a singular, rather than a plural, noun.

The abolition movement, a central catalyst for the events of mid-century, had been one of several moral and social reforms that swept the country in the decades preceding the war. In the 1830s and 1840s, large numbers took part in the fervent religious revivals of the "Second Great Awakening." The activist and millenialist evangelicalism of the period stimulated a variety of crusades to transform American society and politics. The evils of slavery and alcohol were the first and most enduring targets for reform. However, a number of other issues, including women's rights, public education, prison conditions, and improved treatment for the blind, deaf, and insane, all came to prominence.

The variety and enthusiasm of these movements suggest that Americans were engaged in a complex process of self-definition: a quest for personal, social, and national identity. As family obligations shifted, class barriers loosened, and employment patterns changed, Americans sought to define themselves and their culture. Religious revivals were indicative of an attempt to establish a common purpose for an increasingly materialistic and individualistic society. Temper-

ance, with its emphasis on sobriety, dependability, and self-discipline, emphasized the traits required by a newly industrial and mercantile culture.

A faith in progress — both technical and moral — lay at the heart of these movements. In the decades prior to the Civil War, the average American's life was affected by a variety of physical, social, and personal "improvements." In innumerable ways — by taking regular baths, eating with forks, displaying pictures in their homes, and attending educational lectures, for example — middle class Americans began discarding and discouraging the coarse habits of an earlier time. Improvement was understood to be the result of individual self-control and concerted moral action, as well as constant technological innovation. The temper of the pre-war years stressed the betterment of the human soul, individual taste and national character.

This quest for improvement brought a new appreciation for art. In the early decades of the nineteenth century most Americans had expressed little interest in painting and sculpture. Most citizens probably considered the collecting of fine art an elitist activity, and its creation a frivolous use of time. Artists worked in a precarious and sometimes humiliating profession in which mechanical proficiency was rewarded over pictorial or conceptual originality. Portraiture, considered a genre of low significance by artists, represented one of the few consistent sources of income for professional painters. On the other hand, the themes of history and landscape, revered by artists as highly important, attracted minimal public interest and patronage.

In the two decades prior to the Civil War, however, the role of the fine arts in America changed dramatically. Artists organized themselves to promote the social status of the profession and its role as an agent of social improvement. Coincident with a new nationalistic spirit, and various crusades for beauty and refinement, the arts became an important vehicle for celebrating the unique American character, promoting the creative spirit of its citizens, and elevating the taste of the populace. This new acceptance allowed a number of artists to escape the constraints of portraiture for more elevated themes. Landscape, history, and still life paintings were exhibited, reviewed, and collected in increasing numbers. Inexpensive engravings of the most notable works were produced in large quantities and displayed in homes across the nation.

This new prominence of fine art images was part of a larger revolution in the production and dissemination of pictures. The number of illustrations in books and newspapers increased dramatically in the decades before the war. An enormous number of pictures were printed in such illustrated periodicals as *Frank Leslie's Illustrated Newspaper* and *Harper's Weekly*, both founded in the mid-1850s. In addition, publishers such as Currier and Ives produced a wide variety of lithographic prints for display in the parlors of tasteful middle-class homes.

Photography was the most important new picture-making technology of the era. From the moment of its introduction, the camera set the standard for pictorial

veracity and greatly influenced the realms of both art and journalism. Photography drove legions of mediocre portrait painters out of business, and democratized the production of likenesses. Photographs also became valuable references for the makers of popular prints and illustrations. Beginning in the 1840s, an increasing number of these scenes were hand-engraved from photographic originals rather than from written accounts, hasty eyewitness sketches, or the unfettered imagination.

At least three distinctly different photographic processes were invented by European researchers in the first decades of the nineteenth century. Nicephore Niepce, an eccentric French tinkerer and inventor, made a permanent photographic image in 1827 with an exposure of several hours. In England, the humanist and scholar William Henry Fox Talbot began experimenting with photography in the autumn of 1833, and made a successful photographic paper negative two years later. Talbot's negative/positive process — which allowed the production of numerous paper prints from an original negative — underlies our current understanding of the medium. Despite the importance of their work, neither Niepce nor Talbot sought or received public notice in these years.

The general announcement of photography in the summer of 1839 stemmed from the research of a third pioneer, Louis Jacques Mande Daguerre. Daguerre was a Parisian artist and entrepreneur, and the proprietor of an illusionistic, theatrical presentation called the Diorama. After a brief partnership with Niepce, Daguerre went on to develop the daguerreotype process, which produced a unique, direct-positive, laterally reversed photographic image on a highly polished silver-coated copper plate. The daguerreotype conveyed an almost magical brilliance of tone and detail, and became the world's first widely used photographic technique.

Samuel F.B. Morse, the noted American painter and inventor, was in Paris just prior to the official public description of Daguerre's process. In early March 1839 Morse invited Daguerre to a demonstration of his telegraph. The Frenchman responded by allowing Morse to view some daguerreotypes. By the autumn of that year Morse had returned to New York and was one of several Americans to experiment with the new process. By 1840 a handful of pioneer daguerreotypists in New York, Boston, and Philadelphia were producing relatively crude images using handmade cameras and lengthy exposures.

Within a year or two, however, the daguerreotype had become a serious discipline. Technical improvements in lenses and chemical manipulations shortened exposures to the extent that portraiture became feasible. The public responded to the new invention with great enthusiasm, and the profession of photography was born. Young men with an aptitude for optics, chemistry, mechanical tinkering, the arts, or simple entrepreneurship took up the process after paying for an instruction book or lesson. Portrait studios were established in the major cities and itinerant daguerreotypists traveled through rural areas in search of business. By the middle of the 1840s full-time daguerreotype galleries were established in most cities, and commercial supply houses had opened to serve every need of the growing field.

In subsequent decades the photographic profession was characterized by expansion and change driven by technical innovations and shifting public tastes. The mid-1840s to the mid-1850s saw general stability and prosperity as the number of daguerreotypists steadily increased and photographic journals and associations were founded. In the mid-1850s, however, the nature of the business was fundamentally altered when the daguerreotype was superseded by the wet-collodion glass negative process. These negatives could be encased and sold as one-of-a-kind "ambrotypes," or used to produce positive paper prints in quantity. By 1860 the stereograph and carte-de-visite formats were greatly in vogue. In the late 1860s a new standard for commercial portraiture, the 4¼ x 6½-inch cabinet card, came to prominence. A bewildering variety of lenses, chemical formulations, and printing techniques were also debated and adopted by the profession in the years following the Civil War. In the early 1880s the basic nature of the profession changed yet again when the gelatin dry-plate negative replaced the wet-collodion process.

The variety and rapidity of these changes required that successful photographers be flexible, innovative, and responsive to the shifting demands of the marketplace. It may be suggested that this forty-year period, from the era of the daguerreotype to that of the dry-plate, resulted in more dramatic and rapid changes in the profession than the entire century to follow.

The importance of photography in nineteenth-century American culture cannot be overestimated. The medium democratized the practice of portraiture, allowing all but the very poorest citizens to create likenesses of themselves for family and posterity. Photography allowed the myriad events of American history to be recorded with a new and compelling veracity and, as the standard of pictorial accuracy, served as a model for a larger Positivistic attitude toward the perception and documentation of fact. At the same time, the medium was used as a tool for individual and aesthetic expression. Photography was used to inform, entertain, uplift, and persuade, and rapidly became a ubiquitous witness to — and expression of — the American experience. George N. Barnard's career provides an unparalleled study of these formative years.

I

*'good judgment and cultivated taste combined
with scientific knowledge''*

The Making of a Photographer:

1819-1859

I:1 Early Life: 1819-1846

George N. Barnard was born in Connecticut in 1819, during a particularly dynamic period in the area's history. The state had long been characterized by its political and religious conservatism. Indeed, colonial Connecticut was "never a democracy." The leading citizens, "nurtured in the Calvinist concept of a man as evil...abhorred rule by the masses and advocated rule by the 'elect.'"[1] Similarly, the state's dominant Congregationalist Church stressed the corruption of man and the need for constant labor and self-denial. These views were emphasized in long sermons that alternated between "terror and tedium," and through frequent Bible readings at home.[2] The philosophy of "aristocratic" governance and the social dominance of the Congregationalist Church were muted, however, by the new state constitution of 1818, which created a bill of individual rights and decreed the official separation of church and state.[3]

These political changes were accompanied by economic and social transformations. Since the arrival of European settlers, most of the state's residents had been farmers. By the early years of the nineteenth century, however, agriculture began a long period of relative decline. Manufacturing enterprises such as tanneries, rope walks, flaxseed mills, distilleries, and small shops producing glass, pottery, and tinware began appearing throughout the state. The region's predominantly rural character began to change as its working class expanded. The state's increasing population, relatively heavy taxes, restricted commerce, and increasing land speculation caused waves of residents to leave Connecticut beginning in the last decades of the eighteenth century. Many families migrated north to Vermont, where they established conservative, Congregationalist communities similar to those in which they had been raised. Other citizens moved west to New York State or the Connecticut "Western Reserve" in northern Ohio. So great was this movement that the population of many Connecticut towns actually declined between 1790 and the mid-1820s.[4]

George N. Barnard's parents, Norman and Grace Barnard, lived in the quiet community of Coventry, Connecticut. At the time of his birth, this village, located eighteen miles east of Hartford, had a population of just over 2000 residents, with 324 dwellings, three Congregationalist churches, and seven "mercantile stores." Although rye, corn, and oats were successfully raised there, Coventry's uneven terrain was "best suited to grazing, and the dairy business constitutes the primary agricultural interest." Several streams provided waterpower for a variety of manufacturing concerns, including "1 Cotton Factory, 2 Paper Mills, 1 Glass Factory, 1 Manufactory of Carding Machines, 3 Small Distilleries, 5 Tanneries, 3 Grain Mills, 6 Saw Mills and 5 Carding Machines."[5] Despite its modest size Coventry was also noted as the birthplace of Nathan Hale, the Revolutionary War hero, and Samuel Huntington, an early governor of the state of Ohio.

Norman Barnard's ancestors had resided in Coventry for several generations, although periodic relocations to and from Vermont had occurred in the mid- to late 1700s. Norman Barnard himself had been born in Vermont in 1778 or 1779, but returned to Connecticut with relatives in the 1790s. It is likely that he worked on a family farm in Coventry before starting his own in 1803 with land purchased from his relative, Joseph Barnard.[6] It appears that Norman Barnard was a relatively successful farmer, as records indicate that he bought and sold numerous parcels of land between 1803 and 1826.[7]

In about 1801 Norman Barnard married eighteen-year-old Grace Badger. The Barnard and Badger families had resided in Coventry for generations and belonged to the same Congregationalist Church in North Coventry.[8] On May 26, 1805, Norman and Grace Barnard became the parents of a daughter, Mary. A second daughter, Pauline, arrived on August 30, 1811. It is possible that as many as three sons were also born between 1806 and 1818, although no names or dates of birth have thus far been discovered. Census records reveal that the Norman Barnard household contained nine persons in 1810 and eleven in 1820. Both figures may reflect the presence of members of the extended family, including parents, in-laws, or siblings.[9]

George N. Barnard was born two days before Christmas, on December 23, 1819. The child's first name may have been drawn from his maternal line of descent, and he was probably given Norman as a middle name in honor of his father. On January 2, 1820, Norman and Grace Barnard carried their two-week-old child to the Second Congregationalist Church in North Coventry to be baptized.[10]

Young George was born into a particularly close, devout, and upright family. The Barnards and their relatives by marriage maintained close ties in the following decades and it was common for members of the extended family to live with or near one another. Many of George Barnard's moves in later years would be the result of such close familial bonds. Piety, industry, and respectability were characteristic of the family. At the end of her life, for example, Barnard's mother was "widely esteemed as a lady of more than ordinary worth" whose exemplary Christian character gained for her the "respect and esteem of the entire community."[11] Similarly, his older sister, Mary, was later described as

> a lady of more than ordinary energy...; she was active and influential in all good enterprises, proverbial for her social qualities, a generous and hospitable entertainer of all worthy people, a friend to the poor, and a consistent member of the Congregational church.[12]

It may be surmised that George's early years in Coventry were relatively conventional, focusing on farm work, religious observances, and family activities. In this

era children were expected to rise early, carry out domestic chores, and, if of school age, attend classes. In the afternoons they might gather firewood, feed farm animals, or assist their parents in other tasks. Time not devoted to domestic labors, church attendance, or Bible readings could have been spent hunting, fishing, or playing with neighboring children.

George's religious upbringing was important to his character, and involved more than simply enduring long sermons on the horrors of hell. Congregationalists had been intensely patriotic during the Revolutionary War and believed deeply in the political value of independence. The church was also a strong advocate of education, culture, and the Calvinist idea of responsibility for public conditions.[13] The reform movements of the early nineteenth century grew logically from these views.

At the age of six, George's life was changed abruptly by the death of his father on May 12, 1826.[14] Norman Barnard died of consumption (pulmonary tuberculosis), perhaps the most common disease of the period. Since consumption was contagious, the elder Barnard may have been removed from the household shortly after the discovery of his illness, adding to the trauma and uncertainty of this event for the family. Norman Barnard's death occurred at a particularly impressionable time in George's life, and reinforced in the child a profound sense of mortality.

After her husband's burial, Grace Barnard took her children west to live near Badger or Barnard relatives in central New York State.[15] By 1828 they were residing in Auburn, a prosperous community of nearly 3000 residents at the northern tip of Owasco Lake. In addition to numerous churches, taverns, general stores, and manufacturing operations, Auburn boasted its own newspaper, band, Seminary School, and Medical College. The town's citizens enjoyed a wide variety of cultural events held in Columbian Garden, which had a theater for plays and concerts, an amphitheater for circus performances, and "arrangements for fireworks."[16]

The Barnards also had contacts in the Sauquoit area of nearby Oneida County. Sauquoit, adjacent to the villages of Bridgewater, Paris, and New Hartford, was a growing settlement nine miles south of Utica. With waterpower supplied by the Sauquoit Creek, numerous mills and factories had been established in the Sauquoit valley in the first decades of the nineteenth century. Many early settlers of the area had come from Connecticut, including families from Coventry and various branches of the Barnard family. Among the early settlers of Sauquoit, for example, was "a Mr. Barnard" who had erected a "grist-mill and sawmill...early in the century."[17] Barnards also resided in nearby Paris and Utica.[18]

On September 16, 1828, George Barnard's older sister, Mary, wed Samuel Hale, Jr., in Sauquoit. Hale, born in 1799 in nearby Paris Hill, had left home at the age of 21 to begin business as a peddler. Three years later he invested his savings in a general merchandise store at Sauquoit Creek. Shortly after his marriage, Hale moved several miles south to Bridgewater where he engaged in another profitable merchandise business. In 1836 the Hale family moved west to Kenosha, in the Wisconsin Territory. In addition to his successful career there as a businessman, Hale was distinguished by service as a justice of the peace and judge of probate for Racine County. In 1857 the family relocated to Chicago, where Hale opened a furniture store on Randolph Street with his partner John V. Ayer.[19]

After Mary's wedding, it is likely that the rest of the Barnard clan accompanied her to Oneida County. By 1831 Grace Barnard was living with or near her elder daughter in Bridgewater. Here Grace married Zimri Howland, a 63-year old widower and veteran of the War of 1812. Howland had suffered the deaths of two previous wives, and apparently wasted no time in choosing a third. His second wife, Betsey Ann, had died on January 3, 1831. By December 29 of that year Grace Barnard had remarried and joined the town's Congregational Church.[20]

On May 7, 1832, Grace's younger daughter, Pauline, married David C. Gaskill at the Hale family residence in Paris, New York. With her mother now in the Howland household, Pauline apparently took young George into her care.[21] In 1833 the Gaskills moved to Nashville, Tennessee, probably at the suggestion of relatives there.[22] Two years later the family relocated to Gallatin, where David Gaskill became editor of the *Gallatin Union*, a strongly pro-Union weekly. In 1838 39 he also published a magazine entitled *Cumberland Farmer*.[23]

Gaskill left the *Union* in late 1839 to found a monthly literary magazine called *The Southron: or, Lily of the Valley. Devoted to Literature, Instruction, Amusement, &c.* This journal, which debuted in January 1841, was a stimulating compendium of fiction, poetry, historical narratives, and articles on such general topics as education and science. The title was taken from Sir Walter Scott's rather affected term for a southerner. Scott was immensely popular in America — and particularly in the South — for his romantic narratives of medieval heroes, chivalry, and aristocratic life.[24] This influence is reflected in many of the journal's poems and stories, including "Twilight," "The Captive Rescued," "Farewell to Carthage," and "The Damsel of Basque." Gaskill published at least a dozen issues of *The Southron* before returning to the *Gallatin Union* in October 1841 as the paper's co-publisher.[25]

While little documentation of George N. Barnard's formative adolescent years exists, it is likely that he assisted in various family businesses. In the early 1830s he may have worked in Samuel Hale's general store in Bridgewater, and in Tennessee he probably helped Gaskill in his publishing efforts. Despite the lack of specific information on these years, it is clear that Barnard was raised in an unusually progressive and literate environment. Samuel Hale was the archetype of the self-made American entrepreneur, already well advanced in a career of achievement, wealth, and social influence. Gaskill exemplified an equally pervasive faith in the power of ideas, sentiment, and refinement, and the need to elevate the awareness and taste of the public.

Hale and Gaskill shared, and undoubtedly emphasized to George, a basic faith

in individual improvement and social progress. Ambitious, upwardly-mobile young men of this period were strong believers in the virtues of competitive capitalism, hard work, sobriety, and religious faith. They also were fascinated by the power of rational inquiry — in the form of science and technology — to create a more perfect life. Ideas of moral perfectibility, material improvement, and cultural progress were joined in the characteristic optimism of pre-war America.

Gaskill clearly expressed this optimism in a fanciful essay in the September 1841 issue of *The Southron*. Speculating on the future of his publication a hundred years hence, Gaskill envisioned Gallatin in 1941 filled with "sumptuous dwellings" and citizens motoring about in private steam-cars. He enthusiastically described

> the multitude of spires now pointing heavenward from their tasteful locations; the costly and beautiful edifices consecrated to education and science...; the many extensive mechanical and manufacturing establishments; and the luxurious villas in the suburbs...

This utopian vision of prosperity, comfort, and cooperation was perceived as the natural consequence of "industry and enterprise, fostered by wise and equitable political institutions."[26]

An appreciation for the arts was also encouraged in George by the example of other relatives. Rufus Barnard, a resident of Sauquoit, was associated with the "pioneer organ factory in Central New York," an establishment owned by one Oliver Prior.[27] In addition, Joseph W. Badger (George's uncle or cousin) was a noted "miniature painter" in New York City in the mid-1830s, and exhibited at the National Academy of Design and the American Academy.[28]

By 1842 George Barnard had returned north to the village of Sauquoit. He may have arrived from Tennessee a few years earlier to assist his mother (recently widowed for the second time), or to accept an offer of employment. Sauquoit was a small but prosperous settlement located in a picturesque valley just south of Utica. A poetic nineteenth-century description of the area echoes Gaskill's utopian community:

> The lovely valley of the Sauquoit, in full view like a vast panorama; the charming little twin-village at the bottom of the valley; the creek, glistening and rippling along on its winding way, here and there arrested in its course to do tribute to the Moloch of commerce, dammed in reservoirs for the mills and factories, tiny lakes of marvelous beauty; the grand slope of the opposite hillside with its homesteads, orchards, meadows and fields mapped out in plain view, combine to make a picture, which once beheld, is never to be effaced from memory.[29]

A less idealized description of Sauquoit follows:

> This village (or more properly two villages) stands on two parallel streets, about half a mile from each other, on opposite sides of the creek, and united by a cross street. On the west side is a tavern and store, the Presbyterian Church, post office, with quite a number of private dwellings. On the east side is the Methodist Church, the Academy, a store, a tavern, and also a number of private dwellings, mechanics, etc. On the cross street there are various kinds of machinery turned with water power.[30]

At this time Sauquoit included about fifty houses and 300 residents. The Sauquoit Creek, which dropped 620 feet in the course of seven miles, provided ample waterpower for "two large cotton factories, one paper mill, two flouring mills and a clothier's works."[31] Other local enterprises included a cabinetmaker, a tailor, several distilleries, two hotels, a tannery, and a limestone quarry.[32]

Given this diversity of activity, and its proximity to Utica, Sauquoit provided its inhabitants with a variety of cultural and educational opportunities. The famed American botanist Asa Gray (1810-1888), for example, had been born and raised in this village. In his autobiography Gray recalled attending a "small 'select' or private school, taught at Sauquoit, by the son of the pastor of the parish" prior to more formal studies nine miles away at the Clinton Grammar School. Gray also fondly described the

> little subscription library at Sauquoit, the stockholders of which met four times a year, distributed the books by auction to the highest bidder (maximum, perhaps, ten or twelve cents) to have and to hold for three months; or if there was no competition each took what he chose. Rather slow circulation this; but in three months the books were thoroughly read.[33]

Gray served his medical apprenticeship in Bridgewater (1828-31) before embarking on a career of scholarly study and world travel. Interestingly enough, Gray was one of the first Americans to learn of photography. He attended the January 31, 1839 meeting in London of the Royal Society to hear "a paper read of the Hon. Fox Talbot's on the power of objects not only to sit for, but to draw their own portraits..."[34]

On January 24, 1843, George N. Barnard married nineteen-year-old Sarah Jane Hodges in a ceremony performed by J.M. Gray (who may have been related to Asa Gray).[35] Sarah had been born in nearby Madison County, but moved to the Sauquoit area several years earlier with her widowed mother, who took a job in a factory on the Sauquoit Creek.[36] A few months later the newlyweds became members of the Union Society Church on the west side of Sauquoit. With several other initiants, George and Sarah professed their faith and received baptism into the church on May 6, 1843.[37]

This parish contained members of both the Congregationalist and Presbyterian faiths — a common practice in smaller settlements of the period — but by the 1840s it had drifted toward Presbyterian dominance. The latter denomination was the more conservative of the two. Congregationalists advocated "greater liberty for the individual members and local churches," while Presbyterians desired "a better order and greater efficiency of [church] government."[38]

The timing of their initiation suggests that Barnard and his wife were influenced

by the "powerful revival of religion" that swept through Oneida County in the winter of 1842-43.[39] Central and western New York state, which came to be known as the "burned-over district," was the scene of repeated waves of religious enthusiasm in the late 1830s and early 1840s. The most extreme of these revivals promoted an apocalyptic and millenial message. These believers held a deeply pessimistic view of worldly existence in which disease, calamity, and disorder signaled the inevitability of earthly decay and collapse. For example, the 1832 cholera epidemic, which struck the Utica area with particular severity, was viewed by many as divine punishment for sinful living.[40]

For moderates such as Barnard, the religious revivals of the period united personal and spiritual concerns with larger social issues such as temperance and abolition. Barnard's church, for example, included a pledge of temperance in its membership vows.[41] Unlike evangelicals, Christian moderates believed in the basic goodness of human nature and its potential for gradual improvement given the vigilant control of passions and impulses.[42]

While his occupation in the early 1840s remains unknown, Barnard undoubtedly benefited from his friendships and family ties in the Sauquoit area. By 1845, however, he had saved a sum of money and was eager to advance himself. Through family, business, or religious connections he soon met a young man named Grover S. Wormer, then living in the rapidly growing town of Oswego, on the shore of Lake Ontario. Barnard decided that Oswego's size and location offered professional opportunities not available in the quiet Sauquoit valley.

Oswego's economy had boomed in the years following the recession of 1836-37. Industrial growth was spurred by abundant waterpower, while harbor improvements drew shipments of goods and raw materials from Canada and the Great Lakes region. Population grew steadily, from 4658 in 1840 to 12,199 in 1850.[43] In addition to its iron, shipping and lumber businesses, the flour milling industry contributed significantly to Oswego's growth. New facilities were constructed throughout the 1840s, and by 1850 a total of sixteen mills were in operation. In 1848 the first railroad line into Oswego was opened, reducing the eight-hour journey to Syracuse by canal-boat or dirt road to an exhilarating two-hour trip.[44]

At this promising time in the village's economic growth, Wormer asked Barnard to join him in the management of the Oswego Hotel. This prominent structure had been built on the corner of East First and Bridge streets in 1828 by Gerrit Smith, a noted investor, philanthropist and reform activist.[45] In addition to his diverse business interests in Oswego and throughout New York State, Smith devoted enormous energy and money to a variety of moral reform causes. Indeed, "the story of [Smith's] life is in itself almost a history of the reform movement" of the period.[46] In later life Smith became particularly notable for his fierce abolitionism, and his financial backing of John Brown's celebrated raid on the arsenal at Harper's Ferry.[47]

The first reform movement to interest Smith, beginning in the late 1820s, was the temperance crusade. Smith lectured and wrote on the evils of drink and gave enthusiastic support to groups such as the New York State Temperance Society. He quite naturally deplored the "traditional intimacy between liquor and the hotel business" and set about to promote the cause of temperance taverns.[48] Smith stated to a prospective landlord that a respectable hotel should be run "on strict Christian principles," with absolutely "no Balls, no games, and no intoxicating drinks."[49] He started such a dour establishment in Peterboro, New York, in 1827. In the following year Smith built the Oswego Hotel and mandated that it be run on similarly strict principles. But this hotel, even under the able supervision of his Oswego business manager, John B. Edwards, was never really successful. Handicapped by Smith's temperance dictum, the hotel's first manager went bankrupt. Subsequent managers found the business, at best, only marginally profitable.[50]

Wormer began managing the Oswego Hotel in 1843, in partnership with a Mr. Lord.[51] When Lord left the business Wormer recruited Barnard to take his place. This new partnership was announced in an advertisement in the August 20, 1845, issue of the *Oswego Palladium*:

The Oswego Hotel

Grover S. Wormer, the late proprietor and gentlemanly and attentive host of this House, begs leave to inform the Traveling Public, his Friends and the Citizens of Oswego, and its vicinity generally, that he has formed a connection in the business of keeping and conducting the said Oswego Hotel for the accommodation and reception of Travellers and Boarders, with George N. Barnard, Esq., a gentleman of noted urbanity of manners, and assiduity in attention, that hereafter the said house will be kept by the subscribers, under the firm and name of Wormer & Barnard.

They cannot refrain from informing the public that the Oswego Hotel is the best and most conveniently located hotel in the village — very convenient to the landings of the Steam and Packet Boats plying upon the Lake and Canal — is a house in which no attention on the part of the proprietors thereof or others in their employ, will be spared to make the sojourn of its inmates agreeable and pleasant.

A Carriage to convey Passengers, and a Wagon for the conveyance of their baggage, will at all times be in attendance upon the arrival and departure of the Boats free of charge.
GROVER S. WORMER
GEORGE N. BARNARD[52]

Wormer and Barnard labored to repair the appearance and reputation of the hotel, and on April 2, 1846 the *Oswego Palladium* took favorable notice of their efforts.

The Oswego Hotel

This commodious and well regulated public house, which has long ranked among the first hotels in the country, is now undergoing very general and thorough repairs, and will soon be, in every respect *as*

good as new. Messrs. WORMER & BARNARD, the gentlemanly propri-
etors, are admirably qualified for the station, and never allow a patron
to go away dissatisfied. The house well deserves, and we have every
reason to believe, will receive a large share of the public favor.[53]

While Barnard's tenure at the hotel lasted only a year, the experience was
undoubtedly of significance to him. As historian Daniel Boorstin has suggested,
the hotel business embodied important trends and ideas in American culture of
the period.[54] Beginning in the 1830s, hotels became highly visible symbols of new
notions of community, taste, and progress.

Houses such as the Oswego Hotel attracted a combination of transient visitors,
long-term residents, and businessmen. In an age of rapidly expanding road, canal,
and rail transportation, more people than ever traveled for business or pleasure.
Hotels also served as places of residence for the significant percentage of the
population that did not own or rent homes.[55] In addition, it was common for large
hotels to devote some street-level frontage to commercial use. The Oswego Hotel,
for example, had a row of at least seven offices that were rented by various
professionals and small businessmen.

This varied population resulted in a fast-paced intermingling of acquaintances
and strangers. Social distinctions were blurred in this milieu and a new interper-
sonal openness and ease were encouraged. To work successfully in this environ-
ment one needed traditional business expertise as well as a tolerance for individ-
ual and cultural differences. An intuitive understanding of psychology and a
pleasant personal demeanor were also desirable. All of these qualities would be
directly applicable to Barnard's subsequent career in photography.

Hotels were usually the grandest buildings in American cities. These so-called
"palaces of the public" were characterized by their splendor and attention to
details. Expensive wood paneling, carpets, hand-carved furniture, plush couches
and draperies were common in the finer places of business. This concept of lavish
— and ostentatious — display came to characterize several areas of nineteenth-
century commercial enterprise. Fine daguerreotype studios, for example, featured
waiting rooms that combined the comfort of the domestic parlor with the luxury,
refinement, and distinction of the hotel lobby.

In their unending race to attract business, hotels pioneered in the introduction
of various domestic and technological "improvements." Innovations in plumbing,
heating, and ventilating appeared in hotels before being adapted in other struc-
tures. The first American use of gas lighting (1835) and steam heat (1846)
occurred in hotels in Boston, for example. Hotels were also among the earliest
establishments to adopt the passenger elevator, electric light, and telephone. The
highly public nature of the hotel business made these structures "laboratories and
showcases of progress in the technology of everyday life," and served to "whet
public appetite for machines, conveniences and gadgets of all kinds."[56] Given this
era's emphasis on comfort, efficiency, and mechanical invention, it is entirely
appropriate that the daguerreotype came to prominence at precisely this time.

The partnership between Wormer and Barnard was undoubtedly based on
shared religious and moral values. After moving to Oswego, Barnard and his wife
became members of the local Presbyterian church on November 2, 1845. Wormer
was also a member of this parish, and had been married in the church the previous
year. Wormer was active in the conservative Whig party, which dominated the area,
and it is probable that Barnard shared this political perspective.[57] (Barnard was
relatively undemonstrative of these beliefs, however, and did not add his name to
any of the political lists published in the city's newspaper.) Barnard also shared
Wormer's adherence to temperance principles, and the hotel — as mandated by
Gerrit Smith — was operated on this basis.

The popular image of temperance houses in general, and the Oswego Hotel in
particular, is suggested in a curious letter printed in the September 3, 1845, issue
of the *Oswego Palladium.* The writer, a Mr. Robinson, issued a public apology for
his mistaken comments about the hotel at a temperance meeting the previous
evening. Robinson began by describing the widespread prejudice against
Temperance Houses arising from the hypocrisy of landlords who, despite their
profession, kept and sold liquor. He then detailed his recent experience:

> Having stopped for some days at the Oswego Hotel, I had noticed
> particularly that no liquor was drunk or sold there and was thereby
> prompted to the inquiry if liquor was kept in the Hotel, (for I was not
> aware that it was kept upon total abstinence principles). I was an-
> swered by a gentleman whom I mistook for one of the landlords, that
> it was not kept for sale, but was kept in the house for medicine or in
> the case of sickness. I stated in the temperance meeting that the
> Oswego Hotel was a fine house, that I had seen no liquor drunk,
> although informed by the landlord that it was kept. Now here was my
> mistake, and I retract it with pleasure, for the gentleman who made
> the remark was not the landlord as I had supposed, but made this
> remark as a joke upon the landlord who was in hearing; although that
> fact was unknown to me at the time. I am truly pleased to find the
> pleasant village of Oswego graced by so spacious and worthy a house
> as the Oswego Hotel, and cheerfully recommend it to the stranger,
> and only blame our worthy and gentlemanly "host," Mr. Wormer, for
> not making the fact more generally known to the traveling public that
> he keeps, what I am proud to know he does keep, a thorough Wash-
> ingtonian Hotel.[58]

Wormer and Barnard may have requested the publication of this apology in order
to ward off any complaints from Smith.

The temperance movement of this period represented a complex cultural and
political force. Temperance advocates believed implicitly in self-control, industry,
thrift, discipline, respectability, and the triumph of reason over desire. The tem-
perance movement also represented Protestant, rural, traditional, and middle-
class mores in contrast to Catholic, urban, modern, and upper- or lower-class

values. Indeed, for some temperance adherents the movement provided the means for solving the "problem" of immigrants, the urban poor, and non-Protestants.[59]

The Washingtonian movement, which arose in Baltimore in 1840, quickly acquired the largest mass following in the history of temperance reform.[60] This group included both life-long abstainers and reformed alcoholics, and drew its membership largely from the artisan and working class. The Washingtonian movement was a reaction, in part, to the social dislocations of the lingering depression of 1837-43. In a period of widespread job insecurity, Washingtonians promoted sobriety and frugality as both individual and economic virtues. This view implicitly reinforced the belief that poverty and unemployment "were the products of personal failure rather than flaws in the nature of society."[61] For many adherents, however, the temperate life meant merely a dedication to dependability and honest labor.

Mr. Robinson's description of the Oswego Hotel ("I was not aware that it was kept upon total abstinence principles") suggests strongly that Wormer and Barnard adhered to Smith's requirements without proselytizing for the cause. While there is evidence that Barnard's temperance beliefs were maintained in later life, he was clearly not a crusader.[62] In fact, it is likely that Barnard's hotel experience taught him the unprofitability of dogmatic beliefs.

For all its moral purity, Gerrit Smith's hotel was a mediocre business. Smith's biographer has noted that the temperance hotel movement "probably never had the support of a majority of the temperance men of that time" and was indicative only of "the extremes to which some reformers were running."[63] Without the full support of the non-drinking public, temperance hotels were severely handicapped in an age that considered drinking in hotels "strictly part of a business transaction."[64] While Smith had the money to back his convictions, he himself called the hotel "an unfortunate piece of property" and tried repeatedly to sell it.[65] When Barnard left his partnership with Wormer in the summer of 1846, the future of the enterprise looked bleak. On September 23 Smith's business manager in Oswego wrote:

> Our tenant of the Oswego Hotel Mr. Wormer is about making a failure
> of the Business. He is rather too young & cannot compete with Capt.
> Steward the Keeper of the Welland House. I hope we shall soon find
> the right sort of a man to take the House. We are spending much on the
> house & getting but little in return.[66]

Given the dullness of this business, it is understandable that Barnard sought a new career. It was at this time that he decided to take up the daguerreotype as his full-time profession.

I:2 Oswego: 1846-1853

Until Barnard's entry into the profession, Oswego did not have a full-time daguerreotypist. However, the village had been visited by itinerant photographers since 1841 and the local newspapers had taken great interest in the new process. The first traveling daguerreotypist to pass through Oswego may have been a Mr. Young, in June 1841. The *Oswego County Whig* noted that "Mr. Young, an adept at the business, with all the apparatus, is now in our village, and we advise all who desire a likeness 'true to nature' to give him a call. The expense is but a trifling."[1]

The June 16, 1841, issue of the same paper also carried an advertisement by the Plumbe Gallery, in Boston, for prospective students of the new art of photography. Mr. Young, and many like him, responded to the promise of the daguerreotype as a respectable and profitable enterprise.

PLUMBE'S DAGUERREOTYPE, BOSTON

...Mr. PLUMBE, Prof. Photography, having at length succeeded in so far improving his apparatus, as to be enabled to produce a perfect Photographic Miniature in any weather, and consequently without using the direct rays of the sun, proposes to instruct a limited number of Ladies and Gentlemen in this beautiful and valuable art, who will be furnished with complete sets of the Improved Patent Apparatus, by means of which any one may be enabled to take a Likeness or a View in any ordinary room, without requiring any peculiar arrangement of the light... The new apparatus costs only about one half the price of the old, and furnishes the ability to its possessor, of securing an independence in a profession, as honorable, interesting and agreeable as any other, by the expenditure of a mere trifle, and a few days of application. Can any other pursuit in life present the same advantages in supplying the means of genteel support, not to say fortune?...

Those who have never enjoyed the opportunity of seeing a specimen of Photography, can hardly form an adequate idea of the extreme perfection and beauty of a DAGUERREOTYPE PICTURE. It is the work of Nature, not of Art — and as far surpasses the production of the pencil, as all Nature's efforts do those of man. In the creation of these pictures, the light of Heaven alone, constitutes the pencil, and Nature the Artist!²

While Plumbe exaggerated the convenience of the process, three recent technical advances had indeed increased the rapidity and consistency of daguerreotype exposures. These changes, first developed in 1840, all came into general use by

1841. J.F. Goddard discovered that the sensitivity of the daguerreotype plate could be increased by following the normal iodine sensitizing bath with an application of the fumes of bromine, either alone or in combination with chlorine. By the end of 1841 ready-made preparations of this accelerator or "quickstuff" were on the market. In the same year sharper and faster lenses became widely available. The Petzval lens, first designed and manufactured in Germany, was more achromatic than earlier lenses and had less spherical aberration; it thus focused all colors, as well as light passing through various parts of the lens, to a common point. And, with the equivalent of an f/3.6 aperture, this lens cast a much brighter image than any previous design. Finally, gold chloride toning, or "gilding," of the daguerreotype plate became standard practice. This treatment increased the tonal richness and contrast of the image, while rendering the actual surface of the daguerreotype somewhat less fragile.

The theme of the daguerreotype image as nature itself, precisely and eternally preserved, runs throughout the commentary of the period. In its issue of June 15, 1842, the *Oswego County Whig* noted the visit of another traveling daguerreotypist, a Mr. Hiram Cyreuns, and praised "the powers of this wonderful invention":

> Other arts depend for their success on the skill and variable mood of the artist: but in *this*, the limner is Nature herself, acting by an unvarying law, which, when fully understood, renders every production a master-piece. No retouching is required, because no mistake is committed. The exact image is given, and the work done at a single beat. Painting and sculpture are but approaches to reality; the daguerreotype is reality itself. It is a sort of duplicate original, without flattery, without disparagement; a *fac simile* of impartial truth, 'nothing extenuating, and setting down naught in malice.'
> The Daguerreotype, moreover, addresses itself with more force than either of the elder sister arts, to the domestic and social affections, not only by its greater accuracy and fidelity, but by the convenience, readiness and frugal expenditure, by which its services may be procured. An entire family group, for instance, may be obtained for the sum which would be requisite to procure a single portrait from a first rate pencil; and thus the individual members of the precious circle of home may be collected and live on undivided through all time, in the forms of this *second presence*.[3]

This text praised the daguerreotype for its embodiment of values dear to the heart of the thrifty middle class: it was inexpensive, accurate, and quick. And, as ageless and faithful mementos of loved ones, daguerreotypes were indeed the perfect expression of "the domestic and social affections."

Young and Cyreuns were typical of a new breed of businessman: the itinerant daguerreotypist. Following the example of itinerant portrait painters, daguerreotypists such as these traveled from town to town in search of customers. Some traveled continuously; others, particularly in the latter half of the 1840s, owned fixed studios and only journeyed in search of new business during the summer. While some itinerants moved about in fully equipped studio wagons, most traveled by stagecoach, steamboat, or railroad. Once established in rented quarters in the local hotel or boardinghouse, these photographers would talk to the locals, distribute handbills, and advertise in the local paper to stimulate business. These advertisements would invariably promote the operator's expertise while encouraging customers to call without delay.

Despite the difficulties and uncertainties of this life, skilled itinerants could often earn substantial amounts of money. This was undoubtedly possible in Oswego. The daguerreotype process itself was still novel in the early 1840s, and Oswego's growing economy provided a lucrative market for an enterprising portraitist.

George Barnard's introduction to the daguerreotype has long been a mystery. Toward the end of his career Barnard stated that he had begun in the profession in 1842.[4] Unfortunately, he did not elaborate on this important event in his life. By early 1842 traveling daguerreotypists had made their way to Oneida County, and Barnard may well have seen or posed for one of these forgotten pioneers. In that year at least two itinerants temporarily set up business in Utica: C. Jackson, in February and March, and E.D. Palmer, from mid-September to mid-December.[5] In addition, Daguerre's "Magical Pictures" show (the illusionistic Diorama) played in Utica for a week in June under the direction of Messrs. Maffey and Lonati.[6] It is possible that Barnard dated his beginning in the profession to his first visit to the studio of Jackson or Palmer.

It appears considerably more likely, however, that Barnard learned the intricacies of the process from friends in Sauquoit named Leverett Bishop and Alonzo Gray. Bishop, the village's doctor, was well-educated and widely admired, a veteran of the War of 1812, and an elder in the local Presbyterian Church. Gray was the son of the village's beloved grocer, and brother of the man who performed Barnard's marriage ceremony. Bishop and Gray had run for local office together on the Whig ticket (in 1835) and were well known throughout the area.[7]

Sometime in late 1842, perhaps after a visit to a daguerreotypist in Utica, Bishop and Gray began experimenting with the process. By the first weeks of 1843 they had honed their skills by photographing dozens of the area's leading citizens. On January 28, 1843, the team announced with some fanfare the opening of a temporary portrait studio in Utica. In an advertisement that included the names of twenty-six prominent references, Bishop and Gray proclaimed that they were

> fully prepared to furnish all those who will favor them by a call and a few moments sitting, with a Fac Simile of their own identical selves taken upon the latest and most improved style of Photography.[8]

The team operated this studio for at least three weeks. Their subsequent involvement with the daguerreotype is unknown.

It is tempting to speculate that Barnard was not only aware of his friends' new interest in late 1842, but assisted them in their work. There is no evidence,

however, that Barnard practiced the daguerreotype in any active way until the summer of 1846. It is conceivable that he tinkered with the process as an amateur for three and a half years before turning to it for his livelihood. This seems doubtful, however, in the absence of evidence that he used the process in at least a part-time way during his first year in Oswego. It seems most likely that Barnard received some instruction in the process in late 1842, was fascinated by it, but remained unconvinced for several years of photography's commercial viability. This in turn suggests that his personal interests were always guided by financial practicalities.

It appears that Barnard's full-time photographic career was stimulated by (or at least coincided with) an itinerant's visit to Oswego in the early summer of 1846. Beginning on June 2, 1846, the following notice appeared in the *Oswego Palladium*.

Nature Transferred by
DAGUERREOTYPE

Mr. J.F. Becker, of New York, respectfully informs the inhabitants of Oswego and vicinity, that he has taken room No. 3 on the second floor of the Woodruff block, opposite the Welland House, and is now prepared to take *Photographic Likenesses* on a new and improved plan, which gives them the color of life, and renders them perfectly distinct and durable. Having engaged in the business some years since with the determination to excel, he has made it his constant study and practice ever since.

Ladies and gentlemen are respectfully invited to call and give his specimens a critical examination, and he assures them that his work shall be superior to any thing ever offered in Western New York, and nothing shall be wanting on his part to give them entire satisfaction.

Those wishing his services will do well to call soon, as he will remain in town but a few days.[9]

The twenty-six-year-old Barnard probably visited Becker's makeshift studio. Fascinated anew by the process's curious smells, intricate manipulations, and wondrous clarity, it is easy to imagine that Barnard's earlier interest in the daguerreotype was reborn. Given the mediocrity of his hotel business, and the steady expansion of the photographic profession, the decision to change careers came easily.

Barnard's interest in the daguerreotype was shared by other young men of his generation. The intrigue of the early process was later described with humor and fond nostalgia by James F. Ryder:

Along in the forties many daguerreotype men styled themselves "professor," and their titles were seldom questioned. It was but a step from the anvil or the sawmill to the camera. The new business of likeness-taking was admitted to be a genteel calling, enveloped in a haze of mystery and a smattering of science. The dark room where the plates were prepared was dignified by some of the more pretentious

as the laboratory. A "No Admittance" door, always carefully closed by "the professor" on entering or emerging, naturally impressed the uninitiated as something out of the usual, and when he came out carrying a little holder to his sitter and from it drawing a thin slide, revealing from under it the likeness just taken, it was no unreasonable stretch of credulity to recognize in the man something of a scientist and a professor.[10]

In Ryder's recollection, the daguerreotype's combination of science and art seemed to be nothing less than modern alchemy.

The plates used were of copper body and silver surface, upon which the image or likeness was received. The surface of the plate was carefully scoured with fine rottenstone sifted through muslin of close texture and wet with alcohol. A pad of Canton flannel with long and close nap was used as a polisher. It was next buffed with buckskin and rouge until the surface was polished as finely as a mirror. It was now ready for the chemical coating that rendered it sensitive to the action of light. The coating boxes containing glass jars carefully ground at the top, and fitted to slabs of glass also ground, which were made to slide over the top of the jars. When closed, the ground surfaces of the jar top and the covering slab fitted as tightly as stoppered bottles. One of these jars had flakes of resublimated iodine sprinkled over the bottom, from which fumes steadily rose. The other contained a mixture of bromine and chlorine, called "quick stuff," which also constantly gave off fumes. When sufficiently polished for the coating, the plate was adjusted to a small carrying-frame or kit, in the sliding cover, and was then passed over the fumes of the iodine to take its first coating. When it assumed a golden yellow color it was exposed to the fumes of the "quick," or accelerator, until it attained a rose color, then back again a moment over the iodine to secure a harmonious blending of bromo-iodine and then it was ready for exposure on the sitter through the lens of the camera. When the sitter was comfortably and gracefully posed, the light and shade properly distributed, the focal adjustment of the lens made to show clearly the features, the exposure was made. Up to this point no image was visible upon the plate, but exposure to the fumes of heated quicksilver in a bath for the purpose developed the image, and a most interesting sight it was to watch the image coming out of a blank plate and gradually revealing the form and features as they came into being.[11]

Becker's last advertisement appeared in the June 30, 1846, issue of the *Oswego Palladium*. Only five weeks later — giving him scant time to procure equipment and rent and outfit a studio — Barnard had set himself up in business as a daguerreotypist. In a brief editorial on August 4 the newspaper noted his new profession.

Daguerreotype Miniatures

MR. BARNARD, late of the Oswego Hotel, has taken a room in the Woodruff Building, adjoining our Counting Room, for the purpose of

1. Untitled Portrait, ca. 1846-50; daguerreotype; private collection

On March 9, 1847, the newspaper reported that

> Mr. BARNARD, at his room in the Palladium Building, is taking some of the finest Daguerreotype pictures, we have ever seen. They seem to us to be fully equally [sic] to Plumbe's. Mr. B. is one of our most meritorious citizens, and we hope those wanting any thing in his line will give him a call.[15]

In 1847 John Plumbe was one of the most renowned daguerreotypists in the country. He owned studios in numerous cities and had received prestigious awards for his work.[16] It was thus a great compliment for the young Barnard to be compared to him. Endorsements such as this reflected the high quality of Barnard's daguerreotypes as well as his proximity to the newspaper's offices, the journal's natural tendency toward hyperbole, and its policy of ingratiating itself to potential advertisers.[17]

Barnard's daguerreotypes were indeed of superb quality. Portraits from his Oswego studio reveal the photographer's technical expertise, his mastery of composition and lighting, and his attention to the character of his sitters. In his portrait of an unidentified young man (figure 1), Barnard used the simple detail of a hand-held quill pen to suggest his subject's sensitive, literate nature. An unusual group portrait (figure 2) conveys with brilliant clarity the individuality of four solemn, privileged children. These images suggest that Barnard was not limited by a formulaic use of props and poses. Instead, he sought a visual equivalent for the inherent uniqueness of each sitter. Unfortunately, our understanding of his daguerreotype career is severely hampered by the scarcity of portraits clearly identified as his work. While Barnard produced thousands of such images in the first decade of his career, a mere handful of firmly attributed examples are presently included in public collections.

The earliest example of Barnard's own advertising is a handbill, dated March 1847, now in the collection of the George Eastman House (figure 3). This handbill sought to allay two of the most common apprehensions regarding the daguerreotype: the discomfort of sitting for a lengthy exposure and the question of permanence. By 1847, as Barnard noted, exposures had typically dropped to five or ten seconds on sunny days. Such relatively brief exposures made even the rendering of restless children possible, if not altogether easy. The permanence of the daguerreotype came gradually to be accepted as well-processed plates were seen to retain their brilliant tones over the years.

It appears that Barnard temporarily closed his gallery during the summer, probably to permit a brief vacation or a visit to New York for supplies. It is also possible that Barnard spent some time traveling as an itinerant. Whatever the reason for his absence, the city's newspaper greeted his return on August 3, 1847.

Photographic Likenesses

Our friend BARNARD has returned to his rooms in the Woodruff block with his Daguerreotype Apparatus, for the purpose of taking

taking Daguerreotype Likenesses of such as may desire them. Some of his pictures are the clearest and best we have ever seen. He charges but $1.50, so that all can now afford to have their own and childrens' faces taken. Give him a call.[12]

The abruptness of Barnard's career shift is indicated by the fact that a weekly "Wormer and Barnard Oswego Hotel" advertisement continued in the newspaper for another month. Not until September 1 was it amended to reflect Wormer's sole proprietorship.[13]

The *Oswego Palladium* provided Barnard with regular endorsements prompted, in part, by his prominent location next door to the newspaper and opposite the city's most prestigious hotel. On September 8, 1846, the newspaper noted:

> For a beautiful Daguerreotype picture, we advise our readers to call at BARNARD'S DAGUERREAN GALLERY, No. 3, "Palladium Buildings," opposite Welland House. As perfect likeness may be had here as at any establishment in the United States. Cost, only $1.50.[14]

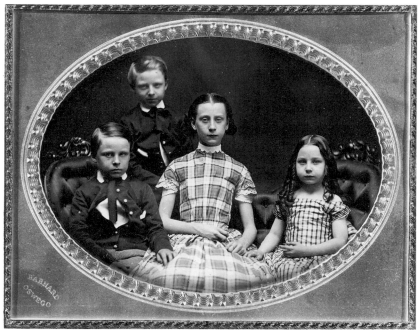

2. Untitled Group Portrait, ca. 1848-54; daguerreotype; Museum of Modern Art, New York. Gift of Mrs. Armand P. Bartos.

Likenesses, and all who wish to
 "Secure the shadow ere the substance fade"
will never have a better opportunity to do so than is now afforded them. Mr. B. is an excellent artist, and gives entire satisfaction to all his patrons, both as regards the prices and the quality of his workmanship. Give him a call.[18]

Barnard's newspaper advertisements provide considerable information on the nature of his business and the tastes of the period. On July 29, 1847, he began running the following ad emphasizing his ability to place daguerreotypes in various forms of jewelry.

DAGUERREOTYPE LIKENESSES

MR. BARNARD respectfully informs the citizens of Oswego and vicinity, that he has again opened his room in the Woodruff Building where he is prepared to take PHOTOGRAPHIC MINIATURES, unsurpassed by any artist in the country.

Persons visiting his rooms, can have their Miniature taken in this beautiful style, and neatly set in Morocco cases, Lockets, Breast Pins, &c. in a few minutes.

The best time for children, is from 9 in the morning to 1 in the afternoon, all others from 9 to 5.[19]

The use of novelty cases began in the early 1840s, and included the placement of small daguerreotypes in brooches, bracelets, and rings.

On January 16, 1848 this ad was replaced with the following variation:

DAGUERREOTYPE LIKENESSES.

MR. G. N. BARNARD

Respectfully informs the citizens of Oswego and vicinity, that he has again opened his room in the Woodruff Building, where he is prepared to take **Photographic Miniatures,** *unsurpassed by any artist in the country for life-like expression, clearness, &c.*

Persons visiting his room can have their Miniatures taken in this beautiful style, and neatly set in Morocco Cases, Lockets, Breast-Pins, &c. in a few minutes.

Heretofore an insurmountable obstacle has presented itself to the production of perfect Family Likenesses in regard to children. Mr. B. is happy to state, that this difficulty is almost entirely obviated—as the time of setting will not now exceed five or ten seconds in fair or from fifteen to twenty in cloudy weather—whereas it has formerly required nearly as many minutes.

An idea has prevailed, that, in time, these Pictures will fade, which has been fully proved to be erroneous, by eminent chymists both of Europe and this country, who give it, as their opinion, that a Daguerreotype, coated with a solution of gold, will stand any length of time, (as the impression is actually between gold and silver;) and when the public are informed that no respectable operator will send out a Picture without this gilding, they may rest perfectly satisfied.

It may be well to remark, that the Picture ought to be taken on a pure silver plate, chymically prepared, to receive the impression; and if the Camera be good, the image of the sitter will be transferred to the plate with a fidelity that no artist, however skilful, can imitate. In fact such Picture is a living resemblance of the original.

"O! what would I not give for such a memorial of my friend!" is an exclamation which none but the most culpable can utter, as the price now is no barrier to the most humble obtaining a relic so desirable and consolatory—taken separately or in groups of any number—in a style that may truly be said to yield a grace beyond the reach of art.

The best time for children is from 9 o'clock in the morning to 1 in the afternoon—all others from 9 to 5.

☞ *Instructions carefully given in the art.*

Oswego, March, 1847.

3. Studio Handbill, 1847; George Eastman House, Rochester

DAGUERREOTYPE LIKENESSES

Mr. Barnard respectfully informs the citizens of Oswego and vicinity that he still is engaged in the manufacture of those beautiful productions of art, which are so much valued and admired by all. The price is now so trifling that every person can afford to procure an accurate likeness of himself and of those whom he holds dear by the ties of association or of consanguinity. And, as "delays are always dangerous," the PRESENT should be regarded as the safest and best time to obtain such a Likeness.

"The People" are requested to call at "BARNARD'S DAGUERREAN ROOMS" in the 2d story of the Woodruff Building, and examine specimens.

N.B. Instructions in the Art carefully given.

A good second-hand Apparatus for sale cheap by cash.[20]

The last sentence may indicate that Barnard had recently updated his equipment. On November 21, 1848, the *Daily Oswego Commercial Times* announced that

Mr. *Barnard,* who has taken up a permanent residence in this City, executes Daguerreotype likenesses at his office, in the Woodruff Block, with life-like truth and fidelity. He has recently procured elegant frames and material for exhibiting, in his office, the beautiful specimens of art and skill, where may be seen to advantage many of the well known and familiar faces of our city. Mr. Barnard merits and, we believe, receives a liberal patronage. For particulars see his advertisement in our columns.[21]

Barnard's display of portraits of residents demonstrated the quality of his work, associated him with noted and influential citizens, and appealed to the vanity of those whose likenesses were featured.

Barnard's advertising strategy took a rather melancholy turn with the "Cholera" ad that began a year-long run on November 21, 1848. As tasteless as this approach might seem today, it accurately reflects the era's deep fear of contagious diseases. In the 1820s and 1830s, mumps, measles, whooping cough, chicken pox, and scarlet fever were prevalent. While less common, cholera was perhaps the most feared of all.

PROGRESS OF THE CHOLERA
Daguerreotype Likenesses

THE CERTAIN AND RAPID strides making towards this continent by the dreadful disease — the Asiatic Cholera — has awakened the deepest solicitude on the part of our most eminent Physicians, and the authorities of several of the larger cities on our sea coast most exposed (from the character of the inhabitants and the denseness of the population,) have, with a most commendable regard for the public welfare, taken the most suitable measures to avert so much as may be possible the horrors of this malignant disease. But human ingenuity and foresight in all probability will fail to erect a barrier sufficiently strong to oppose a foe so powerful and persevering in his attacks, and many "a loved familiar face" will fall before the ruthless destroyer. Sad is the thought — melancholy the reflection. A thousand fears crowd rapidly and in quick succession the minds of the paternal heads of families. To lessen the pangs of the afflicted in the hour of anguish and trials, a DAGUERREOTYPE LIKENESS should immediately be procured of every member of every family. They may be obtained by calling at BARNARD'S DAGUERRIAN GALLERY, in the Woodruff's Building, West Oswego. Persons are requested to call and examine specimens before going elsewhere.[22]

The Asiatic cholera was the "classic" epidemic disease of the nineteenth century, as the plague, yellow fever, and smallpox had been in earlier times. Cholera swept through the United States in 1832, 1849, 1866, and 1873. Barnard himself would have remembered the first of these outbreaks, which had been particularly lethal in Oneida County. The early epidemics were terrifying to the public due, in large part, to the lack of medical and scientific knowledge of the disease. There was little agreement on either the nature or treatment of cholera, and sufferers were subjected to a variety of horrific remedies. The symptoms of cholera were dramatic and frightening: diarrhea, vomiting, cramps, dehydration and chills were all too often followed rapidly by death.

Barnard's cholera advertisement reflected the public's deep fear of this frequently deadly disease. It also played powerfully on "the domestic and social affections" of "paternal heads of families" with a blunt warning to have portraits made in order to guarantee the preservation of every "loved familiar face." Barnard had particular reason to emphasize the power of paternal emotions. Only two days before the appearance of this cholera advertisement, Sarah Barnard gave birth to the couple's first child, a daughter named Mary Grace. The photographer's natural concern for the health and safety of his newborn was undoubtedly magnified by the threat of an impending epidemic. This somber advertisement thus reflected Barnard's own protective instincts and sense of mortality.

Early deaths from many causes were painfully common in the nineteenth century. A seemingly endless number of melancholy poems of the period dealt with the subject of mortality, including this characteristic effort published in the January 11, 1843, issue of the *Oswego County Whig.*

The Carol of Death

Men call me king: and well they may,
For I ride over all in my conquering way;
I cut down together the young and the old,
I stay not for beauty — I yield not for gold....

Ye call me a tyrant! and well ye may,
For I hold ye no mercy — I grant no delay,
I shall summon ye all — I list ye no pray'r!
Take heed of my coming. Beware! *beware!*[23]

The theme of the photographic portrait as a hedge against untimely death was common in the professional literature of the period. In 1855, for example, a photographer noted that

> when those we love and cherish leave us forever...who would not give all they possess for a likeness of that face...The Daguerreotype possesses the sublime power to transmit the almost living image of our loved ones; to call up their memories vividly to our mind, and to preserve not only the sparkling eye and winning smile, but to catch the living forms and features of those that are so fondly endeared to us...[24]

Barnard's "Progress of the Cholera" ad was submitted for publication on November 21, 1848, well before the epidemic reached American shores. He had been following reports of the disease in Europe, however, where it had taken a heavy toll in the summer of 1848. In the autumn of that year, as in 1832, cholera seemed poised for a leap across the Atlantic and American health officials warned of a coming epidemic. Cholera finally arrived in the ports of New York and New Orleans in early December, carried by infected travelers. The disease spread within these densely populated urban areas and inland along primary transportation routes.

After a cold winter gave New York a brief respite, the epidemic struck with full force in the summer of 1849. From mid-May to mid-August, the city of New York came to a halt as middle- and upper-class residents fled to the country. Businesses closed and hotels were nearly empty. Belated efforts at public sanitation were made: the sale of fruits, vegetables, and fish from open carts was prohibited, and filthy tenements were ordered cleaned.[25] Since cholera was spread by infected travelers, Oswego's status as a major shipping and rail terminus gave it reason for concern. Periodic editorials in the Oswego papers reported the progress of cholera outbreaks in surrounding areas, and the efforts made in other cities to cope with the problem. While cholera deaths declined dramatically in New York State in August 1849, outbreaks occurred intermittently across the country for years.[26] On July 9, 1850, President Zachary Taylor fell victim to the disease.

Barnard's business prospered in the late 1840s with the growth of Oswego. He maintained the high quality and relatively low cost of his daguerreotypes by working alone. By the time of the 1850 census his studio produced an annual "product value" of $1500. If his $1.50 per plate retail price can be taken as a guide, this would indicate the sale of up to 1000 finished daguerreotypes per year. With the added cost of hand-colored, custom-mounted, or unusually large-format daguerreotypes, Barnard's yearly total might have been closer to about 800 finished images. He probably averaged slightly over a dozen portrait sessions per six-day week, with a smaller portion of his business devoted to duplicating existing daguerreotypes. For his labors Barnard took home wages of about $40 per month. This compared favorably with the average monthly wages of other skilled workers in Oswego, including millers ($35), blacksmiths ($32), cabinetmakers ($26), farmers ($18), bakers ($23), printers ($16), bookbinders ($33), butchers ($19), sail makers ($30), and coopers ($48).[27]

In 1850 Barnard and his wife lived in a rented single-family dwelling at 105 East Fourth Street. Included in the Barnard household were the couple's infant daughter Mary Grace Barnard (born on November 19, 1848), Sarah's 48-year-old mother Mary Hodges, and Catherine Rodlin, an eleven-year-old Irish girl who probably helped with cooking and household chores. The Barnards lived in a comfortably middle-class area; neighboring households were headed by a carpenter, architect, teacher, sailor, merchant, clerk, ship captain, and grocer.[28]

With the success of his business, Barnard soon moved his gallery to larger quarters. On January 4, 1850, he advertised his relocation to 137 West First Street over E.P. Burt's store.

SKY-LIGHT
DAGUERREOTYPES

G.N. BARNARD, respectfully informs his friends and the public generally, that he has removed in his new rooms, fitted up expressly for taking DAGUERREOTYPE PICTURES, over E.P. Burt's store. He has perfected a powerful sky-light, yet so mellow that he is enabled to take the likenesses of children and all others, in a few seconds, with perfect ease to the sitter, retaining a natural expression.

Grateful to his friends and the public for the very liberal patronage hitherto extended to him, he would call their attention to his new arrangement for producing pictures by the agency of light. Hours for children from 9 A.M. to 2 P.M. Likenesses taken in Clear or Cloudy Weather, in a style unsurpassed, enclosed in neat Morocco Cases, Lockets, Rings, &c., at various prices. Likenesses of sick or deceased persons taken.

Painted or Daguerreotype Likenesses copied.

On hand a fine assortment of Gold Lockets and Fancy Cases.

Instruction carefully given, and instruments furnished.[29]

This new studio was described in a brief editorial in the *Oswego Palladium* on January 12, 1850.

JUST LIKE YOU — BARNARD has fitted up new rooms for taking Daguerrean Likenesses, over Mr. Burt's store, West Oswego. By availing himself of sky-light, he has so perfected his arrangements as to give pictures superior to any ever before taken in this city, and fully equal to any taken in this country. This is no "puff," but fact, of which good judges will testify, and any one may become satisfied by calling at his rooms. Step in — for the pretty faces of the prettiest girls in all creation are there, and it's some pleasure for one to be in such good company even for a little season.[30]

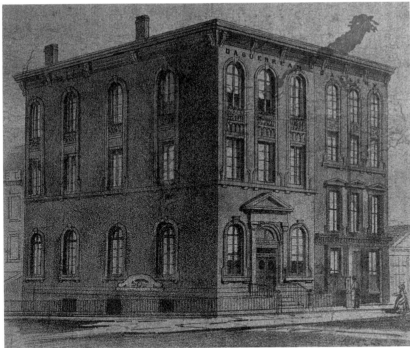

4. Unknown Artist: *City Bank, Oswego,* ca. 1852-55; engraving; Onondaga Historical Association, Syracuse

The last reference was to Barnard's display cases containing daguerreotype portraits of attractive young women and a sampling of "well known and familiar faces of our city."

As Barnard's patronage increased, he moved again in December 1852 to a studio in the new City Bank building at 147 West First Street (figure 4). This handsome brick structure was praised by the *Oswego Daily Times*: "certainly no building ever erected in Oswego, has evinced a higher degree of mechanical skill, judgment, and good taste..." The bank kept its formidable vault in the building's lower level and used the story at street level for its offices.

> The third story is fitted up with two suits of rooms for law offices. The fourth story is occupied by Mr. BARNARD, as Daguerrian rooms, for which purpose it has been splendidly fitted up with sky lights in the roof. Mr. Barnard makes a display in his new rooms corresponding with the high reputation he has won in the art of the profession. The whole establishment is lighted with gas.[31]

Barnard's "Removal" ad announcing these new quarters was first submitted for publication on December 27, 1852.

<div align="center">

REMOVAL
BARNARD'S GALLERY OF DAGUERREOTYPES
*Removed to the City Bank Building,
opposite the Welland House.*

</div>

G.N. BARNARD, would respectfully announce to his friends and the public, that he has opened as above, an elegant suite of apartments, fitted up expressly for the Daguerrean business, and provided with every thing necessary for the comfort and convenience of his patrons.

Every department of his art has separate and appropriate rooms. The operating room is so arranged as to prevent visitors from being offended at the fumes of chemicals used.

Possessing a superior LIGHT, and many years of experience, he flatters himself that he is enabled to produce as fine pictures as the art is capable of giving.

Daguerreotypes will be copied of the same size, and in most cases equal to the original.

The best times for children in clear weather is from 10 A.M. to 2 P.M. Mr. B. may always be found at his rooms between the hours of 8 and 5, where he trusts to receive a continuance of the patronage so long and liberally bestowed upon him. A large variety of plain and fancy cases, frames &c., and a fine assortment of Daguerrean goods for sale.[32]

When his clients had become accustomed to this new space Barnard changed his advertisement on April 7, 1853 to emphasize that "no pains or expense has been spared in fitting this establishment for the production of Daguerreotypes in the highest style and finish the art is capable of producing." Barnard also promoted his willingness to photograph "sick or deceased persons...at their residence, if desired."[33]

A lengthy description of Barnard's new studio was published in the January 1853 issue of *The Photographic and Fine Art Journal.*

> Mr. G.N. Barnard, the daguerrean artist, has removed to the third story [sic] of the City Bank Block. We took occasion yesterday to visit him in his new quarters, and were highly pleased with all his arrangements.
>
> The Reception Room, fronting on First and Cayuga street, is a large well lighted apartment, containing easy sofas and arm chairs for visitors, the walls being hung with excellent specimens of the art, (including likenesses of prominent citizens of this and other places) mirrors, engravings, &c., and the centre table supplied with books, where persons may agreeably while away the time passed among them. The view from this room is excellent, taking in First street as far down as the piers, &c. The view, also, from the Operating Room is one of the best to be had anywhere. But we are anticipating a trifle. Fronting Cayuga street, and leading from the room just mentioned is a Toilet Room for the use of visitors preparing for a "sitting." Mr. Barnard has here supplied a want which we opine will be appreciated by his hosts of friends. The Operating Room is at the other end of the building, and is reached by a passage, where the attention of persons need not be attracted by "noise and confusion" which may occur in the other apartment. The sky-light is very large — fully large enough to let in all the daylight outside, or so adjust as to admit all thereof that is needed. Adjoining this, and entered from the hall, is an apartment

for the disposing of surplus wares, &c., of which he has enough to last him for some time, should communication between this city and New York be cut off by some unforseen cause. On the opposite side of the hall, in a room for the purpose, Chemicals, &c., are kept. This arrangement will be appreciated by those to whom the fumes, arising in the preparation of plates, are offensive. The light admitted into this room is a sort of mellow *twilight* — just the quality desired by the artist. Mr. Barnard may well be satisfied with his suite of rooms. Everything is arranged with an eye to taste and convenience, and though in the hurry of moving he has not been able to have all thing[s] *just* as he desires, we think his facilities for operating are not excelled this side of New York.

Of Mr. Barnard's ability to please as an artist, we do not intend to speak. His reputation is established, and nothing we can say will add one title to what he already possesses.[34]

This description of Barnard's gallery emphasized its cleanliness, comfort, and tastefulness. From its inception the daguerreotype studio business demanded a wide range of talents from its practitioners. Owner-operators such as Barnard needed mechanical aptitude and a rudimentary knowledge of chemistry, as well as the more intangible skills of artistic judgment, business acumen, and an understanding of the public. This occupation depended to an important degree on impressions: both the optical impressions produced by the camera, and those of respectability and congeniality conveyed by the artist's rooms and personal demeanor. Successful operators strove to make their establishments tasteful but not intimidating, and to make the experience of posing a positive one for customers.

It was not always easy to be gracious and solicitous, as a lengthy 1851 essay in the *Daguerrean Journal* titled "Life in the Daguerreotype: The Reception Room" makes clear.

With the thermometer ranging at 90 and 95, there are few more arduous employments than the necessity of rendering yourself agreeable to strangers — of being affable when you wish to be passive, and of ministering intellectually to others, when you feel the stock for home consumption lamentably small. This excessive weather is not favorable to mental growth, though possibly it is wisely adapted to germination in the agricultural world. I take my seat with indifference, to await the first arrival; perchance to speculate, in the interval, on how trade will be effected by our "showcase" at the door...

The author, identified only as Y.T.S., goes on to describe the variety of customers in a typical day: an unsophisticated elderly couple with their unmarried daughter, an impatient businessman, an "Alabama planter and matron" with their noisy "tribe of little ungovernables," and a demure young lady with "dreamy eyes."

Some hours more given to transient visitors and those who enjoy pictures; some moments, perhaps, to quiet reading, and my day's work is done. The twilight gathers, and the hour of thought begins, in which I retrospect the day. There is no calling but may be dignified by

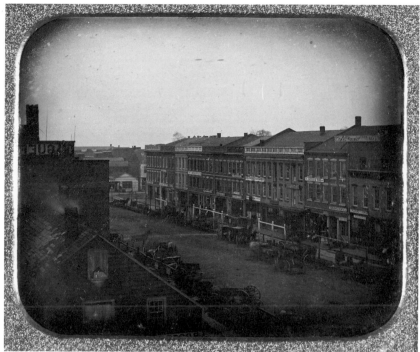

5. *West First Street, Oswego*, ca. 1853; daguerreotype; Canadian Centre for Architecture, Montreal

proper self respect in those who follow it. It is not my place to sell pictures only, but to deal kindly with those who come within my influence; to give pleasure where it is possible and a wise encouragement to the timid. There is no better field for the experience of the true charities of life, than the reception room, and he has little respect for *Art*, who has none for humanity.[35]

Barnard shared these sentiments and knew that the art of daguerreotypy depended as much on his understanding of people as on technical ability alone.

It was probably from the reception room of this new studio over the City Bank that Barnard made a daguerreotype of West First Street in early 1853.[36] While the case of this image bears no identifying imprint, it is likely that Barnard made the photograph shortly after his occupation of the new rooms. This daguerreotype (figure 5) presents a mirror image view of the street looking northwest toward the lake. The sign on the left reading "DAGUER[REOTYPES]" marks the studio over E.P. Burt's store that Barnard had just vacated. It may be suggested that Barnard commemorated his move by depicting from the window of his new studio both his earlier quarters and the thriving street he knew so well. For Barnard, this scene represented his professional progress and the economic vitality of his community. It may also have been intended as confirmation of the *Oswego Palladium's* statement that "the view from [the Reception Room] is excellent, taking in First Street as far [north] as the piers..."

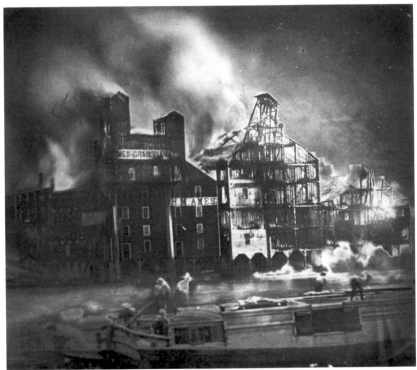

6. *Burning Mills, Oswego*, July 5, 1853; daguerreotype; George Eastman House

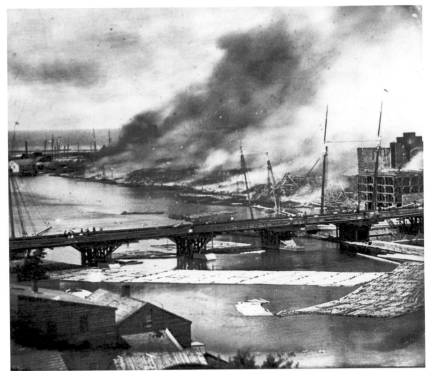

7. *Burning Mills, Oswego*, July 5, 1853; daguerreotype; George Eastman House

Due to the complications of the process and the studio-based nature of the portrait business outdoor daguerreotype views are rare. However, Barnard's unusual interest in such images is confirmed by his remarkable photographs of the great Oswego fire, taken only months later. On the morning of July 5, 1853, a devastating fire broke out on the east side of the Oswego River. While earlier fires had plagued Oswego (for example, on November 29, 1842, and July 30, 1850), this blaze quickly turned into an unprecedented inferno. Under the headline "Terrible Conflagration, A Sad Day for Oswego," the newspaper for that day summarized the disaster in breathless style:

A fire broke out this morning about 11 o'clock, in Fitzhugh's & Co's flouring Mill on the East side, the wind blowing strong from the west, it spread with astonishing rapidity, sweeping every thing before it, till nearly the whole of the 2d Ward of the city is a mass of ruins, covering at least 45 acres.

All the Mills and Elevators on that side are destroyed.
2000 people are without shelter for the night.
The loss is roughly estimated at $1,000,000.
Large amounts of Grain, Flour and Merchandise in store [were] consumed in the Mills and Warehouses.
The scene was terrific beyond description.

The streets and Public Square are crowded with property and groups of homeless women and children with guards patrolling to prevent theft. This is the direst calamity which has ever visited us, and will be a terrible blow to the city. The fire is still burning (4 p.m.) tho' its progress is stopped and several fire companies from abroad with our firemen, are working bravely to extinguish it. The fire originated we believe from friction in a smut machine.[37]

Barnard took his camera outside to make at least two views of this terrifying spectacle. The first photograph, taken shortly after the fire was discovered, was made from the head of West Cayuga Street one block east of Barnard's new studio, looking southeast across the river toward the Ames and Doolittle mills (figure 6). The second view was taken a short time later from a rooftop position two blocks south of his studio near the head of West Oneida Street, looking northeast (figure 7). This latter view conveys the extent of the destruction along the riverbank from the center of East Oswego north to the harbor. Six days later Barnard again ventured outside to record the charred aftermath of the blaze. Copies of the first two of these historic daguerreotypes were acquired by the George Eastman House in 1962. It is not known if the third of these images is now extant.

On July 12 the Oswego newspaper took note of these pictures.

Views of the Late Fire. — Mr. George Barnard, Daguerrian artist,

over the City Bank, has shown us several views of the late fire, which are the prettiest things imaginable. The first is a view of the fire just as the top of Mr. Doolittle's elevator was falling, and the flames were entering Mr. Ames' building. The next is a view of the smouldering ruins on the docks, and the other is a panoramic view of the whole ground as it appeared yesterday morning. It will repay the admirer of the fine arts to step into Mr. B's rooms and take a look at these pictures. Mr. Barnard offers copies for sale — see advertisement.[38]

For two months following July 12 Barnard ran the following ad promoting the availability of these images.

PICTURES OF THE LATE FIRE. DAGUERREOTYPE PICTURES of the late fire taken while burning, may be obtained at Barnard's Daguerrean Rooms. These pictures are copied from large pictures and are faithful representations of the different stages of the fire as it appeared on the 5th. Also views of the Ruins as they now appear.[39]

The small (2¼x3¼″) plates in the Eastman House collection are reduced copy-daguerreotypes made for public sale from Barnard's larger originals. Since they are "mirror images" of the original, laterally reversed daguerreotypes, these smaller plates read correctly. The daguerreotype of the Ames and Doolittle mills is delicately hand-colored, with crimson pigment added to the flaming buildings. As the newspaper noted, these plates had historic as well as aesthetic importance and were praised as both "faithful representations" and "the prettiest things imaginable."

It is significant that Barnard made these images on his own initiative and then sought an audience for them. A leading historian has termed these among "the earliest news photographs in existence."[40] While this is unquestionably true, it does not appear that these extraordinary images were reproduced in the press in any form. Thus, while documents of a newsworthy event, they are not technically part of the history of what is now termed photojournalism. Nevertheless, Barnard's marketing of these images is fascinating and historically significant. Given the tragic nature of the fire and its impact on Oswego, one wonders how many copies were sold in the weeks following the blaze.

I:3 The Profession Matures: The Daguerreotype in the early 1850s

The daguerreotype profession grew steadily in the late 1840s and early 1850s, giving rise to a complex network of personal and business relationships. By the early 1850s Barnard had achieved national prominence in this burgeoning field. He was an active member of important professional associations and won consistent praise for his work. Barnard's talent, integrity, and character made him a respected member of the rapidly developing photographic fraternity.

While the daguerreotype had become an accepted facet of American culture, the very growth of the field and the nature of this public acceptance became cause for some concern. As many as 2000 operators may have been in business by 1850, a drastic increase since Barnard's entry into the profession four years earlier. This army of operators produced an extraordinary number of daguerreotypes, including three million in the peak year of 1853. In 1855 the state of Massachusetts alone recorded an annual total of 403,626 daguerreotypes produced by its 134 resident operators and 260 assistants.[1] This chapter will examine the motivations of daguerreotypists of this era as they sought social respectability and artistic excellence while coping with increasing competition and economic pressures.

While Barnard remained the leading daguerreotypist in Oswego, he was well aware of the problems of competition, particularly from poorly trained operators. On August 31, 1847, for example, the following ad ran in the *Oswego Palladium*.

Daguerreotypes — Mr. Kennedy would respectfully inform the ladies and gentlemen of this place that he has taken rooms in the Eagle Block, where he is prepared to take Daguerreotype likenesses. He does not recommend himself to be the best Daguerrean artist in the country, but if they will call and he does not give them satisfaction so as to get their money, he pledges himself to be sorry.
Also Surgical instruments and Razors put in order on reasonable terms.[2]

While Mr. Kennedy's limited talents were shared by many of photography's early practitioners, the number of skilled professionals was also increasing steadily. In the early 1850s several reputable operators, including Tracy Gray, opened new galleries in town.[3] At the same time, photographers from Syracuse and even New York City began advertising in the Oswego papers. As daguerreotype galleries proliferated, clever ways of increasing business were sought. In 1853 an Oswego haberdashery ran an ad headlined "DAGUERREOTYPE HATS!" promising each buyer a "LIKENESS FREE OF CHARGE, neatly inserted into the lining" of

every new hat.[4] The increasingly competitive climate in the city was described in 1850 by local daguerreotypist James W. Scott, who stated that there "exists between artists a spirit of rivalry and animosity, which is often turned into the most deadly hate."[5]

The pressure to lower daguerreotype prices stemmed from a variety of economic and social factors. Declining prices dominated most segments of the economy in this period; consumer prices fell steadily from 1837 to 1849, then stabilized until 1853 at the lowest levels of the century.[6] Between 1845 and 1853, the years in which the daguerreotype profession reached maturity, the consumer price index in America fell by about eleven percent while the prices paid for wholesale goods by businessmen and manufacturers rose by seventeen percent.[7] This anomaly caught many small businesses in an economic pinch and produced years of relatively thin profits.

Given the downward trend of prices in this period, and the increased ease of the daguerreotype process, it was natural that an effort was made to extend business further into the lower-middle-class population. It is important to remember that, as moderate as the cost of a daguerreotype may have seemed in comparison to a painted portrait, the expense was still substantial. Prices for a custom-made sixth-plate (2¾x3¼") daguerreotype portrait ranged between about fifty cents at a cut-rate establishment to a high of five dollars at the prestigious Boston studio of Southworth and Hawes.[8] The most common price for a sixth-plate portrait at a respected establishment such as Barnard's was $1.50, with an extra charge for hand-coloring or a particularly fancy case. At this time skilled workmen such as masons, stonecutters, painters, machinists, and printers earned an average of $1.50 to $2.00 per day. The usual nightly rate in a first-class hotel (with all meals included) was $2.00, with the finest hotels charging $2.50. One dollar and fifty cents represented the weekly rent for a typical four-bedroom house in Oswego, and 15% of the value of an ounce of gold.[9] Thus, the $1.50 daguerreotype of the early 1850s was probably "worth" no less than $60 to $80 in today's currency.

The increased competitiveness and stiff economic climate of the period created concern for all daguerreotypists. The standardization of each step of the process allowed some operators to produce small, undistinguished portraits for as little as twenty-five cents each. The anger of established operators toward such competition is conveyed in an 1853 statement by Mathew B. Brady.

Address to the Public — New York abounds with announcements of 25 cent and 50 cent Daguerreotypes. But little science, experience, or taste is required to produce these, so called, cheap pictures. During the several years that I have devoted to the Daguerrean Art, it has been my constant labor to perfect it and elevate it. The results have been that the prize of excellence has been accorded to my pictures at the World's Fair in London, the Crystal Palace in New York and wherever exhibited on either side of the Atlantic...

Being unwilling to abandon any artistic ground to the producers of inferior work, I have no fear in appealing to an enlightened public as to their choice between pictures of the size, price, and quality, which will fairly remunerate men of talent, science, and application, and those which can be made by the merest tyro. I wish to vindicate true art, and leave the community to decide whether it is best to encourage real excellence or its opposite; to preserve and perfect an Art, or permit it to degenerate by inferiority of materials which must correspond with the meanness of the price.[10]

Many of the profession's established figures attempted to discourage low-cost daguerreotypists from entering or remaining in the field. The resistance to such operators was usually couched in aesthetic terms by using the themes of excellence, "true art," and the elevation of public taste. In the view of many gallery owners inexpensive work was inherently inferior and thus a challenge to the standards and respectability of the profession. These lofty sentiments were deeply felt and frequently voiced. However, this antagonism stemmed fundamentally from the economic threat posed by high-volume operators to established galleries with higher technical standards and overhead expenses.

Leading members of the profession responded to this competitive pressure by organizing a self-regulatory body. On July 12, 1851, Barnard attended a meeting in Syracuse of some thirty noted photographers who proposed the establishment of a new group, The New York State Daguerreian Association. As reported in *The Daguerreian Journal*,

Remarks were made by D.T. Davie, of Utica, P.H. Benedict, of Syracuse, and G.N. Barnard, of Oswego, stating that the object of the convention to be a union of thought, action, sentiment, a uniform standard of prices, and to devise means to elevate the beautiful art in which we are engaged.

Barnard participated in the drafting of a statement of purpose that was adopted unanimously by those in attendance. This resolution denounced the "many imposters [now] flooding our country with carricatures at a much less price than a good picture can be afforded." In order to provide "fair compensation" for the nation's worthy daguerreotypists it was resolved that: an association be formed with a constitution and by-laws; that, in the name of cooperation and mutual assistance, "all feelings of envy and jealousy be put aside"; and that all operators be discouraged from giving lessons to those without "natural talents and moral standing."[11]

At the second meeting in Utica, on August 20, 1851, it was further resolved that "no person be admitted as a member of this association who will not agree not to take pictures for less than *one dollar and fifty cents*." At this meeting Barnard was appointed to a committee on "Position" and to another to secure a site for the national convention in New York City.[12] At the group's meeting of November 11, 1851, at Brady's New York City studio, Barnard presented his report on "Position"

and was officially thanked for his efforts. He was then appointed to a committee "to attend to printing the Constitution and By-laws", and to a committee on "Light."[13]

At the next two meetings of the association Barnard presented formal papers on the subjects of "Light" and "Taste" (see Appendices A and B). The paper on "Light" was composed by Barnard with a committee of association members. It was general in scope and deliberately avoided "high scientific ground" in favor of "ideas of a more practical character." After stressing the unique "combination of art and scientific skill" required by the successful daguerreotypist, Barnard described the construction of skylights, the colors of window glass, and the placement of sitters.[14]

In contrast to the committee-written tone of "Light," the essay on "Taste" appears to have been written largely, if not exclusively, by Barnard. This lecture centered on the familiar theme of the elevation of photography while suggesting the breadth of Barnard's own interests and influences. In the course of the talk he quoted John Ruskin on public taste and Gilbert Stuart on the extensive study required for artistic success. Barnard also made reference to the "striking views of the Crystal Palace and its contents" (probably by Nicholas Henneman, C.M. Ferrier, and Hugh Owen)[15], and to a painting by Van Dyck in Dresden. The latter, a portrait of Martin Engelbrecht, was seen to exemplify the ability of the masterful artist to transcend his subject matter, and to infuse the "soul of intellect" into his work.

Barnard's talk focused on the need to elevate photography to the status of painting and sculpture. To achieve this new respectability it was necessary to reinforce a view of the photographer as not merely a "mechanical operator with the camera" but a "talented artist [and an] educated and devoted man of science." Barnard called upon the profession to rescue the medium "from the hands of quacks and charlatans" so that photography could achieve the higher aims of "ministering to the necessities of mankind." The "true Daguerreotypist," in Barnard's view, held a rare combination of talents: "...he should be a skilful chemist, profound in natural philosophy, or at least that portion embracing the laws of light and the theory of color, and...he should be a cultivated artist." He observed nationalistically that the "natural advantages" of American culture were to be seen in the technical perfection of the nation's best daguerreotypists.

Given the sophistication of this manipulatory skill, however, Barnard stressed the need for a larger awareness of artistic judgment and taste. He noted that, "after distinctiveness or clearness the chief beauty of a picture depends upon the skilful arrangement of the drapery, the tasteful introduction of adjuncts, [and] the artistic disposition of the sitter, or the grouping." Such arrangements derived from "fixed principles" that could only be grasped after dedicated study and application. These timeless and "well defined laws..., if correctly understood and strictly adhered to, give the work an intrinsic excellence recognized in all ages." Without such guiding principles the daguerreotypist would fall prey to the fitful whims of public taste and the vagaries of fashion.

Barnard praised "the patient investigations, the devotion [and] tireless energy" expended by his peers in the pursuit of artistic excellence. He noted that these efforts were little recognized or appreciated by the public due to the medium's ubiquity and utility. However, he reminded his listeners that photography had helped create a new visual sophistication in American culture, with a resultant increase in the distribution of fine paintings and engravings. In words that now seem to foreshadow Edward Steichen's 1955 exhibition, "The Family of Man," Barnard exclaimed:

> How much does the multiplication of pictures tend to enlighten and unite the Human family! Read and understood by the infant and the aged; scattered from the hovel of the poor to the palace of the great, [this multiplication] extends a humanizing influence wherever it goes.

But these noble and spiritual goals could only be achieved by artists devoted to "a correct standard of Taste" that would "unite the True with the Harmonious and Beautiful." Recognizing that "the field for the exhibition of this developed taste in portraiture of the smaller sizes is difficult," Barnard suggested that photographers expend their highest creative energies on large-scale compositions. On these larger plates the photographer "can show something more than the trick of making a clear and well defined picture: he can exhibit indications of a good judgment and cultivated taste combined with scientific knowledge." Barnard called for his fellow daguerreans to aspire to "genius" and to endeavor to import the "soul of intellect" into their work. He concluded by saying,

> Such is the spirit I would hope to see diffused among our artists;...I would see science wedded to Art, with Truth and Beauty as their Handmaids and our profession soaring above the merely mechanical position which it now holds, aspir[ing] to a place among the higher branches of employment and the Daguerrean ranked as he deserves among the noble, intellectual and humanizing employments of the age.[16]

These idealistic sentiments were an integral part of a daguerreotype aesthetic rooted in an unquestioned faith in the camera's objectivity. In an age that generally considered art as "truth to nature," photography took on an important didactic function as an unimpeachable source of visual information. It was further accepted that the process's transparent clarity and relatively low cost made it a medium of universal communication. The precise and accessible visual language of the daguerreotype seemed the perfect expression of a progressive, democratic society.[17]

The instruction provided by the daguerreotype was seen to have profoundly moral potential. As Marcus A. Root noted, "the great and the good, the heroes,

8. *Mary Grace Barnard*, ca. 1855; salt paper print, probably from daguerreotype original; Onondaga Historical Assocation

It was universally agreed that technical excellence was essential to a successful professional practice. "Taste," however, lay on a higher plane than craft alone, and represented the difference between professional competence and the art of daguerreotypy. Taste stemmed from the artist's innate sensitivity and intelligence, in combination with his experience, self-discipline, and careful study.

A daguerreotypist's art was revealed in the flattering use of light and shade, graceful posing of the sitter, and judicious placement of accessories. These compositional elements were expected to cohere in a harmony of pictorial, psychological, and narrative resolution. It was understood that this unity depended on the portraitist's sensitivity to the deeper essence of his sitter's personality. This rather Platonic notion resulted in images that — to critical twentieth-century eyes — may seem blandly passive and idealized, suggesting few "interesting" anxieties or contradictions. However, the standards of daguerreotype portraiture reflected fully the era's desire for scientific objectivity and its faith in the possibility of personal and social perfection.

These concepts were promoted in the influential writings of the British critic and theorist, John Ruskin. Ruskin's *Modern Painters* (1843-46), for example, created a "sensation" among the American art community of the period.[19] His emphasis on precise observation was seen as an endorsement of photography's unique mimetic strengths. Ruskin's theories braided art, morality, and religion together in tight unity. Art, in his view, was based on a meticulous description of reality but reached its highest goal in the rendering of ideal form and the communication of great truths of religion and the conduct of life. Barnard's understanding of these views placed him among those Americans with an active interest in the theory and meaning of art.[20]

Despite these grand sentiments and ambitions, it was widely acknowledged that the camera's mechanistic nature rendered it artistically inferior to painting and sculpture. Indeed, many daguerreotypists saw their medium's ultimate calling in its service as a "handmaiden" to the older arts. As suggested in the conclusion of Barnard's essay on "Taste," there remained a fundamental desire to transcend the "merely mechanical" in order to achieve the highest levels of social status and moral influence. Consequently, much of the commentary of the period attempted to overcome the profession's own feelings of artistic inferiority and the public's belief in the bald literalness of the process.

Barnard participated enthusiastically in the activities of the New York State Daguerreian Association. Most of his peers, however, quickly lost interest in the group and a May 4, 1852, meeting in Rochester was poorly attended. Barnard tried to write an upbeat summary of this meeting for H.H. Snelling, the editor of *The Photographic Art-Journal*, in New York.

Friend Snelling — There not being any of the N.Y. Daguerreans present at our meeting in Rochester yesterday, I hasten to give you a short notice of that gathering. Although there were few in number, it

saints, and sages of all lands and all ages are, by these life-like 'presentments,' brought within the constant purview of the young, the middle-aged, and the old." Pure, high, and noble thoughts were thus instilled in "the impressionable minds of those who catch sight of them at every turn."[18] While a product of intellect and technology, daguerreotype images were seen to command a special power over the emotions. Their seemingly magical depiction of loved and revered subjects appealed directly to the thought, sentiment, and memory of each viewer. By its nature, the process represented both a unifying communal language and a touchstone for the most subjective feelings. These concepts are evoked in Barnard's sensitive daguerreotype portrait of his daughter Mary Grace (figure 8). This image (which unfortunately survives only as a paper print) represents an eloquent synthesis of Barnard's artistic aspirations and personal feelings.

was one of the best meetings we have ever had...every member present felt himself perfectly at home — a freedom which I have never before seen exhibited in our fraternity....

Our association is bound to flourish, but I regret your N.Y. operators take so little interest in it... How much good might be done if every operator would feel enough interest in associations of this kind to become members and spend one or two days in the year meeting together and exchanging ideas, bringing in note of their discoveries, &c.....[21]

Snelling concurred with these sentiments, hoping that a "well organized society" would encourage the enforcement of standards that would "make the art truly respectable" and thus capable of securing "a high position either in society or the arts."[22]

In his capacity as secretary of the organization, Barnard tried to stimulate interest in the group's May 1853 annual meeting in Auburn. On April 10 of that year he wrote H.H. Snelling,

...Let us have a full representation from all parts of the State as this will be a meeting of the greatest interest. Every member of the association will, by a resolution passed at the last meeting, bring or send a specimen of their skill, which collectively will present a point of great attraction. It is expected that some specimens of extraordinary nature and interest will be exhibited there.[23]

Later that year Barnard again attempted to coordinate a display of daguerreotypes for an exhibition in New York City. Acting upon the members' wishes to have their works beautifully presented, Barnard ordered a special "ornamental frame" from one of the best frame makers in the state. But the promised submissions did not arrive. On the eve of the exhibition Barnard had received "only four pictures from three artists with the promise of two more when the frame arrived in New York." In a letter to Snelling, Barnard stated with exasperation that this total, "for a frame calculated to contain not less than fifteen pictures, was utterly ridiculous."[24]

The failure of this effort was frustrating because it reflected the profession's lack of unity, discipline, and pride. Another opportunity to publicly celebrate the skill and artistic judgment of photographers had been lost. Even more distressing, however, the inability to stage relatively modest displays such as this rendered more ambitious plans all but impossible. Barnard, for example, was one of the leading proponents of a "central collection or State gallery" dedicated to the preservation and permanent display of the art of photography. Barnard had hoped that professional interest in such a collection would grow naturally from the success of smaller, temporary exhibitions. Tragically, this farsighted concept never was realized, and our understanding of the art of the daguerreotype era has suffered accordingly.

Not surprisingly, the New York State Daguerreian Association ceased to exist by the summer of 1854. The organization had been an unsuccessful attempt by smaller, upstate photographers to change the basic nature of the profession. The group tried to curb competitive instincts and personal animosities in order to form a voluntary confederation. Little had been accomplished, however, beyond the airing of selected issues and the development of a sense of camaraderie among certain individuals.[25]

The problem of declining prices, a major reason for the association's inception in 1851, was to remain unsolved. Thirty years later, in 1884, J.F. Ryder stated emphatically in an article on the "Business Management of Photography" that "the curse of our business is this curse of low prices."[26] But professional competition, technical changes, shifts in public taste, and a variety of economic factors made it impossible for photographers to turn the clock back to the seemingly simpler days of the 1840s.

While the association never took on much significance for the profession, the photographic publications of the period were extremely important. These included *The Daguerreian Journal* (1850-51) and *Humphrey's Journal* (1852-68), edited by Samuel D. Humphrey; *The Photographic Art-Journal* (1851-53) and *The Photographic and Fine Art Journal* (1854-60), edited by H.H. Snelling (who also worked as Edward Anthony's general manager from 1847 to 1857); *The Philadelphia Photographer* (1864-88), edited by Edward L. Wilson; and *Anthony's Photographic Bulletin* (1870-1902). These publications presented news, technical information, and aesthetic concepts to a widely dispersed audience of professionals, and served as a common forum for discussion and debate. The approach and ambitions of these publications were extraordinarily broad. Information on the activities of noted American photographers was woven into a complex editorial mix of aesthetics, technique, natural science, foreign news, art history, and criticism.

The early years of the Humphrey and Snelling journals, for example, included pieces on the pendulum as proof of the earth's rotation, the electric telegraph, the sponge business, the lunar surface, the history of the diving bell, the discovery of gold in California, the speed of light, and profiles of artists or writers including Tintoretto, Albrecht Dürer, Frederic E. Church, Hubert Robert, and John Ruskin. Articles with such titles as "Geographic Distribution of Animals in California," "Description of Samples of Ancient Cloth from the Mounds of Ohio," "The Düsseldorf School of Painting," and "Poetical and Artistic Conceptions of Death" were included. In addition to essays on the photography of mountains, or photography through the microscope were nuts-and-bolts discussions of studio techniques, chemical manipulations, and issues of legal or financial interest.

The columns of these publications provided an active forum for the exchange of practical information and a sense of fraternal union. This 1852 letter from Barnard

is characteristic of the information exchanged in the journals, and of Barnard's generosity with trade techniques.

I was much pleased with a letter from N.G. Burgess, Esq., published in the July No. of your Journal, detailing the experiments and success of Mr. Geo. S. Cook, of Charleston, in copying a daguerreotype [to] eight times the size of the original. In accordance with Mr. B's suggestions I beg to add my mite to the general stock of information on the subject. Copying pictures has become a large share of the daguerrean business, and is constantly increasing, and it is well to bring this branch of the art to perfection as soon as possible.

Near the close of his letter, Mr. Burgess indulges in the belief "that there certainly can be some new arrangement of camera boxes whereby the light can be made to fall upon the original so as to avoid all reflections and produce copies equal to the original."

The chief difficulty in making copies has been that the copy is produced in a much lower tone — that is, the lights and shades are much weaker — and that, in the copy, the lines are not so sharp and distinct as in the original. The freshness and brilliancy of a fine tone daguerreotype I fear can never be imparted to the copy, but we can produce one as clear, distinct and strong as the original; further than this cannot be expected of us.

In my process I use a whole sized 6½ x 8½" camera with an aperture in the diaphragm about the size of a dime, and I place the picture to be copied directly in the sunshine, by which all reflections will certainly be avoided — because the direct light is stronger than the reflecting lights.

Reducing the size of the aperture in the diaphragm produces the sharpness and distinctness of the original, and in aid to this, and to obtain the same strength of light and shade, I use a smaller quantity of bromide in the preparation of the plates. Others may have adopted this process, but I believe that it is not generally known...[27]

The journals emphasized the virtues of craftsmanship and aesthetic refinement valued by leaders in the field and considered essential to a successful photographic practice. To encourage these qualities, competitions were held and leading daguerreotypists were encouraged to submit works for judging. Photographers such as Barnard were happy to participate, expecting that any honors received would contribute to their professional reputation and business success. In May 1853 *The Photographic Art-Journal* reported that "most of our best artists are making every preparation for the exhibition of their skill at the World's Fair. With such names before us as Hesler,...Meade,...Barnard, Whitney, Davie, Root, Brady, Lawrence, Piard, Gurney, Harrison...there might be such a display of exquisite daguerreotypes as the world never saw..."[28]

Barnard's stature in the field of early American photography is reflected in his selection as one of ten leading daguerreotypists to compete for the Anthony Prize, a $500 silver pitcher offered by the noted New York photographic supply house of Edward Anthony and Company. For this important competition Anthony assembled a most prestigious jury: inventor and painter Samuel F.B. Morse, scientist John W. Draper, and architect and engineer James Renwick. In addition to their many other achievements, Morse and Draper were celebrated pioneers of American photography. Renwick had employed Anthony as a daguerreotypist on his 1840 survey of the U.S.-Canada border.[29]

Each of the ten entrants submitted daguerreotypes in four unusually large sizes: full plate, two-thirds plate, half-plate, and quarter-plate. After considerable anticipation the jurors met on November 15, 1853, to review the submissions. Upon deliberation, first prize was presented to Jeremiah Gurney, probably the finest daguerreotype craftsman in the country. Samuel Root, in second place, received two silver goblets. Barnard, Gabriel Harrison, Alexander Hesler, S.K. Warren, and J. Brown all received honorable mention.

With only two exceptions, the works submitted for the Anthony Prize were straightforward studio portraits. Gurney's winning entry, for example, included a hand-tinted plate of a mother and child exemplifying the ideals of the studio practice of the period. In its article on the prize, however, *The Photographic and Fine Art Journal* praised the imagination shown by Barnard and Harrison, neither of whom had won the top awards. For H.H. Snelling, the editor of the *Journal*, artistic conception was of far greater significance than mere technical and commercial perfection. For this reason Barnard's *Woodsawyer, Nooning* was chosen for the frontispiece of this issue of the *Journal* rather than images by the first or second prize winners.

...we trust it will not be deemed out of place to say a few words in regard to the pictures contributed. Of the whole forty daguerreotypes, but two were compositions — all the rest were portraits — a class of pictures rendered more easy to perfect, on account of the continued practice, and consequently apt experience of the manipulator. We therefore look upon the man who can step aside from the beaten track, and produce an artistic composition, worthy of honorable mention, superior to him who can simply produce a perfect portrait, just in proportion as that composition is more difficult and artistic. The two daguerreotypes just alluded to, the "Infant Saviour" by Gabriel Harrison, of Brooklyn, L.I., and the "Woodsawyer's Nooning", by George N. Barnard, of Oswego, N.Y., the latter of which is almost perfect...

We must also express our astonishment that men whose talents are so fully equal to the attempt, should neglect this opportunity for giving to the world specimens of their skill in compositions; there is no merit in these men taking a good portrait; their reputations are fully established in this branch. We are grievously disappointed in the result of Mr. Anthony's generous movement for the elevation of the art.

All four of Gabriel Harrison's contributions to the Anthony competition bore highly allegorical titles: *Young America, Helia, or the Genius of Daguerreotyping,*

Mary Magdalene, and *The Infant Saviour Bearing the Cross* (figure 9). Through his use of busts, drapery, and reference to elevated subjects, Harrison sought to liberate photography from the concerns of mere craftsmanship and commerce. These important early examples of American art photography are at once theatrical, sentimental, and boldly innovative.[30] Of his *Infant Saviour,* Harrison confidently wrote:

> This superb ideal picture of the "Saviour of the World," is taken after the style of the old master, and is equal to the richest engraving ever issued in mezzotint. It represents with great fidelity the sweetness of features supposed to be the distinguishing trait of the infant Jesus, as in anticipation of the lingering agonies of death afterwards endured... The cross is borne upraised, while the future sufferer, by a look of unequalled sweetness, seems to utter the words, "Father, forgive them; they know not what they do!" It has always been thought a beautiful conception by artists, and has long been a favorite theme among the most able and talented. The anatomical correctness of form is beautifully preserved in the daguerreotype, and as a picture, is well calculated to excite the admiration and awe of those who love the ideal, and can appreciate a work of excellence.

While Harrison and Barnard alone produced artistic compositions, their works were very different. Barnard's highly praised *Woodsawyer, Nooning* pictured a genre scene recreated naturalistically in the studio (figure 10). While Harrison portrayed sacred and philosophical subjects in idealized human form, Barnard paid loving tribute to a vignette of everyday life. Included in the *Journal's* article on the Anthony prize was a brief technical explanation by Barnard and a poetic interpretation by an unnamed friend.

MR. BARNARD'S PROCESS

Oswego, Oct., 1853

Mr. E. Anthony: The whole size picture is made to represent a "Woodsawyer, Nooning." It was made in my room by sky-light, on a [French] scale plate. The chemicals used were common dry iodine in one box, bromide of lime in the other box; these were the only chemicals used in the coating of the plate. In developing over the mercury I gave about two moments with the thermometer at 80°.

The above description will answer for the other three, as they were all made with the same process, only different arrangement of light. The two-third picture is made on a scale plate. The half and one-fourth on Scovill's. If you wish any more explanation, I will give it to you at any time after the decision of the judges; this I know is imperfect, but I have but a few moments to write it.

Yours, respectfully.

GEO. N. BARNARD

I enclose you a little notice or description of the large picture by a friend by my side:

This picture is on a large sized plate, and will attract more than a

9. **Gabriel Harrison:** *The Infant Saviour Bearing the Cross,* 1853; daguerreotype; George Eastman House

causory glance; combining more of life and spirit, and a stricter attention to artistic rules than usually falls to the lot of a daguerreotype. It represents an aged Canadian Wood-sawyer and his son, surrounded by the instruments and objects of their labor, enjoying their noon-tide meal. The rude table upon which their frugal repast is spread, is composed of a piece of plank, one end supported by the saw-buck, and the other resting on the top of a wheel-barrow.

The old wood-sawyer is sitting on the buck, and on one end of the table, and the boy, in an attitude of over-worked fatigue, is coiled up on the wheel-barrow, the instrument of his industry. The old man, by his upright, sturdy air, plainly shows that he is habituated to it, and retains vigor enough for the calls of the remaining half day. But the chief beauty of the picture is the boy; his languid, over-worked air, his indifference to the allurements of the table plainly indicate that he is in that state of physical suffering which all of us as boys have realized, that of being *too tired to eat.*

10. *Woodsawyer, Nooning*, 1853; crystallotype paper print from daguerreotype original; George Eastman House

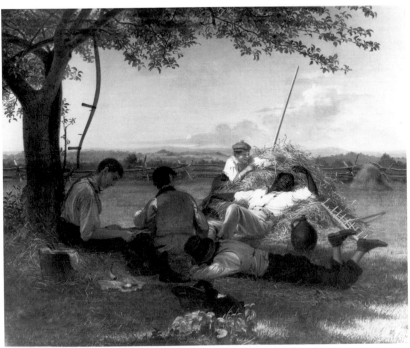

11. **William Sidney Mount:** *Farmers Nooning*, 1836; oil on canvas; The Museums at Stony Brook. Gift of Frederick Sturges, Jr., 1954.

His intelligent, reflective face, while looking directly in your eye, betokens by its abstracted air that his thoughts are absent. Perhaps his imagination is soaring in aerial flight, and enjoys a glance of improved density in the future. In this happy land — as he has learned that rank and title are of no avail in running the race of life — that the lowliest can aspire to the highest attainments. His frank and manly countenance indicate his nature, and who knows but the boy of the wood-sawyer before us, may yet be a brilliant star in the constellation of his country's glory.[31]

It is unfortunate that this writer's identity has gone unrecorded. Could Barnard himself have authored these lines and attributed them to a mysterious "friend by my side" out of professional decorum? If he did not compose them, it is clear that Barnard had friends in Oswego who were conversant in the literary and visual arts, and who reinforced his own aesthetic interests.

Barnard's unnamed essayist found in the *Woodsawyer, Nooning* a range of ideas basic to the photographer's political, religious, and moral outlook. Through a "strict attention to rules," honesty, frugality and pride in hard work, it might be possible for even the "lowliest [to] aspire to the highest attainments." Barnard's woodsawyer is symbolic of the most personal and nationalistic values, while exemplifying the tendency in this era to spiritualize labor.[32] The image also reveals that Barnard followed his own advice (from his essay on "Taste") to use large plates for one's finest artistic expressions.

This daguerreotype strongly suggests Barnard's interest in the art of his day. American genre painting came to prominence in the Jacksonian era as an expression of middle-class taste and a celebration of nationalistic scenes and subjects. These works depicted ordinary life experiences and had a strong narrative content. The leading genre painter of this period was William Sidney Mount (1807-1868). Rural Long Island provided the setting for many of Mount's most characteristic paintings, including *Bargaining for a Horse* (1835), *Cider Making* (1841), and *Eel Spearing at Setauket* (1845). In addition to gaining praise from critics, many of Mount's paintings were widely popularized in the form of inexpensive engravings.

Mount's best known work may have been his *Farmers Nooning* (1835), a depiction of four farmers and a child relaxing on their lunch hour (figure 11). This painting presents idealized figures "playing roles or illustrating stock situations" in a delightfully expressive celebration of rural America.[33] This work, praised in its day as "nature itself, a perfect transcript from life," became widely familiar to Americans.[34] In 1843 the Apollo Association distributed a print of the *Farmers Nooning* to its broad membership and it was also included as an engraving in the July 1845 issue of *Godey's Lady's Book*.[35]

As familiar as he must have been with *Farmers Nooning*, Barnard did not aim merely to duplicate the earlier picture. In addition to changing the occupation of his subjects, the photographer created a greatly simplified pictorial space and

composition. By concentrating on only two figures, Barnard's theatrical tableau emphasizes the dichotomies of age and youth, wisdom and innocence. The *Woodsawyer, Nooning* is a somber and dignified meditation on the bonds between father and son and the virtues of honest labor. It is also tempting to speculate that this carefully considered photograph was a metaphoric recasting of Barnard's own childhood memories.

The woodcutter represented an important theme in the art and literature of the period. Axemen embodied the virtues of strength and individual enterprise, and the larger desire of Americans to better themselves. Wood had long been an essential and profitable commodity. Early settlers shipped wood back to England, and used it themselves in great quantity for heat and in the construction of houses, ships, and fences. Immense tracts of land were cleared to make farms and villages, and the felling of trees became an acknowledged sign of initiative and cultural improvement.

Woodcutters were widely admired for their stamina and skill. As an adolescent, Barnard was undoubtedly told of the legendary Baxter Gage, the "champion chopper of the Sauquoit valley" at the turn of the century. Gage was able to drop trees quickly and with pinpoint accuracy. Spectators watched in awe as he carefully "deep-notched" a series of trees, which were then carried down in succession like dominoes by the felling of a single keystone tree. Witnesses never forgot the "magnificent grandeur" of the sight.[36]

By the 1840s, however, the woodcutter came to be understood in a more complex light. Decades of deforestation had produced a rather stark landscape with greater extremes of heat and cold and other unexpected ecological changes.[37] As they became less common, trees were seen by sensitive viewers as things of beauty rather than mere impediments to progress. In 1841 the painter Thomas Cole protested the destruction of American forests:

> I cannot but express my sorrow that much of the beauty of our landscape is quickly passing away: the ravages of the axe are daily increasing, and the most notable scenes are often laid desolate with a wantonness and barbarism scarcely credible in a people who call themselves civilized. The way-side is becoming shadeless, and another generation will behold spots now rife with beauty, bleak and bare. This is a *regret* rather than a complaint. I know, full well, that the forests must be felled for fuel and tillage, and that roads and canals must be constructed, but I contend that beauty should be of *some* value among us; that where it is not NECESSARY to destroy a tree or a grove, the hand of the woodman should be checked [to preserve] the objects which are among the most beautiful creations of the Almighty.[38]

While Barnard's *Woodsawyer, Nooning* most obviously emphasized the themes of honest labor, piety, and familial bonds, it also suggested the new complexity of the idea of progress. The woodcutter of the early 1850s was a bittersweet reminder that cultural development often required destruction, with ugliness and waste as frequent by-products.[39] As the majestic forests of early America receded into memory, trees came to be seen as emblems of a simpler, more stable time. A nostalgia for this largely mythic American past became an integral part of the nation's continued expansion and technological development. Barnard's use of the woodsawyer motif suggests his understanding of the figure's dual meaning and his own longing for a vanishing, pre-industrial America.

In 1856, *The Photographic and Fine Art Journal* again praised the *Woodsawyer, Nooning* as an outstanding example of the photographic art along with "several other compositions by Hesler of Chicago and Barnard of Syracuse."

> Here we have the original natural objects grouped together, as we desire them, with the true natural expressions given to each. For the painter to produce these effects he must either draw upon his imagination — too often a very bad and incorrect source to depend upon — or else he has — at great cost — to obtain a series of settings from living models...By employing the photographic art, an entire composition can be conceived and executed in a few minutes, requiring very little labor in securing appropriate models, and very little expense in its execution.[40]

For many years the creation of naturalistic scenes in the studio fascinated artistic photographers. In an 1866 article titled "Outdoor Photographs Taken Indoors," *The Philadelphia Photographer* praised a series of photographs by William Notman in terms applicable to Barnard's earlier *Woodsawyer, Nooning*.

> Each photograph is a picture, and each picture has a meaning. They are not merely specimens of delicate manipulation, artistic posing, and magical arrangement of light and shade. Each one shows the expenditure of time, brains, and talent. Each one tells a story...[41]

In addition to his participation in competitions such as the Anthony Prize, Barnard was a charter member of the short-lived American Photographic Exchange Club. Announced in October 1855 as a "fixed fact," this club included twenty-five leading photographers who agreed to exchange fine prints amongst themselves on a regular basis. It was hoped that this monthly or bimonthly exchange would "enable each member to ascertain the degree of excellence to which his fellow members have attained." Such exchange would ultimately stimulate "ideas, theories and improvements" that would lead to a universal advance in the profession.[42] Included with Barnard in the twenty-five charter members were such important and familiar names as Frederick Langenheim, Gabriel Harrison, Alexander Hesler, John A. Whipple, E.T. Whitney, and Henry Hunt Snelling. However, like other cooperative ventures of the period, the Photographic Exchange Club appears to have had a short life.

I:4 Syracuse: 1854-1859

12. Barnard and Nichols: *Reverend Anthony Schuyler*, 1854; daguerreotype; Oswego Historical Society

Barnard had a busy and apparently stressful period in late 1853 and early 1854. During this time he took on Alonzo C. Nichols as a partner, purchased a gallery in Syracuse, and survived a lengthy illness. Nichols had previously operated a daguerreotype studio in Fulton, New York, located between Oswego and Syracuse. Like Barnard, Nichols had been a charter member of the New York State Daguerreian Association in 1851. Their decision to relocate to Syracuse was undoubtedly based on the city's comparatively large size and its prominent location on the busy Erie Canal.

The new Barnard and Nichols gallery was first advertised in the Syracuse newspaper on December 22, 1853. The February 1, 1854, issue of *Humphrey's Journal* observed that "G.N. Barnard has purchased Mr. Clark's establishment in Syracuse, where he now holds forth to the great satisfaction of the citizens of that place."[1] This gallery, situated over the store of Abbott and Company, was located in the Franklin Block, a row of handsome brick structures fronting Hanover Square near the Erie Canal and the commercial center of Syracuse.[2]

The strain of beginning this new business or of commuting between Oswego and Syracuse may have overly taxed Barnard. In either case, he endured a serious but unidentified illness in the spring of 1854. Notices published in consecutive issues of *The Photographic and Fine Art Journal* suggest the duration of this ailment.

> [April 1854:]
> We regret to learn that our friend G.N. Barnard has been very ill, indeed, at the point of death; but we believe the crisis is past, and that he is recovering rapidly.
>
> [May 1854:]
> Mr. Barnard of Oswego, is slowly recovering, although he experienced a severe relapse about three weeks since.
>
> [June 1854:]
> Mr. Barnard has recovered and fixed his permanent residence in Syracuse, while Mr. Nichols, his partner, remains in Oswego.[3]

While Barnard was to experience ill health again in his career, he lived to be 82 years old and seems to have been of generally vigorous constitution.

Fully recuperated by June, Barnard assured the public that normal hours would be reestablished. This ad, from the June 24 issue of the *Oswego Times and Journal*, makes it clear that he had not given up working in the Oswego studio.

A CARD

BARNARD & NICHOLS would return thanks to the public for the liberal patronage heretofore extended to them, and hope to merit a continuation of the same. Mr. Barnard has just returned from New York with a large and choice variety of beautiful Frames, Morocco Velvet, Pearl and Paper Mache Cases. B.&N. have had many years of experience, which enable them with the superior advantages they possess, both in Instruments, Light, &c., to produce Daguerreotype Pictures in the highest state of perfection. Mr. B. has recovered from his late sickness and may be found at his rooms over the City Bank at all hours of the day, between 7 o'clock A.M. and 6 P.M., ready to wait upon his old friends and customers.

A new and beautiful improvement for the first time introduced into this section of the country, may be seen by calling at their Gallery.[4]

This last sentence probably refers to the new ambrotype process.

13. **attributed to Barnard:** *Salina Street Bridge, Syracuse*, ca. 1854; daguerreotype; Onondaga Historical Association

14. **attributed to Barnard:** *Salina Street Bridge and Erie Canal, Syracuse*, ca. 1854; daguerreotype; Onondaga Historical Association

Barnard was in Oswego a few months later to carry out a particularly unique commission. To commemorate the erection of the new Christ Church, on the corner of Cayuga and West 5th Streets, a special photographic memento was conceived. Daguerreotype portraits of leading church officials, made by Barnard and Nichols, were carefully sealed in a lead box and placed in the building's cornerstone. This explanatory note accompanied them:

Photographic Portraits or Daguerreotypes, deposited in the corner stone of Christ Church, October 12, 1854.

No. 1. Portrait of the Right Reverend William Heathcote DeLancy, D.C., D.C.L., Oxon. first Bishop of Western New York.

No. 2. Reverend Anthony Schuyler third pastor of Christ Church Congregation in the second year of his charge. The first is taken from an engraving of the Bishop. That of the latter from life.

These pictures were made by Messrs. Geo. N. Barnard & Alonzo C. Nichols Daguerreans, and are deposited in order that those who see them in future may look upon the present heads of the Church and congregation, and to test the effect of time and darkness upon this late invention.[5]

The cornerstone containing these daguerreotypes was laid in place with great ceremony on the afternoon of October 12, 1854. The *Oswego Times and Journal* reported that, despite unpleasant weather, the solemn occasion was well attended. The event concluded with an address by Reverend Schuyler "which was listened to with marked attention and interest."[6]

These daguerreotypes were rediscovered when the church was torn down in 1976. They are brilliant and flawless quarter-plate (4¼ x 3¼") portraits, one made "from life" (figure 12) and the other copied from an engraving. Both illustrate the extremely high quality of Barnard's work, as well as the longevity of the process.[7] Soon after making these daguerreotypes Barnard and Nichols left Oswego to devote complete attention to their new gallery.[8]

Barnard's unusual application of the daguerreotype to documentary and historical purposes is further demonstrated by two plates of the city of Syracuse taken soon after his arrival. Both focus on the Salina Street Bridge over the Erie Canal in the commercial heart of the city. A date of June 1, 1854, has been attributed to the larger of these images, which records the view north along Salina Street (figure 13). The smaller plate documents the scene looking west toward Salina Street along the route of the waterway (figure 14).[9]

Both plates may have been made as part of a proposal for a replacement span over the canal. The June 2, 1854, issue of the *Syracuse Standard* noted that "plans for the new Bridge over the Erie Canal on Salina Street, prepared at the Canal Engineer's office in the city, show a very neat and tasty design..." The next day's edition of the paper related the possibility that the $5000 iron structure would be erected "this season or the next."[10] While these photographs do not have the inherent drama of Barnard's Oswego fire images, they are nonetheless important examples of the relatively small genre of American urban daguerreotypes. It

remains a mystery whether these views were commissioned by canal engineers to accompany their plan for a new bridge, or made on Barnard's own initiative for these or other purposes.

Barnard and Nichols quickly established a high profile in Syracuse and joined the city's other photographers in displaying work in several annual fairs. These expositions contained a wide range of objects, from fresh produce to mechanical inventions, and were well attended by the public. In March 1854 the team exhibited "a beautiful lot of Daguerreotypes" at the Mechanics' Association Fair alongside such varied items as stuffed birds, specimens of saddlery, brass door trimmings, and marble carvings.[11] In September of that year they mounted an impressive display at the county Agricultural Society Fair. Eager to acknowledge local achievement, the city's newspaper described most of the Fair's 700 displays (which included nearly 4000 objects).

> A splendid lot of Daguerreotypes, by Messrs. Barnard & Nichols, occupied a place in one of the aisles, and drew a large crowd of admirers. His pictures appeared to be noted for their distinctness and happy blending of light and shade, giving the portraits the appearance of standing out from the background.[12]

A later notice by the fair's "Discretionary Committee" praised the team's

> Daguerreotypes and... a number of Stereoscopic Pictures. These were the only pictures of the kind brought to our notice. Mr. Barnard ranks as one of the best daguerreans of the State. These specimens were of great merit, exhibiting every feature with a distinctness that seemed marvellous. We award Mr. Barnard the highest premium, $3, and a Dip[loma].[13]

While stereoscopic daguerreotypes had been seen in Syracuse in late 1853 (in the studio of P.H. Benedict), Barnard may have been the first of the city's photographers to use the technique extensively.[14]

The vivid "distinctness" of Barnard's work may have stimulated the following endorsement, in December 1854, by the *Syracuse Standard*.

> The Holidays are coming, and a well executed daguerreotype makes as handsome a present as anything we can think of. Messrs. Barnard & Nichols, in the Franklin Buildings, will make you one that will almost talk. Take a seat before their camera, and see if they don't paint [sic] you beautifully.[15]

This theme was repeated a few months later.

> Pictures — *Barnard and Nichols*, Franklin Building, enjoy a happy faculty for bringing to perfection *fac-similes* of those whom they intend to represent. The wonderful discovery of the Daguerrean art, is beautifully portrayed by the combination of nature, of art, and their long experience in its development.[16]

In January 1855 Barnard again mounted an impressive display of daguerreotypes at the city's Mechanics' Fair. Like other local expositions, this fair contained a remarkable — if not bewildering — array of artifacts of both aesthetic and applied interest. The hundreds of objects on display included thermometers, clocks, shoes, hats, cigars, chandeliers, tea kettles, bags of flour, fruit, collections of insects, embroidered goods, architectural drawings, French bread, books, wigs, Mexican War relics, railroad lanterns, and samples of penmanship, coffee, and preserves. Curiosities such as a miniature steam engine "standing on a ten-cent piece" and a glass beehive were included. Copies of a Murillo painting of the Madonna and Child, and of Hiram Powers' *Greek Slave* were also on view. Other works of statuary included a bust of Queen Victoria and an alabaster carving of *Moses in the Bulrushes.*[17]

Within this crazy-quilt accumulation of art, commerce, and technology, Barnard's daguerreotypes attracted their share of the public's attention. The local paper noted that in the portraits on view "the visitor will easily recognize the familiar face of Gen. Mosely, and also, those of the accomplished Miss H--t, the beautiful Miss R--r, and the prepossessing Miss R--s."[18]

In addition to displaying his handiwork, Barnard returned to the fair on January 27 to photograph some of the most notable installations. Barnard's activities were witnessed by many interested spectators and reported in both of the city's major newspapers. The *Syracuse Journal* noted that "Mr. Barnard, of Barnard & Nichols' National Daguerrean Gallery, was busily engaged on Saturday in taking daguerreotypes of the exhibition."[19] The *Syracuse Standard* reported that "a number of spectators were present," during Barnard's photographic session at the fair, and that their "familiar countenances form an interesting portion of the pictures. Every thing in the Daguerreotype line that comes from Barnard's hands is sure to be as perfect as art and skill can make it."[20] These plates were added to Barnard's display, and drew additional praise from the local press.

> Several views of the Fair, made by Barnard & Nichols, are now on exhibition. One view of the show-case and articles of Messrs. McDougall and Fenton, is very accurate. They are all beautiful specimens of the Daguerrian art.[21]

Barnard and Nichols were awarded a silver medal for the fair's best exhibition of daguerreotypes.[22]

Critical praise for Barnard's work also continued unabated in national publications such as *The Photographic and Fine Art Journal*. This item from July 1855 reminds us of the importance of post-mortem photography in the nineteenth century.

> Life From The Dead — We have been shown a daguerreotype likeness of a little boy, the son of Thomas Dorwin, taken after his decease, by Mr. Barnard, of the firm of Barnard & Nichols. It has not the slightest expression of suffering, and nothing of that ghastliness and rigidity of outline and feature, which usually render likenesses taken in sickness or after death so painfully revolting as to make them decidedly undesirable. On the other hand it has all the freshness and vivacity of a

picture from a living original — the sweet composure — the serene and happy look of childhood. Even the eyes, incredible as it may seem, are not expressionless, but so natural that no one would imagine it could be a postmortem execution. This is another triumph of this wonderful art. How sublime the thought that man, by a simple process, can constrain the light of heaven to catch and fix the fleeting shadow of life, even as it lingers upon the pallid features of death.

Hail glorious light that thus can timely save

The beauty of our loved ones from the grave![23]

Such photographs stemmed directly from the tradition of painted posthumous portraits, an artistic genre that flourished between about 1830 and 1860. A variety of notable artists, including Raphaelle Peale, Thomas Cole, and William Sidney Mount, found this business unpleasant but lucrative. Posthumous portraits functioned as icons of remembrance and continuity for bereaved relatives. In painted form, these portraits usually presented the subject as if alive, but in a somber and symbolic setting. Photographic post-mortems depicted the deceased in a restful, naturalistic pose suggesting sleep rather than death.[24]

Ironically, the daguerreotype process itself was dying at this time, a victim of the rapid technical changes of the mid-1850s. The daguerreotype, which produced one-of-a-kind, direct-positive images, was being displaced by the glass negative process. These glass negatives could be presented as unique "positives" (in the form of the ambrotype) or used to produce any number of identical paper prints. The changes of the 1850s fundamentally altered the nature of the profession, as "daguerreotypists" became "photographers" and were compelled to learn a variety of new techniques. In this period of change many gallery owners offered their customers no fewer than four distinct photographic processes. By the end of 1855, for example, Barnard promoted his abilities with the familiar daguerreotype, as well as with the new paper print and ambrotype methods. In the fall of 1856 he was also producing melainotypes, or "tintypes."

The negative-positive process of photography had taken years to achieve popularity in the United States. William Henry Fox Talbot's early calotype negative and salted paper print process had been a commercial failure in America due, in part, to the expense of license fees. The paper negative processes of the 1840s and early 1850s were used far more widely in France than in either England or the United States. The earliest American glass negative/paper print process to achieve some commercial success was John A. Whipple's "crystallotype." Whipple had begun experimenting with glass negatives as early as 1844. By 1850 he had patented a process for making "crystallotype" paper prints from glass negatives coated with a mixture of albumen and honey. By the summer of 1853 Whipple was making crystallotypes from collodion, instead of albumen, negatives.[25] The paper prints of Barnard's *Woodsawyer, Nooning*, produced in quantity for the frontispiece of the January 1854 issue of *The Photographic and Fine Art Journal,* were made by this process in Whipple's Boston gallery. Whipple's promotion of the paper print contributed strongly to its adoption by American photographers in the mid-1850s. Paper prints were judged superior to the daguerreotype in several important respects. Although lacking the brilliant clarity of the earlier process, paper prints were cheaper to make, easier to store and ship, and could be produced in editions.

The major innovation of this period was the recognition, by Frederick Scott Archer in 1851, of the photographic importance of collodion. The search for a workable glass negative process had led researchers of the late 1840s to use albumen (egg white) to adhere their light-sensitive solutions to the surface of glass plates. While albumen became the standard for photographic paper emulsions after the mid-1850s, negatives coated with it were of disappointingly low sensitivity. Collodion, a viscous solution of guncotton, alcohol, and ether that dries to a tough, waterproof film, had originally been used for medical purposes. Archer discovered that a collodion emulsion sensitized with potassium iodide and silver nitrate exhibited a remarkable sensitivity as long as it remained moist. Photographers were thus required to coat their negatives just prior to exposure and process them quickly before the collodion dried. Although this "wet plate" process forced photographers to take portable darkroom facilities with them into the field, its advantages were such that it dominated the practice of photography from the mid-1850s to the early 1880s.

The ambrotype, first exhibited in the U.S. in late 1854, was a temporary offshoot of the collodion wet-plate negative process.[26] Developed as a cheap substitute for the daguerreotype, the ambrotype was simply a thinly exposed collodion negative that, when cased in front of a black background, appeared as a rather dull, low-contrast positive. The ambrotype displaced the more brilliant daguerreotype for several reasons: it was easier and cheaper to produce, it lacked the earlier process's mirror-like glare, and it allowed exposures of "less than one half the time of the quickest daguerreotypes."[27] By 1856 some portraitists had achieved exposure times of only "two or three seconds" with the ambrotype.[28]

Despite these commercial advantages, the widespread use of the ambrotype was complicated by copyright claims and demands for license fees by James A. Cutting of Boston. Three patents on the wet-plate and ambrotype processes, issued to Cutting in July 1854, were to remain a source of contention within the photographic community for years. In these patents Cutting claimed not only a particular method for making ambrotype photographs, but the use of bromide of potassium in combination with collodion to prepare wet-plate collodion negatives.[29] The process described in Cutting's so-called "bromide patent" was fundamental to all aspects of wet-plate photography. In theory at least, this patent gave Cutting "a monopoly on the entire practice of collodion photography" in America.[30]

15. Untitled Portraits, ca. 1854-57; ambrotypes; private collection

Many photographers, including Barnard, were understandably confused by these claims and reluctant to pay for the use of techniques that seemed too generic to be patented. Barnard had been led to believe that $1000 would be required for the rights to the ambrotype technique in his area. His letter to *The Photographic and Fine Art Journal* requesting further information on the subject precipitated a lengthy debate on the merits of Cutting's patents and method of binding ambrotypes. In the July 1855 issue of the *Journal*, editor H.H. Snelling responded to Barnard's inquiry. Snelling stated that "ambrotypes are not the invention of Mr. Cutting," and that Barnard had every right to make them provided Cutting's particular method of binding the images was not used.[31]

In the same issue a lengthy letter from Marcus A. Root of Philadelphia defended the importance of Cutting's process. Root encouraged all photographers "to apply to Mr. Cutting of Boston for the right [to make this] novel and exquisite kind of picture." Snelling responded that he could not agree with Root, due to the extreme fees charged by Cutting: $1000 "for a place like Syracuse is not only exhorbitant but extortionate."[32]

The matter did not end there. The next issue of the periodical carried a lengthy letter to Barnard from Cutting's agent, W.R. Howes. In this letter of July 7, 1855, Barnard was advised that the going rate for the process was $100 per 5000 "compactly situated" inhabitants, although "some modification is necessary in large cities and among people who do not appreciate the fine arts." He then offered Barnard the rights to Syracuse and the surrounding county of Onondaga for $800. In an editorial accompanying this letter Snelling indicated that he considered Howes's new price still too high.[33] Some agreement was soon reached with Cutting's agent, however, since Barnard's ambrotypes from this period are prominently stamped "CUTTING PAT[ENT]" on the mat.[34]

Despite Howes's reasoned arguments, Cutting's terms remained restrictive and unpopular. By December 1855 even earlier supporters such as Root were convinced of "the comparative worthlessness of the pretentions set up by Mr. Cutting." Root's mind had been changed, in part, by the "extortionate" fees demanded of Barnard.[35]

While this debate over Cutting's rights continued, the popularity and profitability of the ambrotype led to its rapid adoption by the nation's leading galleries. The quality of Barnard's work in this medium is demonstrated in an unusual double portrait of an unidentified woman (figure 15). These paired images reveal the subtle clarity that well-made ambrotypes could achieve, while suggesting the variety of Barnard's studio poses and props. These plates are also hand-colored, with stippled gold added to the woman's jewelry and a pink wash applied to areas of fabric and drapery.

Barnard also quickly mastered the process of making paper prints from wet-collodion negatives. This process became increasingly important in 1854 and 1855 thanks in large part to Whipple's promotion. In May 1854, for example, *The Photographic and Fine Art Journal* predicted the imminent dominance of the paper print.

> Two years more will effect an entire revolution in the Daguerreotype business throughout the United States. The superiority of paper photographs as illustration, the rapidity with which they can be multiplied, their distinctness, and the great number of purposes to which they are applicable, must cause them, in a great measure, to supersede the daguerreotypes.[36]

This form of photography came to be accepted for many of the reasons cited in this "puff piece" on Barnard and Nichols from August 1855.

> Mr. Editor — When I was first shown some faint specimens of photography, a few years since, I felt fully convinced that the time was near at hand when they would entirely supersede the daguerreotype. That time has nearly, or quite arrived.
>
> Our townsmen, Barnard & Nichols, have shown me specimens of this new kind of picture, which certainly appears to me the most wonderful of all machine pictures. And I am assured by an artist of celebrity from New York city, that he has met with nothing of the kind that excels, or even equals, them in the metropolis.
>
> These pictures possess an advantage over the daguerreotype in many particulars. One very important one is, they do not *reverse* the object represented, as in the daguerreotype, which makes that *wart* which every lady knows is upon the right side of granny's nose, appear upon the left side in her picture!
>
> Another is, one is not obliged to twist and turn in all possible shapes to rid the picture of those reflections of light which attend the daguerreotype.
>
> But what I desire is to call the picture-loving part of community to the works of these men Barnard & Nichols. And all sensible persons

who will take the pains to call at their Gallery and examine, will need no assurance from me to convince them of the real merits of photography. They will there see, doubtless, many of their friends staring at them from the papers, with all the reality of, I was going to say, life itself. They will there see a picture of Beriah Green, so minutely modeled and flesh-like in its texture, that it seems fairly to embody a portion of his spirituality; and I'll venture that a Sculptor might take the picture and model a bust from it, so real does the photograph portray the good man.

There are also many others which need but be seen to draw forth exclamations of unfeigned praise, and will amply pay all who may call and see for themselves these admirable pictures.

Messrs. Barnard & Nichols deserve much credit for introducing this new process into our city, and I hope they may reap the reward so justly due their enterprise. Yours &c., S.T.[37]

In December 1855, Barnard and Nichols displayed a "splendid lot of Daguerreotypes and Photographs" at the city's Second Mechanics' Fair, held in Corinthian Hall.[38] This breadth of expertise characterized the best photographic operators. In commenting on Barnard and Nichols' "rush of business" in the 1855 holiday season, the *Syracuse Journal* noted that "our daguerreotypists are in prime order...to take likenesses either by the old system of daguerreotypes or by the new system of photographs and ambrotypes."[39]

Hand-colored photographs were also much in vogue. In December 1855 Barnard and Nichols advertised

Gifts for the Holidays: Beautifully Colored Photographs, taken from life or copied from daguerreotypes, and colored in Oil by an experienced artist, which surpasses any thing of the kind ever introduced into this city.[40]

Samples of this work were praised by *The Photographic and Fine Art Journal* in March 1856 for the "softness of tone and the artistic arrangement of light and shade." The *Journal* also noted that a visitor to Syracuse had found Barnard and Nichols's hand-colored portraits "not only beautifully colored, but superior in expression, and more life-like than any he had ever seen before."[41]

In addition to this studio work, Barnard continued to photograph significant outdoor scenes. In early January 1856 the "Granite Building" in downtown Syracuse was destroyed by fire. Bitterly cold weather caused the water from fire hoses to form a dramatic "frozen cataract" encasing the structure. The newspaper noted that, "Messrs. Barnard & Nichols intend to take a Daguerreotype or Photograph view of the ruins while the Granite Building presents such a singular appearance."[42] It is not known if these images are now extant.

In April 1856 Barnard and Nichols moved from their earlier quarters in the upper floors of No. 4 Franklin Buildings to a new gallery over the Mechanics' Bank on nearby Salina Street. Barnard probably desired a more visible and prestigious address, and may have been among those offended by the smelly fish market on the sidewalk in front of the Franklin Block.[43] By comparison, Salina Street was described as one of Syracuse's "finest and most attractive streets."[44] In December of that year, the Syracuse paper noted proudly that "South Salina St. is crowded with promenading ladies and gentlemen and teams and is the most beautiful and business like part of the city."[45]

On April 16 the photographers ran an advertisement headlined "MORE LIGHT — REMOVAL!," which promoted the "elegant suite of Rooms, with TWO LARGE SKY-LIGHTS" that were scheduled to open for business on May 1.[46] On April 30 the *Syracuse Standard* noted approvingly both the "central location" of the new address, and Barnard and Nichols' rank "among the best operators in the country," able to "keep pace with all the modern improvements in the art."[47]

On May 14 the photographers began running the following advertisement:

Removal.

BARNARD & NICHOLS
Have removed their PHOTOGRAPH, AMBROTYPE and DAGUERREOTYPE GALLEY, over the MECHANICS' BANK, opposite the Syracuse House.

These Rooms have been fitted up expressly for their business, with TWO LARGE SKY LIGHTS, and every convenience combined to render it pleasant for themselves and customers.

PHOTOGRAPHS.
They are now prepared to execute Plain Photographs, on paper, equal to the Finest Steel Engravings.

COLORED PHOTOGRAPHS.
They would call particular attention to this branch of their business. Call and see.

AMBROTYPES.
This new and Beautiful style of Pictures, on Glass, are made at this Gallery only. The Glass Pictures are particularly adapted to taking Likenesses of Children and Family Groups, as the time of sitting is not one quarter as long as for the Daguerreotype.

DAGUERREOTYPES.
Be it remembered, their Daguerreotypes have never been surpassed in any of the larger cities. One of their rooms is kept expressly for this branch.

GEO. N. BARNARD,
A.C. NICHOLS.[48]

Three days later the newspaper described the new gallery in considerable detail.

DAGUERREOTYPE ROOMS — Yesterday we spent a few moments in the new Daguerreotype Rooms of Messrs. Barnard & Nichols, over the Mechanics' Bank, and can scarcely find words to express our admiration of the convenient and elegant arrangements of the rooms, both for operating and displaying the splendid Daguerreotypes, Photographs and Ambrotypes taken by these skilful professors of the

Daguerrean Art. The third and fourth stories are occupied entirely by Messrs. Barnard & Nichols. The show room is in the third story, and its walls are adorned with as fine a lot of Pictures as can be seen together in the United States. A ladies toilet room adjoins the show room, provided with everything that could be desired by ladies who wish to give the finishing touch to their charms. A large stock room is in the rear of the show room, and the stock comprises everything necessary for carrying on the business in its greatest perfection. In the upper story two large operating rooms have been constructed, with sky-lights capable of being arranged to make any degree of shade or color desired. This double arrangement of operating rooms enables them to despatch [sic] business with the utmost celerity, and not keep customers waiting until their patience is exhausted. The instruments and stock of these gentlemen are of the most improved style, and as operators they are second to none. Call and see their rooms and sit for a picture.[49]

The Photographic and Fine Art Journal reprinted this description in its May 1856 edition, and took further notice of the team by including as a frontispiece in the July issue a portrait of

the Rev. Rob. R. Raymond, Professor of the English Language and Literature, in the Collegiate and Polytechnic Institute of Brooklyn, N.Y. The negative is from the *atelier* of Messrs. Barnard & Nichols, of Syracuse, N.Y., whose rapid progress in the true mastery of this diffi-cult art, has stamped them men of true genius.[50]

Despite such praise, the partnership between Barnard and Nichols was dis-solved by mutual consent on October 2, 1856.[51] Perhaps it was decided that their business simply could not support the overhead expenses of a double studio operation. There is evidence, in fact, that the pair had sublet a portion of their gallery space to a woman who gave lessons in decorative vase painting.[52]

Upon becoming sole proprietor of the gallery, Barnard continued to produce and exhibit fine work. His "Colored and Plain Photographs, Daguerreotypes, Ambrotypes and Melainotypes" were included in the third Syracuse Mechanics' Fair, in December, 1856.[53] Before the end of the year Barnard also displayed a series of "very excellent plain unretouched photographs" at the Fair of the American Institute in New York. It was noted that there was "great uniformity of tone and strength in these pictures, and they do him much credit."[54] A few months later Barnard was praised by a local writer for the uniquely "airy, life-like," and dimensional quality of his ambrotypes.[55]

Barnard's reputation drew several renowned sitters to his studio. In March 1857, for example, the venerable Missouri senator Thomas Benton was in Syracuse. The city's newspaper noted that Benton "visited the Daguerrean Room of Mr. Barnard and sat for a Photograph, which exhibits the well formed features of 'Old Bullion' in the best style of the Daguerrean Art."[56]

At this time Barnard befriended Jacob F. Coonley, a "Plain and Fancy Sign and Ornamental Painter" residing in Syracuse. Impressed by Coonley's skills in oil, Barnard encouraged him in 1856 to apply his talents to hand-painting photo-graphs. As Coonley recalled, "the success of it induced me to accept Mr. Barnard's offer of instruction in photography during my spare time. During the next few months I spent what time I could spare from painting under his skylight and learned the essentials of the business."[57] Barnard's market for colored photo-graphs apparently kept Coonley relatively busy.

In July 1857 Barnard took on J.M. Green, a former resident of the nearby village of Fulton, as an assistant. The editor of that town's newspaper visited the gallery and wrote glowingly of Barnard's reputation:

We called at Barnard's Daguerreotype Gallery in Syracuse a few days since, and felt quite at home as we looked at the pictures of several of our citizens, finished in the style which has rendered Barnard so famous. His pictures always look like the original, — have an easy life like appearance, and stand out in bold relief, with clear and sharp outlines. Our old friend J.M. Green, formerly of this place, is there, and seems to act a leading part. There are but few artists that equal him, and he is now in the right spot with the right man.[58]

Similarly, that month's issue of *The Photographic and Fine Art Journal* included Barnard on a short list of "our most eminent photographers."[59]

Despite such familiar accolades, Barnard resolved to sell his Syracuse gallery. By August 3, 1857, a "Great Reduction at Barnard's Gallery" was being advertised by the new proprietor, a Mr. Lazier.[60] Barnard's reasons for selling probably were based on a combination of personal, economic, and aesthetic factors. After eleven years he may simply have grown tired of the daily routine of the gallery business. Barnard may also have sensed that increased competition and a dangerously overheated national economy held little promise for the immediate future. In fact, at the end of the year, *The Photographic and Fine Art Journal* referred to 1857 as a "disastrous" year for photographers in which a weak economy and increased competition forced many out of business.[61]

The year had begun with a political "wariness and foreboding" over the slavery question, and this trepidation seemed confirmed in the economic realm by the "Panic of 1857."[62] In this regard, however, Barnard's timing seems fortuitous. The Panic, a recession caused by inflation and speculative investments, began with the failure of a leading New York financial institution on August 24, 1857, about three weeks after Barnard sold his gallery. Over the next two months numerous banks failed nationwide, credit dried up, and workers lost jobs. While the financial community recovered quickly from this crisis, the fear and mistrust generated by the Panic had lingering social effects. Businesses regained momentum slowly, and widespread unemployment stimulated public demonstrations for relief.

These economic uncertainties only emphasized the fact that the photographic profession was in the midst of a fundamental and disconcerting transition. Despite

Barnard's demonstration of "rapid progress in the true mastery" of wet-collodion work, it seems likely that he regretted the sudden decline of the daguerreotype, the process that had originally attracted him to photography. Many experienced daguerreotypists watched the demise of the technique with genuine sadness and saw it as evidence of a general "decline of photographic portraiture." In 1858 H.H. Snelling, the editor of *The Photographic and Fine Art Journal,* lamented the rapid eclipse of the earlier process.

> ...that the thousands of miserably executed ambrotypes which have flooded the country for the three last years [have] disgusted the great body of the thinking portion of our patrons of the Photographic Art there can be no doubt...
>
> What is the Daguerreotype? It is the *fac-simile* of the object delineated, possessing in bona-fide light and shade, all the requirements of artistic taste — marred only by one fault — its glassy reflection — with a boldness and roundness that challenges criticism, with a delicacy and softness that cannot be surpassed even by the crayon; perfectly free from angular or abrupt outline, and with exquisite modulations of light and shade, and yet more, what is of greatest importance, a permanence which, thus far, time has failed to compromise...
>
> Now what is the Ambrotype? It is, even in its most attractive form, but a poor frail memento...

Snelling went on to discuss the ambrotype's impermanence and called upon his researchers to ensure the future of the daguerreotype by discovering a way to eliminate its mirror-like reflection and thus render it "visible from all points equally."[63]

Barnard had been an early leader in the campaign against cut-rate daguerreotypes and he did not compromise his standards of quality. The advertisement placed by Barnard's successor is revealing, therefore, for its blunt emphasis on low prices:

> Great Reduction at Barnard's Gallery!
> Photographs reduced from $5.00 to $3.00; duplicate copies $1.00.
> Oil Photographs from miniature to life size at moderate prices. A light has been fitted expressly for Cheap Pictures so that those who wish can have their Ambrotype put up in cases for fifty cents.[64]

The overwhelming demand for inexpensive pictures of indifferent quality may well have dampened Barnard's enthusiasm for the gallery business.

Barnard began applying his technical skills to a new aspect of photographic research: printing on wood for use by engravers. Before the era of the halftone, beginning in the late 1880s, newspapers and books could only be economically illustrated with pictures printed from hand-carved blocks. In order to be "reproduced" by this process, photographs had to be sketched by hand on a block of boxwood and then carved by an engraver. In this tedious process the printed image was doubly removed from the veracity of the photographic original.

The technique explored at this time by Barnard and others permitted the elimination of at least the first stage of the earlier process. Specially prepared pieces of boxwood were coated with a light-sensitive emulsion similar to that used on photographic papers. Photographs could be printed directly on this surface. The engraver then carved the block by hand, following the outlines of the photographic image. The result, when printed in one of the growing number of illustrated papers of the period, was a picture of considerably greater precision and mimetic authenticity than earlier hand-rendered images had conveyed.[65]

The October 1857 issue of *The Photographic and Fine Art Journal* noted the success of Barnard's new endeavor.

> —MR. BARNARD has succeeded in obtaining a method of taking photographic pictures on wood for engravers, which is the best we have yet seen, and is pronounced the best by Mr. Orr and other engravers, to whom all the processes theretofore introduced have been submitted. Mr. Barnard has disposed of his gallery at Syracuse to Mr. LAZIERE, formerly of Picton, C.W., and intends devoting his time to this particular branch of photography.[66]

J.W. Orr, of New York, was an authority on the photography-on-wood process and had received a silver medal at the 1855 Fair of the American Institute for his version of the technique.[67]

At the 1857 edition of this fair, Barnard received a bronze medal for his photographs on boxwood.[68] Unlike the photographs on wood submitted by another entrant, a Mr. Waters, "Mr. Barnard's views were taken in the camera directly from the objects, consisting of views of buildings, machinery, landscapes, and portraits; whereas Mr. Waters' are from engravings." It was noted that "this photographic process is original with Mr. Barnard, and has been put in practical use by several of our first engravers to their entire satisfaction."[69] Barnard's use of photography-on-wood for actual in-camera exposures was distinctly unusual. While this procedure eliminated several intermediary steps of the more common version of the process, it must have been cumbersome and of extremely limited practicality. The size of the final image, for example, had to be precisely determined at the time of the original exposure. Similarly, the substitution of wood blocks for glass plates would have necessitated the construction of new plate holders and probably some modification of the camera itself.

Barnard also worked for John Homer French during this period. There was widespread interest in accurate topographic surveys at the time, and French had been given charge of a complex project to compile and edit a New York State map and gazetteer. Work started on this project in 1855. French's staff in Syracuse was led by an experienced topographic engineer and included experts in natural history, statistics, drafting, map-making, and lithography. By 1859 the map of New York State, revised maps of each county, and a minutely detailed 739-page gazetteer had been published.[70]

Barnard's specific duties for French can only be surmised. Credited as one of three "artists" on the project, Barnard must have been involved in some application of photography.[71] The completed state map included twelve vignettes of landscape or urban scenes that may have been taken from photographs. The views of Rochester, Oswego, and Syracuse, for example, seem particularly photographic in character and may have been from original views by Barnard. These images were also printed in the gazetteer as steel engravings.[72]

It seems probable that Barnard's work for French also included the photographic duplication of maps and drawings. In the process of compiling their maps topographers would generate numerous preliminary drafts and studies. Many of these would be printed in limited quantity for use in the office and field. Photography provided an ideal means for the rapid and inexpensive duplication of these drawings. Original renderings were photographed by the collodion process, with prints produced in any desired quantity from the resulting glass negatives. This process had been used by military engineers in the Crimean War and would prove essential during the American Civil War.

Complications in Barnard's family life may have contributed to his career changes of the late 1850s. There are strong indications that Barnard's marriage was troubled. At some point in the 1840s or early 1850s George and Sarah Barnard suffered the death of their newborn son, Isaac.[73] The trauma of this event is impossible to judge, but it may have contributed to illness or discord. While the truth may never be known, it appears that Barnard's wife left or was involuntarily removed from the household in 1854. This break may have coincided with, or contributed to, Barnard's unspecified illness of that year. Syracuse city directories record that Barnard moved from a house on 75 Union Street to the Onondaga Temperance House, at 40 Salina Street, in about 1854. Barnard boarded in this hotel, "one of the best Temperance Houses in the United States," for several years.[74] His daughter, Mary Grace, was said to have been "left at the age of five [ca. 1854] with her father, who didn't know what to do with her." Grace was subsequently "raised" in a Catholic convent or private school in Syracuse. In later years Grace's husband would joke that his wife had been taught "how to embroider and paint, but not how to boil water."[75]

By 1865 Sarah Barnard was sharing a residence in Syracuse with her cousin, a 28-year-old artist named Voltaire Combe.[76] In 1868 the pair moved to Brooklyn, where they were listed together in the 1870 census. In the 1875 census Sarah incorrectly described herself as "widowed" and 39 years of age (she was actually 51).[77] While no evidence of a formal divorce has been found, it seems evident that Barnard and his wife had drifted well apart by the beginning of the Civil War.

II

"his work is not only elegant and artistic, but vastly important to all classes of military men"

Opportunity and Conflict:

1860-1865

II:1 New York and Washington: 1860-1863

Although his wife and daughter resided in Syracuse through the mid-1860s, Barnard had shifted his professional attention toward New York City by about 1859. He had developed numerous photographic contacts there since 1846. In addition, his recent interest in photography on wood and experiences with J.H. French brought him to the attention of a broad group of publishers and artists. Most importantly, Barnard began close professional relationships at this time with two of the leading figures in mid-century American photography: Edward Anthony and Mathew Brady.

Edward Anthony owned the largest American business devoted to the manufacture and distribution of photographic supplies.[1] (After 1862 the business was operated in partnership with his brother, Henry T. Anthony.) In addition to cameras, chemicals, and paper, the Anthony firm sold photograph albums and a full range of studio equipment. It was also just beginning the mass production of stereographs and carte-de-visite photographs for popular sale. Anthony entered the stereoscopic trade in 1859 with an issue of 175 views and the firm's list of titles grew rapidly. With the broad technological changes of the period and the economic stimulus of the war, the early 1860s was a time of unprecedented expansion and profitability for the business: between 1859 and 1864 Anthony's annual sales grew from $100,000 to $600,000.[2]

Barnard had purchased supplies from the Anthony company since his Oswego days, and was highly respected by the firm. He had been consistently praised by Henry H. Snelling, the editor of *The Photographic and Fine Art Journal* and Anthony's general manager from 1847 to 1857. During this time Barnard sent samples of his work to Snelling and paid periodic visits to the Anthony offices. In addition, Jacob F. Coonley, who had been trained in photography by Barnard in 1856-57, joined Anthony in 1859 to manage the firm's new stereoscopic printing department.[3] Given these contacts, and his broad expertise, it is not surprising that Barnard himself was soon employed by the company.

Stereo photography was rising rapidly in popularity when Barnard began working for the Anthony firm. Introduced on an experimental basis in the 1840s, this technique became commercially viable with the invention (1850) and improvement (1859) of hand-held viewers.[4] American interest in the process swelled in 1858-60 due to the stereograph's novelty, remarkable illusionism, and relatively low cost.

Stereographs created the first real market for non-portrait photographs. Stereos most commonly depicted urban views, landscapes, and genre studies. Through the stereoscope a wide variety of subjects, from the busy streets of New York to the grandeur of the pyramids and the sublime beauty of the Alps, could be studied in the comfort of one's parlor. Stereographs were considered educational as well as entertaining, and made every armchair viewer a vicarious world traveler. This democratization of visual experience suggested a new era of individual awareness and cultural understanding. As Oliver Wendell Holmes noted, the stereograph was "the card of introduction to make all mankind acquaintances."[5]

Stereographs were also the first photographs made in quantity for a mass market. Prior to this time the great majority of all photographs had been one-of-a-kind images — portraits — produced through a personal interaction of photographer and client. Stereographs, however, arose from a very different creative and economic dynamic. The dominance of publishers and distributors in this newly impersonal market obscured the identity of individual photographers from the buyers of their images. At the same time, many professionals enjoyed a new freedom from the routine of the portrait business. Fascinating but previously unprofitable subjects were now open to the labors of stereo photographers. Within clearly understood limits, these photographers were able to work as they liked with some assurance that an audience existed for their images.

The process itself made new subjects possible. For example, the stereo camera's comparatively small plates (usually about 3¼ inches square) permitted exposures as short as about one-tenth of a second. These "instantaneous" exposures allowed the photographic depiction of action for the first time and were seen as a major technical advance. Anthony's earliest instantaneous stereographs of Broadway, issued in the summer of 1859, had been highly praised for their new sense of dynamic realism:

> The noble street is represented thronged with carriages and foot passengers. *All is life and motion*. The trotting omnibus horses are caught with two feet off the ground, boys are running — men walking, riding, driving, carrying weights — ladies sweeping the dirty pavement with their long dresses...[6]

In 1861 Oliver Wendell Holmes described these instantaneous views as "miraculous." He marveled, "what a wonder it is, this snatch at the central life of a mighty city as it rushed by in all its multitudinous complexity of movement!" After ruminating on the metaphysics of motion and stillness, Holmes observed poetically that "motion is rigid as marble, if you only take a wink's worth of it at a time."[7]

A stereographic aesthetic developed logically from the unique characteristics of the process. Photographers routinely used visual devices such as prominent receding lines, or the juxtaposition of objects in the foreground and distance, to emphasize the spatial illusionism of the process. Interestingly enough, stereo photographers often departed from a purely "factual" rendition of space. To duplicate the vision of the human eyes, the twin lenses of a stereo camera must be

16. *The Indian Statue on the Paseo, Havana*, 1860; stereograph (Anthony 130); private collection

set 2½ inches apart. In practice, however, this natural 2½-inch distance was "very seldom adopted."[8] A wider separation was used routinely to create an exaggerated sense of depth, or a feeling of "hyperspace."[9] Barnard and his peers made sophisticated use of this technique to produce images that were both visually dramatic and convincingly naturalistic (see figure 16, for example).

The many thousands of stereographs produced in this era exhibit numerous stylistic similarities. This "collective vision" stemmed from the common use of technical and compositional devices, and the expectations of the mass market.[10] The subjects and viewpoints of stereos were strongly determined by the interests of the general public and popular notions of the picturesque. Stereographs typically presented well known landmarks or subjects of general anecdotal appeal in a manner suggesting the experience of an ordinary observer located at a uniquely advantageous vantage point. Many guidebooks were published at this time detailing the "best" views of popular landmarks and this concept of ideal visual experiences underlies the stereographic aesthetic.

Barnard probably spent a large portion of his time in 1859 and 1860 making stereo views for the Anthony firm. In the spring of 1860, for example, he was sent to photograph in Cuba. By the early summer 134 of Barnard's images were published under the collective title, "Scenes in Cuba — Vistas Cubanas."[11] Within a few years the series was expanded to 191 titles with the printing of an additional 57 of Barnard's original negatives (see Appendix C). Most of these additions (series numbers 135-191) were variants of previously issued titles.

This large series was representative of the timely subjects recorded by Anthony photographers. Cuba had long held a deep fascination for Americans. In 1854, for example, a large panoramic painting of Cuban scenes was shown throughout the United States. This "Kinetoscope" show consisted of the gradual unrolling of the panorama accompanied by an informative narration and a medley of popular Cuban songs performed by two attractive young ladies. Barnard may well have

been among those who enjoyed this presentation in Syracuse in October 1854.[12] In the 1850s Cuba was perceived as a lush tropical paradise, renowned for its aristocratic plantation life, colorful public festivals, and exotic flora. Only ninety miles from the Florida coast, it was also America's primary source of sugar.

By 1860 Cuba had long been a topic of political debate in the United States. For years expansionists had advocated the island's purchase or outright annexation. President Polk had tried to buy the island from Spain prior to 1850, and this effort was continued by Presidents Pierce and Buchanan in the decade preceding the Civil War. Spurred by dreams of wealth and empire, many Americans considered the acquisition of Cuba both necessary and inevitable. Consequently, despite Spain's repeated refusal to sell the island, by 1859 Cuba had become "a central, if not the central, issue in American politics."[13] President Buchanan focused on the acquisition of Cuba as a cause to unite his party and advance his chances for reelection in 1860. The island was thus the subject of renewed discussion and journalistic attention at the time of Barnard's trip.[14]

After reaching Cuba by steamer, Barnard photographed in the city of Havana, the village of Matanzas, and on at least one plantation. In Havana he documented civic landmarks such as the Treasury building, prison, theater, several cathedrals, and the venerable Moro Castle. Other subjects included the Calle de Oreilly ("one of the principal business streets in Havana"), the Dominica ("the fashionable place of resort in the city"), and parks, statues, and gardens. He documented indigenous flora (palms, coconut trees, and cactus) and such colorful vignettes of everyday life as a fish market and a band of street musicians. The city's harbor was of particular interest to Barnard, and the subject of over thirty views (figure 17). He also "had the honor of dining with the Governor-General, of whom he made pictures with his wife and family." Barnard used this occasion to make a small group of photographs inside the Palace of the Conde de Santovenia.[15]

About one-fourth of the photographs in Barnard's Cuba series were "instantaneous" views depicting Havana's harbor and busy streets. Barnard recorded numerous ships in motion in the harbor and made close-up views of the "dashing spray" of waves breaking on the rocky shoreline (figures 18, 19, 25). His instantaneous urban scenes contrasted the geometry of the city's architecture with the dynamic activity of its street traffic. Like the 1859 Anthony views of Broadway, these photographs were made from second- and third-story vantage points. These elevated perspectives allowed the most rapid exposures technically possible (by decreasing the need for much depth of field) while providing dramatic "bird's-eye" views of the city.

Barnard traveled outside Havana to photograph on the plantation "Louisa." His images presented such carefully selected details of plantation life as slaves on their noon break (figure 22) or at work in the kitchen. As a group these plantation views reflect the American fascination with the sugar industry.[16] Barnard recorded slaves engaged in characteristic facets of the sugar milling operation at "Louisa"

17. *Bird's Eye View of the harbor and city of Havana, from the Castle Cabana*, 1860; stereograph detail (Anthony 28); New York Public Library

18. *An Instantaneous View. The harbor with an English Yacht running out past the Moro Castle*, 1860; stereograph detail (Anthony 50); New York Public Library

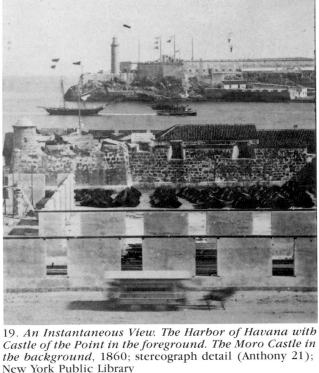

19. *An Instantaneous View. The Harbor of Havana with Castle of the Point in the foreground. The Moro Castle in the background*, 1860; stereograph detail (Anthony 21); New York Public Library

20. *Instantaneous View. From the Dominica looking towards the Plaza*, 1860; stereograph detail (Anthony 127); New York Public Library

21. *A Street View, from the Dominica. A company of Spanish troops returning from Mass*, 1860; stereograph detail (Anthony 39); New York Public Library

22. *Plantation View. The Nooning*, 1860; stereograph detail (Anthony 68); private collection

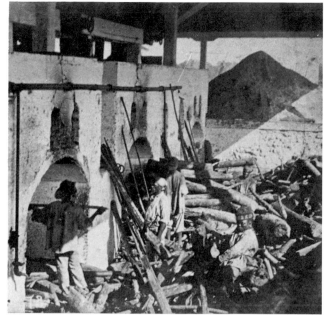

23. *Plantation View. View in a Sugar Mill. The fire holes*, 1860; stereograph detail (Anthony 72); New York Public Library

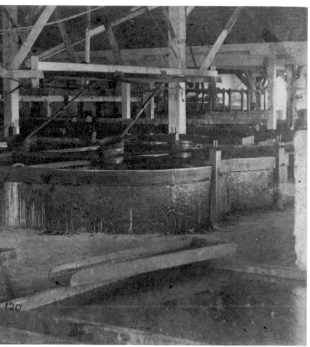

24. *Plantation Scene — Interior of a Sugar Mill*, 1860; stereograph detail (Anthony 120); private collection

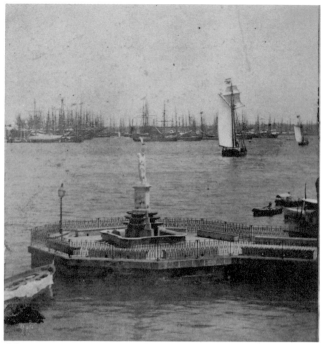

25. *Instantaneous View. The harbor of Havana, with the Fountain of Neptune in the foreground*, 1860; stereograph detail (Anthony 97); New York Public Library

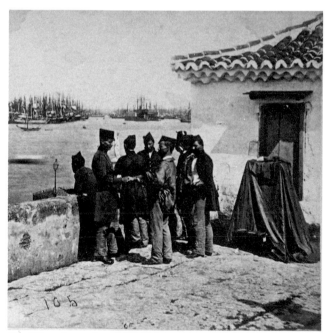

26. *View from inside the Ramparts of the Castillo de la Fuerza. Group of Spanish Soldiers*, 1860; stereograph detail (Anthony 105); New York Public Library

27. *Interior View. Palace of the Conde de Santovenia. The Countess' Boudoir*, 1860; stereograph detail (Anthony 64); New York Public Library

28. *Interior View. Palace of the Conde de Santovenia. The Gallery*, 1860; stereograph detail (Anthony 62); New York Public Library

(figures 23, 24), and also photographed a large sugar warehouse in Havana.

A close examination of Barnard's Cuban views provides revealing details of his working method. From a single vantage point on the Dominica, for example, he made at least two photographs: a quiet, mid-morning architectural study, and a dynamic image of uniformed troops marching through a congested street (figures 20, 21). These stereographs were probably made within a span of twenty minutes. They are remarkably different in content and visual appeal, and suggest Barnard's understanding of the changing aesthetic potential of a world in flux.[17]

In another instance a minor change in camera position produced substantially different images (figures 25, 26). Several of Barnard's instantaneous views of the Havana harbor were made from an elevated position on the ramparts of the Castillo de la Fuerza. His protracted labors there drew the attention of Spanish soldiers who gathered to watch. Finding aesthetic interest in this group, Barnard moved his camera slightly and arranged the troops before the backdrop of the harbor. He then made an informal image of the soldiers conversing beside his own dark-tent and camera case.

Barnard's work inside the Palace of the Conde de Santovenia reveals a sophisticated use of reflections to multiply the inherently spatial effects of his stereographs. In his views of the gallery and the Countess's boudoir, Barnard used background mirrors to double the virtual space of each scene (figures 27, 28). In his image of two women seated in the gallery, a large mirror on the rear wall reflects everything before it, including Barnard's distant camera and a seated male observer. The result is a surprisingly complex image that, like Jan Van Eyck's *Arnolfini Wedding* (1434), looks in two directions at once and contains evidence of its own creation.

Shortly after his return to New York, some of Barnard's instantaneous stereographs provided a topic for discussion at the May 1860 meeting of the American Photographical Society (see Appendix D). This society was a branch of the American Institute of the City of New York, a scientific association with broad interests. After attending a number of meetings, Barnard was elected to membership in the Photographic Society on February 11, 1861.[18]

Submitted for review during the meeting of May 4, 1860, were "specimens of instantaneous photography negatived by Mr. Barnard" and printed by the Anthony darkroom manager, Mr. Kuhns (who succeeded Coonley in this position). When asked to comment on his Havana harbor scenes, Barnard replied that they were produced with a wet-collodion emulsion, slightly more sensitive than usual, that permitted exposures of about "the 40th part of a second." Considerable discussion then followed on the accuracy of this 1/40th-second estimate, the types of chemicals or mechanical manipulations required, and the need for redeveloping extremely thin (underexposed) negatives before they could be printed. One speaker argued authoritatively that photographers routinely overestimated the rapidity of their "instantaneous" images, and that the fastest exposures then possible were, in fact, on the order of "a fifth to a sixth of a second."[19]

Barnard remarked to this group that his Havana harbor views were "simply samples of the work" he was then doing. This comment strongly suggests that Barnard made other stereographic views for Anthony during the period. The remark is particularly interesting given the predominance of instantaneous New York harbor scenes commissioned by the firm in 1859-60. The October 1862 Anthony catalog listed many stereographic views of towboats, ferries, sloops, schooners, and steamers taken in New York harbor and on the East and Hudson Rivers. These subjects provided ideal opportunities for rapid and picturesque exposures, and the quantity of these views suggests their popularity.

In addition to stereos of routine harbor and river traffic, more than twenty instantaneous views were made of the Fourth of July regattas of 1859 and 1860. These festive but unfortunately uncredited stereographs document activities in the harbor and the audience watching from the shore. The title of one 1860 view seems indicative of the pictorial ambitions of these pictures: *Animated scene. The shore crowded with spectators and the water crowded with boats and sailing vessels.* The parade that accompanied the city's 1860 Independence Day celebration was also represented in this "Fourth of July In and About New York" series.

In his work for Anthony, it is also possible that Barnard may have documented such newsworthy events as the October 17, 1859, New York Fireman's Parade, or the arrival of the Japanese delegates in June 1860. The latter event was recorded in a series of twenty-four Anthony stereographs depicting the landing and reception in New York City of the Japanese Embassy. On June 16, 1860, the Fifth, Seventh, and Eighth Regiments of the New York Militia, as well as cavalry and artillery units, assembled at the Battery to greet the Japanese officials. Two days later an Anthony photographer recorded the delegation's arrival at City Hall, where they were received by the mayor and state governor. The methodical documentation of this event (as well as a dry sense of humor) is suggested by the following sequence of titles:

20. *Arrival of the Embassy at the City Hall, to visit the Governor and Mayor,* June 18, 1860

21. *The Seventh Regiment taking position in front of the City Hall, after the Embassy have entered the Building,* June 18, 1860

22. *The Seventh Regiment awaiting the termination of the interview between the Embassy and the Municipal and State Authorities,* June 18, 1860

23. *While the interview between the Authorities and their guests is prolonged, the Seventh Regiment, gallant fellows, are attacked with the pangs of hunger, and stacking their arms, they rush to the neighboring restaurants,* June 18, 1860.

Ten months later, in the first weeks of the Civil War, the colorful Seventh Militia would receive national acclaim.

The full extent of Barnard's work during this time will probably never be known due to the generally uncredited nature of Anthony's stereo offerings. Typical of the numerous geographic or thematic series issued in 1859-62 were "Beauties of the Hudson" (sixty-nine views in and around West Point), "Hills and Dales of New England" (sixty-nine scenic views in Vermont), and "Public Buildings in New York and Brooklyn" (sixty-three stereographs of noted churches, hotels, and streets). Barnard may well have contributed to these, or similar, groups. It is known, for example, that he photographed at Niagara Falls for the Anthony firm in late 1861 or early 1862.

The popular market for relatively inexpensive stereo and portrait photographs stimulated a complex interchange in the early 1860s between three important parties: Mathew Brady, Alexander Gardner, and Edward Anthony. At various times Barnard worked for all three and they, in turn, had various agreements (or disagreements) between one another. The quality and quantity of American Civil War photography is a direct result of the overlapping personal, artistic, and commercial interests of these men.

Mathew Brady had operated a highly prestigious studio in New York since 1844. Renowned as the portraitist of the famous and powerful, Brady had many contacts with American political and military leaders of the period. Although Brady personally made few photographs after the early 1850s, his gallery amassed a large collection of portraits of celebrities. Brady recognized the historical importance of these images and used every opportunity to add new faces to this series.

In 1856 Brady hired Alexander Gardner, a native of Scotland, to work in the New York gallery. Gardner was a fascinating man of varied talents. In addition to his broad knowledge of science and art, Gardner was known for his integrity and strong ideals. His moral convictions led him to write extensively on the plight of the poor and other social issues. In Scotland, Gardner had been involved in planning a utopian community on the American frontier. He was a generous employer, and was admired by all who knew him, including many important political and military men.[20] While Gardner was more active in promulgating his beliefs than Barnard, it is probable that the two had much in common and worked well together.

In February 1858 Gardner was appointed manager of Brady's new studio in Washington, D.C. This lavish gallery occupied the upper three floors of a prominent building at 350-352 Pennsylvania Avenue. The gallery's reception room, decorated with many framed photographic and painted portraits, was on the building's second floor. Finishing rooms for the retouching, coloring, and mounting of prints occupied the third floor. On the top level was the photographic studio itself, with its cameras, decorative backdrops, and all-important sky-light. The sun-printing of photographs was carried out on the roof. Since Brady initially spent most of his time in New York, Gardner acted very independently in his management of this new facility.

Gardner was astute in recognizing the commercial potential of new photographic formats. While in charge of the New York gallery, he had introduced enlarged "Imperial" portraits. These life-size, painted photographs were typically 17x21 inches in size, and retailed for the enormous sum of fifty dollars. For those who could afford them, the Imperials were a sensation.[21]

Gardner also sensed the potential demand for large numbers of low-priced portraits. The carte-de-visite photograph — a small, inexpensive print adhered to a mount approximately 2¼x4 inches in size — had been introduced in France in the mid-1850s. These prints were usually produced with a multi-lensed camera, so that a number of images (typically four or eight) could be made economically on a single wet-collodion glass negative. By early 1861 the carte-de-visite had gained dramatically in popularity and dominated the portrait business in the United States.[22] The February 1, 1861, issue of the *American Journal of Photography* reported that

> card photographs in New York are now in the height of fashion. In several of the leading galleries it makes the chief business, and in one so great is the demand that the actual work is at least a week behind the orders; the patrons make their application and appointments a week in advance.[23]

Under Gardner's direction the Washington gallery was outfitted with quadruple-lensed cameras and quickly became known for these simple, functional images. Before leaving for the uncertainties of the front, many Civil War soldiers had their likenesses preserved for loved ones at home.

A popular market for carte-de-visite portraits of political leaders, military heroes, and other celebrities also arose at this time. To satisfy this demand Gardner convinced Brady to enter into an agreement with the Anthony firm, which had the capacity to produce and distribute large quantities of photographs. Under the terms of this contract Brady's galleries supplied negatives of notable personalities for an annual fee of about $4000, and mass-produced prints were sold under the Anthony imprint. While Brady personally disliked this cheap and seemingly inartistic form of portraiture, he recognized the genre's broad appeal. A similar financial arrangement also covered the many war stereographs made by photographers in the employ of Brady, and later Gardner, that were distributed by the Anthony company.[24]

In the winter of 1860-61, as part of this agreement with Brady, it appears that Anthony assigned Barnard and Jacob F. Coonley the task of making carte-de-visite negatives of "all [of Brady's] collection of distinguished people."[25] This would have been a formidable undertaking involving the re-photographing of daguerreotypes dating back to the mid-1840s as well as more recent paper-print portraits.

After finishing with the stock of photographs in Brady's New York files the team was sent to the Washington gallery to conclude this work. Barnard and Coonley arrived in the nation's capital in March 1861, a time of great political drama.

Tension between North and South had been building steadily in the waning months of President Buchanan's administration. Incensed by Lincoln's election, South Carolina seceded from the Union on December 20, 1860. Three forts in Charleston harbor, under the command of Major Robert Anderson, were perceived as intrusive symbols of Federal power and secessionists demanded their surrender. On Christmas eve Anderson consolidated his three small forces within the protective walls of Fort Sumter, beginning a tense three-month standoff. In January 1861 Mississippi, Alabama, Georgia, and Louisiana seceded from the Union. Similar votes soon followed in Arizona, Arkansas, North Carolina, Virginia and Tennessee. On February 4, 1861, a Peace Convention with representatives from twenty-one northern states met in Washington to begin a protracted and unsuccessful attempt to resolve the nation's disagreements. On the same day, in Montgomery, Alabama, delegates from the seceding states gathered to organize the Confederacy. On February 9 Jefferson Davis, a former U.S. senator and Secretary of War, was elected president of the new Southern nation. On March 4 Abraham Lincoln was sworn in as the sixteenth chief executive of the United States. From his first day in office Lincoln faced the greatest crisis in the nation's history.

Coonley later recalled that he and Barnard arrived in the capital "a few days after" Lincoln's inauguration.

> A short time subsequently the Commissioners from the Southern Confederacy visited the Capital for the purpose of arranging terms for a peaceful separation of North and South. With the result of these negotiations we are all familiar; they are now a matter of history. We made pictures of these gentlemen at the time, and I think this was the beginning of the celebrity work in this country, and *carte-de-visite* being the size then just introduced. A great many notables both military and civilian began to frequent the Capital, and we were kept very busy in making pictures of them for publication.[26]

The three "Commissioners" dispatched by Confederate President Davis were in Washington by March 6 and attempted to meet with Lincoln to formalize the Southern secession. It had been widely assumed in the South that, despite the current tension, "there would be no war, but the two Governments would settle all matters of business in a friendly spirit, and each would go in its allotted sphere, without further confusion."[27] Lincoln destroyed this hope by refusing to recognize the validity of the Confederate government or any of its representatives. Davis's ambassadors left Washington on April 11. One day later the war began with the bombardment of Fort Sumter. Lincoln subsequently issued a call for the enlistment of 75,000 volunteers and ordered a naval blockade of all Confederate ports.[28]

From this period onward the city of Washington bristled with military and political activity. While Coonley was imprecise in his estimation of the beginning

of the carte-de-visite "celebrity work in this country," demand for such images certainly boomed in Washington in the spring of 1861. By April 25, the Sixth Massachusetts and Seventh New York Regiments had arrived in the city, easing Lincoln's fears of a Confederate invasion of the capital. By May 6, six regiments from New York, three from Massachusetts, two from Pennsylvania, and one from Rhode Island were in Washington.[29] Brady's gallery was kept busy servicing the photographic needs of this flood of military personnel, as well as the demand by the national press and a curious public for portraits of newsmakers.

During the following months Barnard apparently worked for both Anthony and Brady, using the latter's Washington gallery as a base. Barnard was probably paid on a daily basis for his labors. Brady, for example, paid experienced photographers $11 per day (and $16.66 on Sundays) for work done on special assignment.[30] While much of Barnard's time may have been devoted to studio portraiture, he was also given several important tasks in the field.

Among Barnard's earliest images made outside the studio were photographs of the celebrated Seventh New York Militia produced in collaboration with C.O. Bostwick in May 1861.[31] This series was stimulated by Brady's friendship with officers in the regiment, and the great popular interest in the Seventh. The Seventh Militia, composed of young professional men from New York City, achieved widespread acclaim as one of the first military units to come to the defense of the nation's capital. The rhetoric used to describe these men illustrates a romantic and rather ceremonial vision of war that was soon lost in the bitterness and blood of protracted fighting. As one historian has noted of this period,

> Americans were a martial but not a militaristic people. They were suspicious of standing armies and the professional militarists of the service academies. But at the same time they delighted in the symbols and pageantry of warfare, the parades, the reviews, and the flag, and they gloried in the martial tradition of a nation that had managed to win most of its wars under the leadership of inspired amateurs. America's best loved military heroes were not her professional soldiers so much as the militia...the volunteers, the "peaceable" men who cast aside their plows and pitchforks and picked up their muskets and had always been victorious in the past. In 1861 everyone was confident they would win again.[32]

The Seventh Militia's march from New York City to Washington, which began on April 19, 1861, was described with some hyperbole as "one of the most remarkable and memorable events in the history of the country." This trip was complicated by an earlier riot in Baltimore, when a secessionist mob assaulted the Sixth Massachusetts Infantry as it passed through the city en route to Washington. As the soldiers were changing trains an angry crowd attacked with stones. Shots were exchanged and several soldiers and civilians were killed.

The threat of further violence in Baltimore effectively closed the rail link between New York and the capital, forcing the Seventh Militia to take an arduous

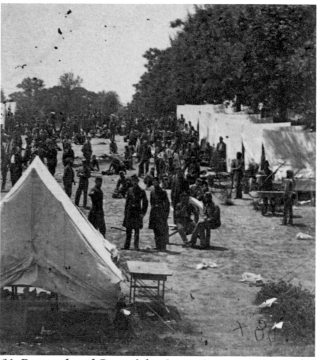

29. **Barnard and Bostwick:** *Gymnastic Field Sports of the Gallant 7th. A Four story pile of men*, 1861; stereograph detail (Anthony 814); New York Public Library

30. **Barnard and Bostwick:** *Camp Cameron*, May 1861; U.S. Army Military History Institute

31. **Barnard and Bostwick:** *Camp Cameron*, May 1861; U.S. Army Military History Institute

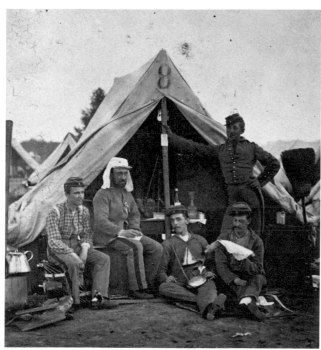

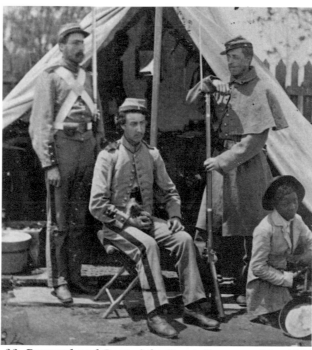

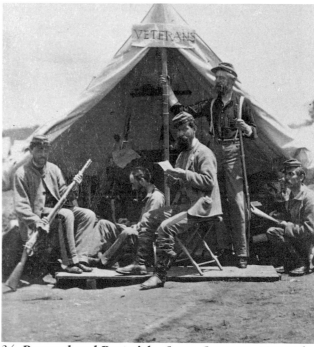

32. **Barnard and Bostwick:** *Camp Cameron*, May 1861; U.S. Army Military History Institute

33. **Barnard and Bostwick:** *Camp Cameron*, May 1861; U.S. Army Military History Institute

34. **Barnard and Bostwick:** *Camp Cameron*, May 1861; U.S. Army Military History Institute

detour. As the regiment slowly advanced toward Washington, then rife with rumors of enemy attack, "the public mind balanced between hope and fear...until at last the glad tidings flew with lightning speed throughout the land" that the city was safe. When the Seventh Militia entered Washington on April 25, it was welcomed with "tears of joy [as] the deliverer and saviour of the country." President Lincoln personally thanked the regiment's commander, and Secretary of War Simon Cameron praised the men in a public address. With great pomp and ceremony the regiment marched in formation down Pennsylvania Avenue and passed in review before the White House.[33]

After several nights in the city's finer hotels, the Seventh established quarters at Camp Cameron on May 2. This forty-acre camp, named in honor of the Secretary of War, was situated on Meridian Hill about two miles from the Capitol building. This elevated site provided an expansive view of Washington, the Potomac River, and Arlington, Virginia. On this beautiful hilltop some 220 tents were erected to shelter the regiment's 1200 men.[34]

The members of the Seventh Militia represented "the intelligence, wealth, and the commercial enterprise" of New York society. Many of these privileged young men had joined the peacetime militia not only as an expression of civic duty, but as a fraternal, "manly pastime." The members of the Seventh Militia projected an almost theatrical image of polish and perfection, and were noted for their "soldierly bearing" and "gentlemanly manners." The streets of Camp Cameron were

> models of neatness and cleanliness, and many of the tents had an air of ease, elegance and comfort...Uniforms were neat and clean, belts white as snow, muskets dazzling with brightness, and upon parade the men stood with veteran steadiness or moved with admirable ease and gracefulness.[35]

A typical day at Camp Cameron was devoted to company and battalion drills in the morning and target practice and camp inspection in the afternoon. At five o'clock the band played stirring martial tunes as visitors began arriving from town. During the evening parade, "the great event of the day," smartly-dressed troops marched in rhythmic precision before a reviewing officer and a crowd of appreciative spectators. "Gymnastic and athletic amusements" were then performed.[36]

Camp Cameron was a highly public place in May 1861. Indeed, "no fair day passed without its throng of distinguished visitors." Between May 7 and May 15, for example, these dignitaries included Major Anderson, the defender of Fort Sumter, the French and Brazilian Ministers, and President Lincoln, who made repeated visits (on May 12, 13 and 15) in the company of various guests.[37]

All of these visitors thrilled to the precision, "manliness," and spirited good humor of this army of bright-eyed amateurs. In May 1861 it still seemed possible that the war could be won (or averted) by virtue of patriotism and gentlemanly zeal alone. Indeed, many in the North believed that "a lady's thimble would hold all the blood to be shed" in the conflict.[38] For most Americans war represented an abstract ideal of "handsome officers leading vigorous young men to the ultimate test of their strength and courage."[39] Success or failure, therefore, was more a product of morality and individual character than of specialized military knowledge. William T. Sherman observed accurately that,

> the appearance of the troops about Washington was good, but it was manifest they were far from being soldiers. Their uniforms were as various as the States and cities from which they came; their arms were also of every pattern and calibre; and they were so loaded down with overcoats, haversacks, knapsacks, tents, and baggage, that it took from twenty-five to fifty wagons to move the camp of a regiment from one place to another, and some of the camps had bakeries and cooking establishments that would have done credit to Delmonico.

Events of subsequent months proved to Sherman that "we had good organization, good men, but no cohesion, no real discipline, no respect for authority, no real knowledge of war."[40]

The photographs made by Barnard and Bostwick at Camp Cameron convey the relaxed and innocent mood of the period.[41] They photographed such "gymnastic sports" as soldiers balanced atop one another in a four-story human pyramid (figure 29). The review of the troops was recorded and numerous group portraits were taken of soldiers posed proudly before their tents (figures 30-34). The photographers also turned their camera on the vista from the camp, and their image of Georgetown was described in the Anthony catalog as "a view of exquisite beauty."[42] Many members of this regiment also came to Brady's gallery to be photographed.

These Camp Cameron photographs were probably all made with a stereo camera. Six views of the most general interest were offered for public sale in this format by the Anthony firm. Most of the rest of these photographs were trimmed to half-stereo or carte-de-visite size. Barnard and Bostwick took scores of repetitious group portraits at this time, but few prints appear to have been made from any of these negatives. This suggests that most of these images were commissioned and purchased by their subjects, and not produced in quantity for national distribution.[43]

Given the idealized rhetoric and imagery that characterized the Seventh Militia, it is significant that they never fired a shot in anger. The members of this state regiment had been sworn into national service on April 26 for a period of only thirty days. The great bulk of this time was spent marching and drilling before spectators on Meridian Hill, in preparation for battles that came only later. While many members of the unit subsequently enlisted in the regular army for a three-year stint, most were back at their jobs in New York City by the middle of June.[44]

In the last two weeks of that month Barnard and Bostwick photographed at Harper's Ferry, the site of John Brown's celebrated raid of 1859. Harper's Ferry had been abandoned by the Confederates on June 14, 1861, and the photographers apparently visited shortly after its occupation by Federal troops. A relatively small

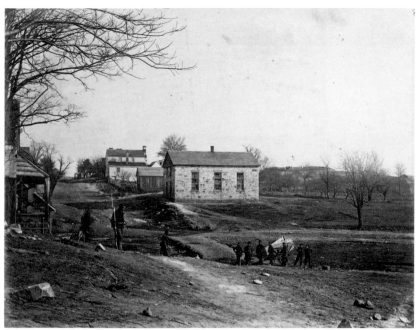

35. **Barnard and Gibson:** *Stone Church, Centreville, Va.*, March 1862; Chicago Historical Society

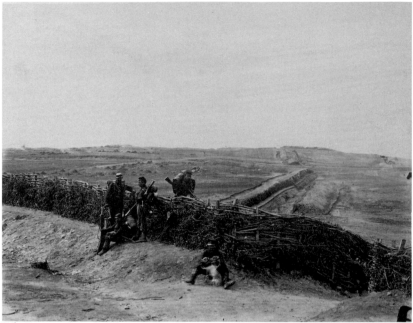

36. **Barnard and Gibson:** *Fortifications on Heights of Centreville, Va.*, March 1862; Chicago Historical Society

series of these stereographs was issued by the Anthony firm under the collective title, "Harper's Ferry in War Time."

The tenor of the war changed radically in the next month. After weeks of maneuvering and isolated skirmishing, Federal and Confederate forces collided in the battle of First Bull Run (called First Manassas by the Confederates) on July 21, 1861. This engagement, the largest fought in North America up to that time, was a stunning Union failure that crushed any hope that the rebellion could be ended quickly or at little cost.

Expectations for a major engagement had been building for days. Confederate forces entrenched themselves near Manassas, Virginia, across the Warrenton turnpike just beyond the Bull Run Creek. Union troops gathered about five miles away in Centreville after marching twenty miles from Washington. The unusual military activity in the northern capital had stimulated much talk among the city's residents, and the employees of Brady's Washington studio undoubtedly received information on the initiative from several sources. For example, General Samuel P. Heintzelman and his staff visited the gallery on July 15 to sit for portraits.[45] These officers were scheduled to leave for Centreville the following day and probably related what they knew of the upcoming campaign.

Given the air of unreality that still characterized the war, and the slack discipline of the inexperienced troops, it is not surprising that many friends and spectators accompanied the Union forces into Virginia. Well-dressed men and women from the capital, expecting to see the first and last engagement of the war, rode to the front in buggies. Brady and Barnard were both part of this unofficial regiment of civilians. Brady accompanied Heintzelman's troops to the front and later recalled,

I went to the first Battle of Bull Run with two wagons from Washington. My personal companions were Dick McCormick, then a newspaper writer, Ned House and Al Waud the sketch artist. We stayed all night at Centreville; we got as far as Blackburne's Ford. We made pictures and expected to be in Richmond the next day, but it was not so, and our apparatus was a good deal damaged on the way back to Washington...[46]

Barnard may have gone to Bull Run with Brady's group, or independently on assignment for Edward Anthony. Surviving accounts are ambiguous on this detail.[47] In either case, the description of Barnard's activities on that confused and discouraging day differ in significant respects from Brady's.

News of a prospective encounter at Bull Run [was] noised about [Washington]. Loads of civilians were carried to the place to witness the engagement. Taking his camera, which weighed something more than the modern instrument, [Barnard] engaged a seat in a carryall, but he got no pictures that day. On the return he overtook a poor fellow, sorely wounded in the leg, trying to get back to Washington. He stopped and put him in his place, shouldered his heavy instrument, and after weary walking he reached Washington, footsore and tired.[48]

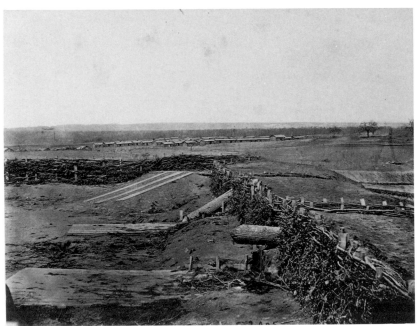

37. **Barnard and Gibson:** *Quaker Guns, Centreville, Va.*, March 1862; Chicago Historical Society

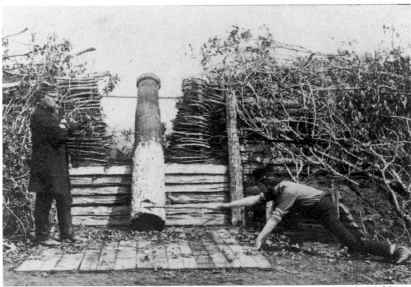

38. **attributed to Barnard:** *Quaker Gun, Centreville, Va.*, March 1862; U.S. Army Military History Institute

The men that fought at Bull Run were only marginally more prepared for real war than the cheering civilians who watched the battle from a hilltop two miles away. In the midst of organizational chaos and miscommunication a ferocious battle began along the Bull Run Creek at 7:30 on the morning of July 21. Union forces, which were able to cross the Bull Run only at specific points, advanced with difficulty under heavy fire. In the early afternoon the stubborn Confederates, led by General Thomas "Stonewall" Jackson, held their ground against repeated assaults by General Irvin McDowell's Union forces. From 2:00 to 4:00 in the afternoon the battle for Henry Hill raged back and forth. Then the engagement began to turn against the Northern forces. When General P.G.T. Beauregard's Confederate troops received fresh reinforcements, the battle became a rout. Exhausted and confused Union soldiers panicked, threw down their weapons, and ran for their lives. The Confederates, sensing their enemy's collapse, followed up with renewed attacks and artillery fire.

Rag-tag waves of terrified men ran toward the rear, passing around and through the recently jubilant crowd of civilian spectators. Most of these civilians were themselves caught up in this mad retreat, and a few were even captured by advancing Confederate troops. Brady straggled back to Washington the following day, and immediately had his portrait made to commemorate the harrowing episode. Barnard walked much of the distance, arriving in the capital exhausted and disheveled.

Confederate forces were unable to follow up their crushing victory with an advance toward Washington due to nightfall on July 21 and rain the following day. They spent the next few days gathering the enormous quantity of material discarded by the fleeing northerners. Horses, wagons, rifles, cannons, hospital supplies, blankets, rations and half a million rounds of ammunition were collected.[49]

Northern reaction to the debacle at Bull Run was profound. A shocked public prepared itself for a bloody and drawn-out conflict while military leaders sought scapegoats and solutions. Within a week McDowell was reassigned and his army, the Federal Division of the Potomac, was reorganized under the direction of General George McClellan. More troops were called up and rigorous training methods initiated. McClellan's confident leadership soon instilled in his forces a new sense of determination and professionalism. While further setbacks would occur, the shame of July 21, 1861, created a hardened Northern resolve to win the war.

Southern forces remained encamped in the Manassas area for eight months before withdrawing. On March 9, 1862, McClellan's troops discovered that long-held Confederate fortifications at Centreville and Manassas had been quietly vacated. By March 11 Federal forces investigating the area found only scattered debris and a landscape "entirely stripped of forage and provisions."[50] Spurred by news of the Confederate withdrawal, Barnard returned to the area with Brady employee James F. Gibson.[51] A shared "Barnard and Gibson" credit indicates

that the two cooperated in the making of large (ca. 8x10-inch) photographs, while Barnard received sole credit for the stereographs made on this trip (see Appendix E).

In Centreville, Barnard and Gibson recorded a street defaced with eroded earthen defensive works (figure 35). The team then turned their cameras on the strong Confederate entrenchments along the crest of Centreville Ridge (figure 36). The landscape beyond these lines had been denuded by Southern forces to render any enemy movement immediately visible. Union soldiers posed for the camera to add human interest to the scene, but a restless dog could not be held still during the lengthy exposure. The photographers also recorded the wooden "Quaker guns" used by Confederate troops to provide the illusion of greater firepower than they actually possessed (figure 37). Barnard even made a comic image of a soldier gingerly "firing" one of these dummy weapons (figure 38).

Barnard and Gibson then traveled the short distance to Bull Run. On the site of the battle of July 21, 1861, they paid particular attention to Stone Bridge and Sudley Ford, the points at which Federal troops had crossed the Bull Run Creek under fire. The bridge, which had been destroyed during the Confederate occupation of the area, was recorded as a picturesque ruin. Nearby, Barnard photographed a mourner paying homage to the rude graves of fallen soldiers (figure 39).

He also documented the Henry, Robinson, and Matthews Houses. Each of these structures was associated with memorable stories of bravery or tragedy. The Henry House, for example, had been near the fiercest fighting of July 21. Mrs. Judith Henry, a bedridden widow, had lived in the house with her son, daughter, and a black servant. When the first shots were fired the family tried to carry Mrs. Henry to safety. She insisted on remaining in her house, however, and the others stayed with her. During the battle Mrs. Henry's daughter stood within the house's stone fireplace for protection only to have her hearing permanently impaired by the reverberations of nearby explosions. Judith Henry was killed by shell fragments as she lay in bed.[52]

Barnard and Gibson found an astonishing scene of wreckage at Manassas Junction (figures 40, 41). During the Confederate evacuation of the area everything of military value had been carried away or destroyed. Burned buildings, dismantled forts, broken wagons, and wasted supplies were scattered over an expansive and seemingly lifeless landscape. The scene suggested the aftermath of a vast natural catastrophe and the soldiers posed in these photographs seem numbed by the destruction around them.[53] At the fortifications of Manassas (figure 42) Barnard and Gibson recorded a more animated scene of Union troops posing playfully on the decayed walls of a fort.

Under the terms of the Brady-Anthony agreement, the photographs produced by Barnard and Gibson were distributed widely. Their large views, issued as 7x9-inch trimmed and mounted prints, were made available as part of Brady's "Incidents of

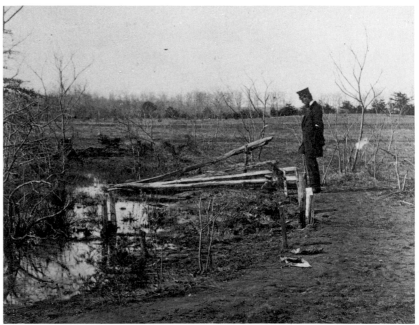

39. *Soldiers' Graves, Bull Run*, March 1862; U.S. Army Military History Institute

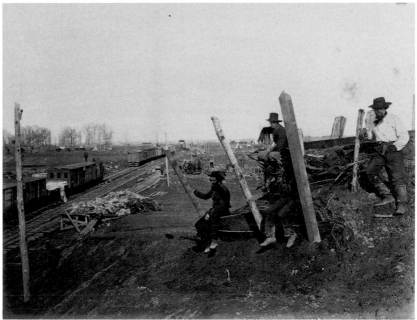

40. **Barnard and Gibson:** *Ruins at Manassas Junction*, March 1862; Chicago Historical Society

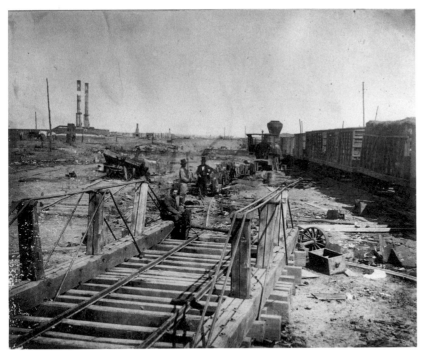

41. Barnard and Gibson: *Ruins at Manassas*, March 1862; U.S. Army Military History Institute

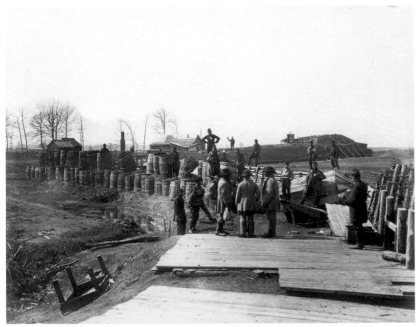

42. Barnard and Gibson: *Fortifications at Manassas*, March 1862; Hallmark Photographic Collection

the War'' series. A group of smaller views in the carte-de-visite format were sold in Brady's ''Album Gallery'' series. And, beginning sometime around early 1863, Barnard's stereos were published by Gardner's Washington gallery and distributed by Anthony. Most of these photographs were listed in Gardner's September 1863 catalog, and several of the larger views were published in *Gardner's Photographic Sketchbook of the War* (1866).

Barnard was busy at this time with a variety of assignments. In either the late summer of 1861 or March 1862 he was commissioned by the Anthony firm to take stereographs at Niagara Falls.[54] Details on this series are sketchy and derive entirely from the comments of Coleman Sellers, a noted authority on photography. In a letter of April 8, 1862, to the *British Journal of Photography*, Sellers described this series with enthusiasm.

> ...I must mention some stereoscopic views of Niagara and its vicinity soon to be published by Mr. E. Anthony, of Broadway, New York. They are from a new set of negatives, and deserve more than a passing notice. Anyone who has visited the Falls cannot have failed to notice how difficult it is to represent on paper or canvas the wonderful grandeur of the scene...Many of the pictures above alluded to are from new stand points, and, besides being charming prints, seem to express more of the striking features of the view than any stereograph heretofore published. Some of them will prove particularly interesting to geologists; for the huge masses of rock laid bare by the wearing back of the falls, through countless ages, is given with all the pre-Raffaelite perfection in detail that the camera only can give; and one is prompted at first sight of the picture to turn to Sir Charles Lyell's graphic description of the geology of the Falls, and to trace with his aid the nature and condition of the strata laid bare. I was glad — very glad — to see these prints, and to hear that they were soon to be published...[55]

It is significant that Sellers pointedly praised the originality of Barnard's approach to this familiar site. Considering that Niagara was ''the most stereographed'' subject in the world, interpreting the falls in a new way was a considerable challenge.[56] Sellers later added that Barnard's views were ''the only pictures of that wonderful cataract which seem to bring back the immensity experienced in witnessing the falls.''[57] One of the photographs Barnard may have made at Niagara is reproduced as figure 43.

Precise identification of these pictures is difficult, as Barnard was almost certainly not the only Anthony photographer to visit Niagara in this period. The firm's October 1862 catalog listed no fewer than seventy-six different stereographs of the falls, including seven instantaneous exposures, and noted that an additional 500 were available. These views documented Horseshoe Falls, American Falls, Terrapin Tower, Niagara suspension bridge, and details such as the rapids and a ''curiosity shop.'' The search for novel viewpoints is suggested in photographs of the American Falls as seen from, respectively, ''back of the Museum,'' ''Goat

Island," "the Canada Side," "the hill back of Table Rock," and "above the Pagoda." Also listed in this catalog were at least ten views of the falls on the Genessee River in Rochester. This latter group could easily have been made on the journey from New York to Niagara by Barnard or another Anthony photographer.

43. **possibly by Barnard:** *The American Fall from Behind the Pagoda, Canada Side*, ca. 1861-62; stereograph (Anthony 633); **New York Public Library**

By early 1862 a greatly strengthened and more confident Union army was ready for action. This was welcome news to the Northern public and administration, which were eager for decisive victories and an end to the war. President Lincoln favored a conventional overland campaign to capture Richmond. General McClellan, however, advocated an amphibious landing at Fort Monroe, located at the tip of the peninsula formed by the York and James Rivers. From there his huge army would advance seventy miles northwest to the Confederate capital. Although skeptical, Lincoln approved the plan.

By early April some 55,000 of McClellan's troops were threatening Confederate defenses near the old Revolutionary War battlefield of Yorktown. Although John B. Magruder's Southern forces numbered only about 13,000, McClellan thought he faced many more. Paralyzed by the belief that he confronted impossible odds, McClellan's greatly superior force sat outside Yorktown for a month while heavy siege guns were shipped in and installed. The delay allowed the Confederates to strengthen defenses further up the peninsula. By May 1 Northern troops had readied their siege guns for a devastating bombardment. Before this was begun, however, Confederate troops withdrew from Yorktown on the night of May 3-4. The sluggish Union advance resumed but precious time had been lost. McClellan advanced to within eight miles of Richmond on May 20, but got no further.

As the Union's major offensive in these months, McClellan's Peninsula Campaign received steady coverage in the national press. For example, *Harper's Weekly* sent its best artists, Alfred R. Waud and Winslow Homer, to illustrate and report on the progress of McClellan's forces. These two correspondents were with Union troops outside Yorktown by early April and sent a number of sketches back to New York for publication.[58]

Barnard's former collaborator, James F. Gibson, photographed in the area in early May. Dated views indicate that Gibson was in the Yorktown vicinity from at least May 1-17, 1862.[59] Gibson made photographs in the Union camp of officers and important visitors. He also made a dozen views of two Federal artillery batteries outside Yorktown. The larger of these installations, Battery No. 4, contained ten 13-inch mortars weighing 20,000 pounds each. In June, Gibson followed McClellan's advance toward Richmond.

Barnard arrived in Yorktown at the end of June, well after most of McClellan's troops had moved north. While Gibson had made views of and from the Union defenses outside Yorktown, Barnard spent much of his time photographing the

44. *Ruins of Old Brick Church, Hampton, Va. The oldest Protestant Church in America*, 1862 (Brady's Album Gallery 466); **private collection**

45. *Georgetown Aqueduct*, ca. 1861-62 (Brady's Album Gallery 288); George Eastman House

46. *Georgetown Aqueduct and College*, ca. 1861-62 (Brady's Album Gallery 289); George Eastman House

recently captured Confederate works in the town itself. He recorded General Magruder's former headquarters and the enemy's abandoned entrenchments and artillery emplacements, now casually populated by Union sentries.

Several of Barnard's photographs focused on subjects of clear historical interest. One of his views depicted Confederate fortifications "built on the site where Cornwallis delivered up his sword," while another documented the Moore house, "where Cornwallis signed the capitulation" ending the Revolutionary War. These subjects, which evoked the revered heritage of American nationalism, only emphasized the tragedy of civil war.

Barnard made several exposures of the wreck of "the oldest Protestant church in America," in Hampton, Virginia (figure 44). Like his views of Revolutionary War sites, this subject carried considerable historic and symbolic meaning. *Harper's Weekly*, for example, reproduced an engraving of this structure in its July 12, 1862, issue, with a short text that concluded:

> Hampton used to be a delightful place of residence, especially in the summer. Rude war and the savage destructiveness of the rebels have now left it desolate, and many a year will revolve before it recovers its ancient aspect of quiet happiness and repose.[60]

Barnard's funerary images of the abandoned church convey his sense of the utter tragedy of war. These photographs are about ruined institutions, shattered social and communal bonds, silence, and dissolution. They suggest the power of the momentous events of 1861-1865 to reshape and even obliterate the artifacts and meanings of the nation's past.

During 1861-62 Barnard also photographed in and around Washington. Images of the Capitol, the Long Bridge across the Potomac, and a steam frigate at Alexandria were made at this time. Barnard also recorded the Georgetown Aqueduct (figures 45, 46), a large engineering project directed by Montgomery C. Meigs. Formerly of the Corps of Engineers, Meigs had been appointed Quartermaster General of the Union Army at the beginning of the war.

Barnard's photographs of the aqueduct are deceptively complex. These images were originally made in the stereographic format and thus convey a great spatial sweep from foreground to background. They also demonstrate Barnard's pictorial approach to subjects of seemingly "simple" documentary interest. His view of the *Georgetown Aqueduct and College*, for example, uses these noteworthy subjects merely as a backdrop for a picturesque grouping of soldiers (figure 46). The numerous figures in this view are carefully arranged for aesthetic effect, yet retain an air of naturalism and spontaneity. The beauty and restfulness of this view contrasts markedly with the destruction Barnard recorded elsewhere during the war. This pastoral scene would have suggested to Northern viewers the security of their national capital, and the poetic camaraderie of the military experience.

Later in 1862 Barnard returned temporarily to Oswego to work in Tracy Gray's gallery. On September 23, 1862, Gray advertised that he had "secured the services,

for a limited time, [of] that celebrated artist, George N. Barnard (formerly of this, and later of Brady's Gallery Washington)." Customers were assured that they would "find Mr. Barnard at Gray's Gallery…where he will be pleased to see his old customers and former acquaintances and friends."[61] Later, in March 1863, Gray advertised that he had "made arrangements with Mr. G.N. Barnard to furnish Card Photographs of distinguished persons for Albums to all who want them."[62] It is uncertain how Barnard received rights to furnish such prints, which were presumably produced from negatives made in Brady's studio.

It is likely that Barnard spent the last half of 1862 and most of 1863 engaged in studio work for Gardner and Brady, and on miscellaneous assignments for the Anthony firm. There is no evidence, for example, that Barnard photographed the battlegrounds of Second Bull Run (August 27-29, 1862), Antietam (September 17, 1862), or Gettysburg (July 1-3, 1863). Views of these and similar sites were made by photographers other than Barnard in the employ of Alexander Gardner.

II:2 Nashville: 1864

By the end of 1863 Union fortunes had improved dramatically in the war's western theater. The defeat of Confederate forces at Chattanooga in the battle of November 23-25, 1863, stabilized the Federal position in southern Tennessee. The successful defense of Knoxville (November 29 - December 4, 1863) extended Union control over the eastern part of the state. These important Union victories allowed the massing of troops in Tennessee for the subsequent advance into Georgia. On October 16, 1863, General Ulysses S. Grant was given charge of the newly organized Military Division of the Mississippi, which combined the Departments of the Ohio, the Cumberland, and the Tennessee. At year's end these armies, occupying a great arc from Vicksburg to Knoxville, were commanded (respectively) by Generals John M. Schofield in Knoxville, George H. Thomas in Chattanooga, and William T. Sherman in Bridgeport, Alabama. On December 21, 1863, Grant moved his headquarters to Nashville, which became the Union command center for the western theater of the war.

The work for which Barnard is best known began on December 28, 1863, when he was hired by the Topographical Branch of the Department of Engineers, Army of the Cumberland. Although the Department of the Cumberland was based in Chattanooga, Barnard's office was in the Military Division of the Mississippi's overall command headquarters in Nashville. Under the direction of Captain of Engineers Orlando M. Poe, Barnard ran the army's photographic operations.

Barnard was chosen for this position on the strength of his prior experiences with Alexander Gardner and his familiarity with other influential civilians and military men. Gardner's work in 1862 for General George McClellan and the Army of the Potomac had involved the photographic duplication of maps drawn by the Topographical Engineers. When McClellan was removed from this command in November 1862, Gardner returned to business in Washington, D.C., and expanded his photoduplication work. Barnard had probably become adept at this process in Syracuse, in 1857-58, and honed his skills with Gardner in 1862-63. In the course of his work for Gardner, Barnard came to know officers on McClellan's staff including Orlando Poe, then in charge of the defenses of Washington. There is also evidence that Poe had been acquainted with Barnard in New York City, and thought highly of the photographer's abilities.[1] Barnard's selection for this important position was also probably aided by his friendship with such highly placed men as Adjutant-General Lorenzo Thomas, who worked with Secretary of War Simon Cameron.[2]

It was particularly appropriate that Barnard was hired by the military engineers, given the close ties between that profession and the photographic community. The curriculum of the U.S. Military Academy at West Point was strongly oriented toward mathematics, science, and the fundamentals of engineering, both civil and military. Many of the best academy graduates began their military careers in the Corps of Engineers, the most elite branch of the army. In addition to their studies in topics such as architecture and mechanics, cadets were trained in chemistry, optics, and topographic drawing. The value of precise visual description — in the form of maps, diagrams, and pictures — was strongly instilled in them. This engineering training engendered in the military leadership an appreciation of the value of photography.

The optical, chemical, and mechanical nature of photography also made it a logical subject of interest for civilian engineers. Edward and Henry T. Anthony had studied and practiced engineering before turning to photography and the photographic supply business. The Anthonys' friendship with similarly trained military men, and their role as the army's primary photographic supplier, gave them considerable influence during the war. The services of such noted war photographers as Thomas C. Roche and Jacob F. Coonley, for example, were subcontracted by the government through the Anthonys. In addition, Coleman Sellers, the writer who praised Barnard's stereographs in 1862, was a practicing civil engineer and a close friend of Quartermaster-General Montgomery C. Meigs. Meigs, a West Point-trained engineer, was also a devoted photography enthusiast. Clearly, Barnard's employment with the Department of Engineers was not the result of chance.

Barnard's work for the army represented an important part of a larger federal use of photography. The Treasury Department, Coast Survey Office, Army Medical

Museum, and Bureau of Military Railroads all had autonomous photographic operations during the war. These were headed, respectively, by Lewis E. Walker, George Mathiot, William Bell, and Captain Andrew J. Russell. Walker and Mathiot spent much of their time copying maps and documents, while Bell recorded battle wounds and amputations.[3] Russell performed a variety of labors for the Bureau of Military Railroads, including an extended documentation of General Herman Haupt's experiments in the construction of portable bridge trusses and techniques of both repairing and destroying railroad tracks.[4] Captain Thomas J. Rodman of the Ordnance Department used the camera to document his own experiments in the casting of large cannons.[5] And Quartermaster-General Meigs commissioned a great number of photographs of ships, warehouses, bridges, and other subjects under his department's jurisdiction.

Photography was also used extensively by the Department of Engineers. In 1855 Major Richard Delafield had been sent as an observer to the Crimean War. At that time he had been instructed by the Secretary of War to pay particular attention to subjects such as "the construction of permanent fortifications..., the engineering operations of a siege in all its branches, both attack and defense..., [and] the construction of casemated forts."[6] To supplement his detailed final report, Delafield acquired photographs of these and other subjects. This appears to have been the earliest official use of documentary photographs by the American military.

As head of the Department of Engineers during the Civil War, General Delafield encouraged the production and dissemination of similar images. Most of these views were produced by civilian photographers commissioned by engineering officers in the field. For example, two teams of New Orleans photographers were paid by Delafield's subordinates to record Fort Morgan, Alabama, in 1864.[7] These and many other views were shipped back to Washington as supplements to official reports.[8] In addition, the Topographical Branch of the department used photography extensively to duplicate maps, plans, and diagrams of all kinds.

Barnard officially began his work for the Department of Engineers in New York City on December 28, 1863, purchasing photographic supplies at the E. & H.T. Anthony Company. He arrived in Nashville a short time later and established operations in the Topographical Office at 89 Church Street. His companions in this office were lithographer Samuel Geisman, assistant engineer and professor James M. Stafford, and draftsmen Charles Schott and Benjamin A. Drayton. Barnard's primary assistant in this office was David O. Adams, a young man who had previously worked as a photographer for the Topographical Engineers in Chattanooga.[9] This department was directed by Corps of Engineers officers Poe and William Le Baron Jenney, both of whom were notable personalities.

Orlando M. Poe (1832-1895) was a brilliant engineer, known for his devotion to duty, precise work, and high expectations of others. After graduating sixth in the West Point class of 1856, Poe had been commissioned by the Topographical

Engineers. Following the outbreak of the war he served on McClellan's staff in Washington, D.C., and was in charge of the defenses of that city. In 1862 he took part in the Peninsula Campaign, the siege of Yorktown, and the battles of Williamsburg, Fair Oaks, Manassas, and Fredericksburg. In 1863 Poe was appointed chief engineer of the Army of Ohio and played an important role in the defense of Knoxville. He served as an assistant to Brigadier-General William F. Smith from January 18, 1864, until April of that year when he was promoted to Chief Engineer, Military Division of the Mississippi, and began reporting to William T. Sherman. He subsequently accompanied Sherman in the field and participated in the series of engagements that culminated in the capture of Atlanta and the March to the Sea. During his time with Sherman, Poe was responsible for a wide range of engineering duties including the construction of fortifications, the preparation of maps, and the destruction of strategic works.[10]

When Poe was in the field, the direct supervision of the Nashville office fell to Captain (later Major) William Le Baron Jenney (1832-1907). The son of a prosperous Massachusetts whaling ship owner, Jenney attended Phillips Academy and the Lawrence Scientific School of Harvard University. He spent the years 1849-51 on a voyage to California and the South Pacific. From 1853 to 1856 Jenney studied engineering at the internationally respected *École centrale des arts et manufactures* in Paris.[11] Jenney moved in a cosmopolitan circle in the French capital that included the artists Whistler and du Maurier.[12] During the war Jenney served under both Grant and Sherman. In the autumn of 1862 he worked as the engineer in charge of the fortifications at Memphis and in 1863 he participated in Grant's Vicksburg campaign.[13] Jenney arrived in Nashville in early 1864, where he supervised the Engineering Department and the city's defensive works.

Jenney was cultured and extroverted in a particularly American way. Frederick Law Olmsted, the noted landscape architect and designer of Central Park, met Jenney in March 1863 outside Vicksburg. Olmsted noted that the young officer was "warm on parks, pictures, architecture, engineers and artists," with a "peculiar zest" for reminiscences of his student days in Paris.[14] After the war Jenney became an innovative Chicago architect, renowned for his minimal ornamentation, "economy, simplicity and structural awareness." Jenney's innovations — he has been called "perhaps the most original structural talent of the Chicago School" — stemmed from his forthright pragmatism rather than a deeply theoretical approach.[15]

Since its capture in February 1862 Nashville had become increasingly important to Federal operations in the western theater of the war. When Chattanooga was secured in November 1863, Nashville became the primary Federal depot in the build-up to the Atlanta Campaign. Supplies from Louisville and elsewhere in the north were brought to Nashville for storage and subsequent transfer south. In the first eight months of 1864 the city saw an extraordinary level of activity. In this time some 140,000 troops passed through Nashville on their way south, while Union

casualties and Confederate prisoners were transferred north along the same route. Enormous quantities of food, munitions, clothing, and medical supplies were brought in by rail and river transport from depots in Louisville and St. Louis.[16]

James F. Rusling, of the Quartermaster's Department, noted that "horses and mules [arrived] by the hundreds of thousands, corn and oats by the millions of bushels, hay by the tens of thousands of tons, wagons and ambulances by the tens of thousands...." Nashville became, in Rusling's words, "the biggest army depot to-day on the face of the earth." In early 1864 the city was "one vast storehouse and corral, with warehouses covering whole blocks, one of them over a quarter of a mile long, with corrals and stables by the ten and twenty acres each, and repair shops by the fieldful."[17] These huge warehouses were constructed along the major rail lines. The Forage House, on the Northwestern Railroad, was 1709 x 140 feet in size. The Eaton Depot (also known as the "Bread Shed") and the Taylor Depot were constructed on the tracks of the Tennessee and Alabama Railroad. The latter structures were assigned to the Subsistence Department for the storage of beef, pork, vinegar, and whiskey.[18]

In addition to these massive warehouses, boatyards and machine shops were built to maintain the transportation system. Sawmills were erected to cut the lumber necessary for buildings, bridges, and corrals. To protect the city's burgeoning population, hospitals and a fire department were also organized. To sustain these various operations the Quartermaster's Department in Nashville spent $5,000,000 a month, and employed over 12,000 laborers, clerks, and mechanics in early 1864.[19]

As the Federal presence in Tennessee became increasingly secure, the "little dilapidated town" of Chattanooga went through a similar process of growth.[20] Sawmills, railroad repair shops, hospitals, and corrals were built there, and by May 1, 1864, eleven military storehouses were newly finished or under construction.[21] By this time the city was receiving up to 130 carloads of supplies by rail each day from Nashville. Most troops and livestock covered this 140-mile distance on foot.[22]

In the spring of 1864 the most advanced units of Federal troops were stationed in Ringgold, Georgia, about fifteen miles southeast of Chattanooga. Twenty miles south of Ringgold, at Dalton, lay the Confederate Army of Tennessee under General Joseph R. Johnston. Sherman's ultimate goal was the defeat of Johnston's army and the capture of Atlanta, with its vital foundries, arsenals, machine shops, and rail connections.

The operations of the Topographical Engineers were essential to the planning of this massive Federal offensive. Accurate maps of Georgia were needed to coordinate the Atlanta Campaign, and rapid updating became necessary as Federal forces moved south into increasingly unfamiliar territory. The Engineers responded to this need by gathering data from the field and issuing maps by a variety of means. Lithographic printing, the most elaborate and time-consuming process, was used for the most important and definitive maps. Photography, on the other hand, was used to duplicate maps needed quickly, in limited quantity, or for merely temporary use. Photography, for example, allowed the issuance of updated maps on a daily basis, if required. While photocopies were distinctly inferior in quality to lithographic maps, they were much easier and cheaper to produce.[23]

Barnard's primary responsibility in Nashville involved the photographic duplication of maps produced by the Department of Engineers. In conjunction with a similar, but smaller, operation in Chattanooga under the direction of Captain William E. Merrill, the Nashville office was responsible for the production of great quantities of maps. Both the Nashville and Chattanooga operations were equipped with a printing press, lithographic presses, a photographic department, facilities for mounting maps and prints, and skilled draftsmen and assistants.

With Barnard's considerable expertise, the photographic duplication of maps was accomplished in a systematic manner. The original topographic renderings, tacked flat to a wall, were photographed with either his 12x15-inch or 18x22-inch camera. Maps could be reduced or enlarged as needed, by adjusting the distance between the camera and the original drawing. Particularly large renderings were often photographed in sections, with copies pieced together from several photographic prints.

While map duplication occupied the greatest part of his time, Barnard was also regularly called upon to make landscape views and portraits. Most of this latter work was done in the carte-de-visite format, although the 6½ x 8½-inch camera was used for a few of his most notable subjects. In his small studio in the Topographical Office Barnard photographed Poe and Jenney, and even sat for a self-portrait. In the early months of 1864 some of the most prominent Union officers came to 89 Church Street to pose, including Generals Thomas, Barry, McPherson, Sherman, and Grant (figures 47-49). These visits were encouraged and facilitated by Poe, who collected autographed cartes-de-visite of his most prominent visitors. On February 11 Poe enclosed several of these portraits in a letter to his wife, noting that,

> Genl. Grant was kind enough to give me his *Autograph* on each of his [two] pictures, therefore be careful of them. The side view was taken to be put on the Medal which Congress has ordered. It will be historical and with the Genl's autograph on it, is very valuable. The picture was taken by my photographer, that is, by the man I have employed in my office.[24]

The medal described by Poe commemorated Grant's earlier victory at Chattanooga. A Congressional resolution recognizing the gallant service of Grant and his men was passed on December 17, 1863 and signed by Lincoln. The painter Emanuel G. Leutze, best known for his immensely popular canvas *Washington Crossing the Delaware* (1851), participated in the medal's design, which featured a profile bust of Grant on the obverse. With the assistance of an engraver from the U.S. Mint, the piece was struck later in 1864 or early 1865. This four-inch diameter

47. *General W.F. Barry, Nashville*, 1864; carte-de-visite; George R. Rinhart, Colebrook, Connecticut

48. *General William T. Sherman, Nashville*, 1864; halftone; private collection

49. *General Ulysses S. Grant, Nashville*, 1864; Library of Congress

medal contained one and three-quarter pounds of pure gold, and required the expenditure of $600 for bullion, design, and labor.[25]

General Sherman also sat for several portraits in Barnard's studio. At least one of these, however, was rejected by the 44-year-old Ohioan as too unflattering (figure 48). In the spring of 1864, as James F. Rusling later recalled, Sherman was

a tall, brisk, wiry man; with dark reddish hair, inclining to baldness; sharp blue eyes, kindly as a rule, but cold and hard as steel sometimes; an aggressive, fighting nose and mouth; considerable of a jaw, and a face a mass of wrinkles. I have his photograph still, taken at his headquarters in the spring of 1864, which is so full of wrinkles he ordered it suppressed. But I begged it of his photographer and preserved it, because [it was] so faithful and lifelike....[26]

Barnard's work outside the studio began soon after his arrival in Nashville. On February 4, Poe instructed Barnard to

proceed with as little delay as practicable to Chattanooga for the purpose of making such photographic views as will serve to illustrate that place and the military works in the vicinity. It is desirable that among them we will have a series of Panoramic views taken from Orchard Knob (Indian Hill). A view of the nose of Lookout Mountain and if possible a view from the top of the mountain of the lines immediately around Chattanooga. It is not to be understood that your labors are limited to these points ennumerated. They may be extended in your judgment to any others. You will consult Capt. Merrill, U.S.

Engineers, with reference thereto. Should the time at your disposal admit of it you can take views of celebrated houses, scenery, &c. — but this must not interfere with the more important object of the expedition.

By command of Genl. [William F.] Smith[27]

Poe also telegraphed Merrill in Chattanooga, giving him authority to designate additional subjects for Barnard's attention.

On February 5 Barnard began photographing in and around Chattanooga with his stereoscopic and 12x15-inch cameras. Three days later Merrill telegraphed Poe that ''Mr. Barnard is here and is succeeding quite well.''[28] During his week in Chattanooga the photographer concentrated on three major subjects: the vital rail link to Nashville, the area's battlefields, and scenic views of and from Lookout Mountain.

The railroad line between Nashville and Chattanooga, which Barnard himself

had just traversed, was essential to Union occupation of the area. Barnard traveled a few miles west of Chattanooga to document one of the most strategic points on this line, a heavily guarded bridge near Whiteside, Tennessee, constructed some months earlier by the army's engineers. Here he made full-plate views of the seemingly fragile structure from the bed of Running Water Creek (plate 4). Barnard also pictured the bridge, its defensive blockhouses, and the surrounding valley from track level, and made a double-plate panorama of the scene from the steep embankment above the Federal encampment (plates 5-7). Closer to Chattanooga, Barnard recorded watchful sentries guarding the rail line at the foot of Lookout Mountain (figure 50).

Sites that had figured prominently in the battle of Chattanooga were also recorded. Barnard made a two-plate panorama of the north end of Lookout Mountain showing the ground traversed by General Hooker's forces, and a single-plate view titled *General Sherman's battle-ground at the North End of Missionary Ridge.* With his stereo camera Barnard recorded a view of Chattanooga from abandoned Confederate trenches near the base of Lookout Mountain.

This mountain, with its striking profile and 1700-foot height, served Barnard as both subject and vantage point. Its looming form figured prominently in several photographs of encampments and rail lines near Chattanooga. Barnard's images of the camps of the Engineer Brigade (figure 51) and Pioneer Brigade (figure 52) emphasize the mountain's commanding presence in the landscape.

Barnard evoked the grandeur of Lookout Mountain and its surroundings in a series of impressive multiple-plate panoramas. He made at least two double-plate photographs of the front and side of the mountain as well as double- and triple-plate views from the crest (figures 53, 54). These latter prints combine stunning vistas of the landscape far below with foreground figures quietly contemplating nature's sublimity. From the nose of the mountain, as one officer recalled, "you look across no less than five distinct ranges of mountains, away a hundred miles to a faint line of blue, that they say is a ridge of great height in North Carolina."[29] Barnard repeated this theme of spectator and spectacle in at least two single-plate views from the mountain's crest (figure 55) and in a stereograph of a majestic waterfall nearby (figure 56).

Barnard's photographs from the summit of Lookout Mountain were taken at several positions. It is clear that he was fascinated by the aesthetic potential of this site, and used a set of visual motifs in a variety of permutations. These motifs included the majestic sweep of the landscape itself, the sinuous path of the Tennessee River, the contrast between rocky outcroppings in the foreground and the forested landscape below, and the presence of self-absorbed spectators within this natural grandeur. While central to the landscape art of this era, these themes had rarely been so eloquently expressed in photography. Barnard returned to Nashville on February 12 with a most impressive set of negatives.[30]

Poe used these photographs as reference material while completing a map of

50. *Base of Lookout Mountain from Chattanooga Creek*, 1864; **West Point**

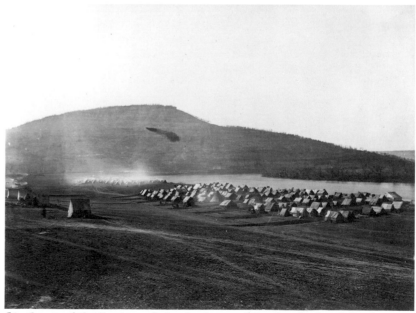

51. *Camp of the Engineer Brigade, Army of the Cumberland; Lookout Mountain, from near the Rolling Mill, looking southwest*, 1864; **West Point**

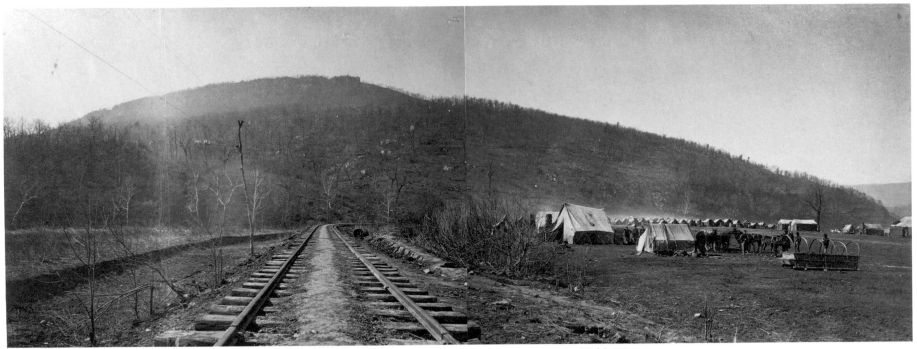

52. *Panoramic View of Lookout Mountain, from the Camp of the Pioneer Brigade, looking southwest,* 1864; West Point

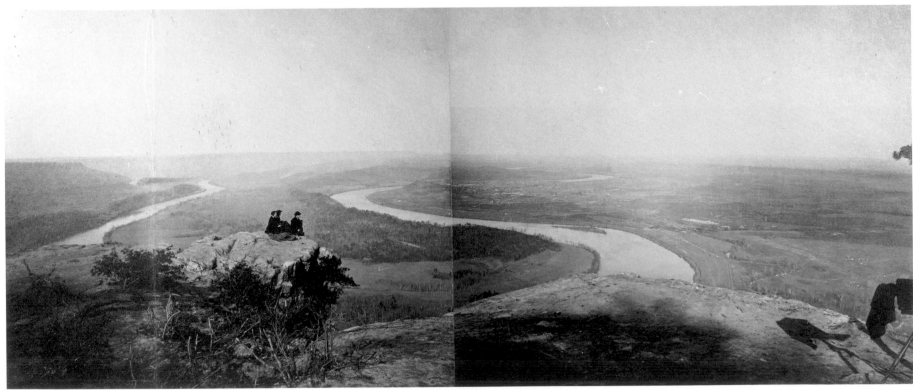

53. *Panoramic View of Chattanooga, Missionary Ridge, and the Valley of East Tennessee, from the top of Lookout Mountain,* 1864; West Point

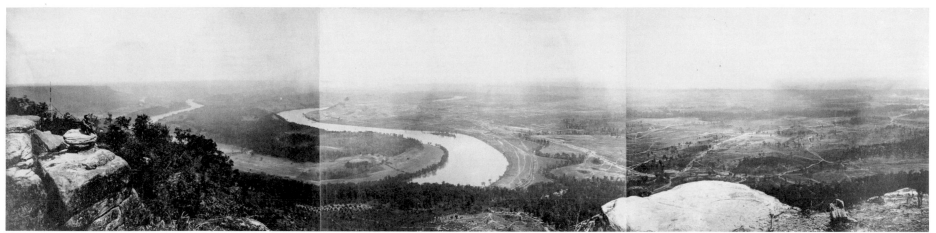

54. *Panoramic View from the top of Lookout Mountain, Tenn.*, February 1864; West Point

the battlefield of Chattanooga (probably based on an earlier version drawn by Jenney).[31] On March 10, 1864, Poe mailed a photocopy of his map to the Engineer Department in Washington, and some of Barnard's photographs may have accompanied this shipment.[32]

At some point in March, Barnard left his map-copying duties to make at least two double-plate panoramas in Nashville. One of these records the view looking northeast from Fort Negley toward the city (figure 57). This fort, which overlooked the junction of the Nashville and Chattanooga, and Tennessee and Allatoona Railroads, was located on what had been a popular picnic ground on St. Cloud Hill. To provide full visibility Union engineers had cut down the beautiful oak trees covering the sides of the hill and destroyed a recently-opened asylum for the blind. This nearly impregnable fort was not fully completed until November 1864, just prior to the decisive Battle of Nashville. In this engagement, on December 15-16, 1864, the Confederacy's last major offensive was crushed by forces under the command of Major-General George H. Thomas.[33] Barnard later made several single-plate views of Fort Negley.

The second of Barnard's Nashville panoramas documents the newly-completed Taylor Depot, a food warehouse maintained by the Quartermaster's Department (figure 58). This view uses the multi-plate format to particular pictorial advantage. Barnard's photograph of this functional structure creates a compelling and monumental visual form through the repetition of architectural elements and the effects of perspective. At this time, or slightly later, Barnard also made single-plate views of this structure (figure 63).

Following the completion of his Chattanooga map, Poe instructed Barnard to accompany him to Knoxville to record the topography of the area and the city's defensive works.

March 12, 1864
To Mr. George N. Barnard, Photographer, Sir:

You will proceed by the first available opportunity to Knoxville, Tennessee, for the purpose of obtaining such views of the fortifications at that point as have been indicated in your verbal instructions. You will take with you such instruments and materials as may be necessary. Photographic Assistant Wheaton has been detailed to accompany you. You will keep an accurate account of the actual expenses of the trip, both for yourself and Wheaton, and upon your voucher, the money will be refunded.

By order of Brig. Genl. Wm. F. Smith.[34]

Poe, Barnard, and Wheaton rode a military train from Nashville to Chattanooga, where they spent the evening of March 14. After a thirteen-hour ride the following day they disembarked in Knoxville at 11 p.m. in the midst of a snowstorm. The winter of 1863-64 had been unusually cold, and bitter, windy weather hampered their activity over the next few days. On March 16 Poe and Barnard toured the city to select the best vantage points for their photographs. At each stop Poe described the events that had occurred five months earlier on the terrain within their view.

When Knoxville had been threatened by a Confederate advance in November 1863, Poe oversaw the construction of defensive lines around the city. These were begun on November 17. As both sides dug in over the next two weeks, Poe laid out trenches, rifle pits, and *cheval-de-frise* works. Much of this activity occurred at or near Fort Sanders, a Union stronghold on the west side of the city. Failed attacks were mounted by Union forces on November 24, and by Confederate troops on the following day before the decisive action of November 29. On that date a major Confederate attack on Fort Sanders was turned back with only light Federal casualties. On December 4 the Southern troops retreated, yielding to Union forces control over Knoxville and eastern Tennessee.

55. *Chattanooga and the Valley of the Tennessee River from Lookout Mountain, showing the nose of the mountain*, 1864; Hallmark Photographic Collection

56. *Rock Creek Falls, Lookout Mountain*, 1864; stereograph; West Point

The success of Poe's defensive works prompted him to write in his official report that

a feeling of intense satisfaction pervaded the whole command, and many persons assured me of their conversion to a belief in "dirt-digging." It certainly proved efficient here. [I] examined the enemy's late position, and was surprised to find so little evidence of good engineering.[35]

Not surprisingly, then, Barnard's Knoxville photographs focused on the fortifications used by both sides during the siege, as well as the overall topography of the area.

An important part of this Knoxville work was devoted to the production of sweeping panoramas. On March 19, after the weather had improved marginally, Poe and Barnard made a remarkable seven-plate, 360-degree view of the entire horizon from the cupola of the University of East Tennessee (figure 59). From this elevated vantage point a clear perspective was provided of the city, Fort Sanders, and important positions held by both armies. This fascinating image suggests the influence of the popular "bird's-eye" topographic or urban renderings of the period. The serene objectivity of this elevated view also suggests the ideal vantage point of the mapmaker. As a West Point textbook stated, "every topographical drawing addresses itself to the eye as if the spectator were situated above [the scene depicted], and looking down equally upon every part of it..."[36] The technical feat of producing seven successful adjoining negatives was formidable and probably required the better part of a day to accomplish.

Over the following two days a four-plate panorama from Fort Stanley and a two-plate view from Mabry's Hill were also produced (figures 60, 61). Fort Stanley was constructed on a hilltop across the river from Knoxville and commanded a clear perspective of the former Union and Confederate lines to the west of the city. Barnard's photograph from Mabry's Hill, to the northeast of Knoxville, looked back toward Temperance Hill and the city.

This latter panorama (11 x 33 inches in size) was made with a large 18 x 22-inch camera. According to Poe's supply requisitions, Barnard was equipped with cameras of at least three sizes: stereo format, 12 x 15-inch, and 18 x 22-inch. (He also made 6½ x 8½-inch negatives with a camera of that format, or by using a separate back on his 12 x 15-inch instrument.) While the largest of these instruments was primarily intended for copy work, it was also equipped for field use. The unusual size (14 x 19 inches trimmed and mounted) of a single-plate photograph entitled *View of the S.W. Bastion of Fort Sanders, looking to the S.E.*, also indicates the use of the 18x22-inch camera (figure 62). On March 20 Barnard made stereo photographs at Fort Stanley. On the following day, back at Fort Sanders, he used two different formats to record Poe with his friend and fellow engineer Lieutenant Colonel O.E. Babcock.

By the time Poe and Barnard returned to Nashville on the evening of March 23, an important change had taken place in the organization of the Union armies. In

57. *From Fort Negley, looking northeast, Nashville*, March 1864; Library of Congress

58. *Quartermaster's Buildings [Taylor Depot], Nashville*, March 1864; West Point

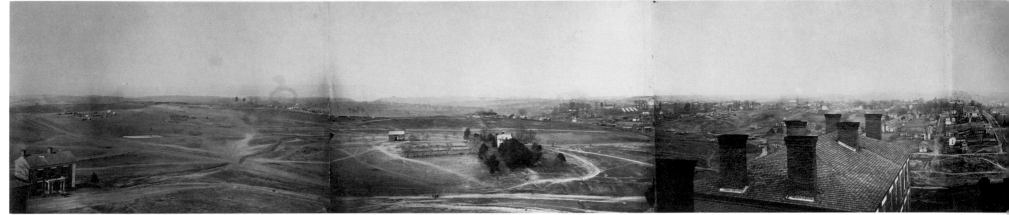

59. *View from the Cupola of the University of East Tennessee, Knoxville*, March 19, 1864; Library of Congress

early March 1864 Grant was promoted to the rank of Lieutenant-General and given charge of all the Union forces. Grant picked Sherman as his successor in the western theater and soon left for the east. Sherman, in turn, selected James B. McPherson as his replacement in command of the Department of the Tennessee. General Sherman moved his headquarters to Nashville and continued the build-up initiated by Grant. The stage was set for a dramatic and unforgettable demonstration of military leadership.

In early 1864 William T. Sherman (1820-1891) was an intense, resolute and decisive leader with vast experience and few illusions. His coldly realistic views on the nature of war have become legendary. With blunt simplicity he noted that ''war is destruction and nothing else,'' and that ''war is cruelty, and you cannot refine it.''[37] Sherman made the brutality of war nakedly clear, knowing that the conflict would end only when the Southern popular will to fight had been broken.

Sherman arrived in Nashville on March 17, 1864, and officially assumed command of the Military Division of the Mississippi on the following day. This huge force consisted of over 100,000 seasoned troops in three armies: Schofield's Department of the Ohio, Thomas' Department of the Cumberland, and the Department of the Tennessee, now commanded by McPherson. These three generals were headquartered, respectively, in Knoxville, Chattanooga, and Hunstville, Alabama. Sherman relocated his own headquarters from Nashville to Chattanooga six weeks later in preparation for the Georgia campaign.

After returning to Nashville on the evening of March 23, Poe again used Barnard's photographs to assist his topographic work. For several months Poe had been working on a map of the approaches and defenses of Knoxville, showing the positions occupied by the Federal and Confederate forces during the siege. Photo-

prints of an early version of this map were made for limited distribution, and a larger lithographed edition was completed later. On April 11 Poe sent his official summary of the siege to his superiors in Washington. The report was accompanied by his completed map and a set of Barnard's photographs. Poe noted that

> the accompanying photographic views are intended to illustrate still further the locality rendered historical by the siege of Knoxville. They are the work of Mr. George N. Barnard, photographer at the chief engineer's office, Military Division of the Mississippi.[38]

Nine days later Quartermaster Montgomery C. Meigs wrote General Sherman from Washington to request a set of Barnard's photographs. Meigs was a recognized authority on art due to his role in the mid-1850s supervising the extension of the national Capitol. In this capacity Meigs acquired and commissioned many paintings and sculptures for the new structure.[39] Meigs also held great personal interest in photography as an active amateur and collector.

> April 20,1864
> ...Captain Poe, in charge of your engineer depot at Nashville, has, I am told, charge of the photographic establishment. Some very interesting photographs of the scenery about Nashville and Knoxville, I am told, have been taken. I have seen a set of Chattanooga views, which are interesting and beautiful. Can you not send me two sets of each, one for my office and one for myself? I should prefer them sent on thin paper, to be mounted here. They are less injured in the mail...[40]

Sherman responded, ''I have sent word to Captain Poe, who will send you two copies of his photograph sketches, which are very beautiful.''[41] Poe immediately sent the prints to Meigs with the following note.

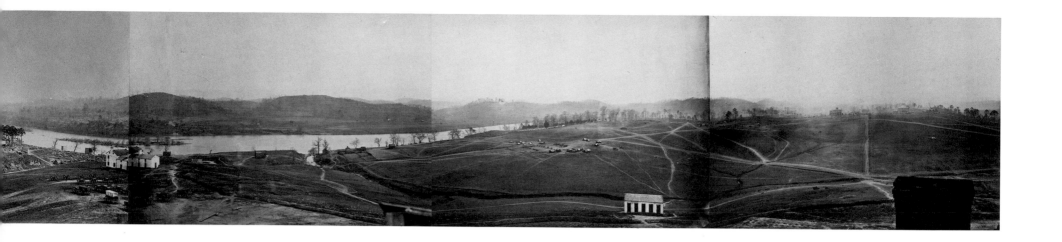

By direction of Maj. Genl. W.T. Sherman I have the honor of enclosing two complete sets of the Photographs, taken by my Photographer, in the vicinity of Chattanooga and also of Knoxville.

I must say of the Knoxville Photographs, that they are intended more particularly to illustrate the operations of the siege of Knoxville — both attack and defense — and are therefore not so satisfactory as mere pictures as they would have been, had the views been different, and for the sole purpose of gratifying the eye. Still, they will be as highly prized, and as fully appreciated, by you. The deep interest you have always taken in Military Photography is well known...

P.S. Mr. Barnard, the Photographer who made the views, desires me to say that it was done under great disadvantages of wind & cold, to which I can testify.[42]

The terminology used in this exchange is revealing, as these military officers referred repeatedly to the beauty and aesthetic interest of Barnard's photographs.

General Meigs was impressed enough by these Knoxville prints to request that Barnard be allowed to take time from his normal duties to make photographs in Nashville for the Quartermaster's Department. Meigs addressed this request to Poe, with a copy sent to Poe's superior, Chief of Engineers General Richard Delafield, in Washington.[43]

This work in Nashville was conducted intermittently during July and August.[44] At this time Barnard photographed the facilities of the Quartermaster's Department, including the warehouses constructed to hold Federal supplies (figures 63-65), and the depot and grounds of the Nashville and Chattanooga Railroad (figure 66). He may also have recorded ordnance shops, stables, foundries, and hospital buildings.

Many of the resulting photographs are unusually sophisticated and complex documents. Barnard often downplayed the inelegant simplicity of his subjects by recording them from oblique angles. This simple pictorial device allowed him to "shape" these structures visually, and thus to make photographs that were aesthetically pleasing as well as informative. The frequent inclusion of notable landmarks in the background also emphasized a larger sense of topographic context. For example, two of Barnard's warehouse pictures (perhaps made from the same camera position) document storage facilities located between the important sites of the Tennessee State Capitol and Fort Negley (figures 63, 64).

Barnard's oblique viewpoints, coupled with the use of a wide-angle lens, charge many of these photographs with an unusual spatial dynamism. He used the taut geometry of roof lines and receding railroad tracks to evoke the large scale and functional precision of his subjects. In the Nashville railroad yards Barnard photographed from elevated vantage points to convey a broad and spatially complex view of his subject. His photographs succeed on several levels at once, and were admired by his superiors in Nashville and Washington.

The value placed on Barnard's service is well documented. Due to bureaucratic red tape Poe was forced repeatedly to write General Delafield to confirm the photographer's salary. On June 18, after Barnard had been employed for nearly six months, Poe wrote Delafield to

...request that the following expenditures be authorized by a letter from the Bureau of Engineers, viz--

One Photographer: services to commence on the 28th day of December 1863 (time when he actually commenced buying in N.Y. the articles of Photography, since invoiced to me by the Engineers Bureau) at a daily compensation of six dollars, and one ration, to be

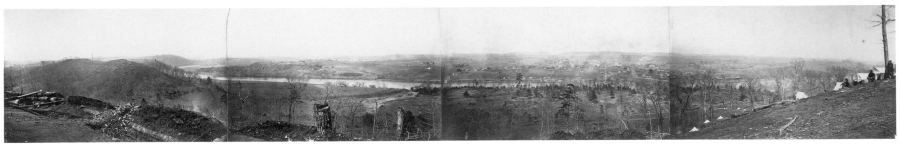

60. *View from Fort Stanley, Knoxville*, March 20, 1864; Library of Congress

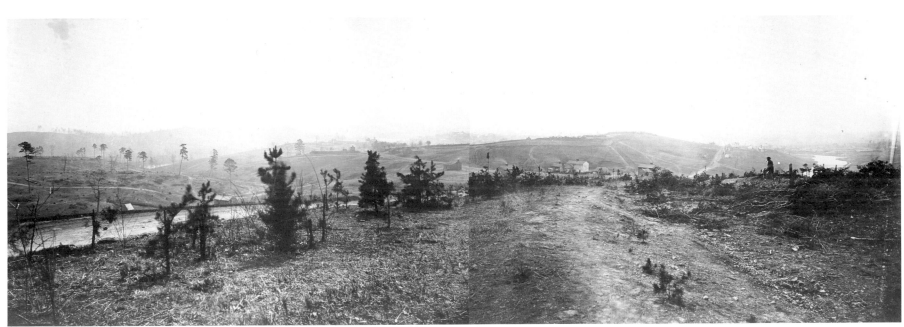

61. *View from Mabry's Hill, looking southwest, Knoxville*, March 21, 1864; Library of Congress

commuted at the same rate as is paid the clerks at Adgt. Genl's office, Hd. Qrs. Mily. Divn. of the Miss.

...I would also request that I be authorized to pay George N. Barnard, from the 1st day of May 1864, a daily rate of six dollars and seventy five cents per day instead of present rates of six dollars and one ration. It will make no increase in salary and will simplify the accounts. I will also state that his services cannot be retained at a less salary. Neither is it possible for me to obtain a sufficient number of draughtsmen to enable me to perform the work which Mr. Barnard does, & even if they could be obtained, it would be vastly more expensive...[45]

On August 7 Poe was still writing Delafield in an attempt to confirm Barnard's salary of $6.75 per day.[46] By this time, however, the frustrated Poe asked General Sherman to resolve the matter through a personal request to Delafield. The importance of Barnard's skill is suggested by the level of his salary, which approximated that of a Colonel of Cavalry or Engineers.[47] He received considerably more than any other employee in the Nashville office; the lithographer, for example, was paid $4.32 per day.[48]

In a letter of July 11, 1864, Poe detailed Barnard's activities in the preceding month.

George N. Barnard, Photographer [has been engaged] in multiplying maps, for use within the limits of this command...[and] in making a series of views of the Q.M. Depots at Nashville for, and by request of, the Quartermaster's Department, the cost of which that Department agrees to refund to the Engineering Dept....[49]

The other employees of the Nashville office were busy preparing and lithographing maps of East Tennessee.

On August 5 Poe reported to Delafield that,

in the office directly under my charge, the Photographer has been engaged in multiplying maps, and in making views of the present condition of the defenses of Nashville, Tenn. These views are nine in number, a set of which have been ordered forwarded to the Bureau of Engineers.[50]

These photographs, which were received in the Washington office by August 18, included four views of Fort Negley and five of the Capitol building.[51] Barnard recorded the view from the fort to the city below, as well as the bastion's nearly impregnable iron-plated gun emplacements. He also methodically recorded the defenses of the Capitol, photographing from all corners of the structure (plates 2, 3; figures 67, 68). These views contrasted the geometry of the building's classical architecture with the rustic fortifications at its base, and the rather mundane structures of the surrounding city. These views would have been of particular interest to Jenney, who oversaw the maintenance of the city's defenses in Poe's absence.

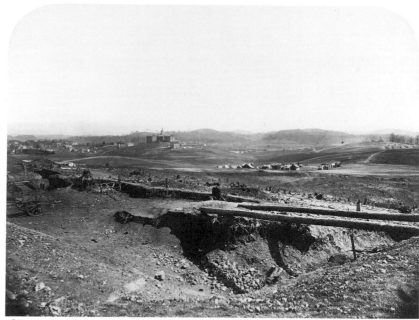

62. *View from the parapet of Fort Sanders, looking southeast, Knoxville*, March [21?], 1864; Chicago Historical Society

There was considerable demand within the military for Barnard's photographs. While Poe felt pressure to fulfill a number of requests for prints, his expenditures for such materials were regularly criticized in Washington. Frustrated by his distance from the Nashville office, and deeply involved in more pressing matters in the field, Poe grew angry over such bureaucratic small-mindedness. In response to these problems Poe heatedly wrote Delafield that

...instruments and materials have liberally been furnished to all who could use them, since I felt that to delay this Army one single hour for want of information was at an expense to the public greater than the cost of the whole Topol. Department in three or four campaigns.

In view of the fact that economy in expenditures has been urged upon me, and that my accounts for photography are now suspended against me, I feel that I must be very careful, as I certainly feel no inclination to distribute with a very liberal hand, property for which I may have to pay out of the present limited salary of a Captain of Engineers.[52]

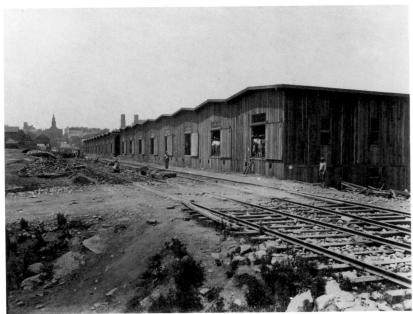

63. *Quartermaster's Buildings [Taylor Depot], Nashville,* 1864; West Point

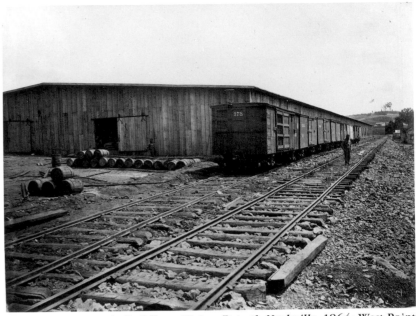

64. *Quartermaster's Buildings [Eaton Depot], Nashville,* 1864; West Point

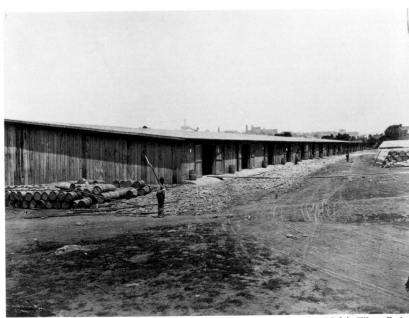

65. *Quartermaster's Buildings [Eaton Depot], Nashville,* 1864; West Point

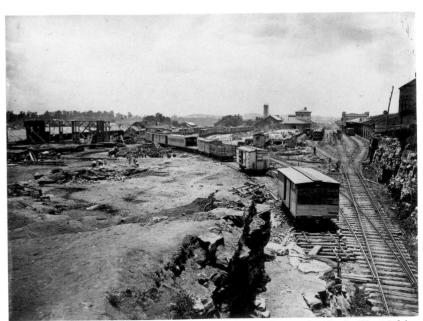

66. *Nashville & Chattanooga Railroad Depot Grounds, Nashville,* 1864; West Point

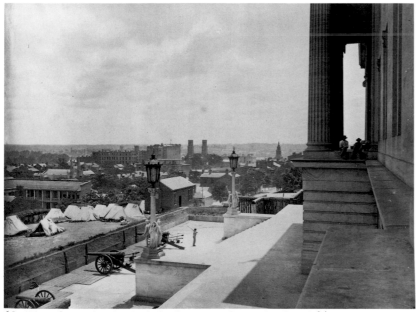

67. *View from the Capitol, looking west, Nashville*, 1864; West Point

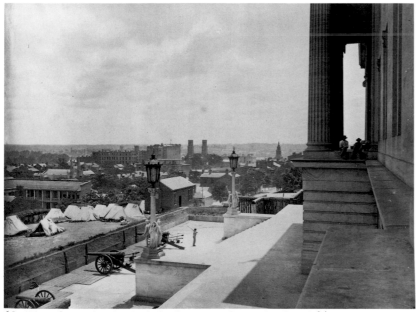

68. *View from the Capitol, looking north, Nashville*, 1864; West Point

II:3 Atlanta and the March to the Sea: 1864-65

Sherman's army began its advance toward Atlanta in May 1864. The Confederate commander, General Joseph E. Johnston, protected his smaller force (44,000 Confederates faced nearly 100,000 Federal troops) by avoiding direct tests of strength and carefully entrenching his men. When frontal assaults proved unsuccessful Sherman was able to force Johnston slowly toward Atlanta through a series of flanking moves. To protect itself, Johnston's army fell back from one carefully fortified position to another, burning bridges and destroying track as they moved. When a direct assault on Johnston's position atop Kennesaw Mountain failed, Sherman's renewed flanking strategy drove the Confederates to their ultimate defensive line in the trenches surrounding Atlanta. After two disastrous offensives by Johnston's successor, the impetuous General John B. Hood, Sherman began a forty day artillery barrage of Atlanta.

At the end of August Union forces moved south of Atlanta to threaten the city's vital rail link to Macon. When Hood realized that this force could not be stopped, he was compelled to evacuate Atlanta on September 1, 1864. The retreating Confederates destroyed much strategic material, including eighty-one railroad cars of munitions. This ammunition train exploded in an immense series of blasts heard miles away. Most of Atlanta's residents had departed by this time, and Sherman's troops met no resistance as they marched into the desolate city on the morning of September 2. The Atlanta Campaign had cost 31,000 Federal casualties (against 35,000 Confederates), but the North had won a critical foothold in the heart of the Confederacy. This triumph renewed Northern morale and contributed significantly to President Lincoln's reelection.

During the advance to Atlanta, Orlando Poe had overseen the production of maps, and the construction of pontoon bridges and temporary fortifications. Upon entering Atlanta on September 5 he personally selected the structure to be Sherman's headquarters. The general arrived two days later and instructed Poe to begin surveying the existing Confederate defenses around the city and planning a new and shorter Federal line.

Poe immediately summoned his photographer to Atlanta. As early as July 28, while Poe was near Ezra Church, he had notified Barnard, "hold yourself in readiness to take the field if telegraphed to that effect."[1] Given the military instability at that time, however, it was clear that Barnard would be more productive in Nashville.[2] Poe telegraphed for his photographer immediately after the fall of Atlanta:

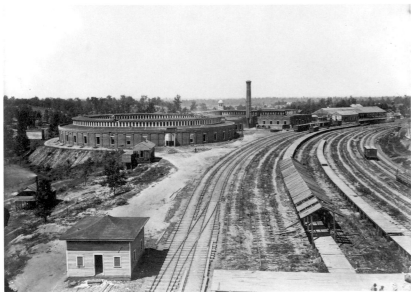

69. *Engine House and Machine Shops of the Western & Atlantic Railroad, Atlanta*, September 1864; West Point

September 4, 1864
Join me at Atlanta, with Photographic Apparatus. Bring your assistants, and materials with you.[3]

Barnard spent several days packing and by September 11 was on a train to the conquered city. On that date Poe addressed a summary of the previous month's activities to General Delafield, with this reference to Barnard:

Mr. George N. Barnard, Photographer, has had less to do this month than usual. He was ordered to hold himself in readiness to take the field whenever telegraphed for. This has at the date of this report been done and he is on his way to Atlanta where there is abundant employment for him. Indeed there is more than it seems possible to do...[4]

Much work was required of the Engineers to consolidate control over the occupied city. On September 11 Poe issued orders to his subordinate officers for a complete survey of the Atlanta area. Poe requested precise transit measurements of all major topographical features, roads, railroad lines, and entrenchments.[5] Much of Barnard's subsequent work in Atlanta was devoted to documenting the areas surveyed by the army's engineers.

Barnard arrived at Poe's headquarters in mid-September. His first days in the occupied city were spent reestablishing his facilities and copying maps. Among the few photographs made outdoors in September 1864 were images of the railroad yards and the blasted remains of Hood's ammunition train (figure 69; plate 44).[6] Barnard also traveled southeast of the city to record the melancholy scene of General McPherson's death.

General James Birdseye McPherson (1828-1864) had been one of the Union Army's most accomplished and admired officers. McPherson graduated first in the West Point class of 1853, and was popular with his professors and peers for his "sunny temper and warm heart."[7] By 1864 he was held in high regard by his superiors, Grant and Sherman, and the men he commanded in the Army of the Tennessee.

On the early afternoon of July 22, 1864, during an engagement on the outskirts of Atlanta, McPherson was surveying the Union line on horseback. While riding through a wooded area assumed to be under Federal control, the general abruptly found himself face to face with a group of enemy infantrymen. Ignoring a call to surrender from the Confederate officer in charge, McPherson instinctively turned his horse and attempted to escape into the surrounding trees. He was crouched low over his charging mount when a rifle bullet struck him in the back. He fell heavily to the ground and died within minutes.[8]

From the first report of his death, McPherson was lauded by both friend and foe as a gentleman and a hero. The Confederate officer who witnessed the shooting later reported,

I ran immediately up to where the dead General lay, just as he had fallen, upon his knees and face...Even as he lay there, dressed in his major-general's uniform, with his face in the dust, he was as magnificent a looking picture of manhood as I ever saw.[9]

Sherman eulogized McPherson as one who "blended the grace and gentleness of the friend with the dignity, courage, faith, and manliness of the soldier."[10] The national press referred consistently to McPherson as a gallant and distinguished officer who had played a "prominent and glorious" part in the epic campaign to Atlanta.[11] McPherson's death symbolized the timeless tragedy of gifted men cut down in their prime, and of a nation relentlessly destroying its own best prospects for the future.

The significance of McPherson's loss — as the only commander of a Federal army to die in battle and a genuinely beloved leader — was widely recognized. However, Barnard was particularly aware of the general's stature. He had met and photographed McPherson earlier in the year, and almost certainly attended his solemn funeral procession in Nashville on the morning of July 25. In the course of its transit from Marietta, Georgia, to his hometown of Clyde, Ohio, McPherson's casket had been ceremoniously carried through the streets of Nashville on its way from the Chattanooga to the Louisville rail depots. Everyone connected with the Federal army in Nashville participated in, or witnessed, this fifteen-minute procession, "one of the most imposing military displays" ever seen in that city.[12]

The scene of McPherson's death was one of the first subjects recorded by Barnard after his arrival in Atlanta. The photographer traveled east of the city, beyond the circle of defense works, to find the spot clearly marked. Only days after the occupation of Atlanta two of McPherson's former subordinate officers had

revisited the fatal site. On a small tree close to where the general's body had been found they carved:

Maj. Gen. J.B. McPherson
Atlanta
July 22d, 1864

A wooden placard bearing a similar, handwritten inscription was also nailed to the tree.[13]

After erecting his dark-tent at this site, Barnard made a series of photographs: at least three in the stereo format and one vertical view with his 6½ x 8½-inch camera (figure 70). Although taken from varying distances and angles, all of these images center on the small tree with its hand-lettered sign. (By this time the inscription carved into the trunk itself was relatively inconspicuous. It had either darkened naturally or been deliberately painted over by the time of Barnard's visit.) Each of Barnard's photographs recorded the site's dense forest growth and the debris of battle that littered the hard, dry ground.

Barnard's photographs represent the most "authentic" views of this historic scene. In early 1865 the Anthony firm offered copies of Barnard's stereographs for public sale,[14] and the single-plate view was reproduced as a wood-engraving in the February 18, 1865, issue of *Harper's Weekly*. The latter illustration was accompanied by the following text:

The adjoining cut, from an excellent photograph by GEORGE N. BARNARD, shows the scene and surroundings of General McPHERSON'S death. A simple inscription upon a tree tells the story so far as he was concerned, while the details of the picture — the shot and shell, the broken artillery-wagon, with the skeletons of horses lying where they fell, the soldier's dilapidated hat and shoe — indicate the scene of carnage just as it was left after the battle had swayed from this to some other portion of the field....[15]

Barnard later revisited this important site (either in early November 1864 or late May 1866) to make a larger, and more artistically considered photograph. While Barnard's first images had been descriptive in intent, his later views interpret and give more precise aesthetic shape to the raw material of the scene. With his 12x15-inch camera Barnard made two exposures from a single vantage point (figure 71; plate 35). The differences between these variant negatives, and the power of Barnard's final image, reveal much about his working method and artistic sensibility.

In the time since his first visit to the scene the evidence of battle had become less obvious. Foliage had grown up and much of the scattered debris had been removed. Using a relatively wide-angle lens, Barnard again centered his camera on the thin tree, which now lacked the earlier wooden sign. Barnard's horizontal format and wider view gave new prominence to a large tree on the left of the picture, while contrasting the openness of the foreground clearing with the

70. *View of the Spot where Maj. Gen. McPherson was killed July 22, 1864*, September 1864; West Point

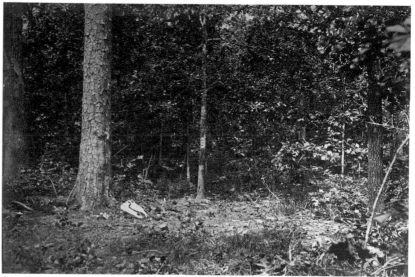

71. *Scene of General McPherson's Death [variant]*, 1864 or 1866; U.S. Army Military History Institute

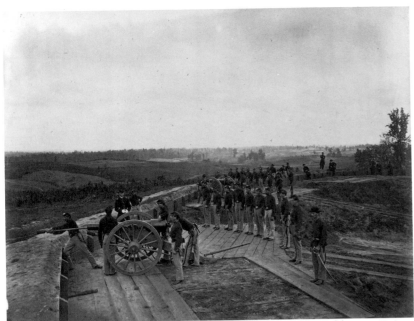

72. *[Soldiers in Federal Fort No. 7], Atlanta,* September 1864; West Point

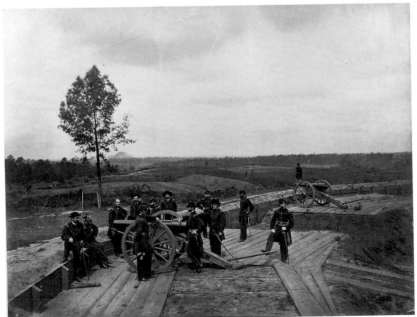

73. *General Sherman and Staff in large rebel fort west of Atlanta (No. 7, new line of defense), Atlanta,* September 1864; West Point

densely wooded background. The result is a sheltered, stagelike setting for a carefully arranged tableau of time and death.

Once satisfied with the placement of his camera, Barnard proceeded to subtly organize the scene before him. He pulled back foliage that intruded into the view from the right, and a well-bleached horse's skull was arranged prominently at the foot of the large tree. It cannot be certain whether Barnard left the cannonballs as he found them, or also introduced them into the scene. Lastly, it is apparent that the inscription carved into the small tree was highlighted. These letters had not been legible in Barnard's previous photograph due to a darkening of the trunk by natural or human action. (Close examination of original prints suggests that the trunk had been deliberately painted to obscure this inscription.) In the first of Barnard's 12 x 15-inch photographs (figure 71) these letters stand out crisply against a starkly light-toned section of the tree. In the second and more famous version (plate 35), three changes are readily apparent: the trunk has been darkened again so as to render the inscription nearly invisible, a foreground branch has been pulled further out of view, and several bones have been relocated near the skull.

These alterations were deliberately made to achieve a more suitable pictorial and artistic effect. The carved inscription, for example, had been visually ambiguous. The small diameter of the tree allowed only a fragment of it to be read from any single viewing position. Barnard may have decided that the carved letters were simply more confusing than edifying, and that their denotative function would be better served by a title or description appended to his photograph.

It also seems probable that Barnard viewed the inscription (and by this time, perhaps, the earlier wooden sign as well) as incompatible with his artistic objective. The success of Barnard's carefully choreographed photograph depended to a large degree on the illusion of unmediated naturalness. The tree's inscription revealed that the site had been visited and commemorated at some earlier time. By suppressing evidence of such previous visits, Barnard's photograph conveyed to viewers a special intimacy and poignance. The elements of this scene, when perceived as the product of purely "natural" forces, provided clear and telling narrative cues. Barnard's precise placement of bones and elimination of blurred foliage simply contributed to the clarity of his subject by more closely conforming to accepted pictorial standards.

In the last week of September Barnard was called upon to photograph a living hero. General Sherman and his staff gathered in Federal Fort 7, a restructured Confederate fortification on the west side of the city. Using his 12 x 15-inch camera, Barnard first recorded troops at attention beside a cannon as Sherman

waited in the background (figure 72). The photographer then reoriented his camera slightly as the general and his staff arranged themselves around the same cannon (figure 73). Finally, Barnard used the stereo format to depict Sherman on horseback surveying the fortifications of Atlanta (figure 74).

Copies of the second group portrait were made available to members of Sherman's staff and the press. Barnard may have made these photographs at the request of Theodore R. Davis, a noted correspondent and sketch artist for *Harper's Weekly*.[16] The December 17, 1864 issue of *Harper's* published a two-page illustration of Sherman on horseback taken directly from Barnard's stereograph.[17]

In October, Barnard was busy photographing the city of Atlanta and representative aspects of the nearly ten-mile line of Confederate defensive works (figure 75). Poe had thoroughly surveyed these abandoned fortifications and discussed with Barnard their significant features. Barnard traveled extensively, reaching at least Confederate forts "D," "E," and "G" on the west side of the city, as well as parts of the line to the north and south of Atlanta (figures 76, 77). While documenting Confederate fortifications on the southeast side of Atlanta in October, Barnard included his own wagon, dark-tent, chemicals, and assistant prominently in one scene (figure 78). This important image provides a unique depiction of Barnard's apparatus in the field.

In a letter to the *Syracuse Standard*, dated October 20, 1864, Captain Moses Summers noted the value of Barnard's work:

> Mr. Barnard, formerly Daguerreotype Artist in Syracuse, is...here. He is at the head of the Photographic Department of the Army, and his work is not only elegant and artistic, but vastly important to Military Engineers, and in fact to all classes of military men. Some of the most perfect and beautiful specimens of Photographs come from his hand, and his views of important incidents and localities must excite great interest when they are given to the public. At present his work is almost exclusively confined to the army, because most of his graphic representations of interesting scenes are like some army news — "contraband."[18]

While Barnard was recording these lines Poe directed some 2600 men in the construction of new entrenchments and a complex of Federal forts numbered 1 through 17. This series of new Federal defenses incorporated some of the existing Confederate forts on the northeast side of the city. The rest were abandoned, however, to create a shorter and tighter defensive line (figure 75). In late October and early November, Barnard systematically recorded many of these new Federal forts. He worked his way from Fort 7, on the west side of the city, through Forts 8, 9, 10, 11, and 12 on the south side of Atlanta. Using the stereo, 6½ x 8½-inch and 12 x 15-inch formats, Barnard usually photographed up and down the fortification line from each of these positions. He also recorded Forts 13 and 19 on a new line at the southeast edge of the city (figures 79-81).

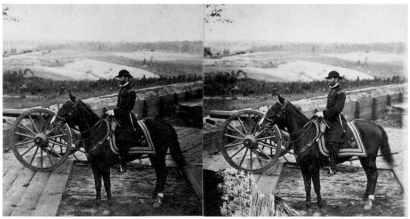

74. *General Sherman on horseback in Federal Fort No. 7, Atlanta*, September 1864; stereograph; West Point

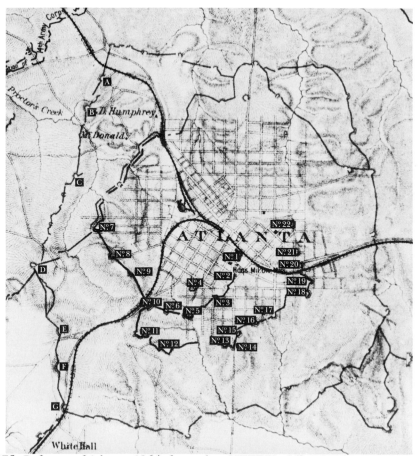

75. Defenses of Atlanta, 1864; from plate LXXXVII, *Official Military Atlas*

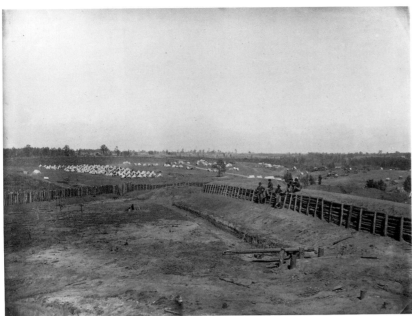

76. *View from large salient of the rebel lines, southeast of Atlanta, looking north. Camp of Michigan Engineers and Mechanics in left middle ground,* October 1864; West Point

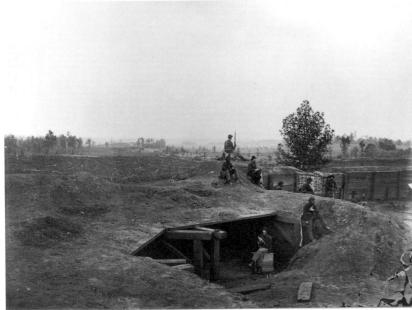

77. *View from casemated rebel Fort "D", looking north. Fort No. 7 of the new line established by Union forces is seen in the right back ground, Atlanta,* October 1864; West Point

Barnard's photographs of these forts reveal both the engineering workmanship involved in their construction, and the relaxed presence of the Union's occupying forces. Despite their advanced position deep in Confederate territory, the Union troops in Atlanta were never directly threatened by enemy attack. Sherman later noted that, by the middle of September,

> things had settled down in Atlanta, so that we felt perfectly at home. The telegraph and railroads were repaired, and we had uninterrupted communication to the rear. The trains arrived with regularity and dispatch, and brought us ample supplies.[19]

The days of occupation quickly settled into a pattern of guard duty, fortification work, and other routine matters (figure 82). In the evenings soldiers gathered to listen to the fine military bands of the Second and Thirty-Third Massachusetts Regiments, or to play cards and talk.

Outside the city, however, Hood's Confederate troops soon began causing disruptions along the rail line to Chattanooga. On a regular basis sections of track were destroyed and telegraph wires cut. While this damage was always rapidly repaired, the defense of this lengthy supply line drew precious resources and men from possible use in offensive action.

On October 5, 1864, the Confederates attacked a vital Union fort protecting the rail line at Allatoona, Georgia. When Sherman's men had first taken this area in June, Orlando Poe had constructed two small forts of timber and earth for the defense of the pass and nearby storehouses.[20] The forts were located on either side of a deep railroad cut and commanded a magnificent view of the surrounding landscape (plates 28, 29). After fierce fighting on the morning of October 5, the outnumbered Union defenders bravely held their ground. Sherman termed this victory a "handsome and important" defense, but it was clear that his forces would not remain on the defensive indefinitely.[21]

The plan for the "March to the Sea" had been forming in Sherman's mind for some time. On October 9 he telegraphed General Grant:

> I propose that we break up the railroad from Chattanooga forward, and that we strike out with our wagons for Milledgeville, Millen, and Savannah. Until we can repopulate Georgia, it is useless for us to occupy it; but the utter destruction of its roads, houses, and people will cripple their military resources. By attempting to hold the [rail]roads, we will lose a thousand men each month, and will gain no result. I can make this march, and make Georgia howl![22]

After some hesitation Grant approved the plan on November 2. Sherman immediately had all unnecessary material, as well as any sick or wounded troops, transported by rail back to Chattanooga. In Atlanta wagons were prepared for travel and loaded with supplies (figure 89).

When it became clear that the city would soon be abandoned Poe began sorting out the affairs of the photographic department. With the army's destination

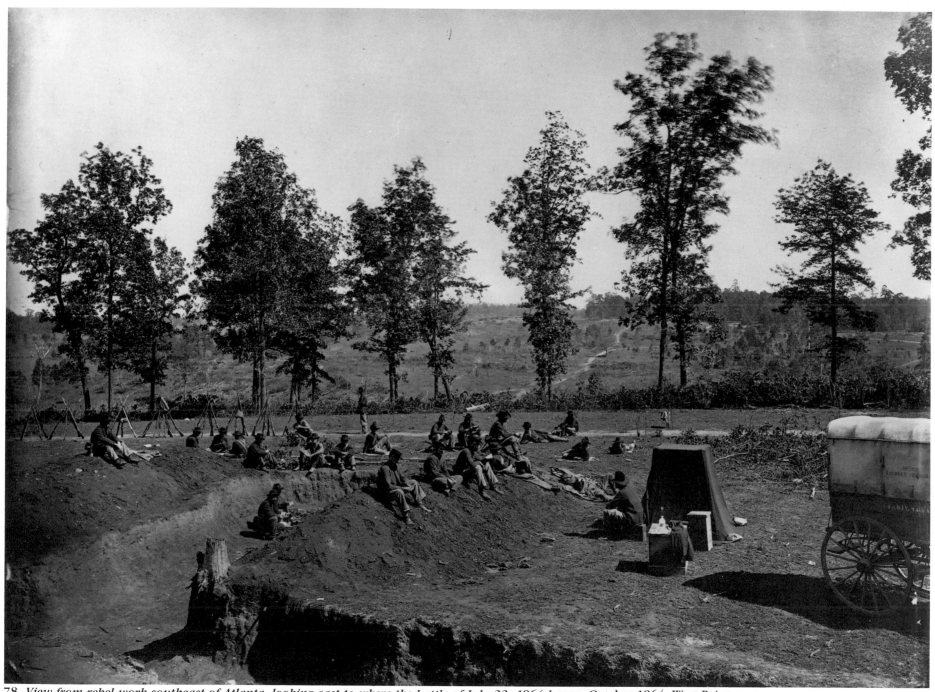

78. *View from rebel work southeast of Atlanta, looking east to where the battle of July 22, 1864 began*, October 1864; West Point

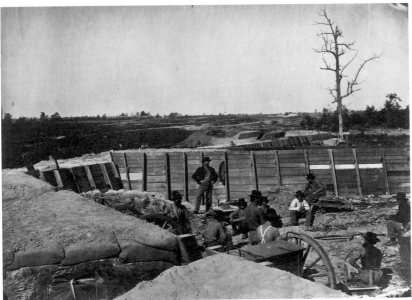

79. *Federal Fort No. 12, looking northwest towards No. 11, Atlanta,* November 1864; West Point

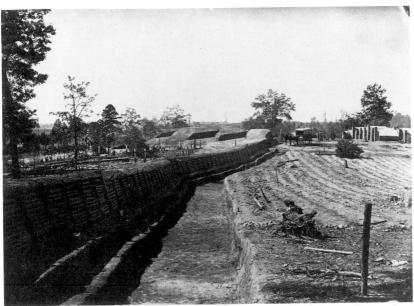

80. *Federal Fort No. 13, looking west towards No. 12, Atlanta,* November 1864; West Point

uncertain, it was deemed prudent to send most of Barnard's fragile glass negatives back to Jenney in Nashville.[23] (Unfortunately, a number of these negatives were subsequently destroyed in transit.) On November 1, Poe also instructed Jenney to distribute sets of Barnard's photographs to Poe's wife, Sherman's wife, Generals Thomas, Jones, and Callum, Professor Bache of the U.S. Coast Survey in Washington, and the Library of the Military Academy at West Point.[24]

On that same day Poe sent a selection of the recent Atlanta photographs to Delafield.

> Sir — I have the honor of transmitting herewith two sets of the Photographic views taken to illustrate the military operations at this place.
>
> Also a set of views intended to convey to the Bureau a knowledge of the character of the new line of works erected at this place under my direction, and intended to provide for a much smaller garrison than was necessary for the old rebel lines. The completed garrison [could be maintained by] 5000 men.
>
> These views are forwarded unmounted on account of a scarcity of cardboard, as well as convenience of transportation. They can be mounted by any Photographer, and I would respectfully request the Chief Engineer to have it done, for the sake of their preservation; for long ere this reaches the Department the city of Atlanta will have ceased to exist, and the ground upon which it stood will have passed out of our hands.[25]

Barnard remained particularly busy in the first two weeks of November. In addition to completing his documentation of the new Union forts, he also produced a large number of views in downtown Atlanta. He made 12 x 15-inch negatives of such important structures as City Hall, the Union Depot Car Shed and the headquarters of Sherman and Poe. He also recorded the streets and buildings of the city in an extensive series of stereographs (figures 83-88). These photographs depict prominent structures such as the Masonic Hall and the Trout House, a noted 100-room hotel. Barnard also recorded a former slave market on Whitehall Street and made other views on Alabama, Collins, and Mitchell Streets.

A letter to the *Syracuse Standard*, written from Atlanta on November 8 by Moses Summers, provides details on some of Barnard's other activities in the last days of the occupation.

> A very fine Photographic view of the Head Quarters of Col. Barnum, with a group of officers composing his Brigade Staff, was taken a day or two since by Mr. Barnard, the well known Artist formerly of Syracuse, but now connected with the Department of the Cumberland.
>
> Mr. Barnard also made a beautiful picture of the 149th Regiment, in which I think most of the countenances of the officers and soldiers will be recognized. Several Stereoscopic views were also taken at the same time, and I need not say all the pictures bear evidence of the artistic skill and experience of Mr. Barnard, a gentleman who stands at the head of his profession. I have no doubt copies of the pictures will

reach Syracuse, and your readers can judge of their merit for themselves.[26]

Colonel Henry A. Barnum, a friend of Barnard's from Oswego, commanded the 149th New York Volunteer Infantry. Barnum posed with his staff on the flag-bedecked porch of his headquarters, the previous occupant of which had been Confederate General John B. Hood.

In addition to these outdoor views, Barnard remained busy duplicating maps. A top-secret map of the terrain between Atlanta and the Atlantic coast, sent to Sherman from Washington, was copied discreetly by Barnard in the first week of November. These photocopies, folded to fit in a coat pocket, became essential during the weeks of the march. One leading officer recalled studying his copy almost hourly on the way to Savannah.[27]

By November 8, election day, the evacuation of Atlanta seemed imminent. On that day Poe wrote Delafield,

> ...The movement of the troops from this place will begin within a few hours and this is my last opportunity to get letters through, as we will have no further communication with the north after tonight...
>
> I have, by direction of Genl. Sherman, copied by Photography the confidential map sent him some time since, from the Bureau. I have not issued any copies yet but am only waiting Genl. Sherman's orders to do so. This will indicate the direction of our movement.
>
> Mr. Barnard, my Photographer, will accompany us, and I hope to be able to accumulate much valuable data...[28]

In fact, the lines of communication remained open until November 12, when the last train left Atlanta for Chattanooga, and the telegraph wires were cut. On that day Poe, following Sherman's orders, issued specific directions to his men for the razing of Atlanta. The following orders are representative of the targets and techniques indicated by Poe:

[To Lieutenant C.F. Wooding:]
> You will please take the detachment under your charge to the Georgia Round House, and destroy the chimneys, arches, &c. of that building, being careful not to use fire in doing so, as the high wind now blowing would endanger other buildings which it is not intended to destroy.

[To Lieutenant W.H. Herbert:]
> You will please take your detachment to the old Pistol factory, and destroy all the steam chimneys, furnaces, arches, and steam machinery from there to the old Rolling Mill, being careful not to use fire in doing the work.[29]

Despite Poe's attempts to conduct this destruction in a rational and strategic manner, it was difficult to maintain order. The evening of November 14 took on a nightmarish quality as fires raged out of control and the heart of Atlanta was gutted. Punctuating this noise and confusion were the periodic explosions of loaded

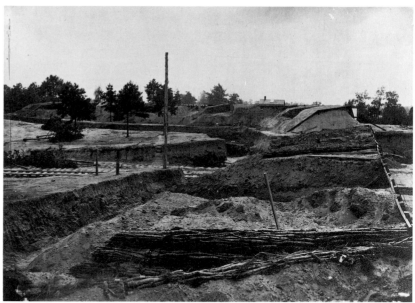

81. *Federal Fort No. 19, looking to the south, Augusta R.R. in foreground,* November 1864; West Point

shells stored in burning structures. The next day Poe noted tersely in his diary,

> Work of destruction of Rail Road and depots in Atlanta going on...Much destruction of private property by unauthorized persons to the great scandal of our Army, and marked detriment to its discipline.[30]

Barnard, too, was "very much troubled" by the seemingly reckless and wanton destruction of the city.[31]

Barnard had just concluded photographing many of the buildings destined for destruction. Hand-inscribed captions on the backs of several of Barnard's stereoscopic views of Decatur, Whitehall, and Alabama Streets indicate that "all buildings in this view were destroyed." Among the few exceptions to this general destruction were City Hall, the area surrounding Sherman's headquarters at the corner of Collins and Mitchell Streets, and a Masonic Hall spared by Federal Masons.

In these last frenzied days of occupation Barnard used his stereo camera to record the most organized, and militarily relevant, aspects of this demolition. At least three stereographs documented soldiers destroying the rail lines within the city, while a fourth recorded the ruins of the Car Shed on November 15 (figures 90-93). By using the smaller stereo camera instead of his slower and more cumbersome 12 x 15-inch instrument, Barnard was able to capture an unusual sense of movement and spontaneity in these photographs.

On November 15, Henry Hitchcock, Sherman's assistant adjutant general, described in some detail the methods used by Poe's engineers to destroy the rails.

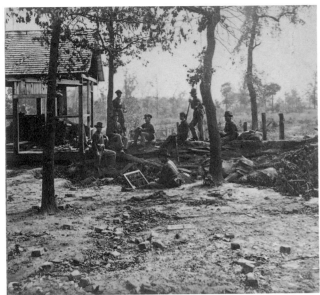

82. *Union Picket Post, southeast of Atlanta*, 1864; stereograph detail; West Point

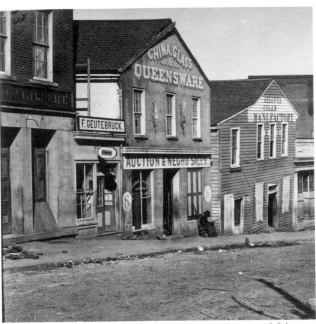

83. *Near the foot of Whitehall Street, Atlanta*, 1864; stereograph detail; West Point

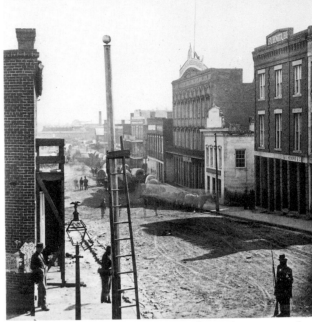

84. *Alabama Street, looking east from the corner of Whitehall Street, Atlanta*, 1864; stereograph detail; West Point

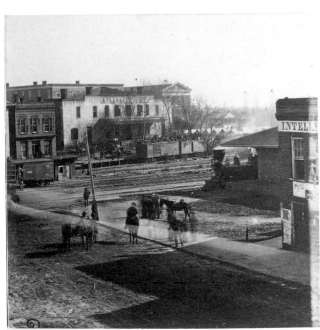

85. *The foot of Whitehall Street, Atlanta*, 1864; stereograph detail; West Point

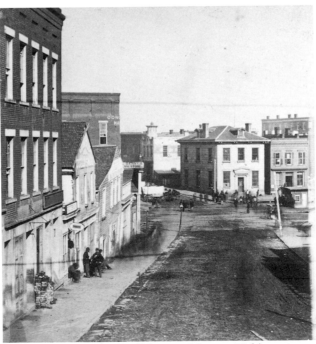

86. *The foot of Whitehall Street, Atlanta*, 1864; stereograph detail; West Point

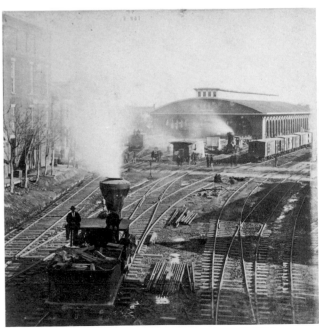

87. *The "Car Shed", or Union Passenger Station, Atlanta*, 1864; stereograph detail; West Point

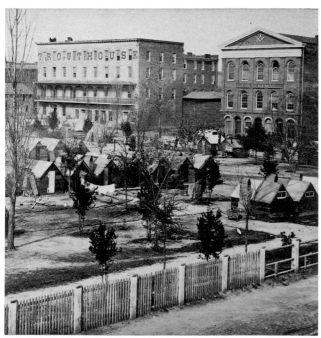

88. *Masonic Hall, Trout House, and Camp of the 111th Pennsylvania Volunteers, Atlanta*, 1864; stereograph detail; West Point

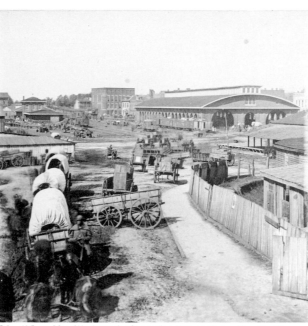

89. *"Car Shed", just before the "March to the Sea", Atlanta*, November 1864; stereograph detail; West Point

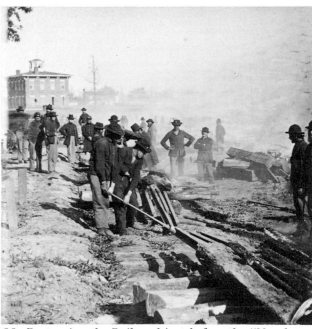

90. *Destroying the Railroad just before the "March to the Sea", Atlanta*, November 1864; stereograph detail; West Point

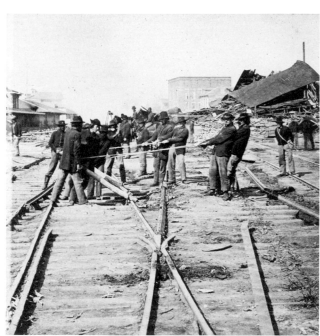

91. *Destroying the Railroad just before the "March to the Sea", Atlanta*, November 1864; stereograph detail; West Point

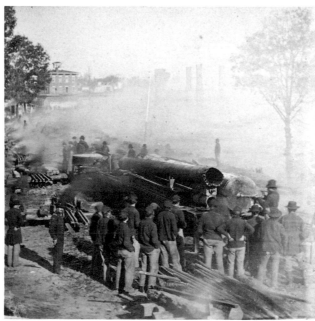

92. *View in Atlanta just before the "March to the Sea", showing manner of destroying Railroads and Machines*, November 1864; stereograph detail; West Point

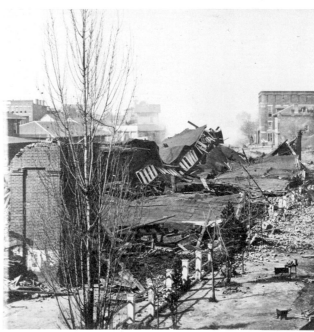

93. *Ruins of the "Car Shed", Atlanta, just before the "March to the Sea"*, November 1864; stereograph detail; West Point

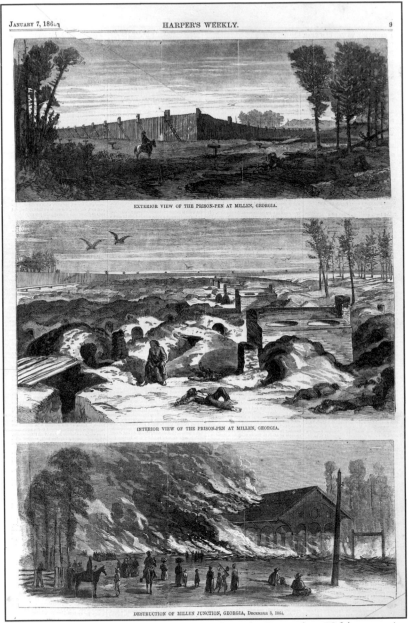

EXTERIOR VIEW OF THE PRISON-PEN AT MILLEN, GEORGIA.

INTERIOR VIEW OF THE PRISON-PEN AT MILLEN, GEORGIA.

DESTRUCTION OF MILLEN JUNCTION, GEORGIA, December 3, 1864.

94. *View of the Prison-Pen at Millen, Georgia*, December 1864; engravings published in *Harper's Weekly*, January 7, 1865; Kansas City Public Library

...Saw Poe's men at work yesterday with his new contrivance for quickly tearing up R. Rd. tracks: simply a large iron hook hung on a chain whose other end has a ring to insert a crow-bar or other lever. The hook is caught on the inside of the rails, but supported ag[ain]st the outside, at the ring & end of the lever with these, the heaviest rails are easily & quickly turned over. As we came [to Atlanta] yesterday from Marietta, every foot of the R. Rd. had been torn up, ties piled & fired, or 9 in 10 of them, bent & twisted out of shape.[32]

Sherman's troops began leaving Atlanta before noon on November 15. On the following morning the general, his staff, Barnard, and the remainder of the Union forces marched out of the shattered city. Pausing on the outskirts of Atlanta, Sherman turned to survey the scene behind him.

We stood upon the very ground whereon was fought the bloody battle of July 22d, and could see the copse of wood where McPherson fell. Behind us lay Atlanta, smouldering and in ruins, the black smoke rising high in the air, and hanging like a pall over the ruined city.[33]

For the next three weeks Sherman's forces cut a wide swath of destruction across Georgia as they moved toward Savannah. Each day's march began at about 7:00 a.m. and covered between ten and seventeen miles. Poe's troops destroyed railroad tracks at intervals along the way, and constructed bridges as needed. Proceeding east from Atlanta through Decatur and Lithonia, the troops marched through Newborn to the state capital at Milledgeville. In the recently evacuated capitol chambers a group of officers, and *Harper's Weekly* correspondent Theo R. Davis, held a mock legislative session in which the state's ordinance of Secession was boisterously "repealed."

On December 2 Union troops entered Millen, near the site of a hated and brutal Confederate prison camp. As his men torched the town's depot buildings, Poe noted with quiet passion that the flaming buildings formed a "magnificent spectacle."[34]

The vile prison near Millen shocked all who saw it. Barnard's reaction to this site was recorded in a uniquely revealing passage in Henry Hitchcock's diary.

December 6, 1864

Barnard, the Photographer, joined us today and showed quite a number of photographic views of Atlanta, &c, &c — all beautifully taken — also same for the stereoscope. He has "negatives" and *when we stop* will print copies...

Barnard went, when we were at Millen the other day, to the *stockade pen* where our men (prisoners) were kept. It was simply a *pen*, surrounded or made by stockades — high posts driven into the ground close to each other, — about 300 yards expanse; no shelter of any kind, no shed, no tent, no roof whatever, in any weather. He went into and all over it and examined closely. Would have photographed it but did not know of it in time enough. It was about five miles up

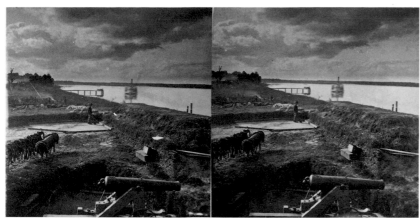

95. *Fort McAllister, looking up the Ogeechee River, from the flagstaff*, December 1864; stereograph; West Point

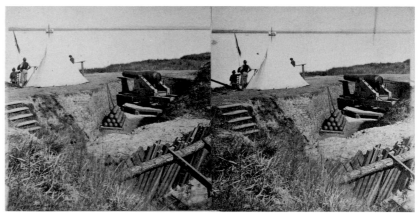

96. *Fort McAllister, looking across the Ogeechee River, from the flagstaff*, December 1864; stereograph; West Point

railroad from Millen — not at the Junction. There was no spring nor well nor any water inside the enclosure. He saw 750 graves, — no head boards nor other designation save that each fiftieth grave was so numbered. He heard that five or six dead bodies of our men were left there *unburied* when they removed the prisoners, — and *he saw one still lying there, unburied, himself.* He said, after telling about the place, (at dinner this evening) — "I used to be very much troubled about the burning of houses, &c, but after what I have seen I shall not be much troubled about it." If B. feels so from *seeing* the prison pen, how do those feel who have suffered in it! The burned houses, in spite of orders, are the answer.[35]

Although he was not able to photograph this horrendous scene, Barnard was credited with making "sketches" of the prison. The January 7, 1865, issue of *Harper's Weekly* reproduced two wood-engravings (figure 94) with the following text:

...the prison-pen at Millen was built of large logs driven into the ground, with sentry-posts on the top at short intervals. No shelter whatever was afforded to the prisoners, who burrowed in the earth. The square buildings shown in the sketch are ovens. Just inside the palisades a light-rail fence ran, which was called the dead line. When George N. Barnard, whose sketches of the prison-pen are here reproduced, was at that place he saw our dead soldiers lying unburied, as shown in the illustration.

Later in the same text Barnard was again given credit for "the graphic sketches of the Prison-Pen at Millen."[36] These references appear to be the only evidence of Barnard's activity as a sketch artist. This issue of *Harper's Weekly* also ran a wood-engraving of Barnard's photograph of General Sherman and staff taken in late September in Atlanta. To render the image more timely, however, the editors altered the background landscape and titled the illustration *Major-General Sherman and Staff before Savannah.*

Barnard apparently made no photographs during the march. The reasons for this involve both the rapidity of the army's movement and the lack of appropriate subjects. Photography was impossible for Barnard without some semblance of a fixed facility, fresh water, and the time to operate. Equally significant, however, was the fact that the March to the Sea produced no battles of any consequence. Poe noted in his diary that the first enemy contact he witnessed occurred on November 25, and was relatively trivial. The widely extended lines of Union troops were engaged in numerous skirmishes, but none that could be considered decisive. Thus there were, in the traditional military sense, few subjects or scenes worthy of record. And it went without saying that the "real" events of the march — the burned crops, looted houses and various acts of savagery or intimidation practiced by Sherman's "bummers" — could not or would not be photographed.

By early December 1864 the Union forces had established camp on the outskirts of Savannah. Regular communication with the north was reestablished, allowing Barnard's Atlanta photographs and sketches of Millen to be transported by ship to Washington and New York. The courier for these images may have been Barnard's assistant J.W. Campbell, who traveled from Savannah to New York City in the last week of December.[37]

In mid-December Poe sent Barnard with a letter of introduction to the commander of Fort McAllister, which guarded the mouth of the Ogeechee River just south of Savannah.

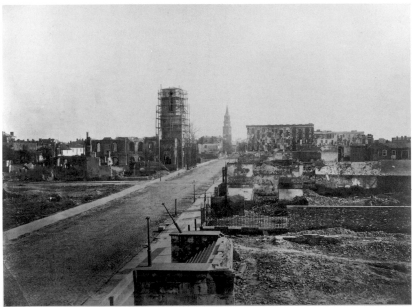

97. *Ruins of Charleston*, March 1865; West Point

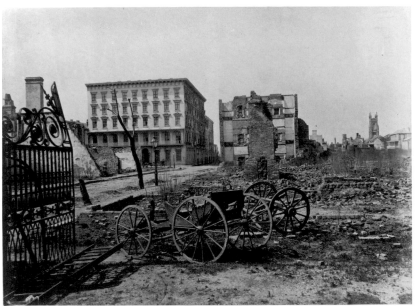

98. *Ruins of Charleston*, March 1865; West Point

To Brig. Gen. W.B. Hazen

The bearer, Mr. George N. Barnard, employed in the Engineering Dept., is sent by me to make such views of Fort McAllister as may be of interest to the authorities at Washington. Any assistance you may render him, in case he should meet with difficulty in getting into, and about the Fort, owing to suspicion concerning his mission & its character, will be duly appreciated by the Department which I have the honor to represent.[38]

Fort McAllister had been successfully assaulted by General William B. Hazen's Federal forces on the afternoon of December 13 in a fierce, but brief, engagement. The capture of McAllister prompted the fall of Savannah, since the fort guarded the major shipping route from the city to the sea. With McAllister taken, supplies could be brought from Port Royal and Hilton Head to re-equip Sherman's troops. Barnard made stereo views of this earthen fortification from vantage points on the fort's flagstaff, mortar battery, and western and southeastern bastions (figures 95, 96).

Barnard also made a portrait of General Hazen, "the hero of Fort McAllister," that was reproduced in the February 11, 1865, issue of *Harper's Weekly*.[39] Barnard's work for the journal continued through the end of the war. On February 18, 1865, *Harper's* ran a wood-engraving of his earlier image of the scene of McPherson's death. A portrait of Poe was published in the April 8 issue, and on July 8, 1865, a retouched version of one of Barnard's Charleston photographs was printed. In subsequent weeks a portrait of Major-General Peter J. Osterhaus and a view of the interior of Fort Sumter were also printed.

Union forces occupied Savannah on the morning of December 21, 1864. General Hardee's Confederate troops had evacuated the city during the previous evening after destroying a number of military vessels. Little else had been harmed, however, and Federal troops were surprised to discover steamboats, railroad equipment, and thousands of bales of cotton intact. On December 22 Sherman entered Savannah and surveyed "the city, the river, and the vast extent of marsh and rice-fields" from the top of the custom house.[40] In 1866 Barnard carried his 12 x 15-inch camera to this same vantage point to make a two-plate panorama (plates 49, 50).

In Savannah, Barnard was "constantly busy" through the first three weeks of January, duplicating new campaign maps, making portraits of officers, and printing fifteen of the Atlanta stereo negatives he had carried on the march. These latter images depicted the departure of the "last train north" and views of the destruction of the city. Although Barnard's printing was slowed by overcast weather, sets of these stereo images were completed and distributed to Poe, Hitchcock, and others.[41] Poe presented these photographs to General Meigs and Secretary of War Edwin M. Stanton on the occasion of their visit to Savannah on January 12. These prints were accompanied by a short note from Poe:

I respectfully transmit herewith a small collection of Photographic views illustrating military operations at Atlanta, Ga. The collection is much larger, but the negatives were sent to the rear when the march to this city commenced. As soon as they are again at hand I hope to have the honor of completing the collection.[42]

After resting in Savannah, Sherman proceeded northward to Columbia, South Carolina, the symbolic seat of the Confederacy. The general left Savannah on January 21, 1865, for Beaufort, South Carolina, where his troops were being gathered. Poe sailed for Beaufort five days later with copies of the new campaign map recently duplicated by Barnard. These were distributed to leading officers and Sherman's great army was once again on the move. On February 17 Poe accompanied the Federal troops into Columbia.

For days preceding the city's capture, the citizens of Columbia had been in a state of panic. Residents packed their belongings and prepared to leave, but the rapid Federal advance allowed no time for an organized evacuation. When the Union army entered the city on the morning of February 17 the chaotic situation deteriorated still further, as Federal soldiers broke into homes to steal jewelry and silver. Worst of all, a devastating fire broke out in the early evening. The scenes of destruction on that hellish night infuriated residents and even shocked many Union soldiers. Poe noted in his diary that,

> ...The citizens very impudently gave our troops liquor, and hundreds of them were made crazily drunk. It was a terrible mistake...as evidenced by the burning of the city — God grant that I may never witness such another scene of destruction, or distress. Many of our men being so stupidly drunk in the houses, were burned to death...

Two days later Sherman instructed his chief engineer to destroy all the city's machine shops and other remaining structures of strategic value. Poe privately noted:

> Attempted it, but found all sorts of persons giving orders, and let the matter take its course...the evident distress...makes me anxious to get out of this city, where nothing but violence has prevailed, and where the United States' uniform has received no lustre.[43]

By March 12, Poe was in Fayetteville, North Carolina, where he directed the destruction of that city's arsenal. From Fayetteville, Sherman's troops proceeded north to Goldsboro and Raleigh. Soon thereafter, however, Grant accepted Lee's surrender at Appomattox. Except for several scattered and futile encounters, the war was over.

Barnard did not accompany Sherman's troops on this final leg of the campaign. Aware of the logistical difficulties of photographing on the march, Poe decided to leave Barnard temporarily in Savannah. He notified the photographer of this decision on January 19.

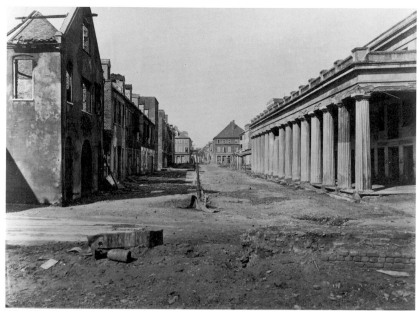

99. *Vendue Range, Charleston*, March 13, 1865; West Point

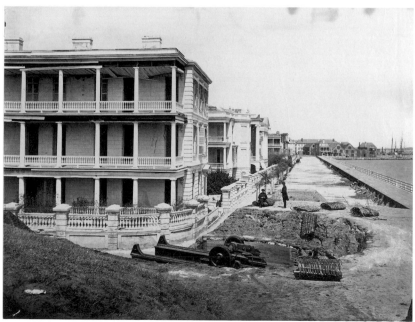

100. *View on the "Battery" with wreck of the 12-inch Blakely gun, Charleston*, March 1865; West Point

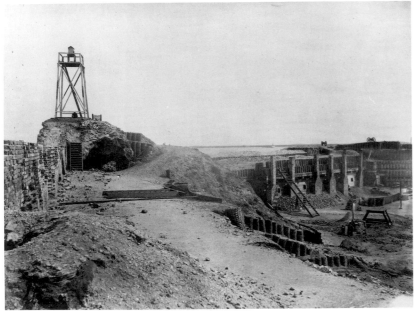

101. *Interior of Fort Sumter*, March 1865; West Point

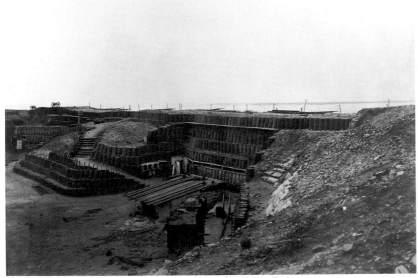

102. *Interior of Fort Sumter*, March 1865; West Point

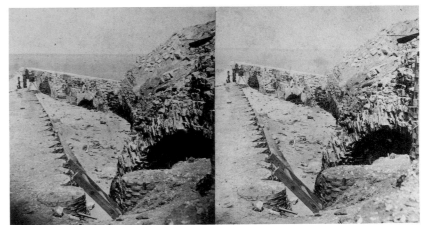

103. *View along the parapet of Fort Sumter, towards southeast*, March 1865; stereograph; West Point

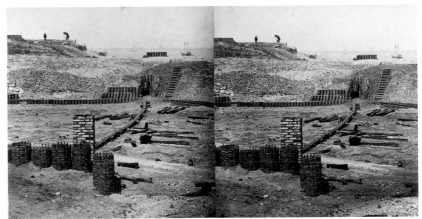

104. *Interior of Fort Sumter, looking across the western front toward Charleston*, March 1865; stereograph; West Point

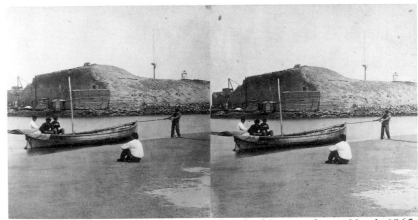

105. *Outside Fort Sumter, from sand bar looking northeast*, March 1865; stereograph; West Point

You will not accompany the movement about to take place, but will retain here that part of this office under your charge until you receive instructions to join the Head Quarters again.

Meanwhile you will employ yourself in taking such Photographic views of this city & vicinity as will be useful to the Chief Engineer, in illustrating the military operations in the neighborhood previous to our occupation of the city.

Corporal Adams will remain with you...[44]

Four days later Barnard was ordered to New York.

January 23, 1865

You will proceed by the first available opportunity to New York City for the purpose of carrying out the verbal instructions which will be given to you. When this duty is completed you are hereby permitted to take thirty (30) days leave of absence, at the expiration of which you will start for these Head Quarters, to report yourself for duty.

The Quarter Master's Department is requested to furnish transportation to and from New York City.[45]

While the details of Barnard's activities in New York are not known, it is likely that he went to the E. & H.T. Anthony firm to deliver some of his Atlanta stereo negatives and pick up fresh supplies. He may have also taken prints to *Harper's Weekly* for use as wood-engravings. Following his leave of absence Barnard sailed for Charleston.

The city of Charleston was a shattered ruin when Barnard arrived in March 1865. The effects of the great fire of December 11, 1861, which destroyed such noted buildings as the Pinckney Mansion (plate 59), remained apparent. Charleston had again been devastated only a month earlier during the Confederate evacuation of the city. Retreating Southern troops started numerous fires on February 17 to destroy stockpiles of food and munitions. These fires raged throughout the night. On the morning of February 18, as the last Southern troops were leaving, a tremendous explosion of gunpowder decimated the Northeastern Railroad Depot, killing nearly 150 people. The blast ignited homes near the station, and by late morning "the city was on fire from river to river."[46]

By February 19 Union soldiers were ransacking the buildings that had escaped the flames. A Northern correspondent described the dismal scene:

A city of ruins, of desolation, of vacant houses, of widowed women, of rotting wharves, of deserted warehouses, of weed-wild gardens, of miles of grass-grown streets, of acres of pitiful and voiceful barrenness — that is Charleston, wherein Rebellion loftily reared its head five years ago.[47]

At the time of Barnard's visit the city was occupied by Federal forces and "a handful of poor unkempt whites and wandering negroes." These forlorn residents foraged in streets littered with papers, broken glass, bricks, and other debris from innumerable burned and damaged buildings.[48]

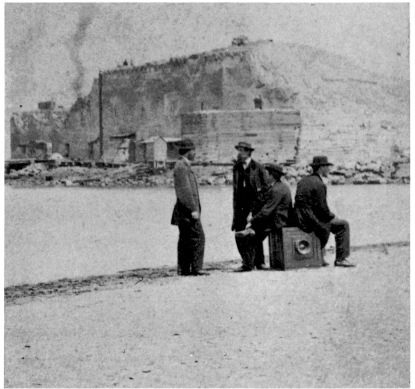

106. *Outside Fort Sumter, from sand bar looking northeast*, March 1865; carte-de-visite detail; South Carolina Historical Society

With his 12 x 15-inch camera Barnard created a powerful series of photographs in Charleston. He made memorable images of the ruins of Saint Michael's Church, the Circular Congregational Church, St. Andrew's Hall, the Northeastern Railway Depot and the Pinckney Mansion (figures 97, 98; plates 59-61). His view of Vendue Range, formerly a busy business district, conveyed the eerie silence of the shattered city (figure 99). On the Battery, Barnard recorded the wreck of a large Blakely gun destroyed by retreating Confederate forces (figure 100). He also photographed noted structures that had escaped significant damage such as Roper Hospital and the Post Office.

In Charleston harbor, Barnard spent considerable time working at Fort Sumter, one of the most important symbols of the war. Barnard's views of the interior of the fort reveal its condition when retaken by Federal forces on February 18, 1865 (figures 101, 102). During the months prior to this reoccupation the Union artillery on nearby Morris Island had withheld fire. During this lull the Confederates had rebuilt the fort's ruined inner structure with *gabions*, or wicker baskets filled with soil. The parade ground had also been cleared of rubble. One of

Barnard's large-plate views of the fort's interior was later published as a wood-engraving in the July 22, 1865, issue of *Harper's Weekly*. At least two stereos of the interior record a photographer (perhaps Barnard, or his assistant, with the 12 x 15-inch camera) at work in the distance (figures 103, 104).

Stereos of the fort's exterior documented clearly the effects of the many artillery sieges endured in previous years. In addition to relatively detailed views of Sumter's outer walls, Barnard made at least two separate trips to a sandbar a short distance away to record the battered landmark.[49] In the foreground of these views the crew of his rowboat struck a series of picturesque poses (figure 105; plate 56). On one of these visits Barnard may have recorded himself with three companions and his large 12 x 15-inch camera (figure 106). Barnard also photographed at Fort Moultrie, on the north side of Charleston harbor, and at Fort Johnson on the harbor's south side.

It is likely that Barnard traveled from Charleston to Columbia in about late March or early April, 1865. The evidence of his photographs suggests that Barnard visited the city a relatively short time after the fire of February 17, 1865. Here he photographed the back of the unfinished new capitol (plate 52). Barnard then entered the structure and made a view of the city from the second floor of the building's front (plate 53). As Barnard arranged his camera for this photograph he watched a handful of workers salvaging bricks from the acres of rubble that had been Columbia. Barnard's work in the South Carolina capital appears to have been limited in scope. While he included four views of the city in his 1866 album (plates 52-55), few other negatives appear to have been made at this time. This seems unusual and suggests some curtailment of his work there.

Toward the end of April, Barnard may have visited New Bern or Raleigh, North Carolina. On April 24, 1865, Jenney, in New Bern, telegraphed Poe in Raleigh that he was awaiting Barnard's arrival. By April 26 Jenney informed Poe, "Barnard still absent. Will send you the order furnished him for transportation here.[50] Poe responded impatiently.

> ...send a messenger for Barnard at once and get the order for transportation so strong that there will be no delay. I don't care whether he comes by way of New York or not, so that he gets here....

Later that same day Poe instructed Jenney to "go for Barnard at once. I am very anxious to get him here as soon as possible."[51]

It is likely that Poe wanted his photographer to record the surrender agreement between Generals Sherman and Johnston at Bennett Place, near Raleigh. Unfortunately Barnard could not arrive in time. On April 26, following ten days of negotiations, Sherman and Johnston signed a uniquely generous — even Lincolnesque — surrender pact. However, in the political climate immediately following Lincoln's assassination, the terms were widely perceived as altogether too generous. Secretary of War Edwin Stanton subsequently outraged Sherman by publicly accusing the veteran soldier of insubordination and a treasonous lack of judgment.

From Stanton's perspective the bitter four-year war should be followed by retribution, not forgiveness.

After the conclusion of hostilities, Barnard remained with Poe for several months in Washington, D.C. While Poe worked to complete a detailed map of the siege operations around Atlanta, Barnard was busy printing the negatives he had made in the preceding months. Upon the request of General Delafield, Poe instructed Barnard to print multiple copies of three of his 12 x 15-inch Fort Sumter negatives (two of which are reproduced as figures 101 and 102). On June 2 Poe sent Delafield seventeen prints "of photographs taken to illustrate military operations in the Charleston harbor."[52] At this time Delafield requested that Poe produce 100 prints each from the three Sumter negatives. Twenty-one of these sets (sixty-three prints) were delivered on June 6, and by June 21 all 300 prints were in Delafield's hands.[53] These Sumter views were eloquent symbols of the failed rebellion and were distributed liberally by Delafield to friends, military officials and political leaders. On June 22, 1865, Delafield thanked Poe for the previous 300 prints, and requested more.

> I have to request that you will continue the printing of these views, as a large number (the aggregate of which you will be duly informed) will probably be requested for issue on the requisition of the Secretary of War.[54]

Poe responded to Delafield's request on June 27.

> Sir — I have to acknowledge the receipt of your instructions to continue the Photographic printing of the Fort Sumter views, and I am compelled to report that I will be unable to comply with those instructions owing to the fact that Mr. Barnard (Photographer) has notified me that he will claim his discharge on the 30th June, and all the time meanwhile will be required to prepare the property for transfer.
>
> The negatives are in good condition and it would be possible to employ another Photographer, but I understood in conversation yesterday that the Bureau preferred having the work done by the photographer now employed there, or by some one under his direction.
>
> I respectfully request instructions concerning the disposition to be made of these negatives.[55]

At the end of June, Poe reported the official closure of his photographic department, and Barnard's discharge on June 30.[56] Barnard left Poe's employ on excellent terms, and was even allowed to keep a number of his war negatives for his own use.

III

*''they surpass any other photographic views
produced in this country''*

The Making and Meaning of <u>Photographic Views of
Sherman's Campaign</u>:

1866

III:1 Production and Promotion

Barnard's wartime experience had been challenging and memorable. He had witnessed one of history's great military campaigns and met many important individuals. The best and worst of human nature had been starkly revealed in the high drama of the war, and Barnard carried to the end of his life the memories of his eighteen months with the Military Division of the Mississippi. Upon discharge, Barnard's first concern was to renew his earlier business contacts. However, his retention of many war negatives indicated the photographer's interest in capitalizing, both artistically and financially, on his unique experiences.

Barnard's subsequent album, *Photographic Views of Sherman's Campaign*, arose from a context of individual initiative, popular interest, and commercial opportunity. The war had been divisive, exhausting, and shockingly bloody. The extent of this sacrifice required that a social process of remembrance and commemoration begin on the day the conflict ended. The war was kept alive in the collective memory in several ways. Northern veteran groups and memorial societies began organizing immediately after Appomattox. Specialized fraternities such as the Union Ex-Prisoners of War Association and the Signal Corps Society were formed as well as large umbrella organizations such as the Grand Army of the Republic. The latter group was begun in March 1866 and held its first national convention on November 20 of that year.[1]

A massive number of memoirs, poems, biographies and studies of individual battles were published in the months and years after Appomattox. In addition to such books as *Campaigns of the Army of the Potomac* and *A Narrative of Andersonville*, a specialized genre of Civil War travel-journalism developed. For example, in July 1865 the new journal *The Nation* commissioned John Richard Dennett to journey through the South and describe what he saw. Over the next eight months the young correspondent sent back thirty-four insightful essays from Virginia, North Carolina, South Carolina, Georgia, Alabama, and Louisiana.[2] These articles, and books such as J.H. Trowbridge's *The South: A Tour of Its Battlefields and Ruined Cities* (1866), documented the condition of the defeated region while providing readers a form of vicarious pilgrimage to sites rich in historic and emotional meaning.

Within this climate of Northern interest in the war, General Sherman was celebrated as one of the Union's greatest heroes. The capture of Atlanta and the dramatic "March to the Sea" were immediately ranked with the most famous military feats of all time. Several volumes appeared in the last half of 1865 documenting and commemorating this campaign. One of the most popular of these books was Brevet-Major George Ward Nichols' *The Story of the Great March*. Nichols, who had served as an aide-de-camp in Sherman's command, composed from his wartime diaries an entertaining account of the march. This book was favorably reviewed in several periodicals, including the August 1865 issue of *Harper's New Monthly Magazine*. Two months later the same journal published a nineteen-page illustrated excerpt, and in December it was noted that Nichols' "unpretending volume...has been eagerly sought and every where read."[3]

By January 1866, when *The Story of the Great March* was in its twenty-second printing, two other books on Sherman were receiving attention.[4] *Sherman and his Campaigns*, by Colonel W.M. Bowman and Lieutenant-Colonel R.B. Irwin, was praised for its accuracy and the inclusion of four "careful military maps" by Orlando Poe. Captain David P. Conyngham's *Sherman's March through the South* garnered fewer critical plaudits.[5] Among the poems commemorating Sherman's campaign was Herman Melville's "The March to the Sea," published in the February 1866 issue of *Harper's New Monthly Magazine*.[6]

The size and expense ($100 per copy) of Barnard's album clearly distinguished it from volumes produced for the general book trade. From its conception, *Photographic Views of Sherman's Campaign* was a deluxe, limited edition item intended solely for wealthy patrons and institutional collections. There was a well-established market for such lavish items. For example, the firm of Scribner, Welford & Co., at 654 Broadway, New York, offered a large selection of deluxe publications for sale, ranging in price from $13.50 to $350 per copy. These encompassed subjects as varied as art, architecture, literature, natural history, music, costume, and topography. In December 1866 this firm advertised sixty such works, including *Meyrich's Ancient Armour* (three volumes with 53 "Large Illuminated Plates", $300), *Great Exhibition Catalog of 1851* (six volumes, $250), *Milton's Paradise Lost* (with fifty "large designs" by Gustave Dore, in morocco binding, $100), and *Hogarth's Works* (elephant folio, $100).[7]

Barnard's beautifully crafted album was a work of art, history, and commerce. The financial success of the project was essential, and Barnard solicited subscribers to the volume before investing his own time and money in its production. In his work for Brady, Gardner, and the Department of Engineers, Barnard had met many of the nation's political and military leaders, and he naturally sought support from this network of influential contacts. Barnard received early orders from such noted Union generals as Henry A. Barnum, Henry W. Slocum, and William F. Smith. There is evidence that at least one of these men may have acquired additional copies of the album for personal distribution.[8] Barnard also solicited orders from foreign diplomats and at one point estimated that fifty copies would be acquired by European collectors. Since Britain, France, and Germany had sent official observers to the war, individuals or government agencies in these nations would have had a natural interest in Barnard's photographs.

The publication of Alexander Gardner's *Photographic Sketchbook of the War* in early 1866 probably provided the immediate catalyst for Barnard's volume. Gardner's album contained one hundred original albumen prints of scenes from Bull Run to Appomattox. Included were views of the battlefields of Yorktown, Gettysburg, and Cold Harbor, scenes in Richmond and Washington, and images of troops in formation, camp life, and unsettling records of the dead. Eight of the *Sketchbook's* photographs were from negatives made in March 1862 by Barnard and Gibson.

Gardner's lavish two-volume set received excellent notices in the press. Reviewers termed his work "superb and unique" and praised the application of photography to this aspect of historical documentation. The deluxe presentation of the album — "it is printed on imperial folio-sized sheets, splendidly bound in heavy morocco, in green and gold" — prompted at least one critic to pronounce it "a remarkably low-priced work," even at the price of $150 per copy.[9]

The reception of Gardner's album reinforced Barnard's belief that such complex productions could be done profitably. In addition, the *Sketchbook's* exclusive focus on the war's eastern theater (due, in large part, to Gardner's close ties with the Army of the Potomac) left the celebrated Sherman campaign completely to Barnard. On March 7, 1866, Barnard outlined his plan to Orlando Poe.

Dear General — I am just now thinking of getting up a set of Photographic views illustrating Gen. Sherman's operations and Grand March through Ga. commencing at Chattanooga.

I have quite a number of negatives which you had the kindness to let me keep but not enough for the purpose I now desire them [,] or in other words the set is not complete.

What I now think of doing is to go to Chattanooga and from there to Savannah and make all views which would be of any historical interest. I want about sixty or sixty five views in all the size of the Atlanta photos, 12 x 15 [-inches. I will] print and mount them on a thick kind of paper and neatly bind them in Book form.

I have mentioned the matter to a number of my friends and they all think favorably of it. Gen. [Henry A.] Barnum thinks he can obtain [for] me twenty-five subscribers at $100 per copy. I will require about fifty before I shall be disposed to commence the work.

I am going to get up a specimen Book with what I have and a few [of the negatives in the government files in Washington] I have written [Treasury Department photographer Lewis] Walker to furnish me which will give a very good idea of what the book will be when completed.

My object in writing you about it is I want a few maps which you may be able to furnish me to put in to the specimen book. Now if it will not be too much trouble for you to get me a few it would be a favor. You know what I want better than I can tell you. If you can get any please give them to Walker and he will send them on with some photographs which I am in hopes to obtain from him.

I would also like your advice in the matter. No doubt many persons [have] seen your collection [of photographs] that I made while with you and will know how they are estimated. To make it a profitable matter, I will want one hundred subscribers but I will commence the work with fifty.

Would it be best to write to Gen. Sherman [?] A few such men endorsing it would have influence with many that otherwise would not notice it.

Should I meet with any success after I get the specimen book ready I shall visit Washington before I go south.

I had a polite note from the French minister Drouyn De Lhuys for the photographs I sent him.

I will be happy to hear from you at your convenience.[10]

Poe responded immediately to Barnard's letter.

March 10, 1866
Dear Barnard — I have your letter of the 7th inst. and will send you some maps as soon as I can get them.

Of course, such a book as that you propose would have very great interest for many persons, but whether you could sell a sufficient number to pay you for the trouble and expenses of getting them up, I do not know. You could judge that better than I can.

It would be of the very greatest use to have a letter from Gen'l. Sherman on the subject, and I am *certain* that he would give you a suitable one, with a great deal of pleasure. You might copy it by *Photography* and bind it with the pictures, and if so advised the General could write it in suitable *form* for copying. I would advise you by all means to write to him.

Those [photographs] you made for me receive, as they deserve, the admiration of all who see them, and I consider it a very great loss to the world that the negatives were accidentally destroyed.

But a book in *popular* sale should have more views of general interest, and fewer that are purely of a military or Engineering character. General views should be given of Chattanooga, Resaca, Buzzard Roost, Dalton, Kenesaw, Big Shanty, Marietta, Milledgeville, about King's Bridge and Fort McAllister on the Ogeechee, Cheeres Rice Mill, the Savannah River, Savannah, Columbia, &c.

Keep me posted by frequent writing concerning the progress of your project, as well as all other matters in which you are concerned.[11]

With this encouragement Barnard wrote General Sherman on March 17 for his endorsement. Sherman had received earlier from Poe a number of Barnard's prints and was well acquainted with the photographer's work. The general replied favorably to Barnard's request on March 24.

Dear Sir — I have your letter of March 17, and approve highly your proposal to publish a series of Photographic views illustration [sic] of our army operations about Chattanooga, Atlanta and generally of what is known as the campaigns against Savannah, and through the Carolinas. I now have a great part of the series and believe that in connection

New York, April 3d, 1866.

DEAR SIR:

During the great campaign of General Sherman from Chattanooga to the sea, I held the position of Government Photographer. The photographs made by me at that time have been so much sought after, and so completely satisfactory to persons familiar with the scenes, that the idea has suggested itself to complete the series.

With this end in view, I shall visit the battle-fields of the Atlanta Campaign—commencing with Lookout Mountain and Missionary Ridge—and secure the best views possible: the size of the views to be 11 x 14 inches. Thence proceeding to Savannah, Charleston, and Columbia, I shall obtain views of the many scenes of interest on the line marched by our troops during the campaign.

These Photographs, to the number of sixty, will be mounted on engraving paper, with a tint plate, on which the name of the subject will be engraved. Letter-press descriptive of the pictures will be prepared; and the whole, handsomely bound in Turkey morocco, will form a book of the greatest value to persons interested in the great campaign to the sea.

As an artistic collection of pictures, those already made are pronounced by artists and connoisseurs to be the most admirable works of the kind ever seen in this country. The number of these books will be limited to one hundred, and the price per copy one hundred dollars.

Officers of the army and others, who are desirous of securing the work, will oblige by sending their names to

GEO. N. BARNARD,
CARE OF E. A. & H. T. ANTHONY,
501 Broadway, N. Y.

Payment of subscriptions upon the delivery of the book.

107. Prospectus, April 1866; Sherman Collection, Manuscript Division, Library of Congress

with the maps, they will be very interesting and instructive to the general reader.

I am truly your friend.[12]

Convinced of the viability of his plan, Barnard printed a prospectus to mail to potential subscribers (figure 107).[13]

It is significant that Barnard carried out this ostensibly personal project under the auspices of the Anthony firm. In addition to receiving his mail at the Anthony office, Barnard probably used their facilities for printing and mounting the (at least) 6100 photographs needed for this project. It must be assumed that Barnard paid the firm a fee, or royalty, for the use of their space and equipment.

On April 10, just before leaving for the South, Barnard again wrote Poe.

Dear General — I shall expect to start for Chattanooga on Sat. of this week. I shall want some maps of the campaign from Chattanooga. I have not a single copy. It will be impossible for me to obtain the views without them.

Will you be kind enough to get me some. I am more particular about the Atlanta campaign map. Direct them to Nashville, Tn. Should it be some days before you can send them then direct them to Chattanooga.[14]

Barnard's interest in these maps reflected his unfamiliarity with the landscape between Chattanooga and Atlanta. He had not accompanied Sherman's troops during this stage of the campaign, and knew that the full significance of the terrain could only be recognized with the aid of Poe's maps.

Barnard left on his photographic trip with James W. Campbell, an experienced photographer who had probably been employed by the Anthonys. Campbell had worked in Chattanooga in late 1863 making portraits for the 20th Army Corps of the Army of the Cumberland.[15] He assisted Barnard in late 1864 in Savannah, and perhaps also in Charleston in early 1865. Campbell subsequently photographed in Charleston independently of Barnard in mid-April 1865.[16] The two may have then worked together in New York following Barnard's departure from Washington in the summer of that year.

After their arrival in Nashville, Barnard and Campbell probably spent a few days gathering maps and supplies. Barnard may have visited relatives or friends but he made few photographs in the Tennessee capital at this time. Both Nashville scenes included in his album (plates 2, 3) were made in 1864. Similarly, the album's views of the Whiteside bridge and valley, located on the railroad line near Chattanooga, also date from 1864 (plates 4-7).

After traveling by train to Chattanooga, Barnard and Campbell acquired a wagon and set to work. Given the lack of Union troops in these images, it is likely that some or all of the album's views of Missionary Ridge (plates 9-12) and Lookout Mountain (plates 13-15) were taken in 1866. One of these views (plate 12) precisely duplicated the camera position of a photograph Barnard had made with his unwieldy 18x22-inch camera two years earlier. Barnard also may have returned to the top of Lookout Mountain at this time to record the majestic vista of the

Chattanooga valley from a different vantage point than those used in 1864. Barnard's deliberate balancing of visual forms resulted in a beautifully successful photograph (plate 14). Barnard worked on this particular view at some length, making at least two variant negatives in his search for the most satisfying composition.

Just south of Chattanooga, on the road to Ringgold, Barnard photographed the John Ross house (plate 16), located near the western entrance of the Rossville Gap. This house, the former property of a "chief of the Cherokee nation", had been used as a hospital several times during the battles of 1863-64. The photographer also made views of Ringgold, Georgia (plate 17), where Federal troops had camped until the beginning of the Atlanta campaign.

Barnard then moved a few miles further south to Rocky Face Ridge, where the first real engagement of the Atlanta Campaign had occurred. This ridge rose nearly 800 feet above the surrounding valleys, presenting a formidable obstacle to Sherman's progress. Mill Creek Gap, known to the locals as "Buzzard's Roost," was the major pass over the ridge and the route of the Western and Atlantic Railway. Johnston's men, entrenched along the crest of Rocky Face Ridge, clashed with Union forces on May 6-10, 1864. Barnard stopped his wagon on the rough dirt road over the pass to record the dramatic view of the valley below. His traveling companions added a picturesque note to the scene by posing in contemplative positions on the opposite edge of the roadway (plate 18).

In a pattern that would be repeated many times in the Atlanta Campaign, Johnston's forces held their positions atop Rocky Face Ridge until forced to withdraw along the rail line to another fortified position further south. The small settlement of Resaca, located on the Oostanaula River, was the site of the next battle in the campaign for Atlanta. Here Confederate forces entrenched themselves along a three-mile line of ridges overlooking the village and rail line. The battle of May 14-15, 1864, contested over broken, difficult terrain, was ferocious and bloody. By the time Johnston's men pulled back across the river and burned the railroad bridge, the battlefields were thickly strewn with the dead.

After exploring the ground at Resaca, Barnard photographed the weathered remnants of Confederate defensive works in a thickly wooded area (plate 21). He also climbed a steep ridge to record a snaking line of trenches overlooking the village and all-important railroad between Chattanooga and Atlanta (plate 22). Most significantly, however, Barnard symbolized the ferocity of battle in repeated views of shattered, blasted trees (plates 19-21). These images suggest the deadly hail of shot and shell that filled the air two years earlier, while providing metaphoric "equivalents" for the broken bodies of those who died there. These photographs present the evidence of this earlier violence within a curiously peaceful landscape. Picturesque elements such as a quaint cabin and well-tended fences suggest a productive, rather than destructive, human presence, and the slow healing of the wounds of war.

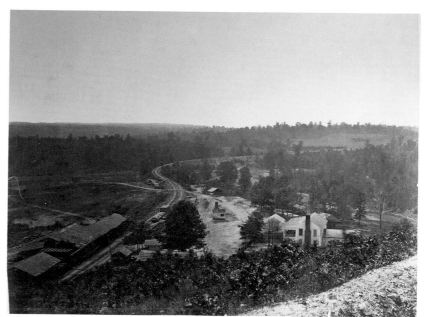

108. *View from crest of Allatoona Pass*, 1866; U.S. Army Military History Institute

Barnard and Campbell continued south along the route of Sherman's forces. Below Resaca the landscape temporarily became flatter and more open, allowing easier travel and broader vistas. At the Etowah River, located between the village of Cartersville and the strategic Allatoona Pass, Barnard stopped to photograph the sturdy defensive works guarding the railroad bridge (plates 23-24). Johnston's forces had withdrawn over the Etowah on May 20, 1864, for stronger defensive positions at Allatoona.

Hoping to avoid the strong enemy fortifications at the Allatoona Pass, Sherman tried a flanking move away from the railroad line. The Confederates had anticipated this action, however, and entrenched themselves along a line from the town of Dallas to a country crossroad known (for its Methodist meeting house) as New Hope Church. The broken and densely forested landscape below the Etowah slowed the Union advance. The Confederates' impenetrable defensive works — constructed by piling dirt on a framework of heavy timbers — stopped it entirely. On May 25, 1864, a fierce battle was waged in the dense woods around New Hope Church. Savage losses and a torrential downpour led exhausted Union troops to dub the area the "Hell Hole."

Barnard and Campbell stopped to record the decayed defensive works at the now-silent battlefield (plates 25-26). In the first of these views Barnard's wagon, dark-tent and assistant are all visible in the midground. A third photograph, also including Barnard's wagon, suggests the chaotic and claustrophobic conditions

109. *[Bonaventure Cemetery, Savannah]*, 1866; private collection

under which the battle of May 25 had been fought (plate 27). The heavy casualties at New Hope Church were symbolized graphically in Barnard's depiction of trees blasted and severed by a torrent of lead.

When Federal cavalry captured the Allatoona Pass on June 1, 1864, Sherman pulled his troops back to their original line of advance along the railroad. Under Orlando Poe's direction earthen fortifications were constructed at that time on the twin crests of the pass. These forts played a decisive role on October 5, 1864, when outnumbered Union defenders turned back a Confederate attack.[17] Barnard recorded Allatoona Pass from track level (plate 28) before climbing the steep embankment to make two photographs from the outer wall of Poe's fort. The first of these recorded the view east across the pass itself (plate 29). Barnard then turned his camera to the south to document the small settlement below and the rail line receding toward Atlanta (figure 108).

Barnard and Campbell then moved a short distance east to Pine Mountain, where Confederate General Leonidas Polk had been killed on June 14, 1864. On that day Sherman had observed Confederate officers on the summit of this hill studying the movements of his forces through field glasses. Sherman ordered the discharge of several volleys of cannon fire at the group, about 800 yards away, expecting only that it would force them to scatter temporarily. The Confederates observed the preparations to fire and promptly sought cover. However, General Polk, "who was dignified and corpulent, walked back slowly, not wishing to appear too hurried or cautious in the presence of [his] men, and was struck across the breast by an unexploded shell, which killed him instantly."[18] Barnard used a single, lifeless tree on the mountain's summit to suggest the freakish and solitary nature of Polk's death (plate 30).

At nearby Kennesaw Mountain, Barnard recorded former Union and Confederate fortifications in the process of slow decay. When Federal forces first entered this region in June 1864, Sherman noted with some amazement that "the whole country is one vast fort and [General Joseph E.] Johnston must have at least fifty miles of connected trenches..."[19] Barnard and Campbell documented the Union entrenchments in front of Little Kennesaw Mountain (plate 31) and the view from behind the heavy Confederate barricades near the top of Kennesaw (plate 32). Barnard then photographed the Confederate defensive works guarding the Chattahoochee River bridge (plate 33).

After his work at the Chattahoochee River, Barnard rode into Atlanta. He had not seen the city in eighteen months, and his most lasting memories of the place probably centered on the frenzied destruction of the final days of occupation in November 1864. While Barnard found the city much quieter in May 1866, the evidence of war was everywhere. His activities in Atlanta can only be surmised, but it is likely that at least six of the album's views (plates 34-37, 45-46) were taken at this time. The remaining seven Atlanta images in Barnard's album (plates 38-44) were from negatives taken in 1864.

During his 1866 visit Barnard probably focused on those areas on the outskirts of the city in which the Battle of Atlanta had been fought on July 22, 1864. He may have revisited the scene of General McPherson's death at this time to make his larger and more carefully considered view (plate 35). Barnard also made at least two photographs in the heart of the city (plates 45, 46). The first of these documents the ruins of the Georgia Railroad roundhouse. The second presents the view north up Peachtree Street from the railroad crossing. The ruined classical structure in the center of the image, the Georgia Railroad Bank, had been intact until the final days of Union occupation in 1864 (see figure 86).

Barnard and Campbell subsequently traveled to Charleston, where they returned to photograph Fort Sumter. Fourteen months after his initial visit, Barnard found the fort's parapet decorated with the tents of resident Federal troops (plate 57). The relatively fragile *gabions* that had been installed in the early months of 1865 had deteriorated noticeably through the effects of weather and neglect.[20] The resulting disorder superficially resembled the destruction caused by shelling during the war. Barnard probably felt that the familiarity of his 1865 views of the fort's interior — which had been printed in considerable quantity for General Delafield's distribution — necessitated a fresh image of this important subject. He probably also photographed the fort's exterior at this time (plate 58). Most or all of the album's remaining Charleston photographs (plates 56, 59-61) may have been from negatives made in March 1865.

On June 12, 1866, Barnard and Campbell took a steamer from Charleston to

Savannah.[22] From the cupola of the city's custom-house, the vantage point used by Sherman eighteen months earlier, Barnard made a dramatic two-plate panorama of Savannah and surrounding landscape (plates 49, 50). He also photographed the elaborate cast-iron fountain in nearby Forsyth Park (plate 51). This city landmark, patterned after a fountain exhibited at the 1851 Crystal Palace Exhibition in London, had been installed in 1858.

Barnard then traveled a few miles from Savannah to visit the famous Bonaventure cemetery. First opened as a burial ground in 1850, Bonaventure's unique ambiance stimulated thoughts of "romance, adventure, suffering [and] sorrow" in all who visited. Towering oaks formed "cloistered aisles resembling a great outdoor Cathedral" while curtains of Spanish moss contributed to the atmosphere of "natural mourning," peace, and repose.[22] Barnard set up his dark-tent amongst these moss-draped trees and made at least two exposures evoking the cemetery's melancholy grandeur (figure 109; plate 48). He then photographed the Savannah River, framed by a network of trees and vines, from the edge of the cemetery (plate 47). On June 16, 1866, their photography completed, Barnard and Campbell departed for New York at 9:30 a.m. on the steamer *Missouri*.[23]

Soon after returning to New York Barnard wrote Poe to report on his trip and to request maps for his album.

> June 22, 1866
>
> Dear General — I arrived in N[ew] York last Tuesday with my negatives safe and sound. I have a fine lot of views. Am quite well satisfied with my trip. I shall be in your city [Washington, D.C.] before many days. In what way can I duplicate the campaign map from Chattanooga to Atlanta [?].
>
> Do you think I could obtain some maps from the Dept. at Washington[?]. Say 150 copies. There [are] two or three that I would like to obtain. I would give them my Book when completed or pay for them. Either way I wish to avoid copying them if possible.
>
> Campbell went with me and is now helping me do the printing. I may want your judgment in selecting from the lot which ones to bind and what to reject. I see Gen. [Henry W.] Slocum today. He told me he wanted a copy. I don't think I will have any trouble in disposing of them. Should you come to N.Y. call and see me at 589 Broadway.[24]

During the first week of July, Barnard visited Washington to show Poe some of the recent photographs, and to pursue the matter of the maps. Poe was unstinting in his efforts to assist Barnard's work. On July 9 Poe wrote J.E. Hilgard, in charge of the Coast Survey Office:

> Dear Sir — Mr. George N. Barnard, of whom you have heard, as the Photographer who accompanied me in the operations of the Army under command of Genl. Sherman, during its operations in the South & West, and just returned from a tour along our whole line of march, and has brought back with him a series of most beautiful photographs illustrating objects of interest. He proposes to bind them in book form, and to sell each volume at $100, for which he has already

received a sufficient number of subscribers to insure its complete success.

> In order to make the volume complete he desires to add copies of such maps as he can get, and amongst them, those published by the Coast Survey illustrating the battle of Chattanooga, and the Atlanta Campaign.
>
> He will want about 200 copies of each — and he wishes me to say that if the Coast Survey office will furnish them, say within the next four weeks, that he will pay for them, such price as may be fixed by yourself.
>
> If you have not the time to do the work, then he desires to procure a transfer copy of each of the two maps referred to, for which he is also willing to pay such price as you may fix — though he would prefer, if it can be done, to have you do the printing, and pay you your price.
>
> I will add on my own account that from what I have seen of it, the work will be a creditable one. It has been extensively subscribed for in Europe, and the matter of the maps is a suggestion of Sir Frederick Bruce's, who is one of the subscribers.
>
> Please let me know whether you can accommodate Mr. Barnard in this matter.[25]

Sir Frederick Bruce (1814-1867), a noted career diplomat, was the British representative in Washington. It is uncertain whether Bruce purchased a copy of Barnard's album for himself or for his government.[26]

During his visit to Washington, Barnard wrote General Sherman to let him know of his progress on the book.

> July 7, 1866
>
> General — I notice in the paper that you are to be in Philadelphia on Monday next and presume you will visit N[ew] York city on your route East. Should you have time to look over my collection of photographs which I am now preparing for publication I should be happy to show them to you and think you would be pleased with them. I have recently returned from Ga. having gone over all the campaign ground from Chattanooga to Atlanta in a private conveyance and obtained views from most of the battlefields. The French and British Ministers called to see me today to look at the photographs. They both requested copies and the prospects are [that] nearly all of the foreign legations in Washington will take copies. I think one half of the one hundred will go to Europe. I am here for the purpose of obtaining maps from the Eng. Dept. The work will be ready by the 1st Sept. for deliv[ery] if I can find a person competent to write the letter press for me. Should you know of such a person will you be kind enough to let me know. I have obtained permission from Brady to use the group of yourself and Gen[erals] taken by him in Washington. I leave for N.Y. tomorrow night.[27]

The group portrait of Sherman and his generals (plate 1) had been made in Brady's Washington studio in May 1865. Brady later recalled the circumstances surrounding this sitting:

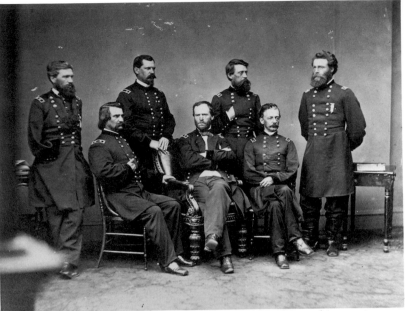

110. **Mathew Brady:** *Sherman and his Generals*, May 1865; U.S. Army Military History Institute

...It was taken during the grand review in Washington in 1865, when I was spending all my efforts in getting the various commanders and their staffs together. I called on Sherman, with whom I had been intimate for years, and told him of my desire. He smiled pleasantly at the idea, but said that all of the officers had been in the field for four years, and now that they were relieved they were away with their wives, children or sweethearts and that to get them together was next to an impossibility. But I persisted and said that I would get them together if he would keep an appointment with me. He agreed to be at the studio at 2 o'clock the next afternoon. In the meantime I hurried around in a hack to the various outskirts of Washington and found every member of the staff and they all promised to be on hand at the appointed time. At 12 o'clock the next day we quit our regular business and got our cameras in readiness.

Among those waiting for sittings was a mother and her three-year-old babe. Sherman and his staff, all but one, were on time. While we were waiting for him Sherman began to play with the baby and before long he was rolling on the floor with the little one to the great amusement of the impatient waiters. We were awaiting...the arrival of General Blair. At 3 o'clock he had not put in an appearance, so we made a negative without him. Later in the day, however, he came in, was photographed and I set his portrait in on the group negative. But I never saw a man enjoy himself so much with a little one as Sherman did that day, and he kept his generals in roars of laughter.[28]

The original negative of this image was marred by a protruding, out-of-focus element on the left side of the frame (figure 110). A wood-engraving of this print, altered to include the standing figures of Generals Kilpatrick and Blair, was published in *Harper's Weekly* on July 1, 1865. A final, retouched version of the photograph was subsequently produced by eliminating the blurred form on the left and inserting a seated figure of General Blair (plate 1).

Barnard and Poe were in regular communication during the summer of 1866 on the details of the volume's production. Poe continued his negotiations with the Coast Survey Office and Engineers Department on the production of maps, and by the end of August, 225 copies each of four maps were completed and delivered.[29]

Barnard was extremely busy in these months with innumerable details related to the production and promotion of his album, and other business ventures.[30] The progress of his volume is revealed in the photographer's surviving letters to Poe. On July 20, 1866, Barnard reported, "I have been Rushed ever since I left Washington [on July 8], and am now very busy in printing." Nine days later he wrote again.

> I have got nearly half done printing the one hundred copies and will continue to print until I get another hundred off. The first lot is nearly all spoken for and there [are] many that do not know that I am getting it up [that] I know will want copies....I presume it will be near the first of Oct. before the Book is ready for delivery. It is quite a job but it is progressing favorably.

On August 14 he reported, "I am still at work printing and I find it more of a task than I anticipated to get ready for binding. I have had trouble in getting plate paper and have obliged to order it made which may delay matters a few weeks."[31]

At this time Barnard was attempting to locate Theo R. Davis, the noted correspondent and sketch artist for *Harper's Weekly*. To enhance the historical and educational value of his album, the photographer wanted to supplement his photographs and the official campaign maps with a written text. Barnard discussed this task with several people and Davis was strongly recommended. Barnard had known the young correspondent for several years and was aware of his skills. For most of the summer of 1866, however, Davis was traveling in the South and could not be reached. But he finally returned to New York City around September 1 and agreed to write Barnard's copy.[32]

Setting to work immediately, Davis wrote Poe on September 9 for information.

> Dear Poe —
> I am just starting the Letter Press for Barnard's Book, and need some help in the way of *Data*. Spend a little time for the benefit of your friends, and answer these queries.
> When was the Capitol, Nashville built — when fortified [?]
> Who built Whiteside Bridge — dimensions — How long did it take [?] — same of the Etowah, Chattahoochee. Length of exterior line of fortifications [at] Chattanooga [and] Rebel line at Atlanta [?] – How far

did Sherman's Hd. Qrs. travel before we got Atlanta [?] – will take that as an average for the army.

I think that this is all though it may not be — Been sick ever since I came home from N[ew] O[rleans].

Barnard has by a new process (double printing) got the most beautiful clouds in his prints, which excel any thing that I have ever seen in the way of photograph[y].

Walker is painting Gettysburg 20 ft x 7½ —

Have seen a number of old friends on this last trip.[33]

The painter mentioned by Davis was his friend James Walker, a New York artist renowned for his large renderings of battles.

As noted by Davis, Barnard made careful use of double-printed clouds in the production of his album. Such effort was justified by Barnard's desire to make his photographs works of both aesthetic and historical merit. The techniques of double-printing had been used selectively by art photographers such as Gustave LeGray for about a decade, but were still relatively unusual in 1866.[34]

An 1863 article in *The Photographic News* had outlined the need for such measures. The author, V. Blanchard, stated that with the "great stride made by landscape photography during the past few years," the "standard of criticism" had risen accordingly. Thus, for work that aspired to artistic distinction, it would not do to have unnaturally blank skies. "As white paper, in place of atmosphere, is now an abomination, the only plan left is to print the blank surface with something that shall bear resemblance to nature." To this end Blanchard recommended that cloud negatives be made at the same time of day, and under the same lighting conditions, as the landscape to which they would be added. However, despite the best precautions, he warned that

> whilst the result so obtained will be pleasing to many it will never quite satisfy the eye of the close observer of nature. [But] it can easily be said that the picture will be quite as true as the great mass of landscape paintings, which are invariably the results of a number of separate studies.[35]

Combination printing required careful preparation and registration of the individual negatives. The sky area of each landscape negative had to be opaqued to provide an unblemished space for the subsequent cloud imagery. Cloud negatives, in turn, were masked in those areas that would overlap ground detail. This process of complementary masking was complicated by any form — such as a tall tree — that disrupted the relatively simple bifurcation of land and sky at the horizon. When it came time to print plate 39, for example, Barnard chose to simplify his sky mask by eliminating the upper portion of the tree in the right midground (figure 111; plate 39). Barnard's finished prints were produced by sunprinting each sheet of albumen paper twice, in separate contact with the landscape and cloud negatives. This required careful monitoring of printing times to achieve tonal consistency in both portions of the final print.

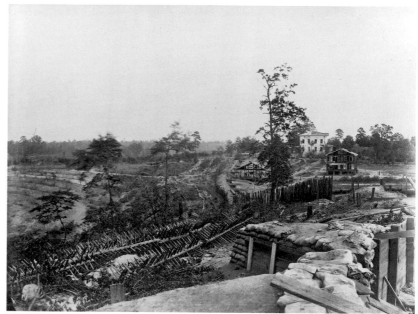

111. *View of first rebel Fort east of the Western & Atlantic Railroad, looking eastward along the rebel lines, Atlanta*, October 1864; West Point

There was considerable variability in this process. Existing copies of the album reveal that the same landscape views were frequently matched with different skies. In other cases the same landscape and cloud negatives were used in different registrations, revealing more or less of the original "cloudscape" from top to bottom or side to side. And, since Barnard reused his favorite cloud negatives repeatedly, in several obvious instances the same clouds are seen to float majestically over landscapes separated, in geographical fact, by hundreds of miles.

The fragility of Barnard's large glass negatives added to the difficulty of this process. In the course of printing between 100 and 150 copies of each of the album's sixty-one photographs, it is likely that several negatives were accidentally broken. It is probably for this reason that two slightly variant negatives were used for several plates in the final album. Ever the professional, Barnard had been careful on his 1866 trip to make back-up negatives for many of his views.

In the finished copies of the album, these changes are apparent in at least four scenes. The two negatives used for plate 18, for example, differ only in the slight change in position of the seated figures in the central mid-ground. Negatives made from marginally different points of view were utilized for plates 34 and 47. Two very different scenes in Bonaventure cemetery were included in various copies of the album as plate 48 (figure 109; plate 48). In fact, these two views were made from the same location, with a 90-degree shift in camera orientation. The better-known of these scenes records the photographer's dark-tent located prominently

in the right background. In addition, it appears that the negative for plate 49 cracked early in the printing process, since relatively few "uncracked" prints exist. Barnard was compelled to finish the edition with the damaged plate due to the importance of the image and his lack of a suitable duplicate.

Many other details were involved in the production of the album. Davis's written copy was completed, proofed, and printed by letterpress in the form of a small pamphlet. This text, with the maps received from Poe, was inserted into each copy of the album. The albums themselves were laboriously assembled by hand. Surviving copies of the volume reveal a considerable diversity of endsheet paper, cover stock, and binding technique. These variations suggest that the selection of materials and actual production were carried out in a relatively rapid and decentralized manner. The assembly of 100 to 150 copies was indeed a monumental and exhausting task, and it is likely that Barnard contracted the work to several individuals or firms.

Finally, in early November, the first completed copies were ready. On November 4 Barnard conveyed his relief to Poe:

> Dear General —
> I have at last finished my Book and will have a few copies ready to deliver by the last of this week. I have two now completed [and] they look well. So everybody says but I have seen them so much I am perfectly sick of them.
> I want Gen. Sherman to see it before he leaves for Mexico. Can you ascertain at what time he will be in Washington[. I]f he does not come to N.Y. ...I can see him [in] Washington. I will meet him there or I will send you a copy of the Book and you can show it to him. I want a letter from him. Gen. W[illiam] F[rench] Smith has seen it and is very much pleased with it and takes a copy and will give me just as strong a letter as he can write.[36]

Barnard showed copies of the album to the leading publishers in New York and was rewarded with at least three excellent reviews. On November 30 the *New York Times* reviewed the volume in its "New Publications" column:

> *Photographic Views of the Sherman Campaign.* From Negatives taken in the field by GEO. N. BARNARD, Official Photographer of the Military Division of the Mississippi. Published by GEO. N. BARNARD, No. 589 Broadway, N.Y.
> Mr. BARNARD'S connection with the Engineer Department of Gen. SHERMAN'S army afforded him facilities and opportunities that he did not fail to turn to best advantage. Supplied with the best of instruments and photographic material for the execution of the work of his department, he was enabled to secure at the same time a series of negatives from which he has lately published a superbly bound volume comprising sixty-one imperial photographs, illustrating the principal historical scenes of the "great campaign." The localities depicted have evidently been photographed after careful artistic con-

sideration. The views thus obtained are among the most successful specimens of the photographic art that have yet been produced in the country. The cloud and atmospheric effect in a number of the views is very beautiful, conveying as it does a fine idea of the effects of light and shade in the sunny clime in which the scenes are laid. The characteristic topographical features of the country are presented with a perfection that causes the beholder to wonder that heavy masses of troops could have been moved successfully against a well commanded army of brave men, protected by natural obstacles of so much strength. From the picturesque views of the great bridges, built in as many hours as it would have taken days under ordinary circumstances, one discovers a part of the secret of Gen. SHERMAN'S ability to execute rapid movements in the face of so many and great difficulties. The views embrace scenes at Nashville, Chattanooga, Atlanta, Savannah, Columbia and Charleston, as well as views of the campaign, maps furnished by the Engineer Department, and a neatly printed pamphlet containing a sketch of the principal events during the march. The price of this volume, of which there will be one hundred copies, is $100, not by any means a great demand for so valuable a collection.[37]

The December 8, 1866, issue of *Harper's Weekly* ran an equally complimentary notice of Barnard's album.

> "Photographic Views of SHERMAN'S Campaign," by GEORGE N. BARNARD, is a splendid volume, containing 61 imperial photographs, embracing scenes of the Occupation of Nashville, the Great Battles around Chattanooga and Lookout Mountain, the Campaign of Atlanta, March to the Sea, and the Great Raid through the Carolinas. These photographs are views of important places, of noted battlefields, of military works; and, for the care and judgment in selecting the points of view, for the delicacy of execution, for scope of treatment, and for fidelity of representation, they surpass any other photographic views which have been produced in this country — whether relating to the war or otherwise. The impressions have been taken with the greatest care — they are splendidly mounted and bound in a single volume in the most elegant style. We believe that only a very limited number of these volumes are issued; but although, from its expense, the book can not be popular, those who can afford to pay one hundred dollars for a work of fine art can not spend their money with more satisfactory results than would be realized in the possession of these views. Before seeing this collection of Mr. BARNARD we could not have believed that there were such magnificent possibilities in an art so purely mechanical as to its mode of operation. Even the tints and cloud-scenery of the sky are exquisite in their perfection. We regret that we have not the space to enter into a more detailed description of the separate views.[38]

Finally, the January 1867 issue of *Harper's New Monthly Magazine* praised Barnard's work.

Photographic Views of Sherman's Campaigns, by GEORGE N. BAR-NARD. Photography has done much to illustrate the details of our civil war. We have before had occasion to speak of Mr. Brady's immense collection of views. These relate largely, though by no means exclusively, to affairs at the East. Mr. Barnard, whose field was mainly the West, has collected into one magnificent volume some threescore imperial photographs of the most important scenes made memorable in Sherman's Campaigns. The subjects are admirably chosen, both in respect to the picturesqueness of the scenes and their historical importance, and the execution of the photographs has reached the highest capacity of the art.[39]

III:2 *Photographic Views of Sherman's Campaign*

The most important components of Barnard's album are reproduced on the following pages from a copy in the Hallmark Photographic Collection. The title and contents pages are copied directly from the original. Plate titles have been reset in modern type. The data in square brackets (plate number and date) did not appear in Barnard's original presentation. It is important to note that the 1866 album presents all sixty-one plates individually on right-hand pages only, rather than on every page as reproduced here. Barnard's photographs were printed from 12 x 15-inch negatives and were trimmed to an average format of about 11 x 14 inches. They are reproduced at about seventy percent of original size.

The eccentric spelling of Barnard's original copy has been retained in this *facsimile* presentation only, and not in other sections of this book. It should be noted that "Ringold" (Ringgold), "Resacca" (Resaca), "Etawah" (Etowah), "Kenesaw" (Kennesaw), "Savanah" (Savannah), "Buen-Ventura" (Bonaventure), and "Sumpter" (Sumter) do not conform to currently accepted form. Barnard's plate titles also substitute "Mission Ridge" for Missionary Ridge, and "Potter House" for Ponder House.

The pamphlet of text accompanying Barnard's volume has not been reprinted here due to its length, its ready availability elsewhere, and the discovery that it was written by Theodore R. Davis rather than Barnard himself. Davis's text is included in Beaumont Newhall's reprint edition of *Photographic Views of Sherman's Campaign* (Dover Publications, 1977).

Accompanying Davis's essay was the following brief introduction by Barnard.

> The rapid movement of Sherman's army during the active campaign rendered it impossible to obtain at the time a complete series of photographs which should illustrate the principal events and most interesting localities. Since the close of the war the collection has been completed. It contains scenes of historical interest in Tennessee, Georgia, and the Carolinas; photographic glimpses of important strategic positions; field-fortifications, with their rude but effective obstructions; and the great bridges, built by the army in an almost incredibly short space of time.
>
> G.N.B.

Photographic Views

OF

SHERMAN'S CAMPAIGN,

Embracing Scenes of the Occupation of Nashville, the
Great Battles around Chattanooga and Lookout
Mountain, the Campaign of Atlanta, March
to the Sea, and the Great Raid
through the Carolinas.

———◆———

From Negatives taken in the field, by

GEO. N. BARNARD,

Official Photographer of the Military Div. of the Miss.

589 Broadway, New York.

CONTENTS.

ERRATA:—Omit "Ringold," in "View of the John Ross House." For "View of Kenesaw," read "View from Kenesaw."

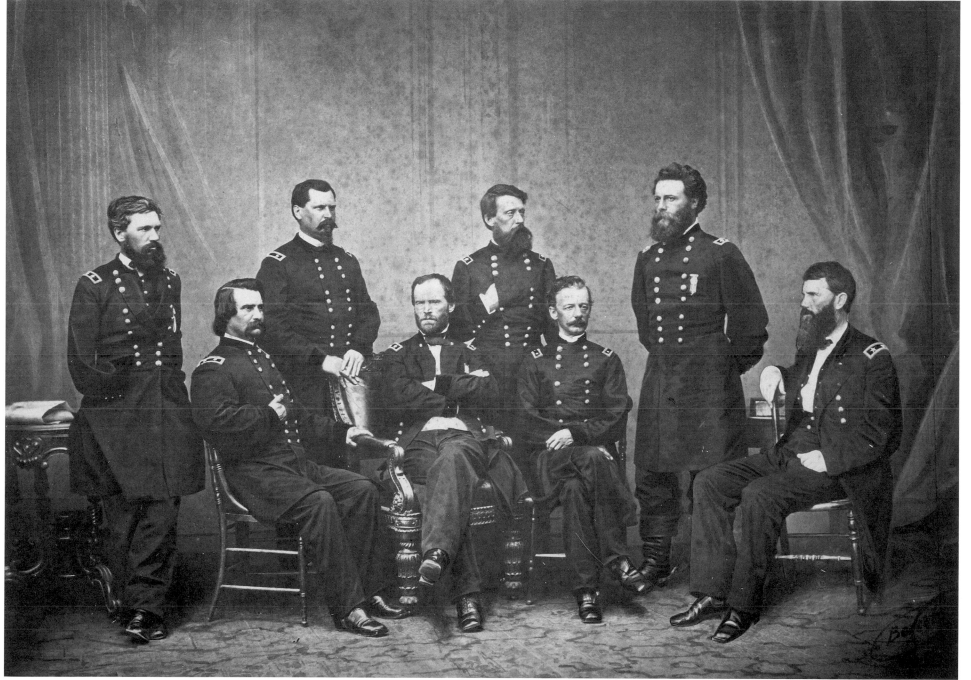

Photo from nature By G.N. Barnard

SHERMAN AND HIS GENERALS

MAJ. GEN. O. O. HOWARD MAJ. GEN. J. A. LOGAN MAJ. GEN. WM. T. SHERMAN MAJ. GEN. H. W. SLOCUM MAJ. GEN. F. P. BLAIR

MAJ. GEN. W. B. HAZEN MAJ. GEN. JEFF. C. DAVIS MAJ. GEN. J. A. MOWER

[plate 1: 1865]

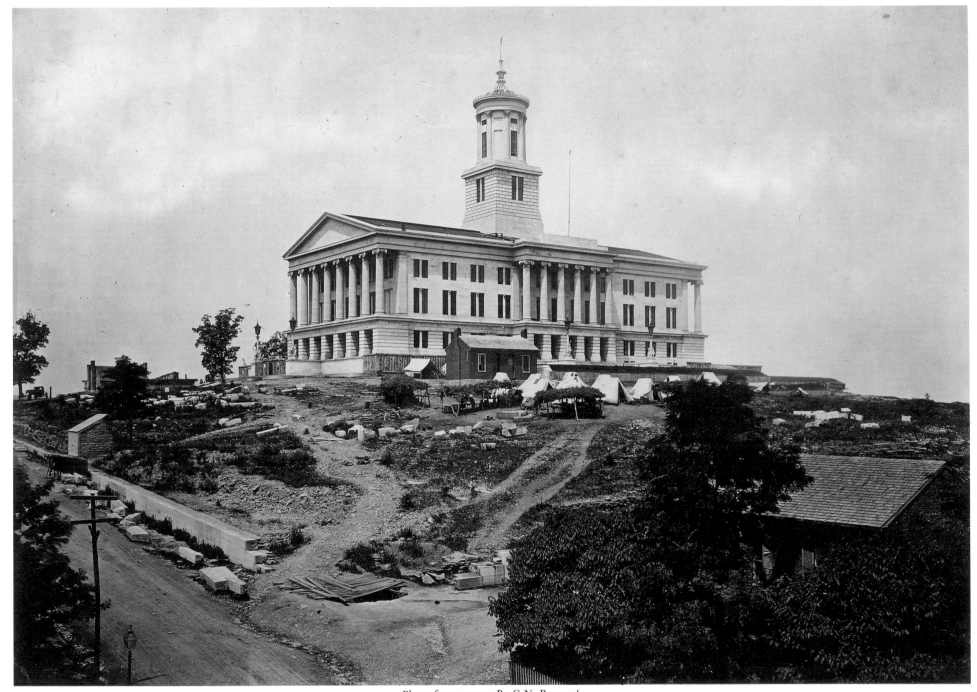

Photo from nature By G.N. Barnard

THE CAPITOL NASHVILLE (TENN.)

[plate 2: 1864]

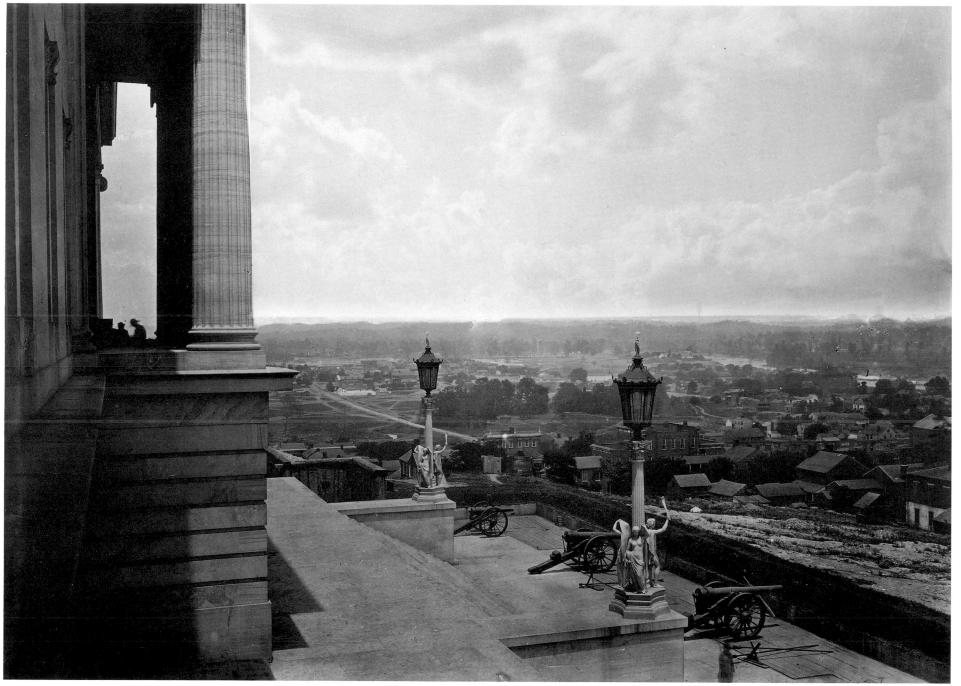

Photo from nature By G.N. Barnard

NASHVILLE FROM THE CAPITOL

[plate 3: 1864]

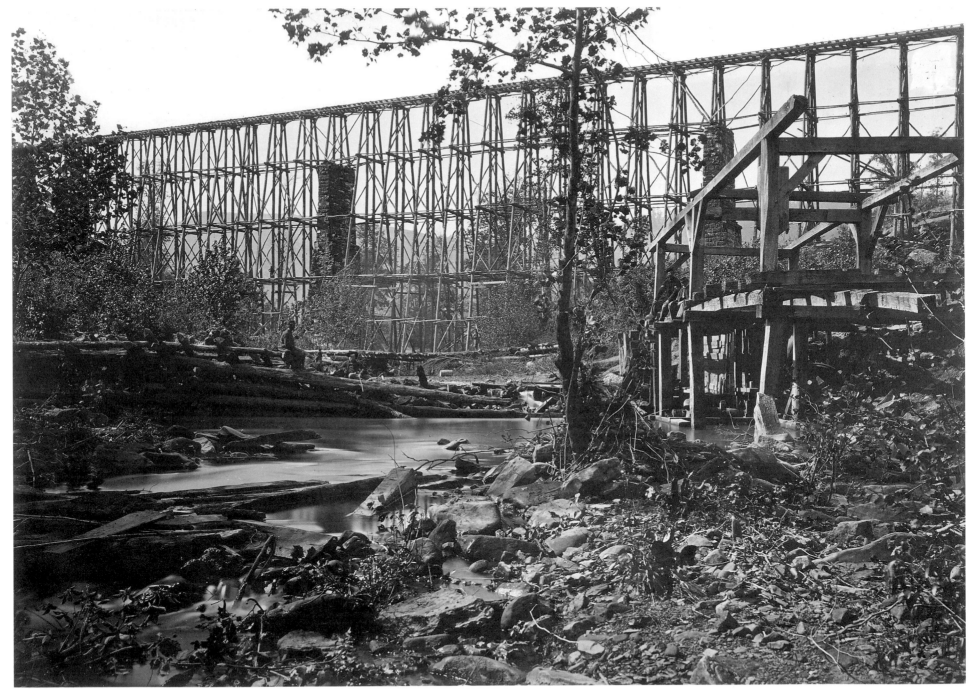

Photo from nature By G.N. Barnard

TRESTLE BRIDGE AT WHITESIDE

[plate 4: 1864]

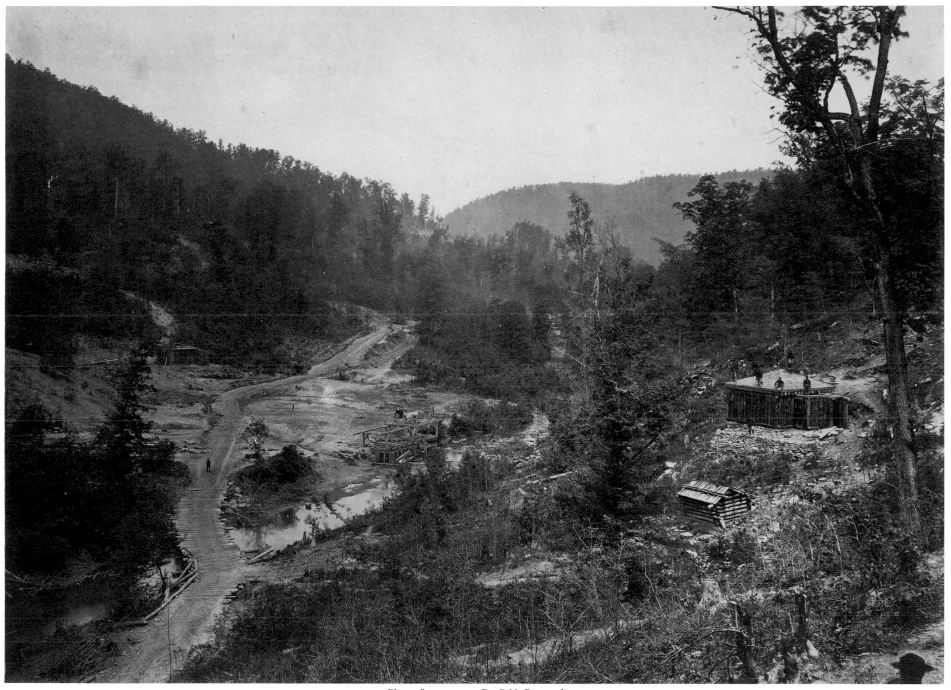

Photo from nature By G.N. Barnard

WHITESIDE VALLEY BELOW THE BRIDGE

[plate 5: 1864]

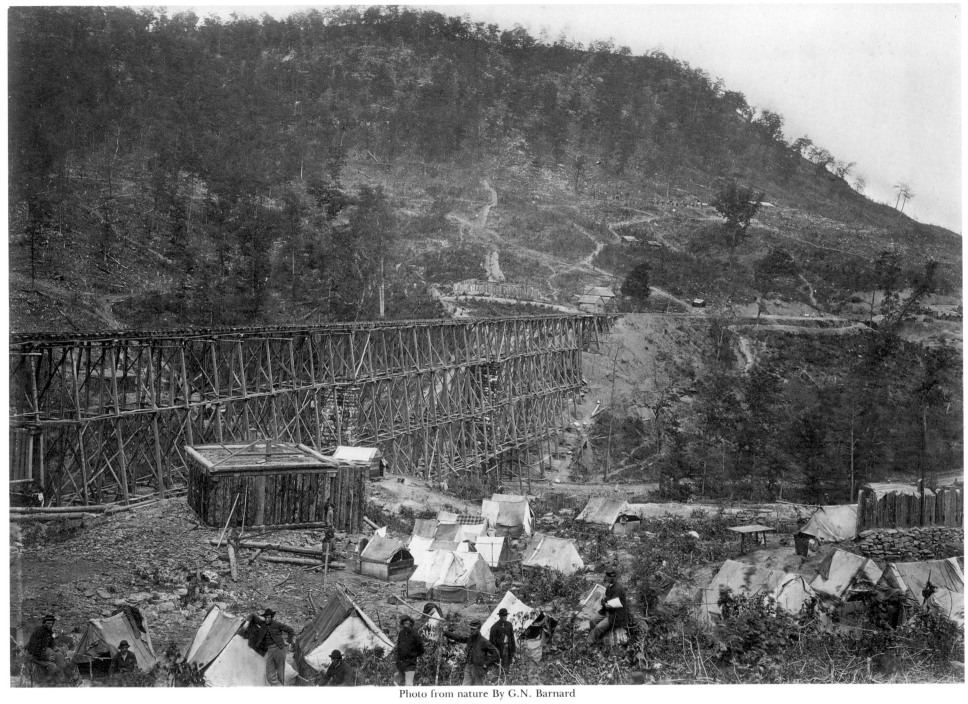

Photo from nature By G.N. Barnard

PASS IN THE RACCOON RANGE, WHITESIDE No. 1.

[plate 6: 1864]

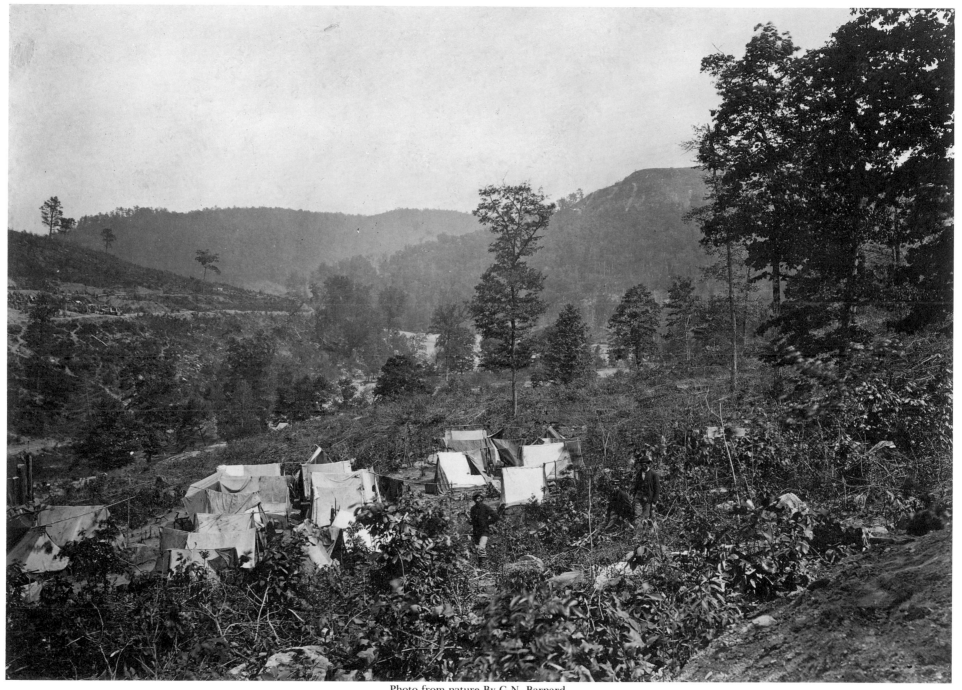

Photo from nature By G.N. Barnard

PASS IN THE RACCOON RANGE, WHITESIDE No. 2.

[plate 7: 1864]

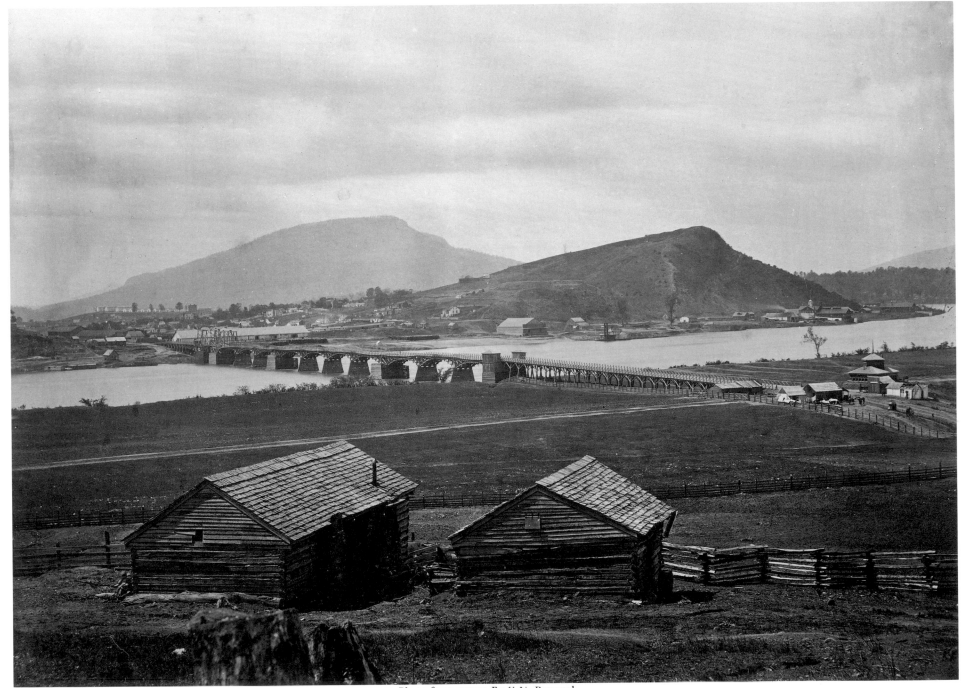

Photo from nature By G.N. Barnard

CHATTANOOGA FROM THE NORTH

[plate 8: 1864]

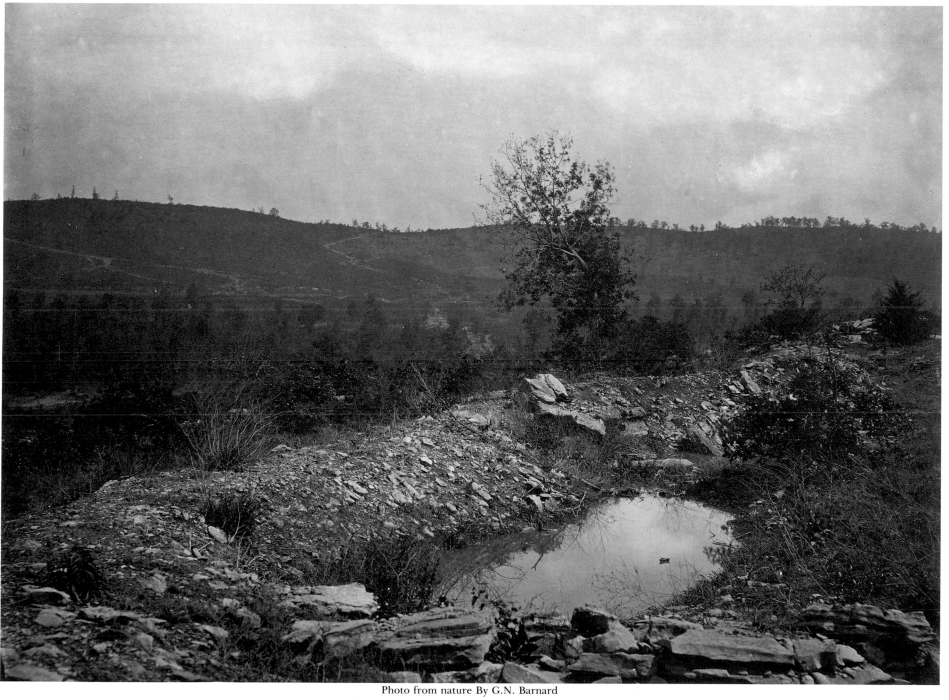

Photo from nature By G.N. Barnard

MISSION RIDGE FROM ORCHARD KNOB

[plate 9: 1864 or 1866]

Photo from nature By G.N. Barnard

ORCHARD KNOB FROM MISSION RIDGE

[plate 10: 1864 or 1866]

Photo from nature By G.N. Barnard

THE CREST OF MISSION RIDGE

[plate 11: 1864 or 1866]

Photo from nature By G.N. Barnard

MISSION RIDGE SCENE OF SHERMAN'S ATTACK

[plate 12: 1864 or 1866]

Photo from nature By G.N. Barnard

CHATTANOOGA VALLEY FROM LOOKOUT MOUNTAIN

[plate 13: 1864 or 1866]

Photo from nature By G.N. Barnard

CHATTANOOGA VALLEY FROM LOOKOUT MOUNTAIN. No. 2

[plate 14: 1864 or 1866]

Photo from nature By G.N. Barnard

LU-LA LAKE LOOKOUT MOUNTAIN

[plate 15: 1864 or 1866]

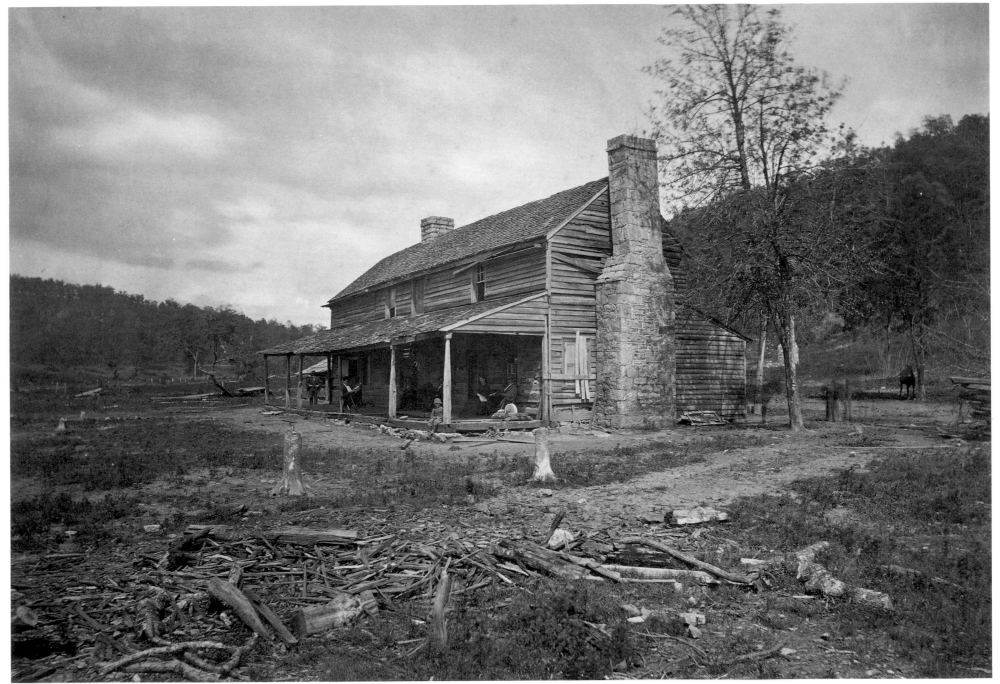

Photo from nature By G.N. Barnard

THE JOHN ROSS HOUSE, RINGOLD, GA.

[plate 16: 1866]

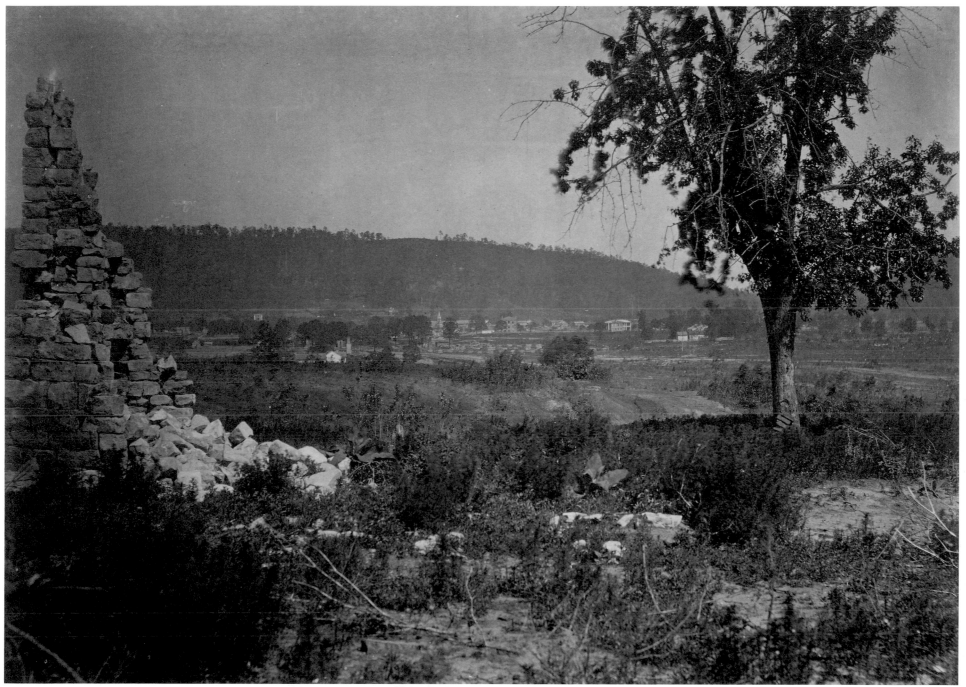

Photo from nature By G.N. Barnard

RINGOLD, GA.

[plate 17: 1866]

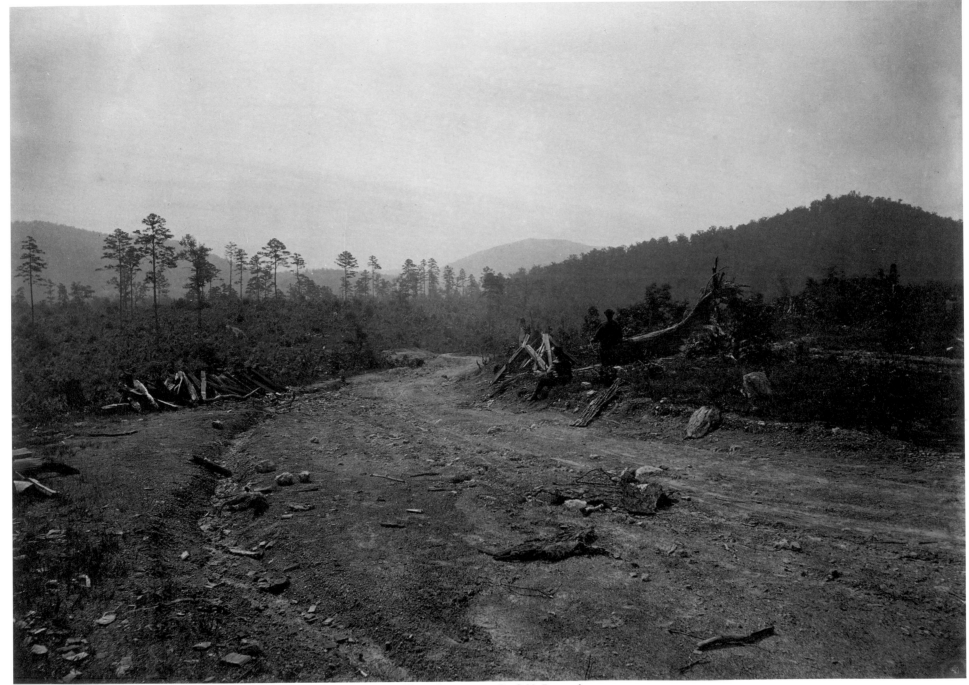

Photo from nature By G.N. Barnard

BUZZARD ROOST, GA.

[plate 18: 1866]

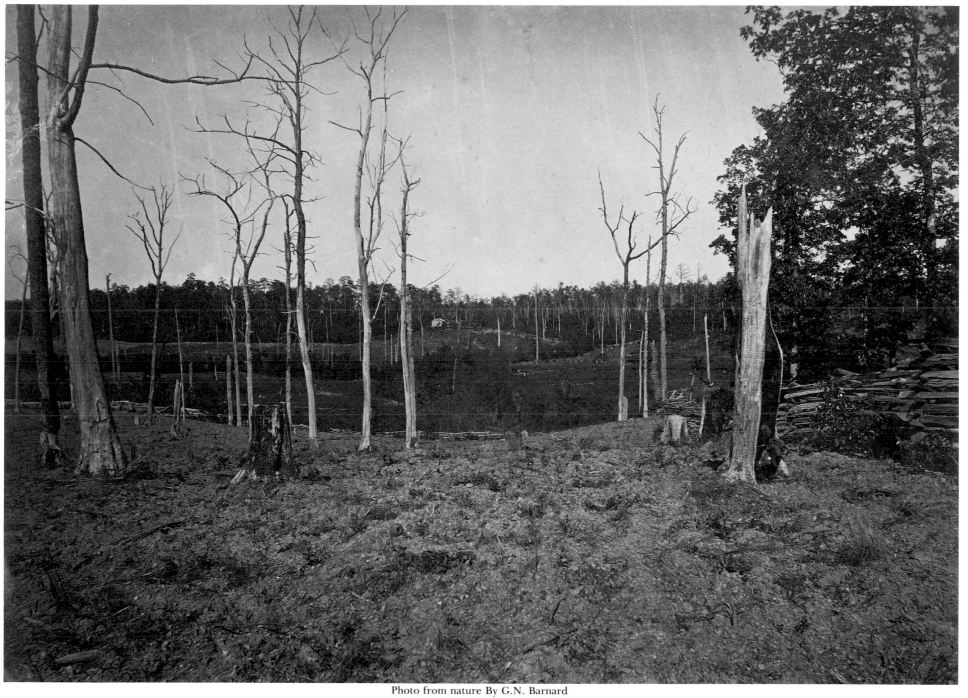

Photo from nature By G.N. Barnard

BATTLE GROUND OF RESACCA, GA., No. 1.

[plate 19: 1866]

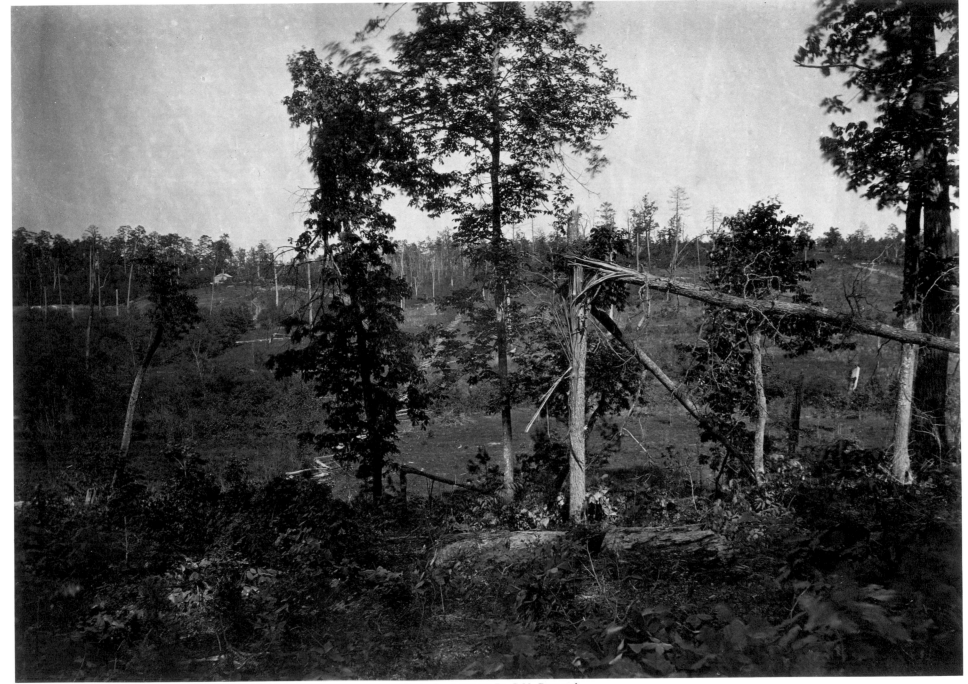

Photo from nature By G.N. Barnard

BATTLE GROUND OF RESACCA, GA., No. 2.

[plate 20: 1866]

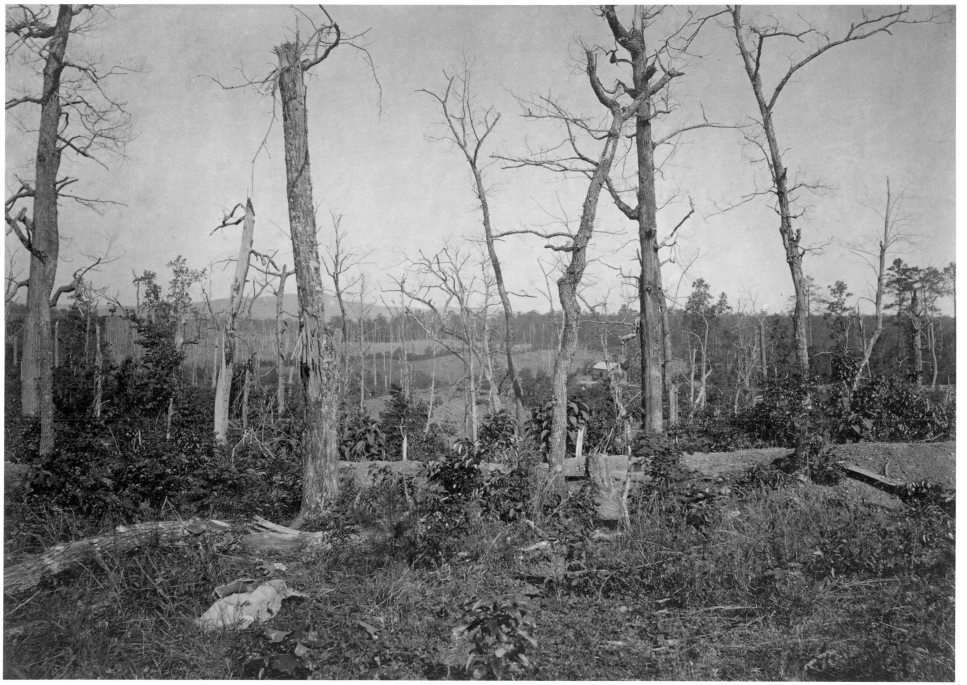

Photo from nature By G.N. Barnard

BATTLE GROUND OF RESACCA, GA., No. 3.

[plate 21: 1866]

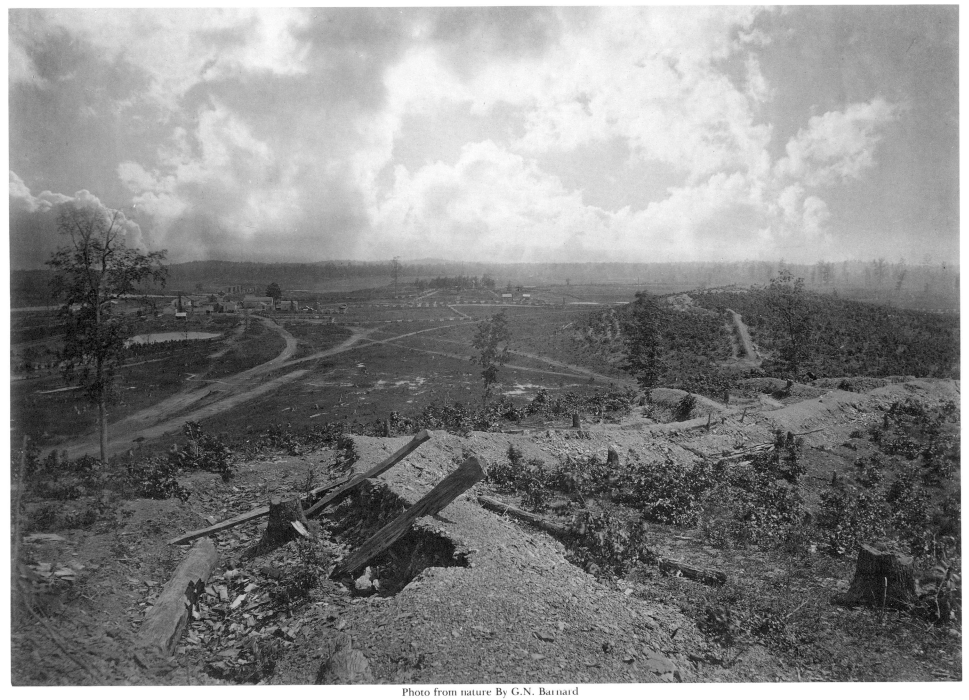

Photo from nature By G.N. Barnard

BATTLE GROUND OF RESACCA, GA., No. 4.

[plate 22: 1866]

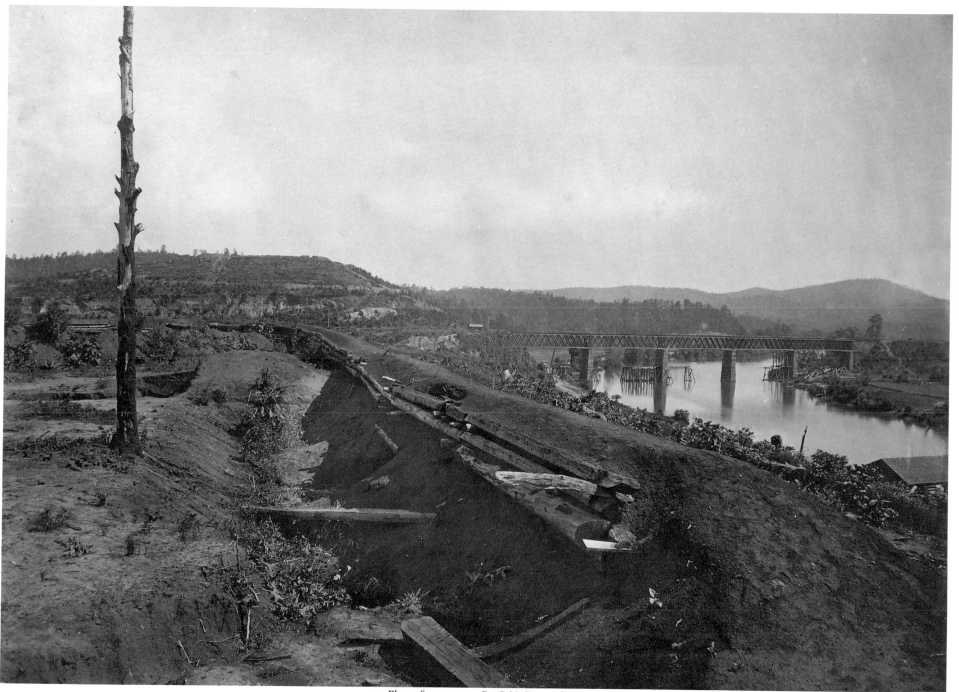

Photo from nature By G.N. Barnard

DEFENCES OF THE ETAWAH BRIDGE

[plate 23: 1866]

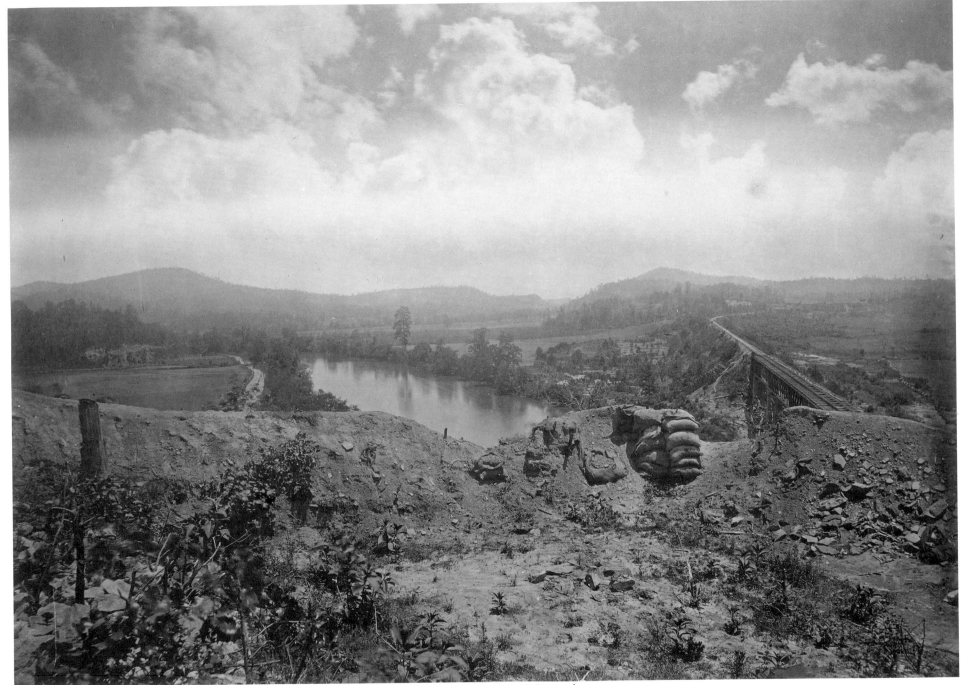

Photo from nature By G.N. Barnard

ALLATOONA FROM THE ETAWAH

[plate 24: 1866]

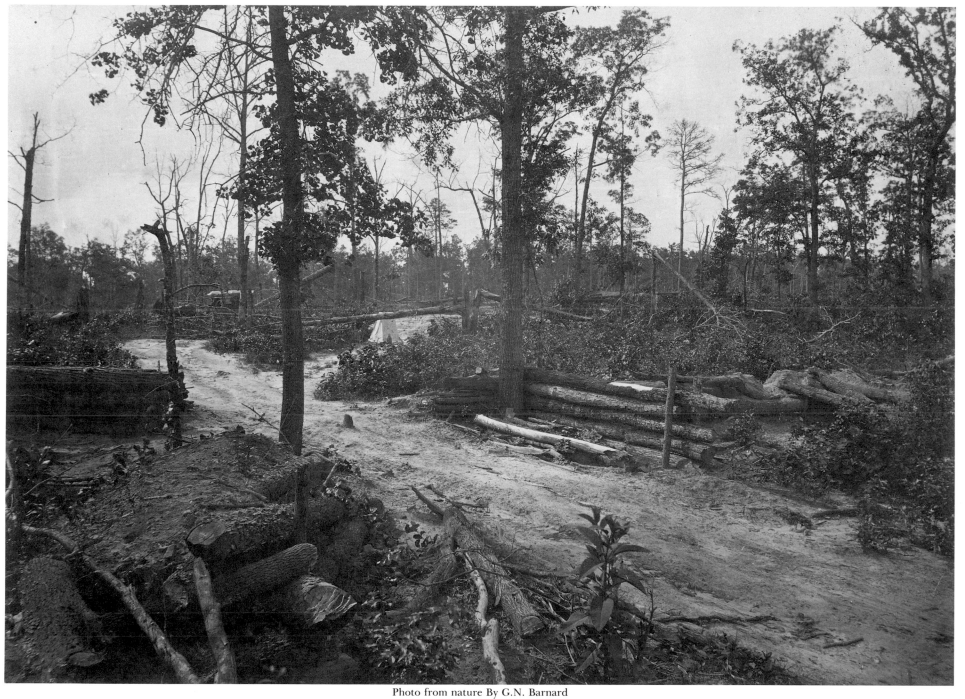

Photo from nature By G.N. Barnard

BATTLE FIELD OF NEW HOPE CHURCH, GA. No. 1.

[plate 25: 1866]

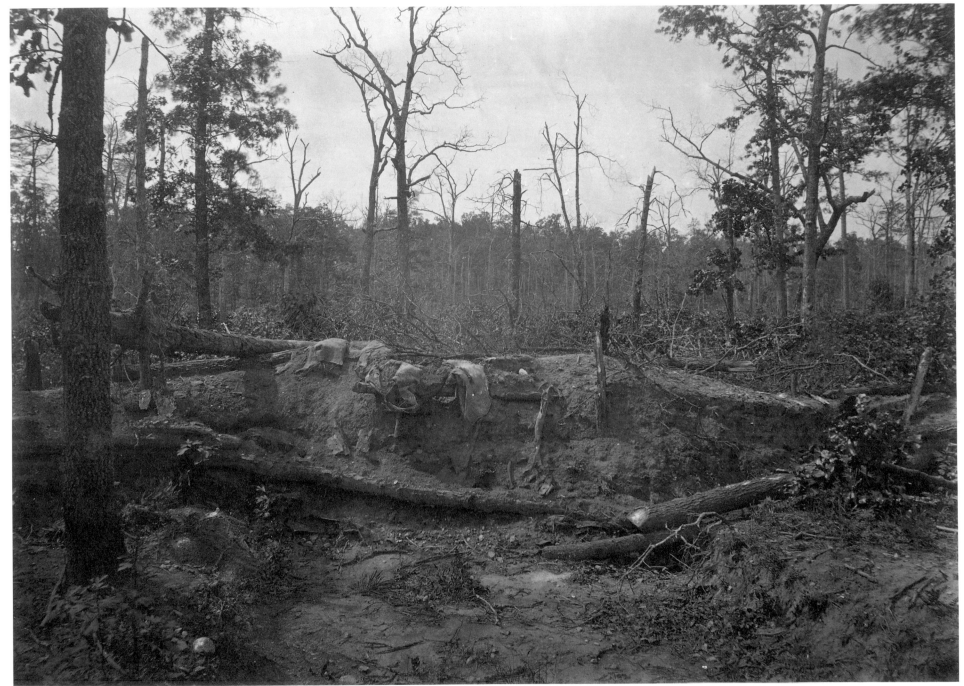

Photo from nature By G.N. Barnard

BATTLE FIELD OF NEW HOPE CHURCH, GA.

[plate 26: 1866]

Photo from nature By G.N. Barnard

THE "HELL HOLE" NEW HOPE CHURCH, GA.

[plate 27: 1866]

Photo from nature By G.N. Barnard

THE ALLATOONA PASS, LOOKING NORTH, GA.

[plate 28: 1866]

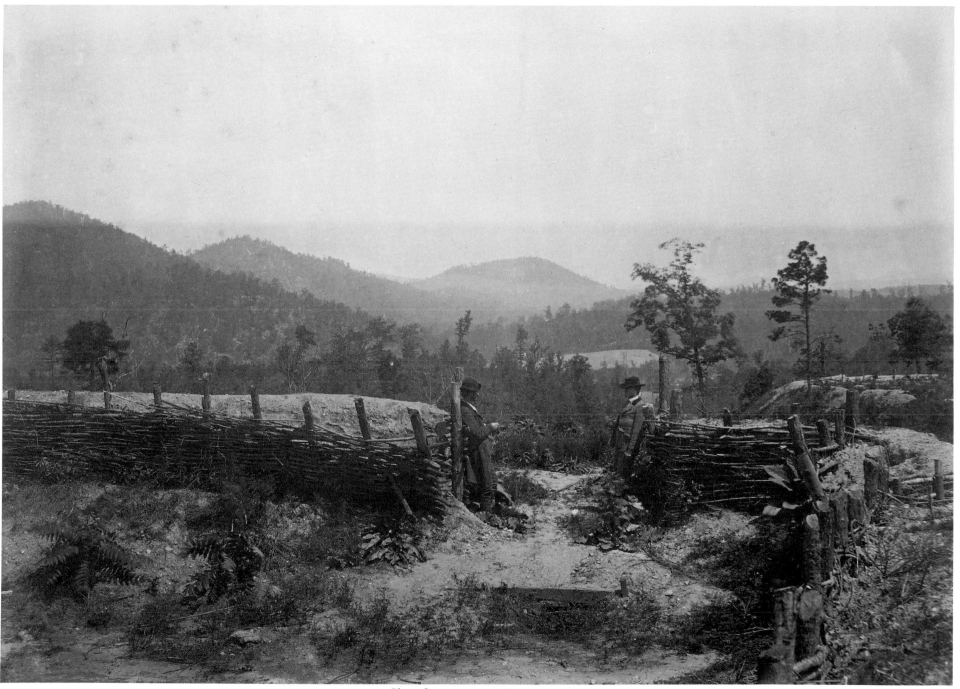

Photo from nature By G.N. Barnard

THE ALLATOONA PASS, GA.

[plate 29: 1866]

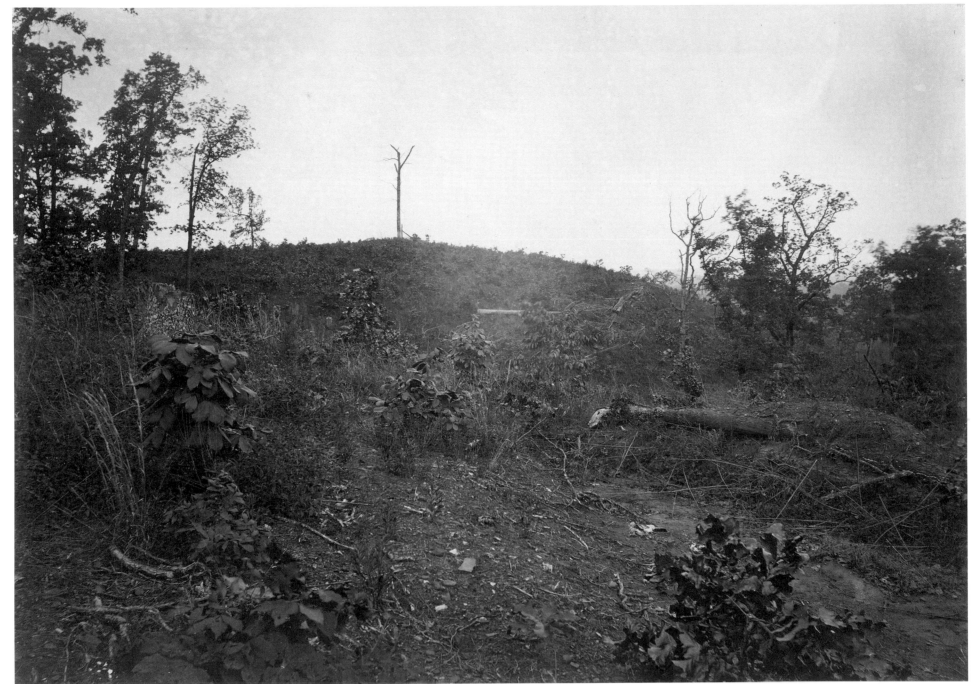

Photo from nature By G.N. Barnard

PINE MOUNTAIN

[plate 30: 1866]

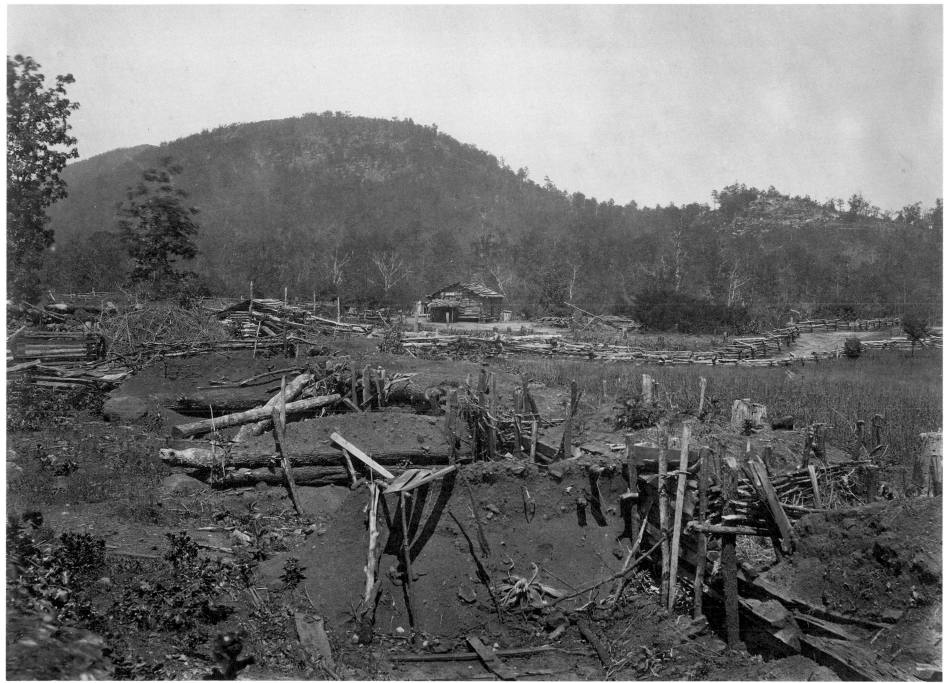

Photo from nature By G.N. Barnard

THE FRONT OF KENESAW MOUNTAIN, GA.

[plate 31: 1866]

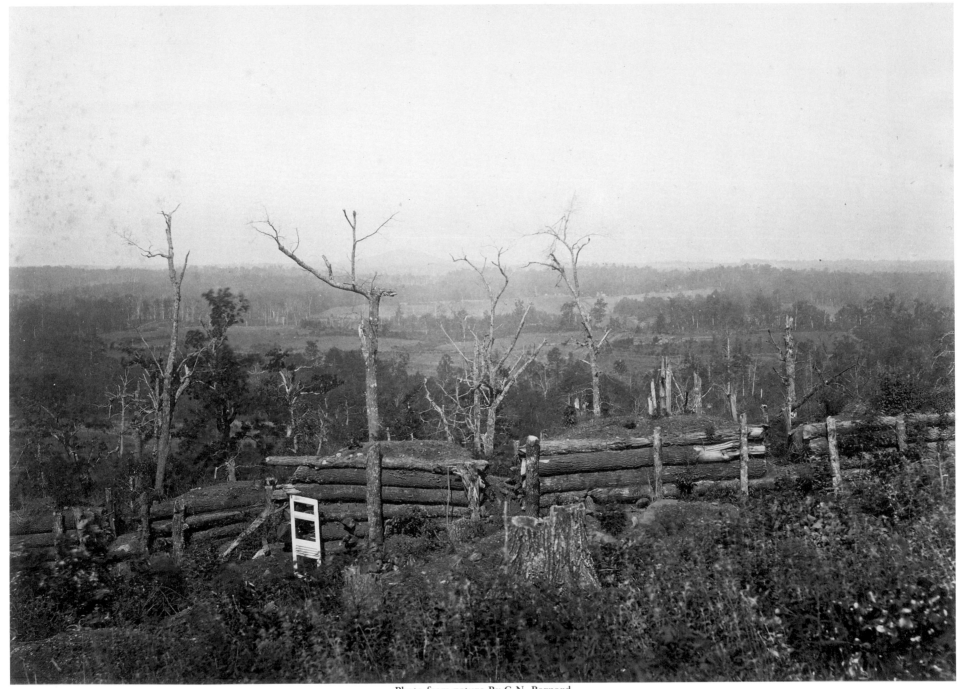

Photo from nature By G.N. Barnard

VIEW OF KENESAW MOUNTAIN, GA.

[plate 32: 1866]

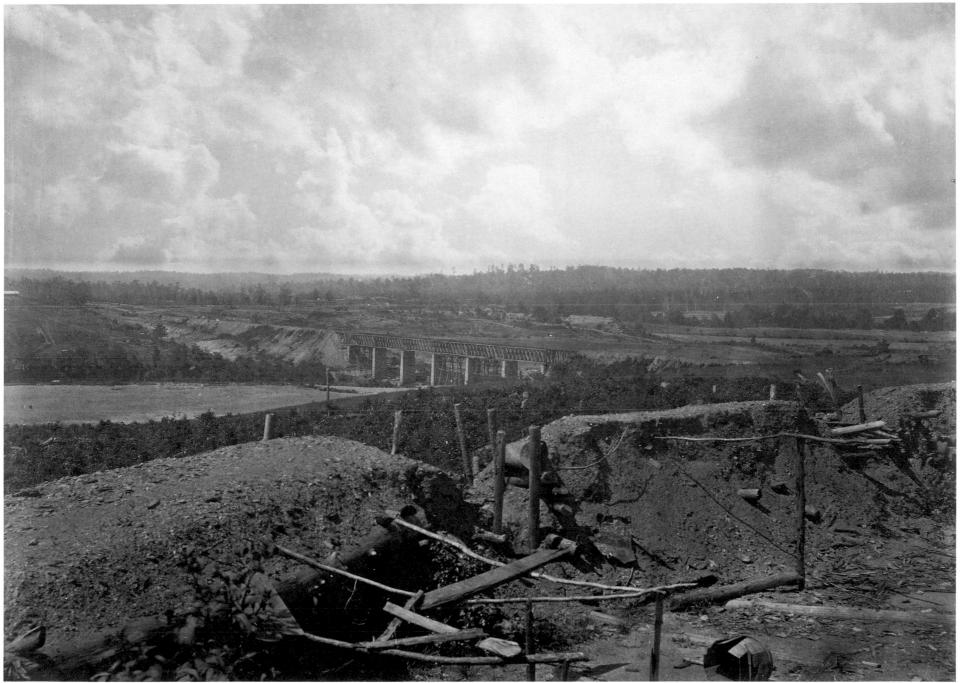

Photo from nature By G.N. Barnard

SOUTH BANK OF THE CHATTAHOOCHIE, GA.

[plate 33: 1866]

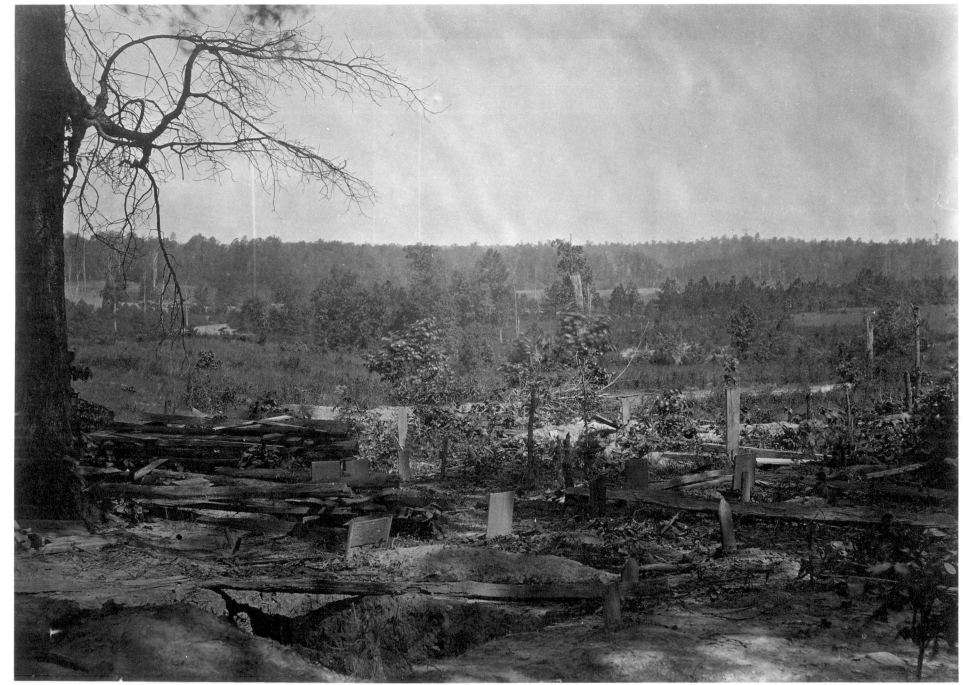

Photo from nature By G.N. Barnard

THE BATTLE FIELD OF PEACH TREE CREEK, GA.

[plate 34: 1864 or 1866]

Photo from nature By G.N. Barnard

SCENE OF GEN' McPHERSON'S DEATH

[plate 35: 1864 or 1866]

Photo from nature By G.N. Barnard

BATTLE FIELD OF ATLANTA, GA. JULY 22$^{\text{D}}$ 1864. No. 1.

[plate 36: 1864 or 1866]

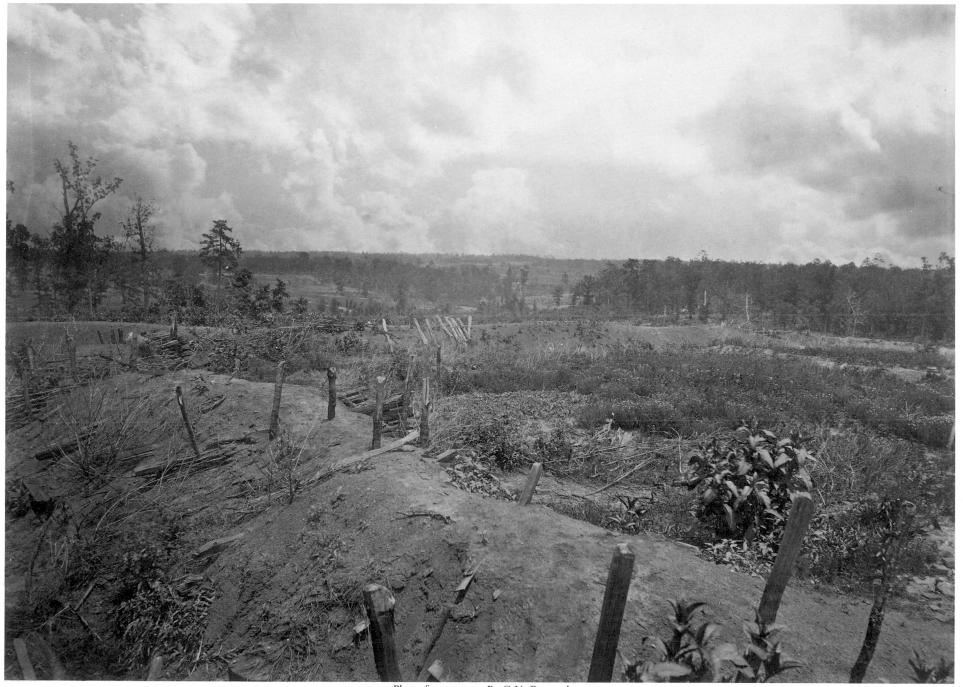

Photo from nature By G.N. Barnard

BATTLE FIELD OF ATLANTA, GA. JULY 22D 1864. No. 2.

[plate 37: 1864 or 1866]

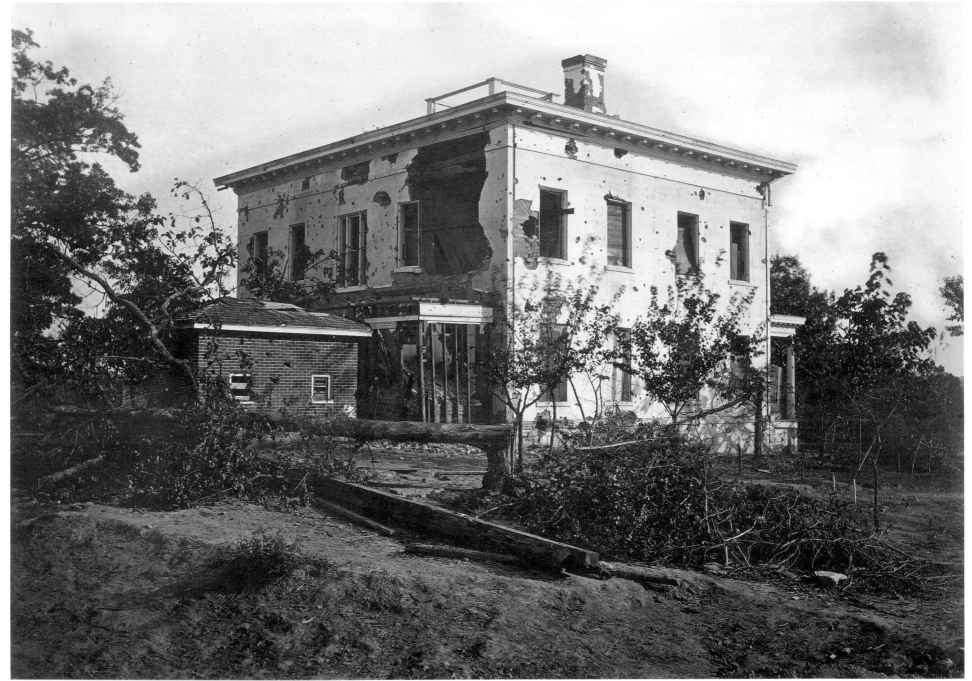

Photo from nature By G.N. Barnard

THE POTTER HOUSE ATLANTA

[plate 38: 1864]

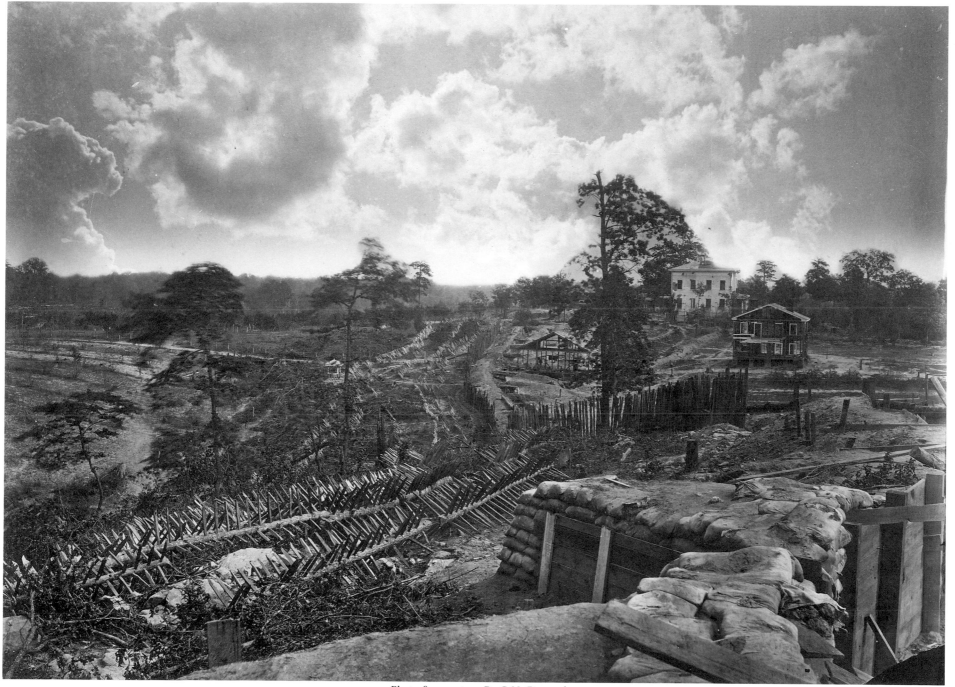

Photo from nature By G.N. Barnard

REBEL WORKS IN FRONT OF ATLANTA, GA. No. 1.

[plate 39: 1864]

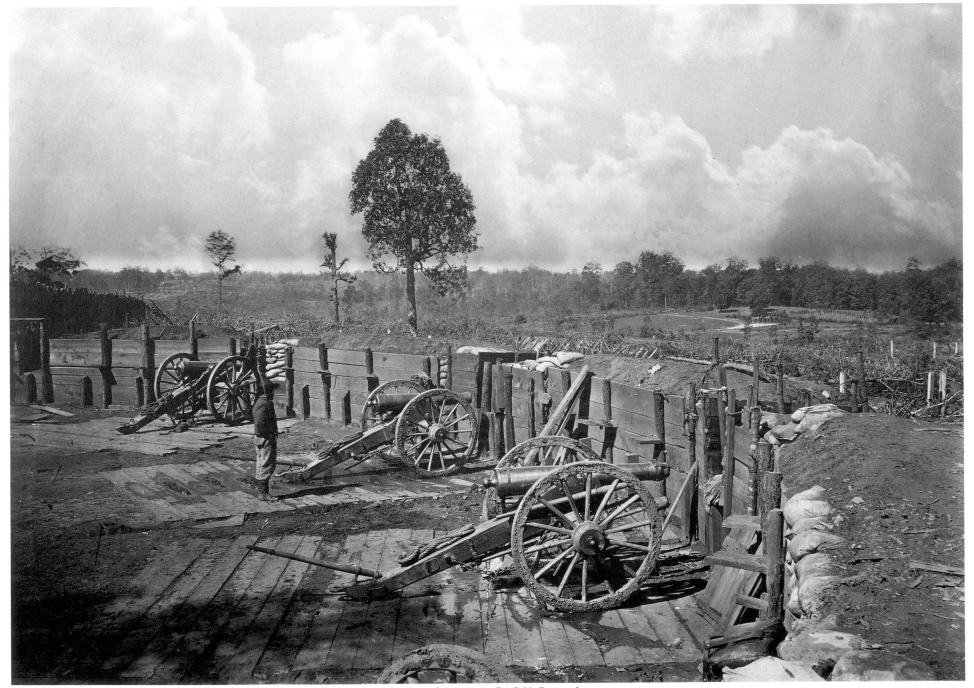

Photo from nature By G.N. Barnard

REBEL WORKS IN FRONT OF ATLANTA, GA. No. 2.

[plate 40: 1864]

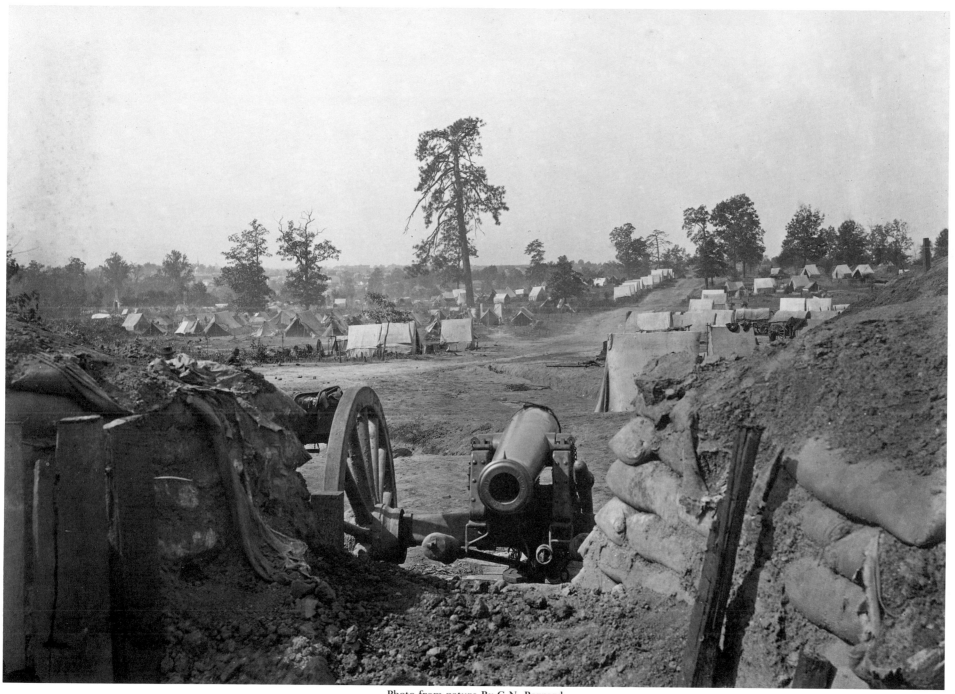

Photo from nature By G.N. Barnard

REBEL WORKS IN FRONT OF ATLANTA, GA. No. 3.

[plate 41: 1864]

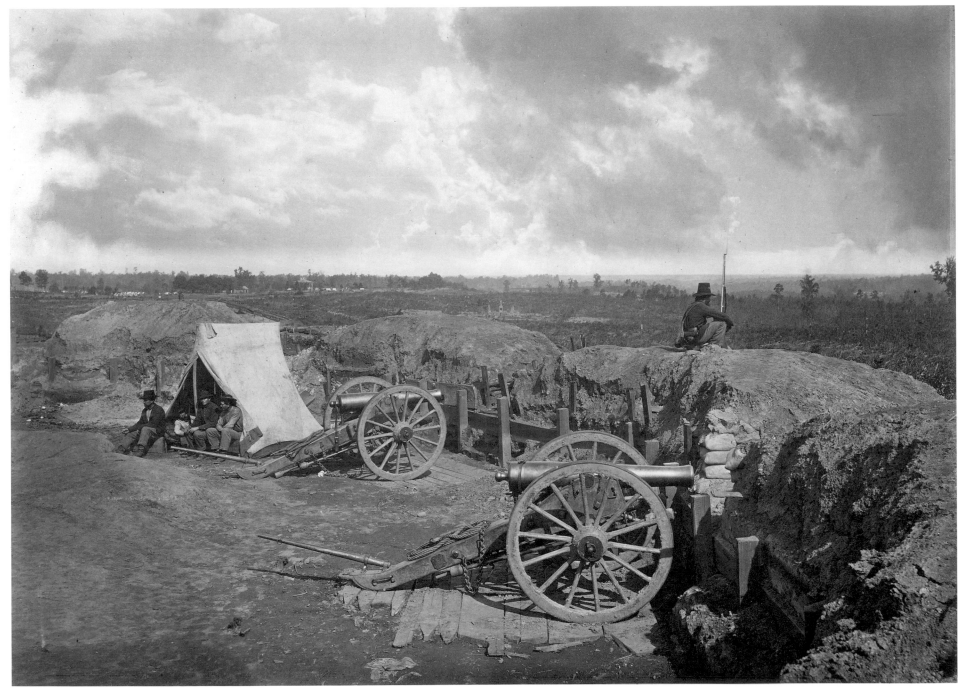

Photo from nature By G.N. Barnard

REBEL WORKS IN FRONT OF ATLANTA, GA. No. 4.

[plate 42: 1864]

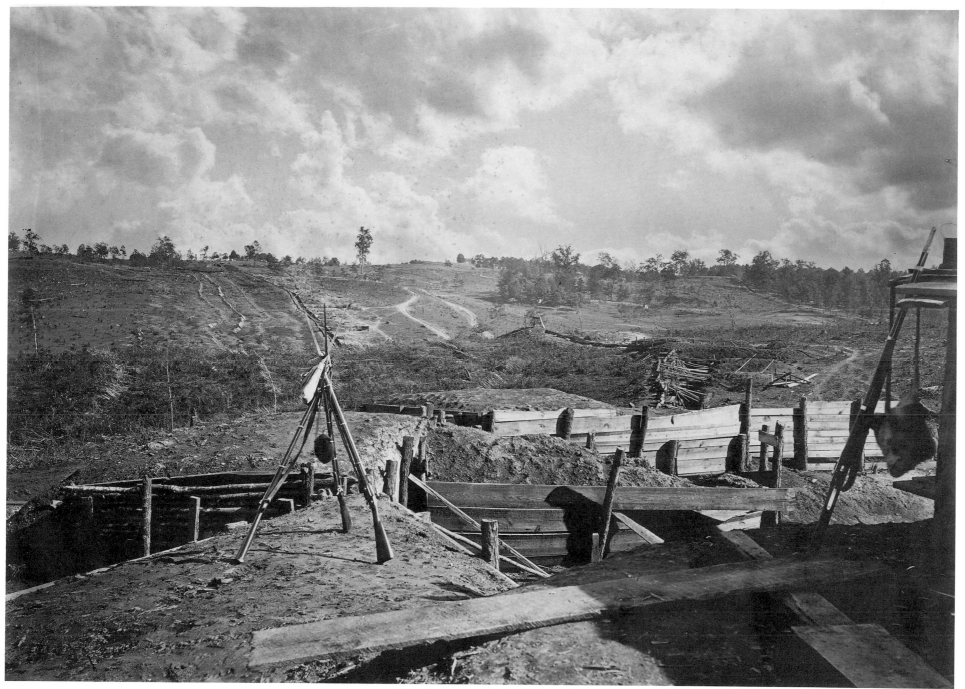

Photo from nature By G.N. Barnard

REBEL WORKS IN FRONT OF ATLANTA, GA. No. 5.

[plate 43: 1864]

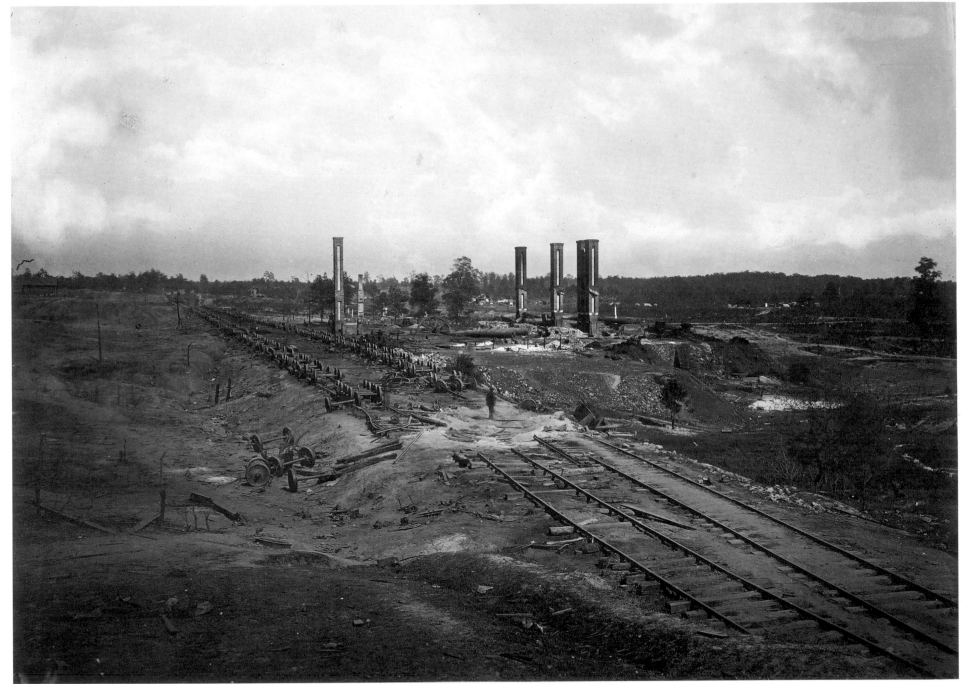

Photo from nature By G.N. Barnard

DESTRUCTION OF HOOD'S ORDINANCE TRAIN

[plate 44: 1864]

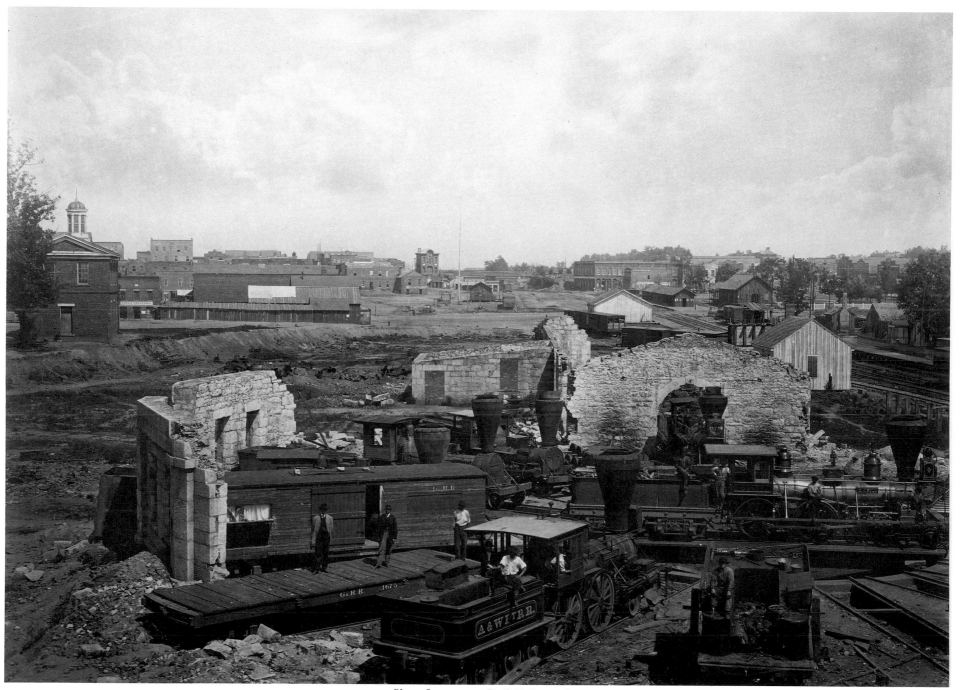

Photo from nature By G.N. Barnard

CITY OF ATLANTA, GA. No. 1.

[plate 45: 1866]

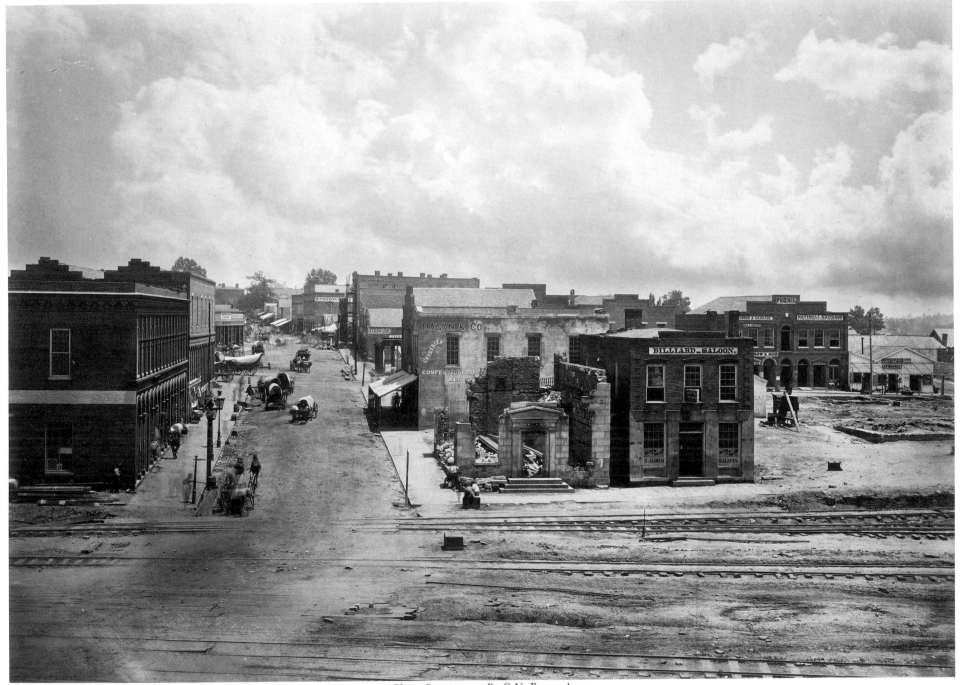

Photo from nature By G.N. Barnard

CITY OF ATLANTA, GA. No. 2.

[plate 46: 1866]

Photo from nature By G.N. Barnard

SAVANAH RIVER, NEAR SAVANAH, GA.

[plate 47: 1866]

Photo from nature By G.N. Barnard

BUEN-VENTURA SAVANAH, GA.

[plate 48: 1866]

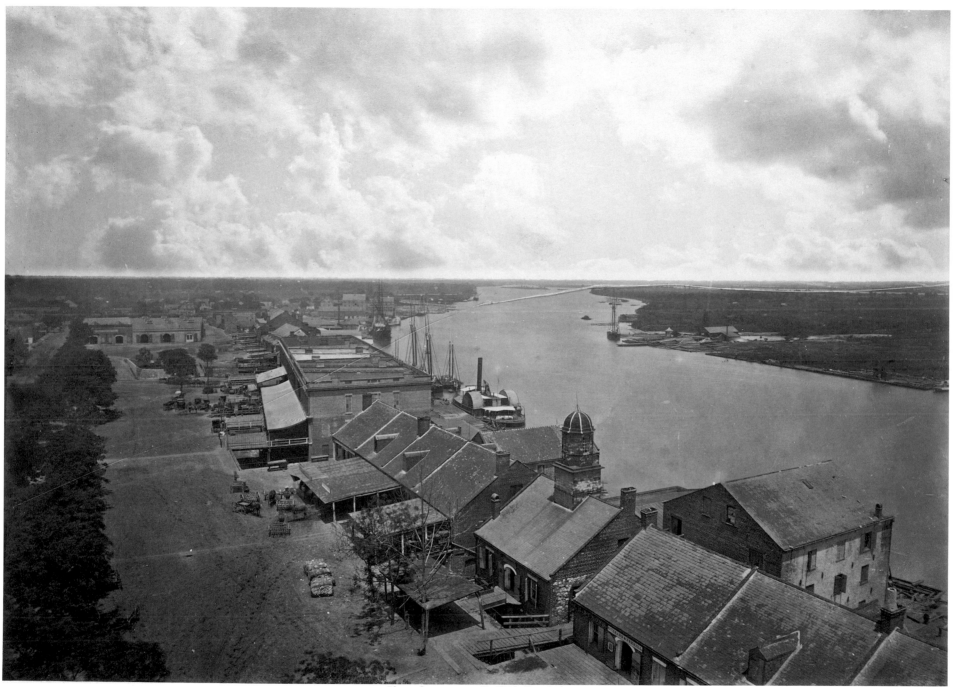

Photo from nature By G.N. Barnard

SAVANAH, GA. No. 1.

[plate 49: 1866]

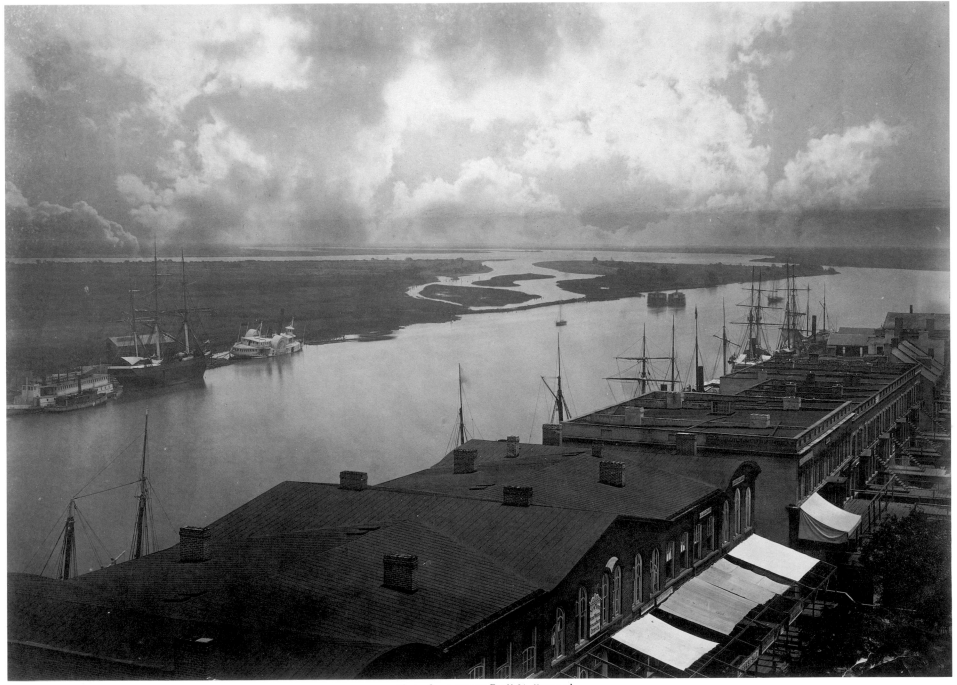

Photo from nature By G.N. Barnard

SAVANAH, GA. No. 2

[plate 50: 1866]

FOUNTAIN, SAVANAH, GA.

[plate 51: 1866]

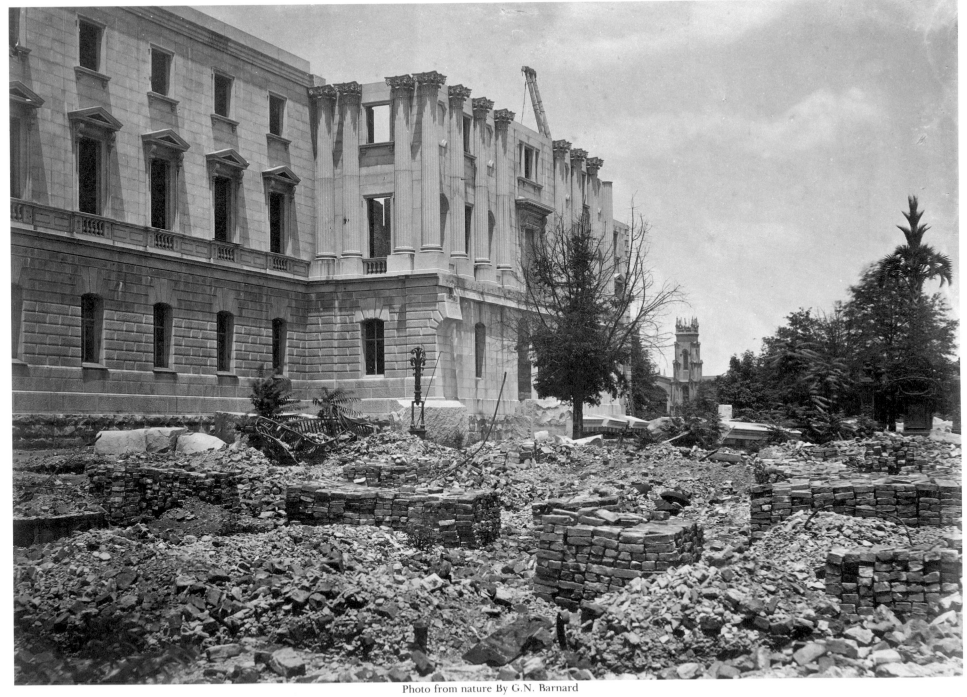

Photo from nature By G.N. Barnard

THE NEW CAPITOL, COLUMBIA, S.C.

[plate 52: 1865]

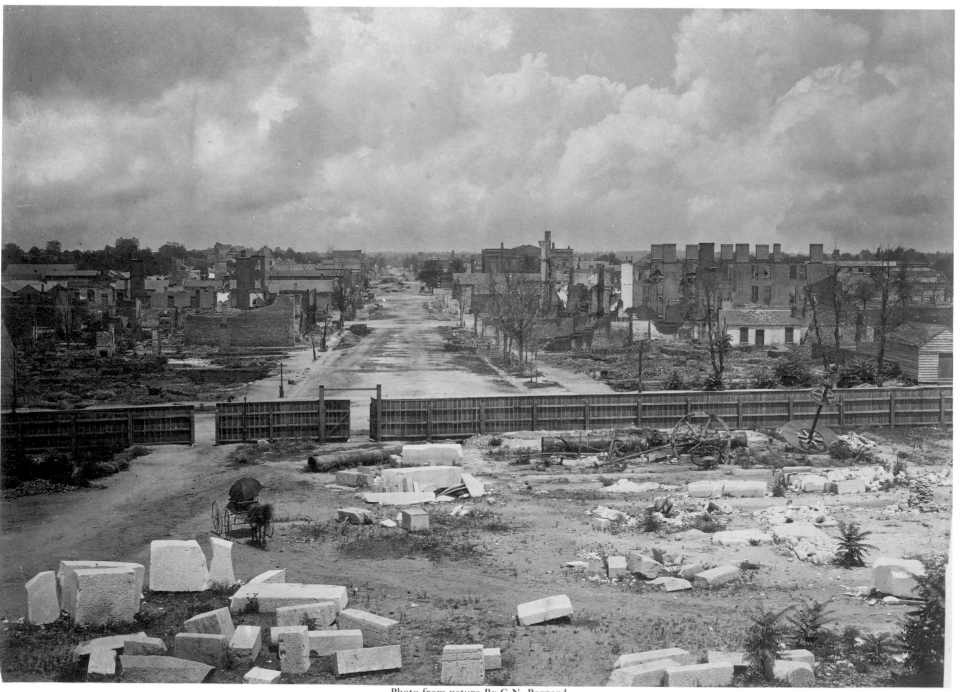

Photo from nature By G.N. Barnard

COLUMBIA FROM THE CAPITOL

[plate 53: 1865]

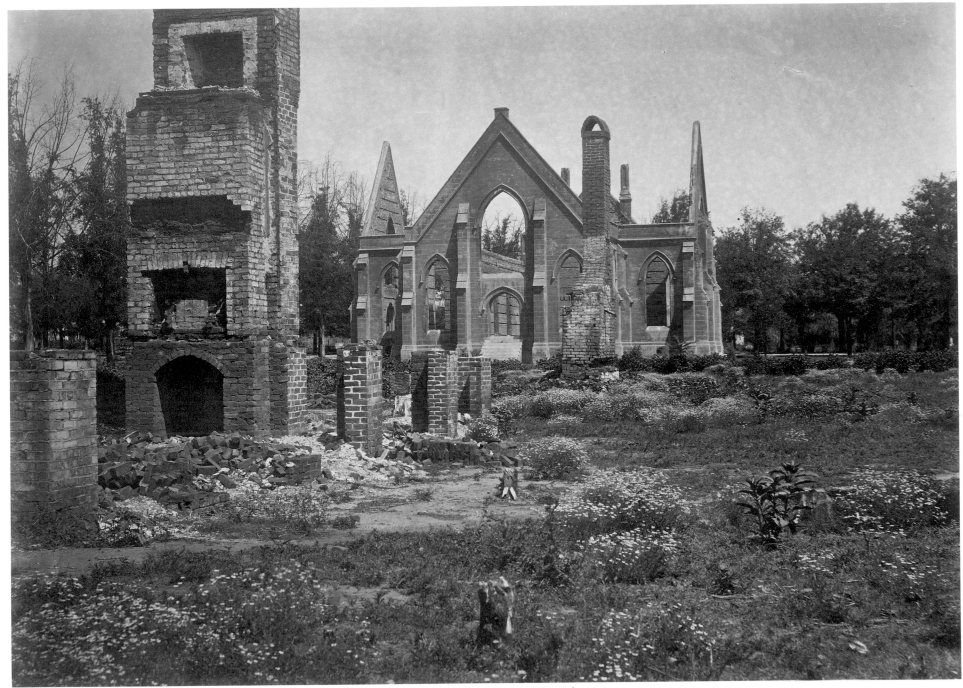

Photo from nature By G.N. Barnard

RUINS IN COLUMBIA, S.C.

[plate 54: 1865]

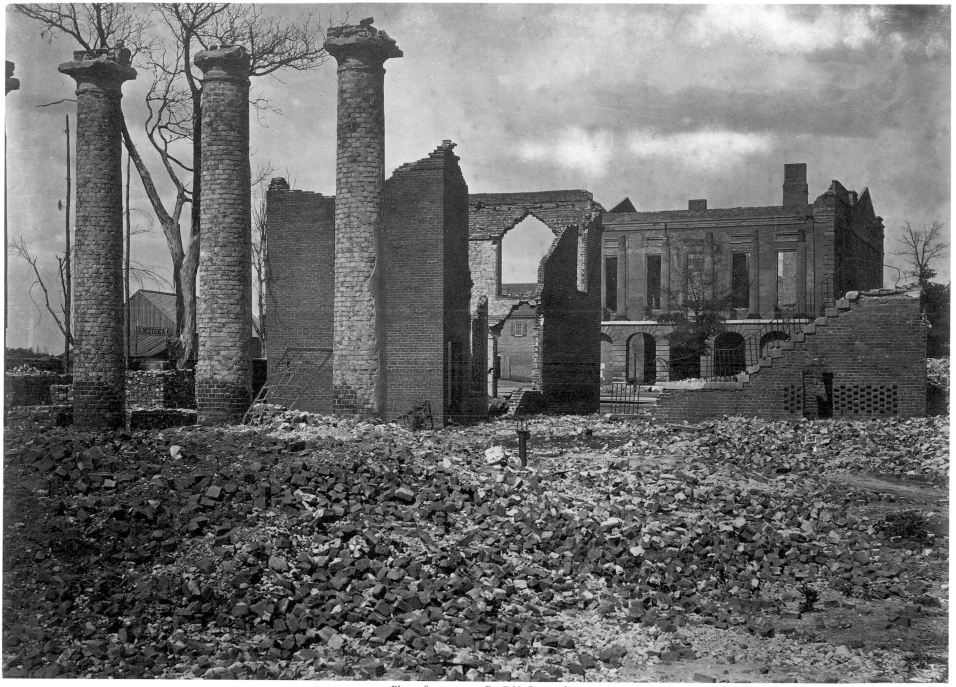

Photo from nature By G.N. Barnard

RUINS IN COLUMBIA, S.C. No. 2

[plate 55: 1865]

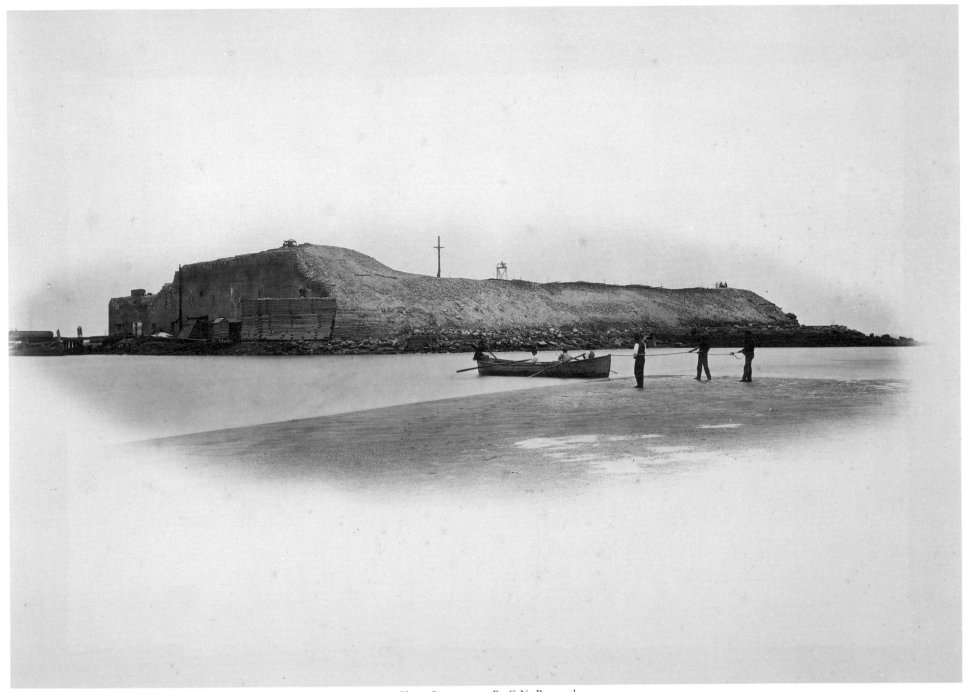

Photo from nature By G.N. Barnard

FORT SUMPTER

[plate 56: 1865 or 1866]

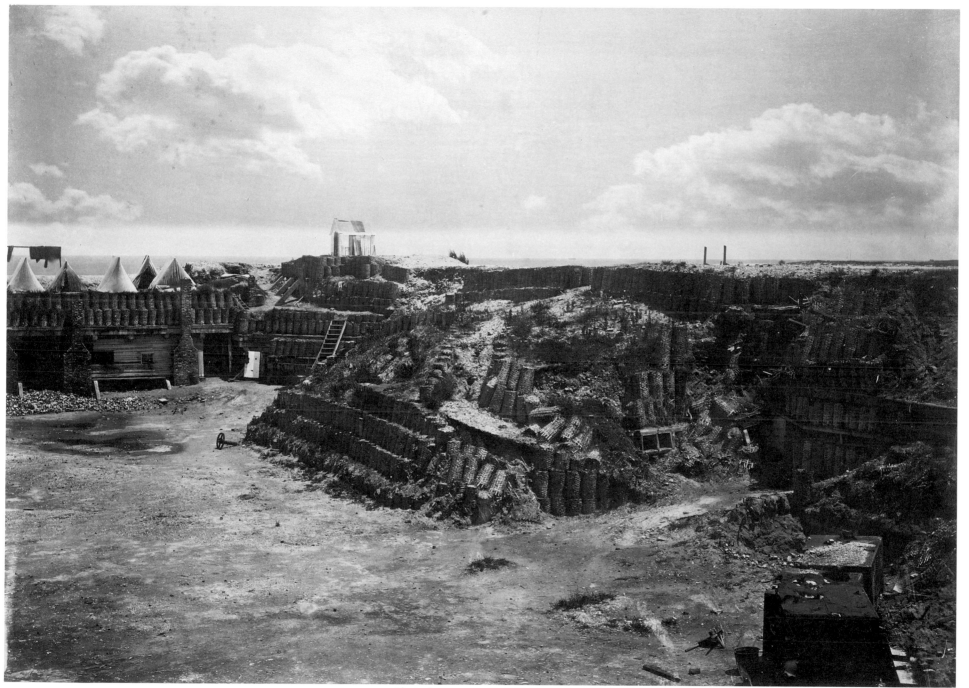

Photo from nature By G.N. Barnard

INTERIOR VIEW OF FORT SUMPTER

[plate 57: 1866]

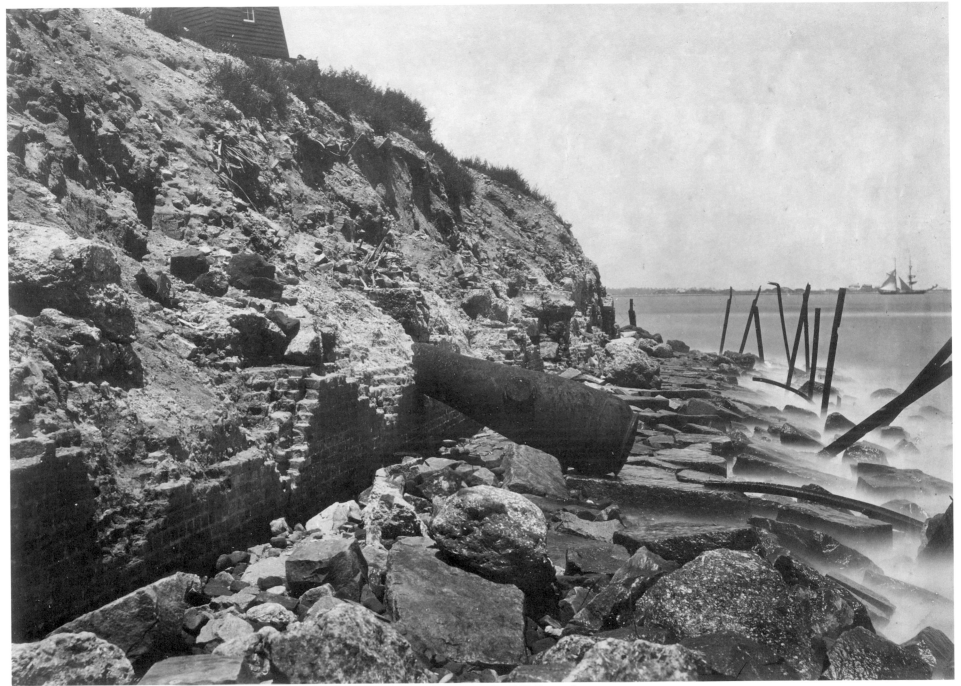

Photo from nature By G.N. Barnard

EXTERIOR VIEW OF FORT SUMPTER

[plate 58: 1866]

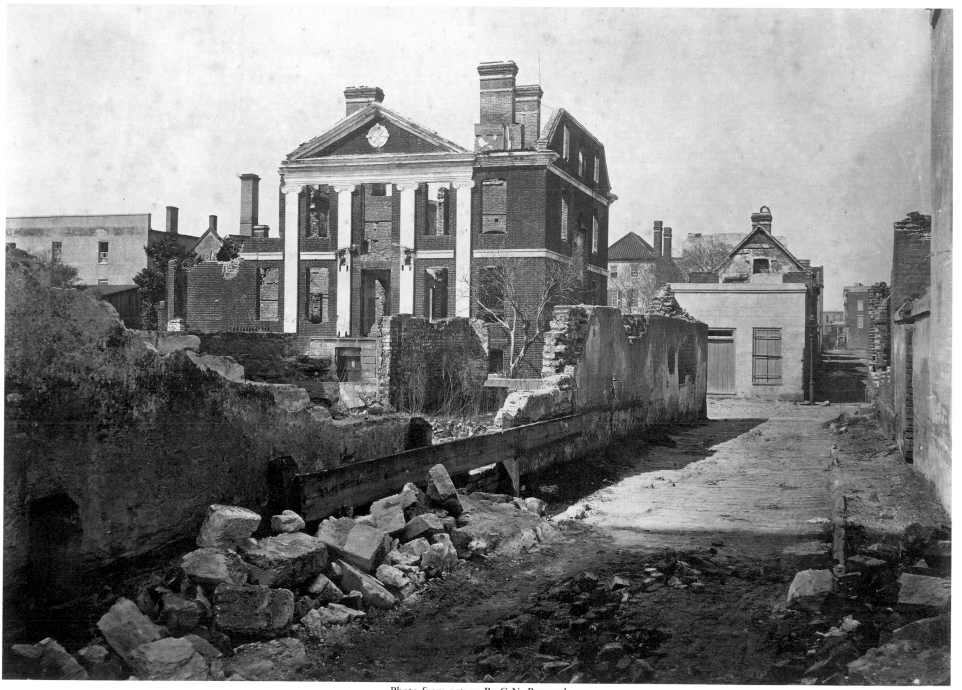

Photo from nature By G.N. Barnard

RUINS OF THE PINCKNEY MANSION, CHARLESTON, S.C.

[plate 59: 1865]

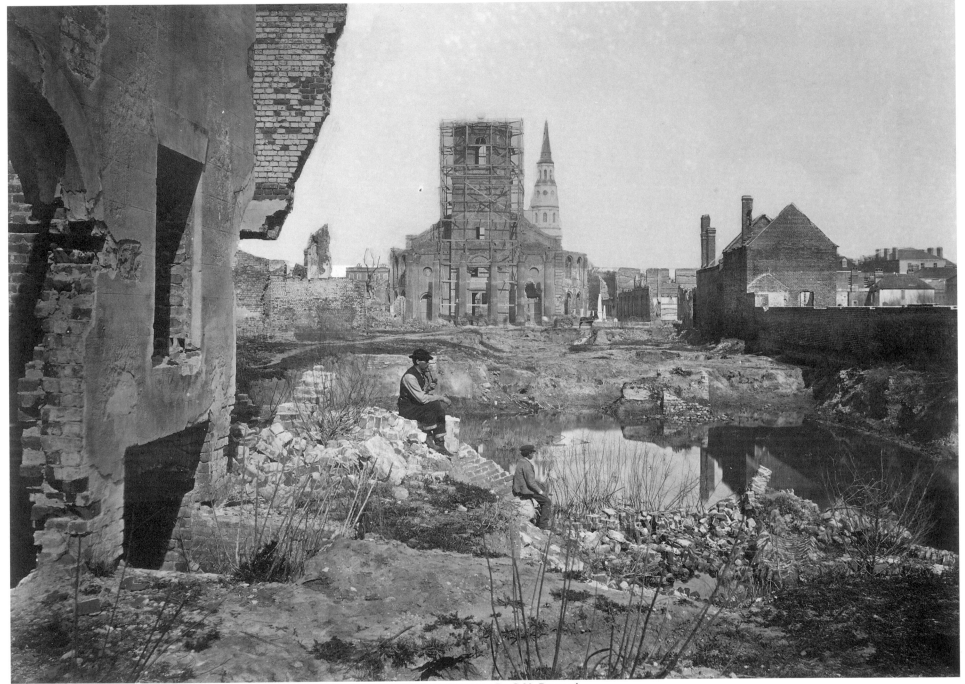

Photo from nature By G.N. Barnard

RUINS IN CHARLESTON, S.C.

[plate 60: 1865 or 1866]

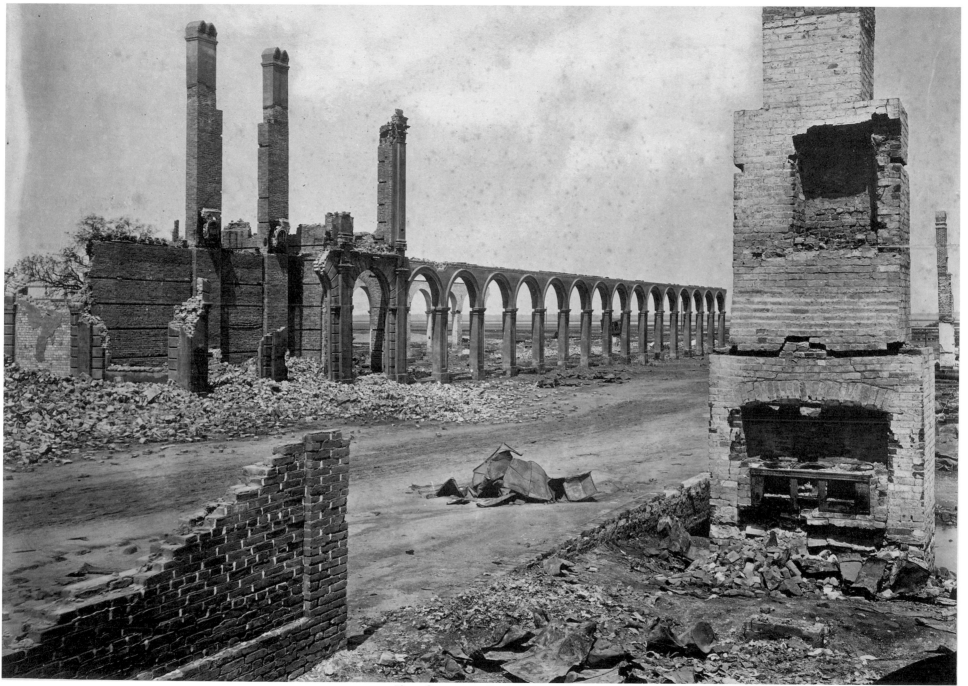

Photo from nature By G.N. Barnard

RUINS OF THE R.R. DEPOT IN CHARLESTON, S.C.

[plate 61: 1865]

III:3 Themes and Sources

Photographic Views of Sherman's Campaign is a remarkable work of great symbolic, historic, and artistic power. It is the result of a complex interweaving of Barnard's personal vision, nineteenth-century pictorial conventions, and larger ideas about war and the American landscape. The album was the most ambitious project of Barnard's career, and has long been recognized as a landmark in the history of photography. This chapter will examine the scope, visual sources, and basic themes of this work.

Barnard's album was praised by reviewers of the period as both an accurate record of topography and a beautiful work of art. However, they suggested neither its complexity, nor — to twentieth-century eyes — its strangeness. This writer first studied Sherman's Campaign in the summer of 1977, when the Helios Gallery in New York City mounted an exhibition of all sixty-one plates.[1] My interest in nineteenth-century photography had been stimulated by studies with Beaumont Newhall at the University of New Mexico, and I was eager to see Barnard's work in depth. I found the photographs fascinating and peculiar. Although physically impressive, the images seemed to be documents of the Civil War in only the most peripheral and oblique way. These melancholy, mute pictures exhibited none of the dramatic action we associate with modern war photography. Some, in fact, contained no evidence of military activity. My first impression was that the photographer had missed, or deliberately avoided, nearly every possible incident of dramatic, historic, or human interest. Barnard's artificial clouds added yet another incongruity to the work. Why, I wondered, had he laboriously added these picturesque touches to views of presumably "simple" documentary interest?

I left the gallery genuinely puzzled by images that did not conform to my preconceptions of what nineteenth-century documentary photographs "should" look like. Yet the photographs were unforgettable, in large part *because* of their oddness. Barnard's views were carefully made, dense with information, and strangely compelling. Unlike nearly every war photograph I had ever seen, these images were understated and subtle, suggesting far more than they revealed. Their intent seemed to be the evocation of ideas and memories as much as the recording of physical fact. They were about reflection rather than action, and they stimulated my own thoughts on the complexity and meaning of photographs.

To better understand these pictures, I sought more information on their maker. The brief biography included in Beaumont Newhall's 1977 reprint edition of Barnard's album provided a starting point. However, the facts of Barnard's life, as known at that time, did not begin to explain his work. I thus set out to discover for myself who George N. Barnard was, and what his pictures might mean. The present volume is the result of that puzzling encounter over a decade ago.

Photographic Views of Sherman's Campaign is a conscious mixture of documentary and artistic intentions, and both more and less than its title would indicate. Theo R. Davis's informative text and Orlando Poe's official maps provide a didactic context for Barnard's photographs. The images themselves are visually sophisticated and deliberately sequenced, uniting historical narrative, scenic travelogue, and symbols of melancholy and mourning in a richly allusive and densely meaningful work of visual literature.

The album begins with a group portrait of Sherman and his generals (plate 1). This Brady Studio image suggests Sherman's gritty determination and the competence of his subordinates. Sherman's authority is indicated by his central position and steady gaze toward the camera. The glances of the other seven generals are all averted, as if in deference to their commander.

Subsequent plates in the album document, in roughly geographic sequence, sites in Tennessee, Georgia, and South Carolina that figured prominently in Union Army operations between late 1863 and early 1865. Surprisingly, *Photographic Views of Sherman's Campaign* contains no depictions of the "March to the Sea," the episode most immediately associated with William T. Sherman. Barnard accounted for this gap in his documentation by citing the technical difficulty of photographing during the army's "rapid movement" toward Savannah in late 1864.

It is important to realize, however, that Barnard consciously chose not to record any site between Atlanta and Savannah during his return visit in the spring of 1866. Since Sherman's men had not dug extensive entrenchments or built large bridges on the march, little evidence of their passage would have been visible at that time. But it is still distinctly odd that Barnard did not photograph the site of the prison at Millen or the Georgia statehouse at Milledgeville, subjects at least as significant as others included in the album.

Barnard was disturbed by the burning of homes and other acts of violence committed by Sherman's aggressive troops. It is fair to speculate, therefore, that his decision not to represent the ground between Atlanta and Savannah reflected a conscious effort to downplay the entire event. While the campaign to Atlanta had been strategically complex and of great political importance, the march probably evoked in the photographer memories of marauding, undisciplined troops. The valor of the earlier campaign was acknowledged even by some Southerners. But the march evoked intense hatred in the South and unease among a significant number of Northerners.

The final section of the album includes photographs made in and around

Savannah, Columbia, and Charleston. Barnard included images of the latter city, which had been bypassed by Sherman's forces, for symbolic, rather than purely military, reasons. The Civil War had begun in Charleston harbor. It was fitting, therefore, that the album conclude with the ruins of Fort Sumter and the city, suggesting a full circle of cause and effect, transgression and retribution.

In addition to their geographic diversity, Barnard's views represent different vantage points in time. The album's sixty exterior photographs were made in two discrete periods: from the late winter of 1864 to March 1865, and from April to early June 1866. This combination gives the album a narrative tension between the "present" of the war itself, and a retrospective memory of the conflict. Barnard blurred this distinction by sequencing his prints according to the chronology of wartime events and by not dating individual views.

The album's photographs are also thematically varied. Engineering feats, ruined cities, and pastoral landscapes are all depicted. At the heart of this diversity is a union of documentary and aesthetic concerns that may seem curious to twentieth-century viewers. The significance of photographs of railroad bridges and ruined cities may seem self-evident to us. But what, it is fair to ask, can a tranquil mountain lake (plate 15) or a cast-iron fountain (plate 51) have to do with Sherman's campaign? The logic of such views stems from Barnard's interest in the larger, historic and metaphoric meaning of the sites he visited. The poignance of battle-fields and ruined cities was only emphasized by their proximity to places of great natural beauty and examples of cultural refinement and taste. Barnard's varied subjects reflect both the breadth of his narrative ambition and the pervasive aesthetic climate of the period. His photographs represented several facets of the Southern landscape and appealed to viewers for their beauty as well as their documentary precision.

The integration of aesthetics with technical and professional concerns was exemplified in the curriculum of the United States Military Academy at West Point. In addition to their studies in mathematics, engineering, and the sciences, cadets were taught drawing and formed music and art appreciation clubs. This course of instruction instilled an admiration for the beauty of useful things as well as a respect for the social and moral importance of art.

These aesthetic interests shaped many soldiers' perceptions. At Vicksburg, for example, William T. Sherman noted that the sight of troops crossing a bridge by torchlight made "a fine war-picture." Later, in the "carnage and noise" of the battle of Chattanooga, he "could not help stopping to look across that vast field of battle, to admire its sublimity."[2] Peak experiences such as these suggested the perfection of pictures. Paintings and photographs, in turn, allowed viewers to savor the memories of hallowed places and heroic events.

This aesthetic sensibility was particularly apparent among the army's engineers, who were trained in sketching and in the production and interpretation of maps, diagrams, and pictures of all kinds. Given the nature of Barnard's employment in

1864-65, it is to be expected that his photographs reflect the interests and needs of the military engineer. Topographic sketches and photographs, for example, were characterized by elevated, panoramic, and wondrously unobstructed vistas. These supremely objective vantage points suggest a synthesis of two related experiences: that of an eyewitness ideally located in the landscape, and of an analyst contemplating a map of the scene. Barnard's panoramic photographs exemplify this mode of vision.

It was also natural that Barnard recorded subjects built by the Department of Engineers. The railroad, which was essential to Sherman's success, is depicted in at least ten photographs in Barnard's album. He also recorded the sites of the military engineers' remarkable achievements in bridge construction. The 600-foot Etowah Bridge, for example, had been rebuilt in June 1864 in only five and a half days. The 780-foot Chattahoochie Bridge had been reconstructed in merely four and a half working days in early August of that year. Given the renown of these temporary structures, it is curious to note that Barnard's photographs at these sites (plates 23, 33) record the permanent iron bridges subsequently installed by Federal troops in the summer of 1865.

Entrenchments and fortifications are also depicted repeatedly in *Sherman's Campaign*. Whether obvious (e.g., plates, 23, 26, 40) or subtle (plates 11, 13, 21), these subjects are visible in forty percent of the album's sixty exterior views. This frequency reflects the role of Barnard's superiors in the design and construction of defensive works and the relative longevity of these features. Since fortifications provided graphic evidence of past battles, Barnard recorded their crumbling remains often in the spring of 1866.

Entrenchments also symbolized the new realities of war. In the first year of the conflict chivalric notions of heroic hand-to-hand fighting were ended forever by the brutal reality of anonymous killing on a previously unimagined scale. The range and accuracy of the rifled musket expanded the lethal zone of the battle-field, doomed the heroics of the open frontal assault, and made field fortifications essential. This pragmatic respect for defensive action challenged a traditional military emphasis on the offense and led to new strategic options. In the Atlanta Campaign, for example, both sides protected themselves behind timber and earthen barriers at every opportunity. As Sherman noted, "during this campaign hundreds if not thousands of miles of...intrenchments [sic] were built by both armies, and, as a rule, whichever party attacked got the worst of it."[3]

In addition to evoking the interests of the military engineer, Barnard's photographs bear a complex relationship to the informative, poetic, and sensational images presented in the era's illustrated press. In several instances, Barnard's photographs served as direct sources for *Harper's Weekly* illustrations. On other occasions the same subjects were interpreted in interestingly varied ways by Barnard and the journal's artists.

Two plates in *Photographic Views of Sherman's Campaign* are remarkably

112. **Theodore R. Davis:** *Our Army Entering Resaca, Georgia, on May 16, 1864*; engraving published in *Harper's Weekly*, June 25, 1864; Kansas City Public Library

113. **Theodore R. Davis:** *The Crest of Pine Mountain, Where General Polk Fell, June 14, 1864*; engraving published in *Harper's Weekly*, July 16, 1864; Kansas City Public Library

similar to earlier *Harper's Weekly* illustrations. *The Capitol, Nashville* (plate 2) duplicates the perspective of an engraving in the journal's March 8, 1862, issue. While it is possible that Barnard's photograph was influenced by this earlier view, it seems as likely that both artist and photographer simply chose the same well-positioned vantage point. In the case of plate 22, *Battle Ground at Resaca, No. 4*, the truth may be more complex. This 1866 photograph is notably similar to an earlier sketch by Theo. R. Davis (figure 112). Despite the imprecision of the engraving's foreground, it is clear that the two pictures were made from nearly identical positions. This similarity suggests the possibility that Barnard conferred with Davis before his 1866 trip, or carried *Harper's Weekly* tear-sheets with him as reference material.[4]

A great difference is revealed in views of Pine Mountain by Davis and Barnard (figure 113; plate 30). Davis's engraving, depicting the view from the summit of the hill, is undistinguished. Barnard, however, used a camera position midway up the slope to record a blasted tree as a metaphor for the freakish death of Confederate General Polk on that spot. The photographer ignored the scenic view from the crest to produce a wholly original interpretation of the human and historic significance of the site.

More different yet are views of the destruction of General Hood's ammunition train. The lively interpretation of this incident published in *Harper's Weekly* emphasizes the explosion's awesome violence (figure 114). By necessity, of course, Barnard's view depicts the silent evidence of the aftermath (plate 44). Near the center of this photograph, where the explosion originated, a single ghostly figure suggests the scale and unearthliness of this man-made inferno. Barnard well knew the capabilities of his medium and its inability to render purely imaginative scenes. This profound understanding enabled him to produce an image all the more eerie and memorable for its deathly stillness.

Barnard's awareness of the history and practice of art also influenced his photographic work. During his years as a daguerreotypist, Barnard read John Ruskin's writings and the articles on art history and criticism published in the photographic journals of the period. He may also have read specialized art publications such as *The Crayon*. During his time in New York City, between about 1859 and 1867, Barnard lived and worked in the heart of the nation's artistic community, near dozens of studios, publishers, and dealers.[5] It is likely that he took advantage of this opportunity to study works by the leading artists of the day.

Barnard's understanding of artistic principles is revealed in his sophisticated use of landscape motifs. Indeed, his volume is distinguished from all other compilations of Civil War photographs by its meditative mood and the centrality of landscape imagery to its overall effect. The art and culture of mid-nineteenth century America drew profound inspiration from nature. In the picturesque harmony of rural landscapes and the awe-inspiring sublimity of the uninhabited wilderness Americans perceived solemn evidence of national destiny and God's favor.[6]

The representation and celebration of the American landscape in painting and poetry was well established by the 1860s. Photography, however, due to its small scale and limited ability to idealize, was slow to develop in this genre. While there are scattered examples of landscape photographs made by the daguerreotype and paper-negative processes, these were conspicuous exceptions to the studio-based nature of the profession prior to the late 1850s.[7]

American landscape photography commenced as a serious genre with the stereograph. Beginning in 1859-60, innumerable views of such celebrated subjects as the White Mountains, Hudson River, and Niagara Falls were offered in this format for public sale. While these monochromatic views could not compete with the color and physical scale of paintings, they provided the illusion of depth and a uniquely intimate viewing experience. Barnard is not known to have made large format landscape photographs before 1864. However, his expertise in stereo photography probably explains the sophistication of his landscapes in *Photographic Views of Sherman's Campaign*. Barnard's unusual interest in the spatial tension between foreground and background (seen, for example, in plates 4, 22, 23, 31, 33, 37, 39, 41, and 43) probably also stems from his stereographic experience. The depiction of deep space was far more common in the stereo format than with plates of larger sizes, which required longer exposures and allowed less depth of field.

Barnard's understanding of landscape conventions is demonstrated throughout *Sherman's Campaign*. Three of the album's photographs (plates 14, 15, 47) are "pure" landscapes. Nature completely dominates the military elements of at least four other scenes (plates 9, 12, 13, 18). In many of the remaining views, Barnard balances a picturesque landscape aesthetic with historic and documentary concerns. This synthesis may be seen in his careful use of trees as framing devices (plates 10, 17, 34) or his depiction of a lone rustic cottage (plates 19-21), a traditional icon of the picturesque.

The solitary spectator, or *doppelgänger*, was a characteristic element of the painterly aesthetic of the era. These figures provide a measure of scale and a comforting sense of unity with nature. They also allow audiences a means of empathetic "entry" into the scene. The *doppelgänger* figure was used in paintings and photographs to encourage viewers imaginatively to experience the work from "inside" the frame. Barnard's deliberate use of this motif is seen in plates 4, 18, 29, 44, and 60.

The frequent depiction of water in *Photographic Views of Sherman's Campaign* suggests the importance of this subject in nineteenth-century landscape art. Smooth and peaceful liquid surfaces added meditative elements to paintings and photographs of nature. The transparency and reflective property of water produce extraordinary visual effects while suggesting a mysterious communion between earth and sky. Fifteen plates in *Sherman's Campaign* use water for both emotional and pictorial effect.

114. **attributed to Theodore R. Davis:** *Destruction of Cars by General Hood Previous to the Evacuation of Atlanta, September 1, 1864*; engraving published in *Harper's Weekly*, October 1, 1864; Kansas City Public Library

115. **Thomas Cole:** *The Oxbow*, 1836; oil on canvas; The Metropolitan Museum of Art. Gift of Mrs. Russell Sage, 1908.

116. **John A. Whipple:** *Ruins of the Pemberton Mills, at Lawrence, Massachusetts*; engraving from original photograph, published in *Harper's Weekly*, January 21, 1860; Kansas City Public Library

Clouds represent another important element of Barnard's landscape vision. Clouds had been given particular attention in John Ruskin's *Modern Painters* and such leading American landscape artists as Thomas Cole and Frederic E. Church devoted much time to observing and painting them. Clouds were admired for their delicacy, variety, and color. Their lofty presence overhead suggested an ethereal purity and the mysteries of the infinite. They were also perceived as invitations to reverie and fantasy.[8]

Sentiments such as these prompted Barnard to add clouds to his otherwise blank or mottled skies. Whether created by double printing or (less frequently) by retouching the original negatives, synthetic clouds appear in at least one-third of the album's plates. These clouds added nothing to the documentary value of Barnard's photographs: their sole function was aesthetic. Paradoxically, these clouds enhanced both the naturalism and artificiality of the images by providing a ''painterly'' drama that could not be achieved in straight photography. Barnard's theatrical skies thus drew attention to themselves for their photographic ''impossibility'' and their artistic necessity.

Barnard's depiction of trees reveals a brilliant use of yet another important landscape motif. Trees in American art symbolized the grandeur of the virgin landscape and, by extension, of the nation itself. Gnarled, dead, and splintered trees were frequently perceived anthropomorphically as symbols of turmoil and mortality. Barnard used trees symbolically throughout *Sherman's Campaign*. In particular, his views at Resaca and New Hope Church (plates 19-21 and 25-27) use broken trunks to evoke the firestorm of battle and the human lives shattered in these areas. Barnard's photographs of a brutalized landscape are deeply felt meditations on the waste of war and a larger destruction of national ideals.

Barnard's deft orchestration of painterly motifs is demonstrated in his *Chattanooga Valley from Lookout Mountain, No. 2* (plate 14). This photograph shares a marked similarity in structure and content with Thomas Cole's noted painting *The Ox-Bow* (figure 115). Both pictures present expansive views of a river valley, centering on the curvilinear form of an ox-bow, and framed by a foreground land mass. Cole's painting may have been known to Barnard, but the photographer probably did not consciously attempt to duplicate it. Rather, he simply utilized the compositional and thematic motifs familiar to artists of the period.

Barnard's imaginative synthesis of these motifs is revealed in the similarity between plates 14 and 15 of the album. Both photographs convey dynamic spatial movements from foreground to background, while contrasting the textures of trees, rocks, and water. Both also center on distinctive natural features (ox-bow and waterfall) in the middle distance. In basic composition, these images are, in fact, mirror-images of one another.

An appreciation for ruins was central to the literary and artistic aesthetic of Barnard's era. Ruins inspired romantic meditations on human frailty, the vastness of time, and a larger realm of myth and dream.[9] Decayed structures presented a

174

picturesque counterpoint to the haste and practicality of modern life and cautioned implicitly against excessive human pride. The era's fascination for ruins developed from a combination of sources: the aesthetics of the sublime, the discoveries of early archaeologists, and the popularity of related images in the national press (figure 116).

The theme of destruction runs throughout Barnard's career. The terrible fascination of calamity is revealed in his Oswego fire daguerreotypes, much of his Civil War work, and his 1871 views of the Chicago fire. While the newsworthiness of these subjects is clear, Barnard's depiction of ruins in *Sherman's Campaign* suggests an unusually complex set of associations.

American ruins drew much of their meaning from European models. It was in Italy and Greece that American travelers typically studied the melancholy evidence of ancient civilizations. These sites were impressive for their silence, mystery, and humbling antiquity. American painters such as Thomas Cole and Frederic E. Church drew great inspiration from these sites, and sought a comparable sublimity in their native landscape. Barnard's views of war ruins stem from this artistic tradition. His photograph of the rail depot in Charleston (plate 61), for example, echoes the eerie emptiness and vast space of Cole's *Roman Campagna* (figure 117).

Barnard's album contains several allusions to classical antiquity, reflecting the importance of these cultures to the fabric of American thought. *Sherman's Campaign* begins with images of the Greek revival Tennessee statehouse (plates 2, 3) and ends with Barnard's evocation of a Roman aqueduct (plate 61). Other buildings patterned on classical models are depicted in plates 46, 52, and 55. This theme is explained in part by Barnard's interest in symbols of civic order — including banks and state capitols — that have been traditionally conceived in classical styles.

Barnard's vision of the defeated South in *Photographic Views of Sherman's Campaign* reflected his era's moralistic interpretation of history. It was commonly understood that the fall of Greece and Rome had been caused by malaise, pride, and injustice. Parallels were regularly drawn between these fallen empires and the Confederacy. In 1864, for example, a Professor Tayler Lewis wrote a defense of the Union cause titled *State Rights: A Photograph from the Ruins of Ancient Greece.* Lewis's volume (which has nothing to do with photography itself) argued that the divinely-inspired integrity of nations was far more important than the "petty sovereignty" of every state. "All the dire calamities of Greece," in his view, were rooted in the selfish desire of individual states for autonomy. Lewis stated unambiguously that "God has given us a mirror in the past," and Barnard's photographs cast this analogy into compelling visual form.[10]

The cemetery, another important motif of the period, united aspects of the related themes of landscape and ruins. The iconography of death and bereavement permeated nineteenth-century culture. Barnard's era was characterized by

117. **Thomas Cole:** *Roman Campagna*, 1843; oil on canvas; Wadsworth Atheneum, Hartford. Bequest of Mrs. Clara Hinton Gould.

melancholy sentiment, elaborate rituals of mourning, and a "cult of memory."[11] In the 1830s and 1840s this cultural mood found expression in the rural cemetery movement. The most prominent of these park-like cemeteries were Mount Auburn, Laurel Hill, Greenwood, and Bonaventure, located, respectively, near Boston, Philadelphia, New York, and Savannah. Removed from the haste and noise of the city, these burial grounds represented tranquil islands of introspection in which life, death, faith, and the infinite could be pondered. Rural cemeteries evoked the great religious symbolism of the garden, and embodied the era's picturesque and pastoral landscape ideals. Visitors enjoyed these sites for their beauty, restfulness, and atmosphere of solemn moral instruction.[12] The commemoration of war dead shifted the significance of cemeteries from the realm of personal remembrance alone to one of nationalistic purpose.[13]

The notion of hallowed ground — of sites made sacred by heroic sacrifice — is central to Barnard's work. He recorded graves (figures 39, 44; plates 34, 48), the location of particular deaths (plates 30, 35), and notable battlefields. Indeed, Barnard's concentration on emblems of death and decay give *Photographic Views of Sherman's Campaign* a decidedly funereal air. His collection of views evokes the picturesque solemnity of a vast cemetery: a landscape rendered sacred by the enormity and mystery of death, and capable of stimulating the most profound reflections.

Barnard's photographs suggest a complex duality of meaning. His austere views celebrated the heroism of Union soldiers and, by extension, the Northern cause.

Photographic Views of Sherman's Campaign may also be interpreted as a eulogy for the old South by an opponent of slavery who, nevertheless, had a genuine fondness for the region. Indeed, Barnard would spend one-third of his remaining life in former Confederate states. Barnard's vision in *Sherman's Campaign* transforms the entire South into a melancholy realm of memory and loss, completely removed from the commercial and technological vitality of the North. His photographs suggest that the silence of the region, like that of the rural cemeteries familiar to Northerners, contained important moral lessons.

The genre of history painting was related to that of landscape for its devotion to moralistic and nationalistic themes.[14] The depiction of inspiring historical events — epitomized, perhaps, by Emmanuel Leutze's *Washington Crossing the Delaware* (1851) — was considered "the noblest and most comprehensive branch" of art.[15] In the decades prior to the Civil War, hundreds of artists worked in this genre despite a widely-held belief that the nation's brief history lacked a true grandeur and an appropriate pantheon of heroes. Many felt that this need for a "more historic life, to make us a truly great people" was filled by the drama and terrible sacrifices of the war.[16]

Photographic Views of Sherman's Campaign was one of the most important interpretations of the war to stem from this historical art tradition. Unlike the often overblown allegorical works of the 1850s, Barnard's volume reflected a new artistic interest in contemporary events. In 1866, the year of the album's production, a critic noted that the most valuable historical art was "a record of what the artist sees and knows in his own time."[17] *Photographic Views of Sherman's Campaign* embodied the hope that the war had purged the nation of political and moral impurities, allowing a new unity and greatness of purpose. In certain respects, Barnard's album reflects Horace Bushnell's idealistic view that "our battlefields are henceforth names poetic, and our very soil is touched with a mighty poetic life."[18]

Despite these lofty sentiments, surprisingly few artists chose to depict the recent conflict. The 1867 National Academy of Design exhibition, for example, did not include a single battle painting.[19] This may be explained by artists' declining interest in the historical style, and the disillusioning effect of the war. While eloquent speakers such as Horace Bushnell announced that "our dead...have given us the possibility of a great consciousness and great public sentiments," most Americans were simply numbed by the length and cost of the war.[20] There was a powerful ideological need to justify the horrible losses of 1861-65, but the bitter conflict had undermined the nation's idealistic self-image.

Barnard's album evokes this tension between glorification and disillusionment more fully than any other visual work of the period. Barnard's photographs convey his profound respect for the sites depicted. At the same time, however, *Photographic Views of Sherman's Campaign* is ambiguous in meaning and anti-heroic in mood. It did not reassure viewers that the war represented "the most

glorious genius and deeds of man," or that it had stimulated a "lofty public consciousness."[21] The war of *Sherman's Campaign* is more tragedy than triumph, with waste and emptiness overwhelming any sense of ultimate redemption.

Barnard's vision of the war stems in large part from the limited role played by the human figure. When people appear in Barnard's photographs, they seem to be passive witnesses rather than active protagonists. In Alexander Gardner's *Photographic Sketch Book of the War*, by comparison, people are portrayed more often and more dynamically than in Barnard's volume. The difference is significant. While Gardner evoked a relatively traditional vision of war as a product of human intelligence and action, Barnard's photographs suggest a more modern, and chilling, notion of war as brute power divorced from rational control or personal valor.

Barnard's work thus implicitly questions the importance of individual courage and will. When force replaces conviction as the determining factor in combat, a constellation of cultural values is threatened. Is heroism possible or meaningful in this kind of war? Is there any connection between morality and victory? The war made no sense if such questions could be answered in the negative.

Photography, by its nature, contributed to these discomforting implications. It is instructive to contemplate the depiction of death in Civil War photographs. The vast body of these photographs includes many images of living soldiers, and a much smaller number of views of inert corpses. To this writer's knowledge, however, no clearly identified photographs exist of *dying* soldiers. History painters such as Benjamin West had long recognized that the poignance of wartime death was most powerfully conveyed in the stoicism and unwavering conviction of the mortally wounded soldier. But the technology of Civil War photography made such images impossible. As a result, the emotion and particularity of death went unrecorded by Barnard and his peers. Their resultant photographs seem too often to suggest that wartime death was not a willful sacrifice as much as a mere nullification of existence.

This neutrality is suggested in the contrast between Barnard's *Scene of General McPherson's Death* (plate 35) and an archetypal work of heroic battle art such as Benjamin West's *Death of General Wolfe* (1770). In West's theatrical painting, the handsome young general clings gallantly to life as he comforts, and is comforted by, his retinue. *McPherson's Death* stems from this grand artistic tradition but eschews overt human sentiment for the melancholy associations of the unidealized physical evidence at hand. Far from depicting McPherson's actual death, Barnard could not even record his corpse, and this haunting sense of *absence* characterizes his album: an absence of people, of action, and of moral certainty.

Ultimately, *Photographic Views of Sherman's Campaign* seems to embody Barnard's own shaken faith in the ideology of progress. As a personal, political, and religious ideal, progress represented the ever-increasing perfection of human existence. This concept of continual improvement had given meaning to all

aspects of Barnard's life, and seemed to confirm both human wisdom and the benevolence of God. It was exceedingly difficult, however, to reconcile this optimistic concept with the reality of the Civil War. For many of the period, the death, destruction, and bitterness of the conflict simply could not be convincingly interpreted as evidence of a new national purity and enlightenment.

Barnard's album represents his continued need to believe in rationality, heroism, and progress, and his fear that these traditional values had been tragically compromised by the war. The optimistic, linear trajectory of progress was threatened by a very different interpretation of human destiny: a fatalistic, cyclical pattern of destruction and renewal positing mankind's inherent nihilism against the regenerative power of nature or the purifying fire of biblical apocalypse. The emotional and intellectual power of Barnard's album stems from the dissonance between these views.

Barnard's vision has particular resonance at the end of the twentieth century because we share his fundamental doubt. From the imagery of war and eschatological religion, Barnard depicted a landscape of stillness and destruction. Contemporary apocalyptic visions, while primarily secular, are just as pervasive and forbidding as those of the mid-nineteenth century.[22] For the last thirty-five years we have lived uneasily with a variety of catastrophic threats, ranging from technological breakdown and ecological disaster to the possibility of nuclear annihilation. The savagery and moral ambiguity Barnard sensed in the Civil War have only been confirmed in this century's conflicts, and his metaphor of the silent, brutalized landscape remains powerfully evocative. As Donald Kuspit has written:

> the idea of traditional, limited war implies the intrusion of a particular death in a general paradise; the idea of modern, total war implies the absence of the slightest hint of paradise — of pastoral retreat, of sanctuary — in a general wilderness of death.[23]

It must be emphasized, however, that the meaning of Barnard's photographs cannot be identical for late twentieth-century viewers and those of Barnard's time. Audiences of 1866 were familiar with the events and anecdotal associations of battle sites as only historians are today. It is also very difficult to separate our interpretations of Civil War photographs from a knowledge of the 125 years that have followed. The futile sacrifices of World War I, the holocaust and saturation bombings of World War II, the domestic discord of the Vietnam era, and the ominous threat of automated nuclear destruction all shape our understanding of war, patriotism, and heroism in the modern age. Artists are not clairvoyant, and Civil War photographs do not "predict" these subsequent events. By the same token, however, we should not presume that casual hindsight alone allows us to understand these earlier images. Barnard's work arose from a rich cultural fabric of ideas, aspirations, and possibilities that is different from our own, and can never be completely explained or exhausted.

Barnard's album remains challenging today for its pictorial complexity and narrative ambition. Far more than a simple document of the campaigns of General William T. Sherman, *Photographic Views of Sherman's Campaign*, is, in fact, a remarkable attempt to make sense of American history and the nature of modern war. Barnard's disquieting masterpiece documents the moment when technological power outstripped the limits of human rationality and morality. The scope, thoughtfulness, and subtlety of this work mark it as one of the most extraordinary achievements in nineteenth-century American art.

IV

"a man of long experience and varied accomplishments"

Late Career:

1867-1902

IV: 1 Charleston and Chicago, 1867-1880

After the publication of his album it is likely that Barnard continued working in New York City while his family remained in Syracuse. The Syracuse city directory, which lists only heads of households, identified Barnard as residing at 228 Townsend Street from 1866 to 1868. His occupation was given as "Photographer" in 1866-67, and "Artist" in 1868. However, it is uncertain if Barnard was working in Syracuse at this time. It is possible that his wife and daughter maintained the family household while Barnard visited at irregular intervals from New York. One such visit must have occurred on September 22, 1867, when his daughter Mary Grace Barnard married Edgar O. Gilbert.

Two weeks later, from New York City, Barnard wrote an endorsement for one of E. & H.T. Anthony's products.

> New York, October 6, 1867
>
> Messrs. Anthony,
>
> Gentlemen--I believe I was one of the first to use your celebrated Flint Varnish, and I have continued its use ever since. Having tried many other kinds, I have never found any that has given me the satisfaction that the Flint does, and for durability I believe there is nothing in market that equals it. I owe the safety of all the negatives I took when I accompanied General Sherman in Georgia, entirely to the Flint Varnish. They got such rough usage, that nothing but superior Varnish saved them.
>
> Yours truly,
>
> G.N. Barnard[1]

Barnard's close relationship with the Anthony firm was reflected in a similar endorsement written four years later. In 1871 the National Photographic Association offered prizes for important technical advances. Henry T. Anthony submitted for consideration his process for adding alum to the printing bath. When asked to provide information on the effectiveness of this bath in warm weather Anthony asked Barnard, then residing in Charleston, for his support. Barnard wrote that the addition of alum was "a very valuable discovery" that prevented the discoloration of the paper in "this warm and damp climate." Charles W. Hull, of New York, presented Barnard's letter to the association and testified that the veteran photographer was "an *altogether reliable* man."[2]

Barnard relocated to Charleston, South Carolina, in about 1868. This move was stimulated by a variety of cultural and personal factors. After the war the nation's political attention remained focused on the South and the challenge of reconstructing the region's economy and society. The army had responsibility for preserving civil order in the former Confederate states, and many of the officers Barnard had known during the conflict were involved in this effort or in the work of the War Department's Bureau of Refugees, Freedmen, and Abandoned Lands. The region's shattered economy and civic institutions attracted many northern investors, businessmen and politicians and Charleston drew its share of these ambitious new arrivals.

Charleston had long had strong commercial links with the leading northern cities. Particularly close connections had developed before the war, for example, between the photographic communities in Charleston and New York, and a number of photographers worked in both locations.[3] This exchange was resumed after Appomattox.

Barnard's peripatetic friend Jacob F. Coonley was one of these northern photographers who journeyed to Charleston soon after the war. In 1867-68 Coonley was employed as the manager of Charles J. Quinby's gallery.[4] Quinby had earlier owned a studio in New York City, where he had undoubtedly known both Coonley and Barnard.[5] When Coonley returned north in 1868, it appears that Barnard came from New York to take his place in Quinby's studio. Given Quinby's other financial interests in town (as partner with J.R. Read in the latter's drygoods business) it is likely that Barnard did all or most of the gallery's photographic work.[6] The Quinby Photograph and Fine Art Gallery was located at 261 King Street, above J.R. Read's store, an excellent address in the heart of Charleston's most fashionable commercial district.

During the three years of Barnard's partnership, the Quinby & Co. gallery was respected as one of the finest in the region. In addition to standard carte-de-visite and cabinet card work, the gallery specialized in enlarged photographs made with a "solar camera." These oversize prints were usually hand-painted in oil or India ink, and custom framed. In addition to this studio work, Barnard made stereographs of scenes at Fort Sumter and in the city of Charleston.[7] Several of his 1865 Charleston views were also reissued in the carte-de-visite format under the Quinby & Co. imprint. In addition, Barnard was careful to maintain his contacts in New York. In its issue of September 26, 1868, for example, *Harper's Weekly* published a Quinby & Co. portrait of General R.K. Scott, the Governor of South Carolina, probably taken by Barnard.

Barnard's earlier interest in expositions was rekindled at this time. On October 25, 1870, the local newspaper noted that "yesterday afternoon those accomplished photographers, Quinby & Co.," had made pictures of the grounds of the South Carolina Institute Fair. The fine arts section of this exposition included a handsome "gallery of photographic art, with likenesses of prominent citizens and female subjects, done in the Rembrandt, Porcelain and India Ink styles, and on canvas" from Quinby & Co. Quinby and Barnard were awarded a diploma for the fair's "Best Display of Photographs."[8]

In addition to this photographic work, Quinby and Barnard became engaged in

the promotion and sale of chromolithographs. The history of these mass-produced color prints reveals interesting parallels to the development of photography. The processes were introduced to America at almost precisely the same time: photography in late 1839 and chromolithography in 1840. In addition to its many utilitarian functions chromolithography — like photography — was praised for its democratic, moral, and educational influence.

> Surrounded by such suggestions of the beautiful, and such reminders of history and art, children are constantly trained to correctness of taste and refinement of thought, and stimulated — sometimes to efforts at artistic imitation, always to the eager and intelligent inquiry about the scenes, the places, and the incidents represented.[9]

Chromolithographs were produced of innumerable subjects of aesthetic, historical, and nationalistic interest, including landscapes, genre scenes, and portraits of military and political leaders. These were most frequently acquired by middle-class women eager to beautify their parlors and to demonstrate their good taste.

Beginning in the 1850s, the production of illustrative chromolithographs became big business. The firms of Louis Prang, and Currier and Ives, for example, manufactured thousands of designs in editions that occasionally surpassed 100,000 copies. While most of the nation's chromolithographers were located in New York, prints were sold nationwide through premium systems, traveling salesmen, art galleries, book and furniture stores, stationery shops, and photographic galleries. This national system of production and distribution hit its peak beginning in the 1870s.

The Quinby gallery periodically acquired groups of chromolithographs wholesale, probably from a distributor in New York. Quinby and Barnard had these prints individually framed in black walnut or rosewood, and displayed them in their gallery. Details on the works were provided in specially produced catalogs. These displays drew great public interest and frequent notices in the press.[10] After about a week the works were sold in public sessions conducted by Charleston's leading firm of auctioneers. The framed chromos typically brought $2.00 to $15.00 each at auction, somewhat below standard retail rates.[11]

It was regularly noted that these prints were of an unusually high technical quality, and the product of "English, German, French, Italian and American" manufacture.[12] The pictures sold by Quinby & Co. varied widely in subject matter, but invariably included representations of "the principal works of the great masters." Among the prints sold from the Quinby gallery in 1870 were *Faust and Marguerete, Romeo and Juliet*, copies of Murillo's *Beggar Boys* and Reuben's *Wife*, numerous landscapes, and "natural, historical and physical subjects."[13]

In 1870 the Quinby gallery held at least four of these sales. On May 30 nearly 200 framed prints were purchased in just under three hours of enthusiastic bidding. Another 150 were sold on June 27. Less than two weeks later some sixty chromos, engravings, and pastels were auctioned. And on December 9 yet another selection

of chromolithographs in "Superior Walnut and Gilt Frames" was offered for sale "for the adornment of...drawing rooms."[14]

The success of these sales prompted Quinby and Barnard to expand their operation, which already bore the title "Art Gallery." On June 21, 1870, the *Charleston Daily Courier* published the following notice.

> We...learn, and make the announcement with pleasure, that it is the intention of Messrs. QUINBY & Co. to fit up one of their commodious rooms, the coming winter, as an Art Gallery, where a collection of rare pictures will be kept on exhibition at all times. The Gallery will be open to the public, thus enabling the lovers of the fine arts to pass an hour or two in gazing upon the productions of masters who depict scenes from life quite as true as nature itself. Messrs. QUINBY & Co. deserve great credit for their zeal in this matter, and we hope they will receive sufficient encouragement to enable them to carry out their design...[15]

Exhibitions of prints and paintings were subsequently presented in this renovated space.

Despite the apparent success of this business the Quinby-Barnard partnership was dissolved in the spring of 1871. On May 5, 1871, the studio was sold to Bertha F. Souder, and subsequently operated by Souder's husband or son, Stephen T. Souder, under the firm name S.T. Souder.[16] The assets of the gallery were carefully listed in the official mortgage records:

> one Solar Camera, 4000 Photographic Negatives, four Backgrounds, six Iron Head Rests, one Sarony's Head Rest, two ½-size Voigtlander lenses and box, two 3-inch Globe lenses and box, one 4/4 lens and box, one 12x15 View Instrument, one Photographic Tent, one Copying Instrument, one B[lack] Walnut dressing bureau, eight office chairs, one mirror, one stove, one card press, one Brussels Carpet, one large stereoscopic instrument, two bookcases, one Sofa, [and] one show case at door.[17]

The backgrounds and headrests were standard portrait equipment, while the photographic tent was used to coat and process wet-collodion negatives in the field.

In 1871 Barnard moved to Chicago at the urging of his sister, Mary (Barnard) Hale, and her family. Mary's husband, Samuel Hale, Jr., had established himself as a successful businessman in Kenosha, Wisconsin, before relocating to Chicago in 1857. Hale and his partner, John V. Ayer, first operated a furniture store on Randolph Street. They subsequently entered the iron business and opened a large establishment on Michigan Avenue between Lake and Randolph Streets. Barnard's brother-in-law amassed a "large fortune" in this business, and was an admired and influential member of the community. He was a Republican, a

Presbyterian, and "an energetic, progressive citizen... much loved by all."[18]

Mary Hale had given birth to two sons and two daughters between 1829 and 1839. Their youngest child, Mary Frances Hale, married Reverend James Thomas Matthews in about 1861. From 1860 to 1864 Matthews served as pastor of the First Congregationalist Church in Kenosha, Wisconsin, where he met Mary Frances Hale.[19] In 1864 Matthews and his wife moved to Chicago, where he became pastor of the newly-established Eighth Presbyterian Church on the corner of West Washington and Robey Streets. However, "feeble health" forced Matthews to resign this position in 1868 or 1869.[20]

After his retirement from the ministry, Matthews founded and edited a Presbyterian newspaper titled *The Interior*.[21] The direction of this journal apparently passed out of Matthews's hands, however, and his relatives sought ways to keep him gainfully employed. By this time Barnard had tired of his partnership with Quinby in Charleston. When Samuel Hale offered to underwrite a new photographic gallery in Chicago, to be operated jointly by Barnard and Matthews, the offer was quickly accepted.

Barnard's brother-in-law put up two-thirds of the approximately $6000 required to start the gallery.[22] In late May or June of 1871 Barnard rented rooms at 29 Washington Street, between Wabash and State, in an area known for fine photographic galleries. The office of Barnard's Nashville supervisor, William Le Baron Jenney, was located about four blocks away at 73 Clark Street. Four blocks in the opposite direction, at the foot of Lake Street, was the city's main rail station, the Great Central Union Passenger Depot. Barnard boarded at 470 West Washington Street, next door to the Samuel Hale residence at 468 West Washington. Matthews and his family boarded with the Hales.

Given his inexperience and ill health, Matthews apparently contributed little to the daily operation of the studio. Barnard's two employees, a Mr. Devoe and a Mr. Pond, probably provided all the assistance the veteran photographer required.[23] During its brief existence, it is likely that the Barnard and Matthews gallery operated smoothly and profitably.

When Barnard arrived in Chicago, the city was a dynamic industrial and commercial hub of 300,000 residents. The grain, meat-packing, steel, coal, and lumber industries all had grown at a rapid rate in the years since the war. A superb transportation system made Chicago the focus of both the world's largest inland waterway system, and a rail network that embraced 10,750 miles of lines.[24] Livestock, grain, and a wide variety of raw materials poured into Chicago from all directions. Processed goods were shipped back out on the same routes. The "fervor and devotion and energy" that the city spent on the creation of wealth amazed visitors. Chicagoans, as Louis Sullivan observed, were "the crudest, rawest, most savagely ambitious dreamers and would-be doers in the world."[25] The rough vitality of making, selling, and building dominated the mood and character of the city.

Within five months of Barnard's arrival in Chicago, however, this lively and confident city had been decimated. The most destructive fire in American history broke out at 8:45 on the evening of Sunday, October 8, 1871. Thirty-six hours later 300 persons were dead, 90,000 were homeless, and $192,000,000 of property had been turned into smouldering rubble. Some 18,000 buildings over an area of more than three square miles were destroyed.[26]

Shoddy buildings constructed largely of wood, unusually dry conditions, and a strong southwest wind all contributed to the fire's rapid movement and horrendous devastation. Three-thousand-degree heat melted cast-iron beams and safes.[27] The river itself "seemed to boil, and clouds of steam rose from its surface to mingle with the smoke from the flames."[28] The violent convection currents generated by these temperatures carried sparks and burning material high into the air.[29] The fire thus spread with terrifying rapidity, leaping effortlessly over empty lots, streets, and rivers. Buildings were consumed by the block "within an incredibly short space of time...as if by magic." Even the "fire-proof" structures of iron and brick were destroyed "as though they had been the cardboard playthings of a child."[30]

Residents reacted frantically to save themselves and their possessions. Amidst smoke and flame professional men attempted to rescue papers and equipment from their offices. Under a hellishly lurid nighttime sky families loaded furniture and clothing into carts. Frightened horses ran wild in the streets. It was a scene of apocalyptic destruction that witnesses remembered for the rest of their lives.

Barnard was among those who hastened to the business district some time after midnight on the morning of October 9. On his way to the gallery he located one of his assistants, and the two gathered all the equipment and important papers they could carry. These were probably loaded into a cart. The advancing flames forced the pair eastward toward Lake Michigan. It was noted succinctly in Barnard's 1902 obituary that "he and his printer moved and removed the instruments till they reached the lake, finally deserting them as the flames drove them" into the water.[31] They carried a few of the best lenses and cameras into the cold water of Lake Michigan, holding them overhead as they watched the city burn.

When it was safe to proceed, Barnard worked his way south along the shore of the lake. At a suitable distance from the fire's leading edge he then turned west toward his residence. It may have been after daybreak when he finally arrived home, filthy and exhausted, with a few of his valued instruments.

The fire gradually died out on the morning of Tuesday, October 10. Residents ventured out to gaze in horror and amazement at the wreckage of their city. On October 12 the *Chicago Evening Journal* mourned the devastation:

> Never on the face of the earth has there been so extended ghastly a scene of ruin and desolation as that now presented throughout the destroyed South and North Divisions of Chicago. The ruins of Pompeii, Herculaneum, Rome or Moscow did not present a more awful spectacle. Hundreds of streets — an area of 2,500 acres — are covered

by mere heaps of stone and brick, with here and there a standing wall. For a distance of four miles along the lake front, and a distance of from a mile to half a mile westward, all is one general scene of ruin and desolation.

Thousands of people — men, women and children — are wandering through the desolated streets, like groups of mourners in a vast graveyard.[32]

Photographers flocked to Chicago before the embers had cooled to record the fire's aftermath. As many as thirty cameramen arrived from cities as distant as New York.[33] One of the most productive of these photographers, W.E. Bowman, of Ottawa, Illinois, made a set of 125 stereographs in the days following the blaze. Many Chicago photographers, including P.B. Green, Alfred Hall, Henry Rocher, and the team of Copelin & Hine, also produced views of the ruins. While most of these photographs were made in the smaller stereographic or lantern slide formats, at least two photographers — Joshua Smith and a Mr. Landy — worked in the 14x17-inch format. These views were immensely popular. By the end of November, W.E. Bowman reported selling "tens of thousands" of his stereographs.[34] Joshua Smith later recalled making $5000 from the sale of prints from his 14x17-inch negatives.[35]

It was natural for Barnard to have also photographed the ruined city. As soon as new equipment and materials were located he set to work recording scenes eerily similar to his 1864-65 views of wreckage in Atlanta, Charleston, and Columbia (figures 118-129). Barnard worked systematically, documenting the ruins of such important public buildings as the Chamber of Commerce, Court House, and Post Office, as well as notable banks, businesses, bridges, and churches. His approach to the Court House, at Clark and Washington Streets, is indicative of his working method. After recording this structure through the ruins of several adjacent buildings, Barnard then photographed the city from an elevated position within the Court House, looking southeast, northwest, and then north and south along Clark Street (figures 119, 120).

Barnard's movement through the ruins may be surmised from the sequence of his published stereographs (see Appendix F). Beginning with the Pacific Hotel, on the corner of Jackson and LaSalle, Barnard proceeded north on LaSalle to record the Bryan Block and Republic Insurance Building. At the corner of LaSalle and Washington Streets he photographed the ruins of the Open Board Building (figure 118) and the Chamber of Commerce. At Clark and Washington he made eight views of the Court House, and three of the Fifth National Bank (figures 119-121). At Dearborn and Monroe Barnard documented the wreckage of the Post Office. A block further north, at Madison and Dearborn, he made eight photographs of or from the ruined Tribune Building (figures 122-124).

Moving another block east, Barnard recorded the wreckage of Bookseller's Row, at Madison and State Streets. At State and Washington, near the site of his former studio, Barnard made three views of what remained of the First National

Bank and the prominent drygoods store of Field & Leiter (figure 125). Further east on Wabash Street he recorded the ruins of a Universalist Church.

After making a view of the collapsed Clark Street Bridge, Barnard crossed the river to record the site of the Chicago Historical Society at Ontario and Dearborn (figure 126). Prominently included in the foreground of this photograph are the shadows of Barnard's wagon and camera. In this vicinity he also photographed an Episcopal Church on Dearborn Street, and two other churches at Washington Park (figure 127). Barnard then returned south of the river to document the Van Buren Street bridge (figure 128) and revisit several notable areas. In the course of this work it appears that Barnard or a companion recorded his camera at the corner of Clark and Adams Streets (figure 129). A view firmly identified as Barnard's was made from the precise perspective of the camera depicted in this stereograph.

As a group, these stereographs reveal Barnard's characteristic synthesis of documentary and aesthetic concerns. The vast scale of the destruction is suggested in views along receding streets or from elevated perspectives (figures 118, 120, 124). Other images use relatively close vantage points (figure 125) to convey the calamity of the scene. Barnard's attention to pictorial effect is seen clearly in his views through ruined structures (figures 119, 122, 127). These images use the spatial illusionism of the stereograph to particular advantage while creating complex juxtapositions of architectural form and the effects of sunlight and shadow. Barnard also used the familiar motif of the lone *doppelganger* figure (figures 119, 121, 128) to convey a sense of human scale and pathos. Barnard took occasional creative liberties in making these views. For example, his *Interior of Fifth National Bank — Cooling Off a Safe* (figure 121) is almost certainly a reenactment of events that occurred in the first days after the fire.

Scorched safes and shattered architectural details carried great and tragic symbolism for Chicagoans. It is interesting to note that William Le Baron Jenney, then a rising Chicago architect, was commissioned to design a "Fire Monument, to be Built of Safes and Columns taken from the ruins." Twelve of Barnard's half-stereos were used to illustrate a limited-edition book, titled *The Lakeside Memorial of the Burning of Chicago*, documenting Jenney's planned memorial.[36]

Barnard published many of these stereoscopic views himself from an office at 376 Van Buren Street. However the full set of sixty-three stereo photographs was printed and distributed by the firm of Lovejoy and Foster in a series titled "Among the Ruins of Chicago." After being burned out of their 87 Clark Street address, Lovejoy and Foster quickly opened a new establishment at 309 W. Randolph Street. By October 20 they were advertising "Views of the Ruins" for sale, and six days later their stock of fire photographs consisted of "stereoscopic, 11x14, and card views" available on both wholesale and retail terms.[37]

On the evening of November 1, only three weeks after the fire, Barnard and two other Chicago photographers exhibited "a large collection of stereoscopic views of the ruins" at a meeting of the Chicago Photographic Association. Barnard was

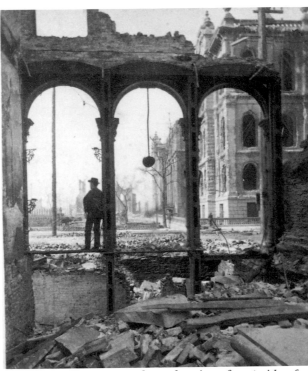

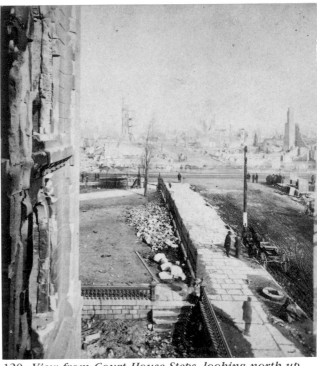

118. *Open Board Building, N.W. Washington St. between LaSalle St. and Fifth Ave., Chicago,* October 1871; stereograph detail (Barnard 7); Hallmark Photographic Collection

119. *Court House, seen through ruins of east side of Clark Street, Chicago,* October 1871; stereograph detail (Barnard 11); Chicago Historical Society

120. *View from Court House Steps, looking north up Clark Street, Chicago,* October 1871; stereograph detail (Barnard 16); Hallmark Photographic Collection

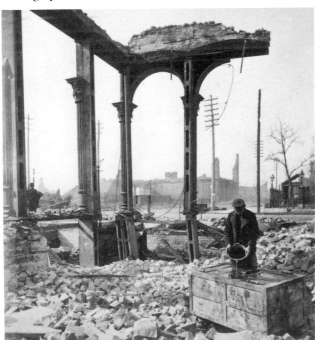

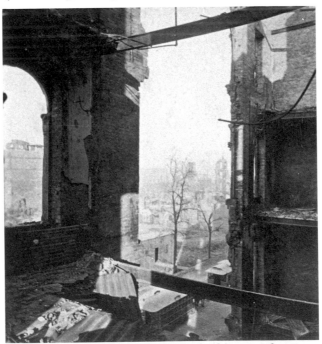

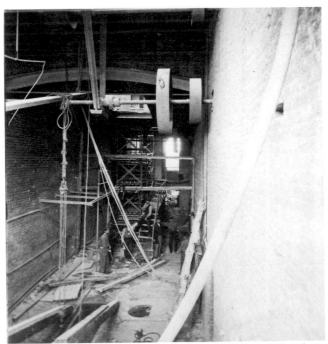

121. *Interior of Fifth National Bank — Cooling Off a Safe, Chicago,* October 1871; stereograph detail (Barnard 20); Chicago Historical Society

122. *View from Tribune Building, looking northeast, Chicago,* October 1871; stereograph detail (Barnard 30); Chicago Historical Society

123. *Press Room in Tribune Building, Chicago,* October 1871; stereograph detail (Barnard 33); Chicago Historical Society

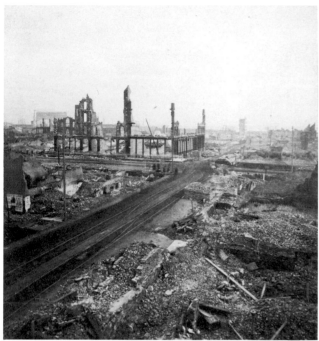

124. *General View of the Ruins from Tribune Building, Bookseller's Row in the centre, Chicago*, October 1871; stereograph detail (Barnard 34); Chicago Historical Society

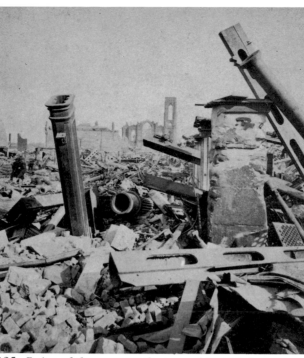

125. *Ruins of the mammoth store of Field & Leiter, corner State and Washington Sts., Chicago*, October 1871; stereograph detail (Barnard 39); Hallmark Photographic Collection

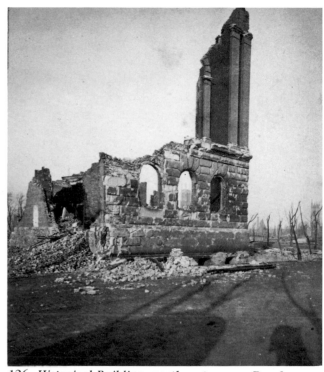

126. *Historical Building, northwest corner Dearborn St., Chicago*; October 1871; stereograph detail (Barnard 44); Chicago Historical Society

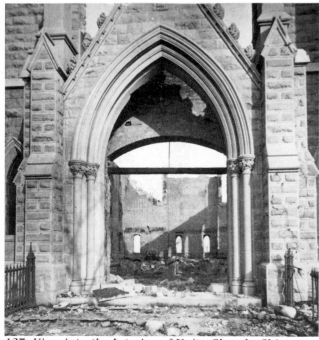

127. *View into the Interior of Unity Church, Chicago*, October 1871; stereograph detail (Barnard 50); Chicago Historical Society

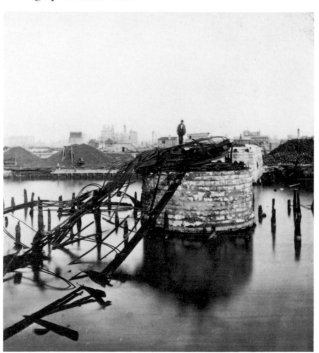

128. *Van Buren Street Bridge, Chicago*, October 1871; stereograph detail (Barnard 59); Chicago Historical Society

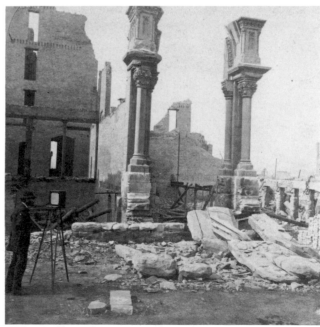

129. **attributed to Barnard:** *Lake-Side Publishing Co., corner Clark and Adams Streets, Chicago*, October 1871; stereograph detail (Lovejoy & Foster); Chicago Historical Society

elected to membership in the group and participated in the evening's topic of discussion, "The Future Prospects of Photography in Chicago."[38]

Barnard also sent copies of these stereographs to friends in New York. On the evening of November 7 "a large collection" of Barnard's Chicago fire photographs was exhibited at a meeting of the Photographical Section of the American Institute. These views were praised as "very beautiful representations of the ruins of the burnt city."[39]

On November 18 a special meeting of Chicago photographers was held to officially tally the profession's losses. Forty photographic businesses had been destroyed, each of which had employed from one to twenty-five persons. In all, some $250,000 in losses had been sustained by the city's photographers. In his turn Barnard told the gathering of his efforts to save his gallery, the extent of his losses, and his plans for the future. The Barnard and Matthews gallery had suffered $10,000 in damages, and expected to receive $3500 in insurance. At that point Barnard noted that he was "making and publishing views [but] not certain of resuming gallery work again.[40]

Barnard was active in the Chicago Photographic Association during the following months. At the group's January 3, 1872, meeting he was one of three members elected to the Executive Committee.[41] At the following meeting, on February 7, he was appointed to a two-man committee to oversee the reading of papers on photographic subjects at each association meeting.[42] On March 8 Barnard was assigned to another committee to plan the group's attendance at the upcoming national convention in St. Louis. He then read a paper on "Successful Retouching," which stimulated "animated discussion." Some members considered retouching "simply a commercial aid [to] sell an otherwise imperfect picture." Others argued that a judicious use of retouching minimized the facial freckles and moles that were "so much exaggerated by the camera." Barnard concurred with the latter view, and "gave an account of some experiments he had made in softening shadows with cyanide."[43] The May meeting of the association was held at Barnard's new gallery on West Madison Street.[44]

The fire had ended Barnard's brief partnership with Matthews. The ex-pastor had contributed so little to the business that further collaboration was apparently deemed pointless. For a few months Barnard carried on his stereographic publishing from his 376 Van Buren Street address. During this time he apparently also photographed Horace White, the respected young editor of the *Chicago Tribune*. In the days following the fire Barnard had made numerous photographs of the ruined Tribune building, including an unusual view of the press room (figure 123). Barnard's portrait of White could have been made at the request of *Harper's Weekly*, which reproduced it on February 24, 1872, with a short profile of the newspaperman.[45]

By May 1872 Barnard was engaged in a partnership with Briggs L. Rider, at 335 West Madison Street. Barnard's new partner had worked in photography for nearly a decade. Like so many other Chicago photographers, Rider had lost everything in the fire. With no insurance to pay for his losses, Rider had subsequently gone to work for Lovejoy and Foster as a printer.[46] In this position Rider printed Barnard's stereographic negatives of the fire, and it is likely that their partnership grew from this contact.

In May 1872 the editor of *The Philadelphia Photographer* visited the leading Chicago galleries to gauge their progress since the fire. The journal reported that in every gallery visited, including Rider and Barnard's, the owners "were cheerful and busy, evincing the pluck and manliness that is so creditable in times of adversity." In this same issue, the editor noted the receipt from Barnard of some "beautiful views" of Chicago. Unfortunately, no information on the format or specific subjects of these views was given.[47]

The Rider and Barnard partnership lasted about a year. By mid-1873 Rider was in business with a Mr. Heywood and Barnard had returned to Charleston.

Barnard had maintained his Charleston affairs while in Chicago. The Charleston city records show that he paid real estate and personal property taxes throughout the early 1870s.[48] During Barnard's time in Chicago, S.T. Souder had occupied the old Quinby rooms at 261 King Street as well as the adjacent 263 King Street address. On July 1, 1873, Barnard purchased the old Quinby & Co. gallery from Bertha Souder for a total of $7000. Included in the gallery's contents were the items listed in 1871, with the addition of a double whole plate camera, two sofas, five plush chairs, a bronze chandelier, and a black walnut writing desk and wash stand. In addition, the Souder firm had added 3500 negatives to the original 4000 included in the 1871 sale.[49]

In each of these transactions, it was considered standard practice for the previous owner's stock of negatives to be transferred with other gallery assets. This very straightforward business concept renders futile any attempt to establish conclusively the authorship of many nineteenth-century photographs. Certain of Barnard's 1865 views were issued on Quinby & Co. mounts in 1869-71 with no credit to Barnard, and many of S.T. Souder's views came from Quinby's stock (and thus could have been originally taken by Barnard). When Barnard repurchased the studio in 1873 his stock of available negatives included images made by Quinby, himself, S.T. Souder, and Souder's employee Frank A. Nowell. Later, after Barnard sold out to Nowell in May 1880, most of Barnard's views were offered for sale under his successor's imprint. Despite these inherent uncertainties, it is probable that the 3500 Souder negatives included in Barnard's stock in 1873 were studio portraits. It is likely that most of the outdoor views bearing Barnard's imprint were, in fact, his own work.

Barnard's gallery occupied the entire third floor, and front half of the second

floor, of a newly renovated building on King Street. The office of Dr. Theodore F. Chupein, a dentist, was located in the rear half of the second floor. The building's first level was occupied by the prominent drygoods business of J.R. Read & Co.

When Barnard returned to Charleston in mid-1873 the city was vigorous and confident. In August of that year the local newspaper noted that the usual summer decline in business had not occurred. In fact, trade had been "far above the average."[50] In early 1874 a traveling journalist noted the "elastic spirit and remarkable courage" of the city's merchants, as well as the lively activity along the waterfront.[51] There seemed much to celebrate in the vitality and beauty of this city of 50,000 residents.

Visitors marvelled at Charleston's luxurious gardens and picturesque magnolia trees. The Battery, with its grand houses and views of the harbor, was also a prominent attraction. On King Street, the location of Barnard's gallery,

> one sees the most activity in the lighter branches of trade; there the ladies promenade, evening, morning and afternoon, shopping; there is located the principal theater, the tasty little "Academy of Music", and there also, are some elegant homes.[52]

Near these attractions, however, the evidence of war remained. As he sailed into the harbor a visiting journalist noted that Fort Sumter lay "isolated and in semi-ruin, looking, at a distance, like some coral island pushed up from the depths."[53] Much of the damage from the city's devastating fire of 1861 remained unrepaired at the time of Barnard's return in 1873. In areas removed from the active harbor area an eerie "stillness of death or desertion" reigned, and many former mansions lay in ruins.[54] Despite the enthusiasm of its business community, the city was deeply in debt and unable to rebuild quickly.

It was probably this very mix of progress and picturesque decay that appealed to Barnard. Charleston's attraction lay, in large part, in its special blend of modern comforts and pre-industrial tradition.

> The city has a character of its own, and is like nothing but itself. It never seems to be growing or racing ahead, like the Northern towns; but finished, complete...with settled, mature ways and habits.

The area was "rich in colonial memories and Revolutionary legends, verified and emphasized by the old houses and gardens," without the "crowding population, the manufactories, the haste and bustle, of the busy North."[55]

Indeed, as the embodiment of distinctly Southern values and traditions, Charleston represented a culture ultimately doomed by the Union victory of 1865. The cultural ideology of the region rested on racial inequality and "the traditional values and networks of family, kinship, hierarchy and patriarchy."[56] As the "center of Southern pride and nationalism," Charleston epitomized these attitudes.[57]

Declining cotton prices had caused the economy of Charleston to stagnate years earlier. This in turn led to a desire to preserve the artifacts and ambiance of an increasingly distant golden age. The region's aristocratic, agrarian ideal was maintained by wealthy planters. Fearful of the social changes that accompanied urbanization, manufacturing, and free labor, this influential class perpetuated an increasingly obsolete pre-industrial society. Charleston "entered the second half of the nineteenth century an economic anachronism" and, despite optimistic reports in the city's press, continued to lose ground after the war.[58] Charleston's anti-industrial reputation attracted fewer outside investors than other southern cities such as Atlanta and Chattanooga. By 1880, when Barnard decided to leave, Charleston was "a minor seaport of little more than local economic and social significance."[59]

During this time the North developed into an industrial capitalist society of large cities, factories, free workers, and class discord. The North's urban density, rapid technological and industrial development, and increasingly powerful central government had given it a great wartime advantage over the Confederacy. Indeed, these values came increasingly to be seen as progressive, mainstream *national* values. For many Americans, however, this cultural shift was discomforting and alienating. For them the South's slower pace of change, largely agrarian economy, and rigid social structure seemed the last vestige of a comfortably "traditional" way of life.

This image of the South must have been particularly apparent to Barnard on his return in 1873. The contrast between Chicago and Charleston could not have been greater. The cities had a six-fold difference in population and an immeasurable dissimilarity in pace, ambiance, and historical associations. Much of Chicago's relatively brief history had been erased by the fire of 1871, and the city's rapid regrowth only emphasized its orientation to the uncertain potential of the future rather than the comforting patterns of the past. Chicago's innovative architecture symbolized its culture: urban form tended to follow economic function rather than traditional aesthetic notions or preservationist sentiment.

As the manufacturing and financial hub of the entire American midwest, Chicago operated at a frenetic pace. Charleston, by contrast, relished its relaxed life and sensual pleasures. Many inland planters owned townhouses in Charleston, which served as the "leisure capital" for this "idle aristocracy."[60]

A variety of attractions reinforced in these languid visitors the faded glories of the past. The Charleston area was steeped in history and natural beauty, with a romantic abundance of time-weathered ruins and exotic foliage. The city was bounded by the picturesque Ashley and Cooper Rivers. The Ashley "was once the scene of great magnificence, the residences and the ways of living being modeled upon those of the English nobility..."[61] Drayton Hall, a dozen miles upstream from Charleston, was one of the few surviving relics of the Ashley's former grandeur. This mansion had been built in 1738 from the costliest materials. By the 1870s it was a ghostly shell (figure 131).

A half-mile from Drayton Hall lay the world-renowned Magnolia Gardens (figure 132). This twenty-five-acre preserve featured an extraordinary abundance

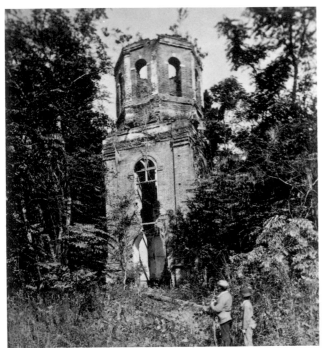

130. *Ruins of the Old Dorchester Church on the Ashley River*, ca. 1874-75; stereograph detail (Barnard 54); South Carolina Historical Society

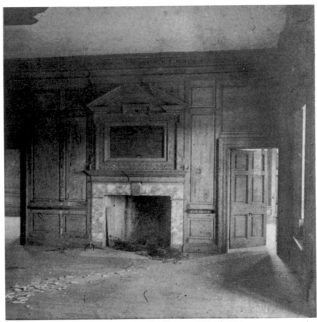

131. *Interior of Drayton Hall*, ca. 1874-75; stereograph detail; Charleston Museum

132. *Magnolia Gardens*, ca. 1874-75; stereograph detail; Onondaga Historical Association

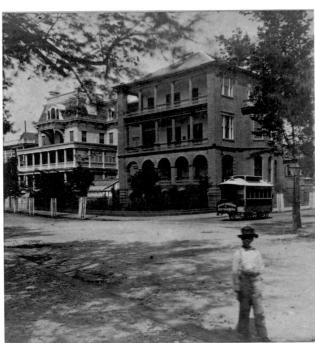

133. *South Battery, from Meeting Street, Charleston*, ca. 1873-76; stereograph detail (Barnard 57); New York Public Library

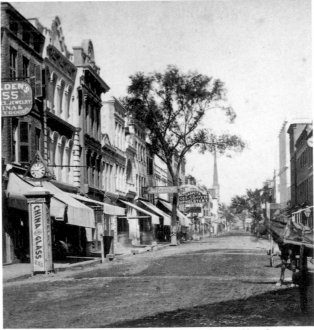

134. *View of King Street, from Beaufain, Charleston*, ca. 1873-76; stereograph detail (Barnard 12); Hallmark Photographic Collection

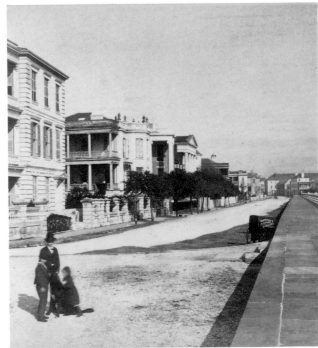

135. *East Battery, Looking North, Charleston*, ca. 1873-76; stereograph detail (Barnard 2); private collection

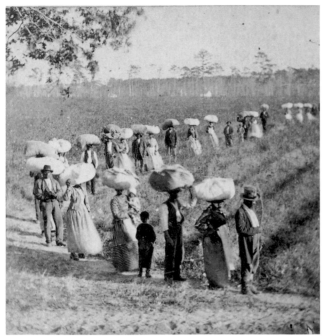

136. *Laborers Returning at Sunset from Picking Cotton, on Alex. Knox's Plantation, Mt. Pleasant, near Charleston, S.C.,* ca. 1874; stereograph detail (Barnard 84); Hallmark Photographic Collection

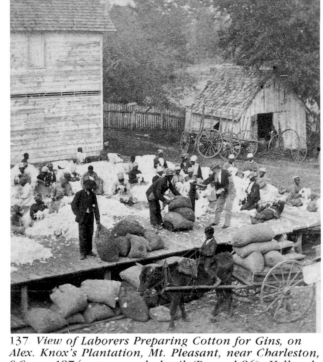

137. *View of Laborers Preparing Cotton for Gins, on Alex. Knox's Plantation, Mt. Pleasant, near Charleston, S.C.,* ca. 1874; stereograph detail (Barnard 86); Hallmark Photographic Collection

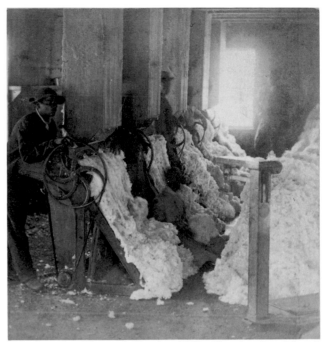

138. *Interior View of Ginning Mills Ginning Sea Island Cotton, on Alex. Knox's Plantation, Mt. Pleasant, near Charleston, S.C.,* ca. 1874; stereograph detail (Barnard 85); Charleston Museum

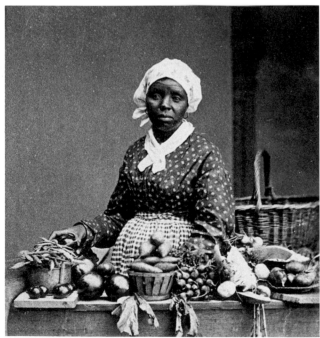

139. *Market Woman, Charleston,* ca. 1874-75; stereograph detail (Barnard 73); Onondaga Historical Association

140. *Fifteenth Amendment — A Good Specimen,* ca. 1874-75; stereograph detail (Barnard 48); New York Public Library

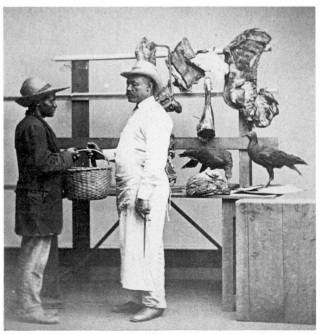

141. *Market Scene,* ca. 1874-75; stereograph detail (Barnard 24); Onondaga Historical Association

of azaleas, live oaks and other rare trees and shrubs. Magnolia was described enthusiastically as "a mad artist's dream of hues; it is like the Arabian nights; eyes that have never had color enough find here a full feast, and go away satisfied at last."[62] Appropriately, Barnard's unusually large stereographs of this site were brilliantly hand-colored.

Seventeen miles from Charleston lay Goose Creek, a branch of the Cooper River. This area had been "the most wealthy and thickly settled neighborhood in the province, and the favorite residence of distinguished families."[63] Magnificent avenues of century-old oaks lined what had once been the entrances to baronial estates. With most of these mansions now gone, these sheltered passageways evoked a melancholy sense of mortality and nostalgia.

In the mid-1870s Barnard issued a large series of stereographic views of these and other characteristic subjects in and around Charleston. Intended primarily for tourists and local collectors, these photographs avoided most evidence of wartime damage, economic malaise, or radical social changes. Traveling in his well-equipped photographic wagon, Barnard recorded prominent structures in Charleston such as the Old Post Office, Market Hall, and the Orphan House ("the finest public building in the city"), as well as noted monuments, churches, and residences. From the top of the Custom House and St. Michael's Church he photographed the city's rooftops and harbor. He also recorded King Street, Broad Street, White Point Gardens, the East and South Batteries, Magnolia Cemetery, and other points of interest (figure 133). In a stereograph titled *King Street from Waverly House, looking North* (figure 134), Barnard was careful to include his own gallery prominently in the scene (the second building on the left side of the street). In another view from this series Barnard recorded his photographic wagon parked at the Battery (figure 135).

Barnard promoted these views locally and nationally. In a city directory of the period Barnard advertised himself as a "Portrait and Landscape Photographer" with a wide selection of "Stereoscopic Views of Charleston, Fort Sumter, Old Goose Creek, Ingleside, Drayton Hall, Magnolia Gardens, painted and plain, and other points of view in this vicinity." These were offered on both wholesale and retail terms.[64] He also sent samples of these photographs to *Anthony's Photographic Bulletin* in New York. The journal's June 1875 issue noted the receipt "from Mr. G.N. Barnard [of] a number of artistic size stereos of the grounds at Magnolia, on the Ashley River, the residence of Rev. J.G. Drayton — perfect specimens of sylvan beauty."[65]

In about 1874 Barnard made a particularly impressive stereographic series on a plantation at Mount Pleasant, across the river from Charleston. The photographer documented various structures on the estate of Alexander Knox, including the old homestead, cottage, stables, and sawmill. He also recorded such aspects of the cotton industry as workers picking in the fields and the interior of a ginning mill (figures 136-138). Despite the size and uniqueness of this series, Knox was not a particularly notable planter. He had only acquired this property in 1873, and may have resided in the area for a relatively brief time.[66]

Barnard's depiction of black laborers in these images suggests the popular market for views of the "traditional" South prior to Emancipation and the upheavals of war. In paintings and photographs of the 1870s, freedmen were frequently portrayed in characteristic tasks on cotton or tobacco plantations. The theme of cotton pickers, seen in Barnard's stereographs, was also explored by the painter Winslow Homer, and regional photographers such as J.A. Palmer, of Aiken, South Carolina, and J.N. Wilson, of Savannah, Georgia.[67]

In addition to his outdoor images, Barnard created a fascinating series of black subjects in the studio. His portraits of female street vendors are carefully composed and deeply respectful (figure 139). While visitors to Charleston bought these images as examples of local "types," Barnard succeeded in conveying some sense of each subject's individuality. Like his *Woodsawyer, Nooning* of twenty years earlier, these images celebrate the virtues of personal initiative and honest labor.

Barnard's hopeful idealism regarding the future of Southern blacks is indicated clearly in his stereograph of an attentive child titled *Fifteenth Amendment — A Good Specimen* (figure 140). Made in an age of growing Ku Klux Klan violence in the South and eroding support for the liberal goals of Reconstruction in the North, this photograph represents an unambiguous political sentiment. The rights of newly-freed slaves had been written into law during the first years of Barnard's residence in Charleston. The Fourteenth Amendment, approved on July 28, 1868, guaranteed citizenship for blacks. The Fifteenth Amendment, ensuring the right to vote, was passed on March 30, 1870. Both measures had been controversial. The second, however, was considered particularly radical by many whites. For blacks, it was an occasion for public celebration.[68] The right to vote meant (in theory at least) that blacks would enjoy political as well as economic freedom, and thus would be full and equal American citizens. This dignified depiction of a well-dressed, intelligent child suggests Barnard's confidence in the outcome of this momentous social change.

In his *South Carolina Cherubs (after Raphael)*, Barnard created a sensitive and particularly complex image of young black models (figure 143). Patterned directly on a detail of Raphael's famous *Sistine Madonna* (figure 142), this homage reveals the photographer's admiration for the great art of the past and the sophistication of his own pictorial ideas.

Raphael's painting was a powerful religious icon for nineteenth-century viewers. As a work of art, it is also a brilliant synthesis of palpably real figures and a deliberately theatrical effect. The strong physical presence of the Madonna contasts markedly with the *trompe l'oeil* framing device of the parted curtains and foreground parapet, which emphasize the two-dimensionality of the major figures and the space they inhabit. Two winged cherubs rest on the pictorial "shelf" at the

bottom of the canvas and seem to project from the painting's virtual space into the actual space of the world. These somewhat irreverent figures are thus emblems of both the ideal heavenly realm and the illusionistic conventions of painting itself. Barnard's stereograph evokes similar spatial effects: his models rest their arms on a narrow horizontal plane with only the slightest hint of space behind them.

Barnard's image is much more than a simple replication of Raphael. Respecting the inherent specificity of his medium, Barnard does not attempt to embellish his models with *papier-mache* wings or surround them with billowing cotton clouds. Instead, Barnard's title and direct, naturalistic style clearly identify this image as a product of his own time and place.

This unaffected photograph nevertheless suggests important parallels between the historic past, timeless sacred truths, and the events of the post-Civil War era. Barnard's use of young black models in this image is strongly indicative of his sympathy for the goals of Reconstruction. For example, this stereograph suggests the dual meaning of "cherub," as both an angel renowned for knowledge and a particularly beautiful and innocent child. Barnard's angelically serene models thus may be seen as symbolic of individual grace and the intellectual potential of an entire people.

By restaging this detail of Raphael's famous painting, Barnard evoked the original in the minds of knowledgable viewers. The central subject of Raphael's majestic painting — the Madonna and Christ child — in turn suggested the full symbolic meaning of the stereograph. Raphael's cherubs and Barnard's youths are all participants in events of profound human significance: the salvation of mankind and the freedom of an oppressed race. Barnard's models are thoughtful, patient, and serious, as if already aware of the moral and social importance of their lives.

In *Market Scene* (figure 141) Barnard introduced a comic element to these studio tableaux. In this rather odd image, buzzards nibble on a butcher's wares as he politely waits on a customer. Barnard focussed more closely on these stuffed birds in another studio image entitled simply *Buzzards*.

Barnard's advertisements in the *Charleston News and Courier* reveal much about the nature of his business. His first, submitted for publication on July 7, 1873, simply stated his acquisition of the Souder establishment and his intention to "continue the photographic business in all of its branches."[69]

On March 11, 1874, Barnard published a large advertisement promoting his expertise "with all the latest improvements in the Art." In addition to a new series of stereographs of Charleston and vicinity, the photographer noted his ability to copy old pictures "to any size or style, plain or painted in Oil, Water Colors, Crayon, or Ink." Barnard stated that "especial attention" was given to baby pictures and that he possessed a uniquely "quick working instrument" for this purpose. He also indicated that views of residences and of "large and small machines" were a specialty. Customers were assured that they would receive

142. **Raphael:** *The Sistine Madonna*, 1512-13; oil on canvas; Art Resource, New York

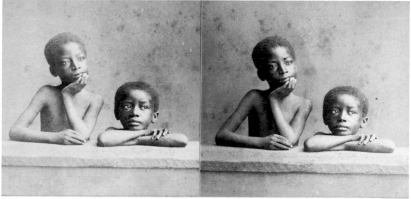

143. *South Carolina Cherubs (after Raphael), Charleston, S.C.*, ca. 1874-75; stereograph (Barnard 70); Charleston Museum

191

consistently fine service, since "Mr. Barnard personally attends to all sittings."[70]

The range of services offered in this advertisement suggests the many applications of photography during this period. While portraiture still represented the bulk of the profession's business, a variety of other uses had become economically significant. In 1871, for example, *The Photographic Times* noted the growing demand by merchants and manufacturers for photographs of their products:

> Where the commercial traveller formerly carried great trunks of samples with him he now takes but a small case of photographs. They represent his wares to the satisfaction of buyer and seller, and make sales as readily as samples of the goods themselves. The furniture dealer may thus cram a whole set of household furniture into his side pocket; the hardware man may pack anvils, and vises, and cutlery...by the ton, into his valise, while the builder of locomotives may carry a dozen of them in a small parcel....The manufacturers of chandeliers and gas-fixtures display some of the most beautiful photographs we have ever seen.[71]

Barnard's advertised ability to record "machines" of various sizes suggests that he was familiar with this aspect of commercial work.

144. Barnard Studio Interior, Charleston, ca. 1870s; stereograph detail; Onondaga Historical Association

On the evening of November 13, 1875, for the second time in only four years, Barnard again lost his gallery to fire. At 11:30 on a Saturday night a blaze broke out beneath the staircase leading to Barnard's second-floor studio. The fire, subsequently attributed to arson, damaged a number of businesses and resulted in property losses of nearly $100,000. The *News and Courier* noted that

> Mr. Barnard, the well known photographer...lost one of the finest and most complete stocks of photographic material in the South. His studio contained the negatives of all the places of prominence and interest in and around the city, and those also of probably two-thirds of the residents of Charleston, embracing the collection of nearly twenty years. The stock was valued at not less than $15,000, and was insured for $6,000....It was totally destroyed.

Included in this loss was an exhibition of paintings, valued at $600, by a local artist named Henri Collin.[72]

Within ten days Barnard had acquired "a complete set of new and improved Instruments, New Materials and a full assortment of fine Frames," and was prepared once again "to give good work at reasonable rates."[73] On November 24 the *News and Courier* noted Barnard's recovery:

> Barnard, the popular photographer, whose gallery was burnt out lately, announced that he will be prepared, on Saturday next, at his temporary location, corner of King and Liberty streets, to make pic-

tures in his usual excellent style. Everybody will be glad to hear this, for Barnard has become one of the institutions of Charleston.[74]

While construction proceeded on a new three-story building at his former address, Barnard spent the winter of 1875-76 in temporary quarters nearby.

The new structure at 263 King Street was finished in April 1876 and quickly praised as a tasteful and handsome addition to the city's business district. On the evening of April 10, 1876, the building's completion was celebrated in what the newspaper described as "the event of the season on King Street." From seven to ten in the evening the J.R. Read drygoods store was opened to public inspection. At ten o'clock,

> the proprietors and employees of the establishment, together with a number of invited guests, repaired to the second story and joined the architects in a bountiful champagne lunch, provided jointly by Read & Co. and Barnard, the great photographer, who occupies the upper stories of the new building. While the company were discussing the viands, the St. Patrick's Cornet Band appeared upon the scene and enlivened the occasion with the sweet strains of music.[75]

The "bountiful champagne" suggests, at the very least, that J.R. Read did not share Barnard's earlier temperance beliefs.

In his advertisement of April 12, 1876, Barnard noted that he had "fitted up his Rooms with all modern improvements and supplied himself with new and costly instruments." In an editorial in the same issue, the newspaper praised Barnard's new quarters.

A Splendid Picture Gallery. — Barnard, the favorite Charleston photographer, announces this morning that he is ready for business in the new, capacious and really elegant gallery which has been constructed for him at his old stand over the store of J.R. Read & Co. His establishment, though not yet fully completed, may, nevertheless, fairly claim to be the finest photographic studio in this section of the country. From the new and improved skylight, to the reception room with its frescoed walls and beautiful pictures and furniture, no pains or expense has been spared to render each department as nearly perfect as possible. This has always been the favorite Charleston gallery, but Barnard's extensive improvements have made it more attractive than ever.[76]

Barnard occupied the second and third floors of this new structure. The studio entrance featured modern gas fixtures and display cases filled with examples of his work. The carpeted reception room was equipped with a chandelier, parlor stove, numerous pieces of plush furniture, two additional display cases and frescoed walls.[77] (It may have been this room that Barnard proudly recorded in an undated stereograph reproduced here as figure 144.) Before posing for his camera visitors composed themselves at a marble-top washstand equipped with a large mirror. Portraits were taken in the sitting room, which contained a special posing chair, headrests of various sizes, and a painted scenic backdrop. The studio was well equipped with cameras in the stereoscopic, 8x10-inch and 14x17-inch formats, as well as a variety of lenses.[78]

On August 16, 1876, Barnard began running an advertisement promoting his new gallery as "the Most Spacious and Elegant Photographic Establishment in the Southern States." The copy of this ad stressed Barnard's ability to make "every description of PORTRAIT, from the smallest Ring Medallion to the life-size Picture in Oil."[79]

Among those who sat for a portrait in Barnard's studio were the photographer himself (figure 145) and members of his family. Barnard maintained close ties with his daughter, Grace Barnard Gilbert, who probably visited Charleston several times from her home near Rochester, New York. Each visit was probably commemorated by a studio portrait. During one winter visit Grace Gilbert posed in her most elegant outfit for an unusual full-length portrait (figure 147). On one or more of these visits, Barnard's daughter was accompanied by her husband's widowed mother, Emma Jane Chapin Gilbert. Despite her rather stern appearance before the camera (figure 146) Mrs. Gilbert and Barnard had warm feelings for one another and were married several years later.

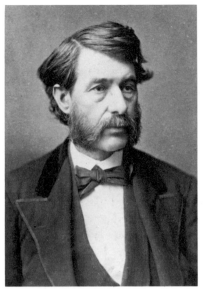

145. George N. Barnard, Charleston, ca. 1873-75; carte-de-visite; Onondaga Historical Association

146. Emma Jane Chapin Gilbert Barnard, Charleston, ca. 1873-75; carte-de-visite; Onondaga Historical Association

During his years in Charleston, Barnard maintained his ties to the national press. In 1874 his photographs were reproduced as wood-engravings in a series of articles in *Scribner's Monthly* devoted to the southern states. Several views from Barnard's 1866 album (plates 12, 47, and 51) were used without credit as source material for these illustrations. His stereographs of Charleston may also have served as the basis for illustrations of such subjects as the Battery, Roper Hospital, the Orphan Asylum, and Magnolia Cemetery.[80] Copies of these photographs could have been purchased by the *Scribner's* writer during a visit to Charleston in early 1874, or they may have been available in New York through other sources.

Between 1876 and 1878 four of Barnard's Charleston scenes were also published in *Harper's Weekly* to accompany short articles. These included an image of the new Fort Moultrie Centennial Monument (issue of July 8, 1876), two views of the cotton wharfs (January 19, 1878 [figure 148]), and a photograph of the Liberian ship *Azor* (April 20, 1878). The latter cut depicted the first ship to take former slaves from the American South to Liberia, where they hoped to begin a new African nation. *Harper's* noted that the ship's owners planned to convey up to 250 passengers on each trip, and that the vessel would return with African produce. Other examples of Barnard's outdoor work were included in the 1880-81 *State Gazetteer*, which reproduced wood-engravings of photographs of the Charleston Library and Custom House.[81]

147. Mary Grace Barnard Gilbert, Charleston, ca. 1868-71; cabinet card; Onondaga Historical Association

In 1877 Barnard's technical interests led him to adopt the carbon process. Introduced in England in the 1860s, this method of printmaking was celebrated for its rich and stable image. The tendency of silver prints to fade prompted a lengthy quest by nineteenth-century photographers to find a truly permanent photographic process. In the 1860s and 1870s, this search led to the use of a variety of new techniques, including the carbon, woodburytype, collotype, and artotype processes.

Soon after its introduction in the United States in 1867, the *New York World* enthusiastically praised the carbon technique.

> As far as pictorial beauty is concerned, we have never seen anything in silver that compares with the new prints....The minutest details of the finest negative, each delicate gradation of light and shade, and every monochromatic tint possible in art, is reproduced with an accuracy that is truly remarkable. The albumen gloss so much objected to in silver prints is rendered unnecessary by the new process, and the lusterless surface adds greatly to the effect of the pictures. The permanency of this work, however, is its chief advantage....The image is taken on a bed of India ink, carbon, or some other permanent pigment, and it may be easily demonstrated that the picture will last as long as the paper on which it is printed.[82]

Although their beauty and permanence were widely acknowledged, carbon prints were about three times more costly and time-consuming to produce than standard albumen prints. These drawbacks quickly discouraged some American photographers from pursuing the complex process. Alexander Hesler, for example, felt that carbon "is at present too much trouble to make people appreciate the difference, and pay the advanced price over silver prints."[83] But, while it never achieved the dominance predicted by its adherents, the carbon process was actively discussed in the 1870s and used successfully by a number of photographers.

The American popularization of the carbon process was stimulated by Leon Lambert. In 1876 Lambert arrived in the U.S. from England to promote his method of carbon printing, modestly named the "Lambertype." Lambert's business was aided by the support of the Anthony firm, which held an exhibition of 355 Lambertypes in January 1877.[84] Barnard was impressed with the process and by early November of that year was advertising his expertise in carbon.

ONE OF THE GREAT PROBLEMS
OF SCIENCE SOLVED.

———

PERMANENT PHOTOGRAPHS AT LAST.

———

Mr. BARNARD, at great expense, has purchased The Sole
Right for this City to make the

PATENT CARBON PHOTOGRAPHS.

This new method of producing the Photo-Portrait while preserving all the softness, delicacy and excellence of the finest chemical Photographic picture, has all the PERMANENCE OF THE STEEL ENGRAVING, thus overcoming the great objection to the ordinary photograph that it will fade in a few years.

Permanent Photographs made from old negatives at reasonable rates.

The public are cordially invited to call and examine Specimens at

BARNARD'S GALLERY,

263 King street.[85]

A year later Barnard advertised that his was the "only Gallery in the State where PERMANENT PHOTOGRAPHS are made."[86]

On December 20, 1877, Barnard attended a large gathering of "carbon workers" in New York held in conjunction with an exhibition of "Permanent Photographs" made by the process. At this meeting a national organization of Lambert's licensees was formed, with "vice-presidents" chosen for each state of the Union and province of Canada. Barnard was selected to represent South Carolina in this capacity.[87] In the spring of 1880 he was also named to the Executive Committee of a new group, the Photographer's Association of America.[88]

While Barnard participated in such professional organizations throughout his long career, his public involvement in non-photographic activities was much less common. He does not appear, for example, to have taken any public stance on the political issues of his day. It is revealing, therefore, that Barnard's interest in the fine arts prompted him to join other professional men in Charleston in sponsoring a fundraising theatrical production. The objective of this December 13, 1877, play was to raise money for a bronze bust of the local writer William Gilmore Simms (1806-1870). The bust was to be placed on a granite pedestal in Magnolia Cemetery.[89] Barnard's photograph of this memorial was subsequently published as an engraving in *Frank Leslie's Illustrated Newspaper*.[90]

Simms, a Charleston native, had been "the most prolific, the most versatile, and the most successful Southern antebellum man of letters."[91] Between 1833 and 1859 he published more than thirty works of romantic fiction, as well as other volumes of history and biography. Simms's oeuvre celebrated the character, history, and social structure of the South, and he was an ardent defender of both slavery and the Confederacy. At the time of his death Simms was "a symbol of Southern nationalism...heroism and dedication."[92] Barnard's commitment to honor Simms' memory suggests something of the photographer's literary taste as well as his natural inclination toward a project of such fervent local interest.[93]

The competitive pressure toward lower prices remained an integral part of the photographic profession, particularly in the lean times of the mid-1870s. The Panic of 1873 had begun in September of that year with the failure of a leading banker's attempt to finance a new railroad line. The collapse of Jay Cooke and

148. Cotton Wharves, Charleston, ca. 1877; engravings from original photographs, published in *Harper's Weekly*, January 19, 1878; Kansas City Public Library

BARNARD'S

Photographic Gallery,

No. 263 King Street, Charleston, S. C.

*All persons wishing Photographs of any Size
or Style, should not fail to make a
visit to this well-known*

GALLERY OF ART,

——IT IS THE——

Largest and Best=Arranged Gallery

—IN THE STATE.—

The PRICES HAVE BEEN REDUCED, and the work improved. The very
best material used, and satisfaction guaranteed to all. Old Pictures
Enlarged to any size, colored, or in Ink or Crayon.

A Large Assortment of Frames

ALWAYS ON HAND,

☞ And will be sold at very Low Prices. ☜

Velvet Goods in Great Variety.

☞ *Call and be Satisfied before giving your
orders elsewhere.*

149. Advertisement in 1880-81 Charleston city directory; Charleston
Library Society

Company in Philadelphia grew into the first major depression of the industrial era, lasting until at least 1878. These were years of steadily declining prices, bankruptcies, and rising unemployment.

Given this economic climate, Barnard was keenly aware of the need to promote his services on the basis of both quality and affordability. In 1876 he had advertised "PRICES TO SUIT THE HARD TIMES" within copy otherwise devoted to the craftsmanship and artistry of his work.[94] By November 1878 his ads emphasized the issue of cost above all other factors, with "reduced rates" for all sizes of photographs and frames "cheaper than ever."[95] In late 1879, with the national economy in the process of slow recovery, Barnard promoted his gallery as "the largest and best arranged" in the state, with reduced prices, improved work, and "the very best material used" (figure 149). At this time he also carried frames and "velvet goods in great variety."[96]

By the spring of 1880 Barnard decided to leave his business for "reasons of health."[97] At the age of sixty he had probably wearied, once again, of the daily studio routine. He also expected that the proceeds from the sale would allow some financial freedom. In May 1880 he sold his gallery to Frank A. Nowell, a 33-year-old photographer then working next door at 267 King Street in the studio of J.H. Anderson. In the early 1870s, before his employment with Anderson, Nowell had worked for S.T. Souder in the studio subsequently purchased by Barnard. Nowell announced himself as "Successor to G.N. Barnard" in an advertisement dated May 11, 1880.[98]

Nowell operated this business for nearly a decade, reissuing many of Barnard's images under his own imprint. Nowell was plagued, however, by chronic financial difficulties. He had agreed to pay Barnard a total of $5000 for the gallery and its contents in thirteen promissory notes due between January 1881 and June 1885. This schedule was gradually stretched out, and the final note for $600 remained unpaid at the end of 1888. Barnard finally received his money when John R. Read, the owner of the drygoods business beneath the gallery, bought this last note in January 1889. A year later, with Nowell unable to make payment to Read, the gallery was closed and its contents sold for $1000.[99]

IV: 2 Late Work: 1880-1902

From Charleston, Barnard moved to the suburbs of Rochester, New York, to live near his daughter's family. Mary Grace and her husband, Edgar O. Gilbert, a farmer, had lived in the town of Henrietta for more than a decade on an eighteen-acre plot of land. In 1880 the Gilbert household included Edgar (age 37), Grace (31), sons George (11) and Orlin (7), and Mary Bycroft (21), a domestic servant.[1]

There were other reasons, apart from his health, for Barnard's move north. He had apparently been living alone since separating from his wife, Sarah, as early as the mid-1850s.[2] Emma Jane Chapin Gilbert, the widowed mother of Barnard's son-in-law, had also been single since the death of her husband in 1849. After her son's marriage to Mary Grace Barnard, Mrs. Gilbert resided with the young couple. Barnard and Mrs. Gilbert grew closer over the years, and she visited the photographer in Charleston in the 1870s. They decided to marry in the first half of 1880. By June 10 of that year, when they were visited by a census taker, Barnard and his new wife were established in their own household. Harvey Jackson, a 57-year-old bachelor farmer, boarded with the couple.[3]

Barnard may have assisted on his son-in-law's farm in Henrietta. Most importantly, however, he maintained his photographic contacts and kept abreast of technical progress in the field. Given his experience and knowledge it is not surprising that Barnard soon became associated with George Eastman's nascent dry-plate business in nearby Rochester.

Since the beginning of his photographic career in 1846, Barnard had seen radical changes in the profession. The daguerreotype portrait had been replaced by the ambrotype, tintype, carte-de-visite, and cabinet card formats. The wet-collodion glass plate negative process allowed the practical introduction of paper prints, while stereo photography had been immensely popular from the end of the 1850s. Barnard had mastered all of these, and other, processes. In 1880 he was fascinated by the rise of the dry-plate technology.

Introduced on a limited basis in the late 1870s, the mass-produced gelatin dry-plate soon eliminated the wet-collodion process from the market. The dry plate offered many advantages of convenience and speed. Indeed, photographers found the dry plate to be four to ten times more sensitive than the earlier wet plate. This increased speed permitted successful images of fidgety children or pets, and of adults on overcast days. One studio owner reported his success with the most difficult subject imaginable:

Last week I made a portrait of a lunatic, whose expression changed about forty times a minute, and secured a very fine negative in a second or so. Ultimately, I presume, dry plates will become invaluable to any photographer, especially for groups, aged persons, children, the sick, and for late afternoon sittings.[4]

Another photographer succinctly stated that "by the use of the Eastman Dry Plates on dark days, late in the afternoon, for children's groups, and other difficult subjects, I have secured a great many dollars which otherwise I should have lost."[5] Despite their advantages, however, the new plates were difficult to use. Their manufacture was at first inconsistent and many photographers were wary of the expensive and frequently unpredictable new product. Even experienced photographers had to be instructed on the care, exposure, and development of these plates.

George Eastman had begun in photography as a serious amateur in 1878. Fascinated by the potential of the dry-plate process, he soon acquired the financial backing to begin the Eastman Dry Plate Company in Rochester. The success of Eastman's plates led to a distribution relationship with the Anthony firm, with which Barnard had long been associated. Although there were some twenty-eight businesses manufacturing dry plates by the end of 1883, Eastman's company was destined for dominance in the field.

Anthony's Photographic Bulletin described the busy Eastman Dry Plate Company in its November 1881 issue. The journal noted that although dry plates had been "introduced commercially in this country but little more than a year ago, their manufacture has already become an important industry." This demand prompted Eastman to erect a new four-story factory building in the early summer of 1881. The editors noted the "perfection" of the establishment, and the "liberal outlay of capital" that had been invested in it. Rooms were specially designed for every aspect of the manufacturing and packaging process and included chambers for the weighing of chemicals, "cooking" of emulsions, storage of glass, and packing of finished plates. Equipped with elevators, steam-heat and "a perfect system of ventilation," Eastman's factory produced plates that were "clean, free from spots and defects of all kinds, and of great sensitiveness."[6] As demand for the plates increased, production volume rose and retail costs were reduced. Anthony advertised that, as of December 1, 1881, "much lower prices" would be charged for the full line of Eastman's plates, from the 3¼x4¼-inch format to the mammoth 20x24-inch size.[7]

As a respected pioneer of American photography, Barnard was hired by Eastman "to introduce his dry plates among [Barnard's] many acquaintances."[8] In this capacity the veteran photographer demonstrated the new plates to encourage their use by studio operators. Barnard was one of Eastman's earliest employees (he was given employee number 24) and records of payment appear in the first Eastman Dry Plate Company ledger. Seven entries between February and October 1881 show that Barnard was paid a total of $416.29 by Eastman in this period. These

payments vary considerably in amount, indicating that Barnard worked on assignment and was not a full-time, salaried employee.[9] Eastman's demonstrators were typically paid about three dollars a day plus expenses.[10] While Barnard's name does not appear in Eastman's records after October 1881, it is possible that he continued promoting Eastman's plates for the Anthony firm, which had by then taken up national distribution of the product.

Barnard's first excursion to promote Eastman's plates was to Chicago in January 1881. Given his technical skill, pleasant personality, and earlier experience in the city, Barnard was an ideal spokesman for Eastman's product. Barnard's time in Chicago was reported in *Anthony's Photographic Bulletin* by a local correspondent.

> The gelatine dry plate is growing in favor, and the various commercial brands are being tested with more or less success. The latest candidate for notice is the Eastman plate, now being introduced here by that veteran photographer, Geo. N. Barnard. The Eastman Dry Plate Co. made an excellent business stroke in sending out their products in the hands of such a competent and skillful manipulator as Mr. Barnard, to demonstrate free of charge to any one interested just what to do with a dry plate. It will be the means of establishing a large demand, and as they claim the highest merit for the Eastman, they will reap their reward for the expense of showing it up.[11]

This writer went on to note that dry plates had been accepted by a number of photographers despite their higher cost and initial difficulty. "Some who have mastered the dry plate are quite radical in the new gospel, and have boldly remodeled their dark rooms and cast aside all their wet plate" apparatus. He also humorously noted the new plate's consistency and ease of use.

> The photographer working dry plates is now very hard to distinguish from his fellow mortals: no black fingers, no odor from the laboratory, no anxious, careworn look — an index of a disturbed nervous system. He can appear in neat attire, he smells like other people, and he is calm and peaceful.[12]

Barnard was a featured speaker at the February 2, 1881, meeting of the Chicago Photographic Association, devoted entirely to the topic of the dry plate. In his introductory remarks Barnard noted his pleasure in visiting many old friends after eight years absence from Chicago. The veteran photographer recalled "the pleasant and profitable hours" spent in association meetings of 1871-73. He also expressed pleasure at the evening's large attendance, which "showed that in Chicago photograpers were alive to the growing spirit of the age." The association's president then noted that Barnard's "well known modesty" had prevented him from describing the reason for his visit. "Mr. Barnard is in our city to show photographers all about using the Eastman Dry Plates, and will visit any of their studios and demonstrate the exposure and development, and show what can be done with the gelatino-bromide plate, which is creating so much excitement all

through the country." With the help of an assistant Barnard then began his demonstration. He "exhibited a large number of prints, both outdoor views and portraits, made in the studio, all from dry plate negatives" which were "greatly admired and favorably criticized by the members."[13]

Barnard stayed in Chicago for several more weeks to meet individually with photographers. He also made a presentation at the next meeting of the Chicago Photographic Association, a session attended by "eighty enthusiastic photographers." Numerous prints from dry-plate negatives were displayed to illustrate the application of the process to portrait, interior, and landscape work. The negatives for many of these prints were also presented for study on a back-lit display case.

> The business of the evening...was introduced by Mr. Greene, who read a paper criticising the various published developers, more particularly the pyro.
> Mr. Geo. N. Barnard followed with a few remarks about the ferrous-oxalate development, and the subject was further enlarged upon by Messrs. Hesler, Beebe, Edgeworth and Joshua Smith, after which the lights were all turned out and the ruby light from the lanterns gave a weird effect to the scene.
> Messrs. Greene and Barnard proceeded to the development of plates exposed for the purpose, Greene using pyro, and Barnard the oxalate. It was carried on in a conversational way, the demonstrators giving an account of the methods used, and answering all questions, although on account of over-exposures the developments were not as satisfactory as hoped, yet it was instructive and useful to those who had not tested the dry plates.[14]

Barnard continued promoting dry plates in 1882-83. There is also evidence that he engaged briefly in his own manufacturing concern. A notice in the December 1882 *Philadelphia Photographer* reported

> Furman and Barnard
> The Rochester Dry Plate (manufactured by Furman and Barnard, Rochester, N.Y.) is the last candidate for photographic favor.[15]

Barnard may have met Robert H. Furman as early as 1860, when both men were working in New York City. After several years residence there, and twelve years in business in Brazil, Furman moved to Rochester in 1877. Like Barnard, Furman had worked for Eastman during the first years of the dry-plate business. Despite their combined experience, however, the Rochester Dry Plate company does not appear to have lasted long.[16] By September 1883 Barnard was again representing George Eastman at dry-plate conventions.[17]

On January 14, 1884, Barnard and Eastman were elected to membership in the Rochester Photographic Association. The evening's discussion was devoted to the topic "Wet Plates vs. Dry Plates." Barnard unhesitatingly supported the new process, stating

> in my travels I have seen a great deal of photographers and photographs, and am decidedly of the opinion that finer work is now being

done than formerly with wet plates. Photographers are now learning to work dry plates much more successfully than at first. Having quick plates enables them to secure many subjects they would otherwise lose; therefore they now have fewer re-sittings, and consequently can give more attention to securing more artistic work.[18]

It is revealing that Barnard praised the speed of dry plates, in part, for the attention they allowed photographers to devote to "more artistic work." In his promotion of this new technology, Barnard skillfully balanced issues of quality and quantity, aesthetics and commerce. He recognized and addressed the practical interests of his listeners. At the same time, Barnard stressed the importance of technical improvement and individual taste, themes which had first gained prominence in the daguerreotype era. Barnard's continued idealism, vast practical experience, and technical knowledge made him a uniquely credible and effective spokesman.

Two weeks later, on January 28, the Rochester Photographic Association met again, with "Wet Plates vs. Dry Plates" continued as the topic of discussion. Three queries, characteristic of the more mundane professional concerns of the era, were drawn from the "Question Box" and discussed:

1. What is the best method for reducing strong gelatine negatives?
2. Is it advisable to use alum in the fixing bath for dry plates? If so, in what proportion, and what effect does it have on the plates?
3. If only a plain hypo solution be used, how strong should it be made?

Following this exchange a letter from Barnard was read aloud by the association's secretary.

January 28, 1884

GENTS: Absence from town will prevent my taking part in the dry plate discussion this evening, therefore I would like to say a word or two on the question in favor of dry plates and the manner of working them. I wish to state briefly a few observations.

In discussing processes on which many of our best photographers differ in opinion, it would be difficult for me to advance any theory without some practical demonstration or other proofs that would convince any one present for or against either the wet or dry plates.

It is known to most of you that I have been actively engaged in our profession for many years, having begun it in 1842, and have been familiar with most of the improvements in photography from the commencement to the present time; and I now think (taking into account all the photographer of to-day can do with dry plates,) that this is the greatest invention the art has yet seen.

At the last meeting it was stated that Dr. [Herman] Vogel said recently that as good work could be made with dry plates as with wet, but never better. I will go a little farther than the Doctor, although I regard his views highly. Still I think better negatives under most if not all conditions can be made with dry plates. With the advantages of great rapidity over wet plates you are all familiar. Uniformity in the manufacture of dry plates in the United States can now be relied upon,

and they are within the reach of all, and fine chemical results can now be obtained with care in working.

Barnard went on to stress the importance of precise development in the successful use of the new plates.[19]

In his research and work for Eastman, Barnard had become an authority on dry plates. At the age of 64 he decided to put this knowledge to work by engaging full-time in the studio and manufacturing business. Early in 1884 Barnard and his wife moved to Painesville, Ohio, a picturesque community of 4000 residents near Cleveland.[20] The Barnards were accompanied by the Edgar Gilbert household.

Barnard joined in partnership with Horace W. Tibbals, a Painesville photographer with thirteen years experience. The first Tibbals & Barnard advertisement appeared in the March 20, 1884, issue of the *Painesville Telegraph* under the bold headline "AN AVALANCHE in the price of PHOTOGRAPHS." Customers were urged to

Come early and secure the benefit of current prices. We have lately increased our facilities for the production of first-class work, by the addition of new and improved instruments, accessories, and appointments in our Gallery. Have also fitted up rooms for the manufacture of Instantaneous Dry Plates, which are equal to the best; by the use of which we are enabled to secure in an instant the best expression of the sitter.

Cabinet-size photographs were offered at $3.50 per dozen, with small card photographs at $1.00 per dozen and a free cabinet photograph made for "all persons 80 years of age or over."[21] A later advertisement added "photographs taken in cloudy weather as well as clear."[22] This gallery was located at 43 Main Street in Painesville and was equipped with a telephone, "No. 50."

On May 15 the Painesville newspaper ran a long and complimentary article on the new business, emphasizing Barnard's great experience.

A New Enterprise

Having recently called at the gallery of Tibbals & Barnard we found them busy as usual, and were informed that with the combined force of seven persons they were unable to promise work under about two weeks. This speaks well for the business management of the firm.

We were shown some very fine photographs taken recently, some of which were taken direct 14x17 by a new improved instrument called "The Euriscope," also some very excellent samples of instantaneous work. We noticed some photos of dogs, notably "Amos" and "Sinbad", belonging to Mr. J.H. King, the expression of these are very amusing. The excellence of work at this establishment, needs no comments.

We also inspected their laboratory for the production of the instantaneous dry plates which we should judge was very complete, and undoubtedly saves a large expense in the production of photographs. We understand there is no other gallery in the state that makes their

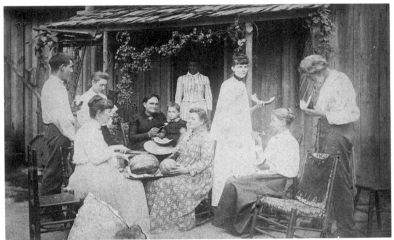

150. Family Portrait, Gadsden, Alabama, ca. 1890; Onondaga Historical Association

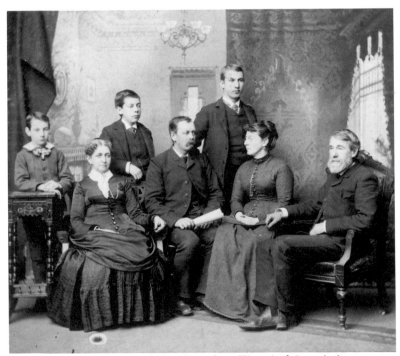

151. Family Portrait, ca. 1890s; Onondaga Historical Association

own plates. Mr. Barnard who has had an extensive experience in the manufacture of plates informs us that it requires very delicate manipulation to make them successfully and up to the present state of perfection, and his experiments, which have cost him at least three thousand dollars, they are now giving the public the benefit of, in prices which we considered extremely low for first class work. Mr. Barnard also manufactures albumenized paper, both of which are used in the gallery.

We should consider Mr. Tibbals very fortunate in associating himself with a man of such long experience and varied accomplishments.

We understand Mr. B. has been in the photograph business over forty years, and during the war his eminent qualifications were such that he was employed by the government. We were shown quite a number of very fine views, taken by him, of scenes in the South, some of which are very valuable to history.

To summarize we should say that with the extensive experience of both, with the finest apparatus that can be bought and with the present facilities at first cost, of a good share of the most expensive articles which go towards making photographs, that they have the inside track in the business.

We understand they will soon put their plates in the market. They having already supplied some of the photographers of Cleveland, but have been unable to fill many orders on account of rush of business.

Mr. B., on account of health, recently sold one of the finest galleries in Charleston, S.C., where he has been located for the past few years, and liking our beautiful town of Painesville concluded to locate here. We wish the firm prosperity.[23]

Barnard's manufacture and marketing of photographic materials was unusual. One of the major virtues of the dry-plate technology was that it freed individual photographers from the difficult chore of making their own plates. Barnard was one of the few working professionals of the 1880s who also manufactured the new plates. In so doing, Barnard significantly lowered the expenses of his own business, and generated an additional source of income.

Competitive price cutting, which first became an issue in the late 1840s, remained an integral part of the gallery business in the 1880s. While Barnard ran one advertisement headlined "First-Class Photos," the public paid more attention to price than to quality. Due in part to undercutting by competitors in town, Barnard's longest running advertisement (from November 1884 to March 1888) featured the headline "Reduction in the Price of CABINET PHOTOGRAPHS." However, "First-Class Work" was retained in smaller type in the body of the copy. By January 1885, Barnard had cut his price for a dozen cabinet photographs from $3.50 to $1.50. Carte-de-visite prices dropped from $1.50 to $1.00 per dozen.[24]

A short time after his only child, Emma, eloped with a young gallery employee, Horace Tibbals relinquished his part ownership of the business. In advertising beginning November 20, 1884, Barnard was listed as the sole proprietor of

"Tibbals' Old Gallery." Tibbals stayed on briefly as an "artist" and the gallery advertised that it was

...making a specialty of 14x17 Ink and Crayon portraits at the unprecedented low price of $6.00 the same as is charged in the cities $15 and $20.

Mr. Tibbals has charge of the Ink and Crayon Work. His reputation as an artist is too well known to need comment. Call and see for yourselves before going elsewhere.[25]

Tibbals left for Detroit a short time later.

As in past years, Barnard continued his work outside the studio. In 1886 and 1887 he made photographs that were reproduced as engravings in the *Historical Collection of Ohio: An Encyclopedia of the State* (1888), compiled by Henry Howe. Credited to Barnard were a photograph of downtown Painesville and views of the interior and exterior of President Garfield's home, "Lawnfield," located a few miles west of Painesville in the town of Mentor.[26]

Barnard's last advertisement in the *Painesville Telegraph* ran for four weeks beginning March 29, 1888. He offered "Tintypes both large and small cheap at Barnard's Gallery for 30 days. Cabinet Photos for $1.50 and $2.00 per dozen."[27] After the end of April, Barnard's name does not appear again in the paper.[28]

Barnard closed this business with the intention of retiring to the south. On April 2, 1888, Barnard's son-in-law Edgar O. Gilbert purchased ten acres near Gadsden, Alabama, a settlement of about 6000 located midway between Birmingham and Chattanooga. Six months later Barnard acquired an adjacent tract of 150 acres.[29] A wide variety of crops were raised, including tomatoes, corn, strawberries, peas, peaches, grapes, peanuts, and watermelon, and sold in nearby Gadsden. Cattle and other animals were probably also kept. A black man and woman lived with the family and helped with chores. Barnard's daughter earned spending money by giving painting lessons, and it is likely that Barnard supplemented his income by making an occasional portrait.[30] The photographer made an unusual group portrait of himself and his family eating watermelon on the rustic porch of their Alabama home (figure 150).

The primary reason for this move from Ohio probably involved the mild climate and scenic beauty of northern Alabama. The Gadsden newspaper reported that the area had "the finest climate in America," with summer temperatures seldom above ninety degrees, and nights that were "always cool." In the winter temperatures rarely fell as low as twenty degrees. The region's picturesque hills and cool breezes were promoted as both pleasant and healthful. The family was also attracted by the majestic Noccolulu Falls, located about two miles from Gadsden and only a brief walk from the Barnard and Gilbert houses. These falls measured ninety-six feet in height and stood at the head of a scenic gorge some 200 feet wide and nearly a mile long.[31]

In late 1892 or 1893 the Barnards and Gilberts moved from Alabama to a Gilbert

152. **Dinturff Studio:** *George N. Barnard*, ca. 1890s; Onondaga Historical Association

153. **Unknown Photographer:** George N. Barnard and Great-Grandchild, ca. 1900; Onondaga Historical Association

family farm in the rural community of Cedarvale, near Syracuse, New York. In addition to raising crops characteristic of the area, the household grew two acres of watermelon, which had never before been successfully raised in the area.[32]

Although now past seventy years of age, Barnard maintained his interest in photography. He set up a simple studio in the farmhouse, using a curtain as a backdrop, to make portraits of family members and neighbors. At the end of each school year he also made class pictures of children posed on the steps of the nearby schoolhouse. As late as June 1898 Barnard took his camera to Otisco Lake to make a class portrait of teachers and students on a school picnic.[33]

Barnard was remembered in later years as a gentle man who enjoyed children and told fascinating stories about the Civil War and the great Chicago fire. One sitter described him as "a kindly old man with...big hands and...snowy-white hair."[34] His gentle character is suggested in portraits made in the 1890s. In a studio in Gadsden or Syracuse, Barnard posed with his wife, Emma Chapin Gilbert Barnard, his daughter and son-in-law, Mr. and Mrs. Edgar O. Gilbert, and his three Gilbert grandchildren (figure 151). At the Dinturff Studio in Syracuse, Barnard sat for perhaps his last formal studio portrait (figure 152). At about this time a family member made a spontaneous snapshot of the increasingly frail old man holding his great-grandchild (figure 153).

By the turn of the century both Barnard and his wife were in failing health. This placed a severe burden on their children, and Emma Barnard was sent temporarily to the home of her grandson, Orlin B. Gilbert, for care. In November 1901, Emma returned to the family residence "much improved." By that time, however, her husband was "very sick with no hope of recovery."[35]

George N. Barnard's long career finally ended on Tuesday, February 4, 1902. He died quietly in the midst of the worst snowstorm to hit the Syracuse area since the great blizzard of 1888.[36] When the weather cleared Barnard's body was buried in the small Gilbert cemetery near the family farmhouse on Pleasant Valley Road. The cause of his death was officially listed as malignant brostatitis. His wife died ten months later, on December 24, 1902, and was buried next to her husband. Their graves were marked simply "Father" and "Mother." The April 1902 issue of *Anthony's Photographic Bulletin* carried Barnard's obituary and a lengthy summary of his career (Appendix G). As if to signify the end of an era in American photography, the *Bulletin* itself ceased publication with that issue.

By the time of his death, Barnard's significance had been clouded by time, his own modesty, and a general disinterest in the history of photography. Recognition of his importance came slowly, as a nascent scholarly interest in photography stimulated a gradual reappraisal of the medium's history. In his seminal book of 1938, *Photography and the American Scene*, for example, Robert Taft emphasized the importance of knowing "who...the actual photographers of the Civil War [were] in addition to Brady."[37] These important efforts were continued in the work of historian Beaumont Newhall and a handful of others. As late as 1936 or 1938,

however, Barnard's descendants destroyed all his letters to his daughter from the 1860s and 1870s. In the 1930s the larger historical value of these documents was not at all clear.

Beginning in the late 1950s, research on Barnard's career was initiated by the staff of the Onondaga Historical Association, in Syracuse, New York. His grave was identified by an elderly Gilbert family member residing in the area, and on June 7, 1964, a ceremony was held to commemorate the importance of Barnard's life and work. A new marker was installed at the head of Barnard's grave, bearing the simple but accurate inscription:

George N. Barnard
1819-1902
Pioneer in Photography.[38]

A quarter-century later, and almost ninety years after his death, this process of discovery continues.

IV:3 Conclusion

Barnard retired from professional life in 1888, one year before the celebration of photography's fiftieth anniversary. The medium had undergone profound changes in this half century, as an essayist for *Harper's New Monthly Magazine* in 1889 noted:

Can our readers picture to themselves the comic situation of a victim of the daguerreotypist of 1839, screwed to the back of a chair, his face dusted over with a fine white powder, his eyes tightly closed, obliged to sit a full half-hour in the sunlight? Dr. Draper, of the University of the City of New York, to lessen the painful fatigue of the brilliant light, placed between the sitter and the sun a large glass tank filled with ammonia sulphate of copper, a transparent blue liquid which filtered out most of the heat rays, and before the end of 1840 succeeded in doing away with the whitened face, and reduced the sitting to a few minutes.

Contrast this with the possibilities of today, when in the darkest of dark caves or cellars, or on the blackest of nights, the tyro photographer, armed with his little camera, and pistol loaded with magnesium cartridge, can obtain a picture full of vigor and marvellous in detail. This chasm has been bridged over in the fifty years since Daguerre gave before the French Academy of Sciences the secret of his wonder-

ful process. The journey down the photographic history of those fifty years is full of wonderful struggles of mind over matter, strange hopes awakened [and] magical discoveries...[1]

It was astonishing to contemplate the medium's achievements in 1889. By this time over sixty photographic journals and 161 societies were in existence worldwide. In conjunction with the microscope and telescope, photography had made important contributions to the study of medicine and astronomy. Edward Muybridge's sequential studies of the physiology of human and animal motion — made with exposures as short as 1/2000th of a second — depicted an amazing and hitherto invisible aspect of everyday life. Photography's application in publishing was constantly increasing, particularly with the introduction of the half-tone method of printing illustrations. Businessmen used photographs routinely to advertise and sell a great variety of goods. Photographs of criminals were beginning to be produced and disseminated to aid police work. Military technicians used the camera to miniaturize maps and documents for secret transport. To stimulate sales, artists mailed small photographs of their paintings to distant clients.[2] Many twentieth-century applications of photography — including illustrated merchandise catalogs, "mugshots," microfilm, and art slides — stemmed directly from such precedents.

The introduction of the inexpensive hand camera was perhaps the most important technical innovation of the era. George Eastman's "Kodak" camera reached the market in early 1889. By September some 13,000 had been sold.[3] The relatively fast shutters of these simple cameras made "instantaneous" photographs routine and liberated the process from the static vision of the tripod. Barnard had never used a camera apart from a tripod during his entire forty-two-year professional career. From this date forward, however, photographers increasingly regarded this freedom as paradigmatic of the medium. The rapidity and spontaneity of the amateur camera produced a photographic aesthetic — the "snapshot" — radically different in nature from the rectilinear precision of the tripod-mounted view camera.

The amateur camera also liberated its users from the demands of darkroom work and, indeed, from the need for any technical knowledge whatever. The Kodak was sold fully loaded with a 100-shot roll of flexible film. After all 100 exposures had been made, the entire camera was mailed back to Eastman's plant in Rochester. Professional lab technicians processed the film, made prints, and reloaded the camera. Everything was then returned to the owner for another round of photographs. Eastman's marketing phrase, "You Press the Button — We Do The Rest," accurately reflected the simplicity of the new process. The medium was now woven into the fabric of American society to a degree that would have been unimaginable to the nation's first generation of photographers.

However, this revolution in picture-making also removed photography forever from the exclusive domain of the trained professional. The profession continued

to expand, of course, but pragmatic Americans thought of the medium in an increasingly matter-of-fact way. It was now clear that anyone could operate a camera and make competent photographs by the hundred. The medium's very ubiquity and familiarity mitigated public acceptance of loftier claims of artistic merit. The celebratory article on photography's first fifty years, cited at the beginning of this chapter, ended on a rather downbeat note:

> One cannot close even so incomplete a review as this of the first half-century of photography without a reference to the position it now holds with regard to art. Though it would require a long essay to deal with the subject as it merits treatment, it is important to make certain confessions of blighted hopes, and at the same time to look with tempered enthusiasm into the future. As an aid to science, as a recorder, as a duplicator, photography has helped advance civilization. Of itself it has failed to occupy the place it may yet hold as a means for expressing original thought of a fine order. With its recognized qualities, and in the hands of a thoroughly trained worker perfectly familiar with the laws of chemistry and optics, and with artistic feeling and training, it may be placed on a plane where its beauties will force from all acknowledgment that it has powers which rank it as one of the finest of the graphic arts.[4]

Photography had accomplished far more as a beautiful and expressive art than this writer acknowledged. However, it seemed apparent to photographers of the time that idealistic hopes for the medium had gone unrealized. Barnard and his peers had fought long and hard for the "improvement" and "advancement" of photography, and for its broader acceptance as a medium of artistic expression. While these efforts had been largely ignored by the public, they represented the beginning of a protracted struggle for artistic prestige. The fight in America for "photography as art" did not, as often suggested, begin with Alfred Stieglitz and his circle at the turn of the twentieth century. This struggle was deeply rooted in the earliest years of the daguerreotype profession and continues (remarkably unchanged in many respects) to this day.

For Barnard's generation, the art of photography reflected scientific knowledge, technical excellence, and aesthetic sensitivity. Optical clarity, the subtle use of light and shade, and graceful compositions — in the service of realizing the higher essence of one's subject — all distinguished a man of taste from a merely competent operator. For these photographers, the highest ambitions of the medium were social rather than narrowly self-expressive. Artistic excellence was perceived as a flawless adherence to a demanding set of established ideals rather than an idiosyncratic violation of accepted standards. With few exceptions, the art and business of photography were one, uniting the highest aesthetic ambitions with the tastes and interests of a largely middle- and upper-middle class public.

Similarly, the meanings of beautifully made daguerreotype portraits, or representations of esteemed leaders and hallowed battlefields, were derived from a widely shared set of beliefs and ideals. Stereographs of distant lands or reproductions of paintings served to educate viewers: to raise their level of awareness and sophistication and, ultimately, to make them better citizens. It is too easy, at the end of the twentieth century, to reject these ambitions as naïve or trivial. They were neither.

The fight for photography's artistic prestige has always been founded on a subtle or overt form of elitism. For Barnard and his peers, that elitism was reflected in the perceived need to elevate the taste of the public. This presumed, of course, that the average person's aesthetic sensibilities were deficient. However, this attitude also clearly acknowledged the public's importance as a worthy audience for fine work, and as the source of the democratic, progressive spirit that animated the nation.

By contrast, the art photography movement of the turn of the century, led in America by Alfred Stieglitz, rejected the public as an arbiter of artistic merit. While Barnard's generation regarded the idea of political, cultural, and artistic union as supremely important, Stieglitz and his Photo-Secession group advocated a clear break with the perceived philistinism of the masses and the banalities of applied photography. Modern art photography became increasingly insular and subjective. To separate themselves from the mundane competence of professionals and the unreflective simplicity of amateurs, these artists emphasized subjective impressions over "mere" optical facts, and produced one-of-a-kind prints of exquisite quality. From this time onward art photographers also increasingly sought not only to ignore middle-class expectations and values, but to upturn them.

Despite real differences in values and objectives, there are important continuities between the artistic ambitions of photographers of the mid-nineteenth century, the early twentieth century, and today. In each of these periods photographers have been motivated by the power of ideas and the use of their medium for spiritual, social, or political improvement. The democratic idealism of Barnard's era thus has a real parallel in the dreamy utopianism of the Photo-Secession, and in the strident social criticism of the 1980s avant-garde. Close study of nineteenth-century American photography is needed to better understand these continuities.

Barnard was a central figure in the formative years of photography due to his unusual talent and breadth of experiences. This study of his life and work suggests the importance of such issues as the profession's economic foundation, networks of influence and patronage, the tension between documentary and imaginative concerns, and the relationships between commerce and art, and between high and low culture. The changes in photography's 150-year history have been evolutionary rather than revolutionary. During these years a spectrum of techniques and concepts has been applied to a relatively unchanging core of fundamental interests. The personalities and issues of Barnard's era are thus deeply relevant to a richer understanding of the nature, reception and potentials of photography as a whole.

The task of clarifying the historical record is difficult, however, and much work remains. Significant aspects of Barnard's life and work are still unknown, and may remain so. The careers of most of his associates are but superficially documented. The authorship of a significant percentage of nineteenth-century work — and in particular much Civil War photography — remains frustratingly uncertain. These and similar gaps provide fertile ground for future research. In the course of this work it is critical that individual photographers be studied as fully rounded personal, professional, and economic beings. Only then can the function and larger significance of their photographs be meaningfully suggested.

Barnard lived to see his greatest work pass into the cultural vernacular. Beginning in the 1880s, his Civil War photographs were reproduced frequently, often in drastically cropped or altered form (for example, compare figure 154 with its source, plate 41). If credited at all, these images were usually cited as Brady's work. Barnard must have been deeply frustrated by these distortions and appropriations. The lack of recognition accorded Barnard and most of his fellows reflected the widespread notion that photographers were simple technicians undeserving of individual study or respect. After the war Barnard's original glass plates were mixed into larger collections of war negatives that were subsequently reorganized, divided, sold, and carelessly handled. These transactions and losses have greatly hampered a complete understanding of the military work of Barnard and his peers.

The historical importance of this great, confused mountain of Civil War photography has always been recognized. These images have provided vital touchstones of authentic national experience for generations of Americans. However, issues of authorship, sponsorship, and meaning have only begun to be adequately addressed. In the first half of this century most historians and photographers viewed Civil War photography as an essentially undifferentiated mass authored by a single mythic, protean figure. "Mathew Brady" symbolized an abstract documentary ideal: the heroic, unpretentious craftsman who worked with sublime simplicity, and at great personal sacrifice, to preserve precious vignettes of American history. The truth, of course, is far more complex and interesting than this.

While his Civil War photographs constitute the single greatest facet of his life's work, Barnard's full stature is revealed only in the length and diversity of his overall career. Few, if any, of his contemporaries had Barnard's technical expertise, artistic sophistication, pictorial originality, and broad network of professional contacts. His career provides a unique cross-section of the ideals, issues and personalities of nineteenth-century American photography. This period is deeply fascinating in its own right and represents the foundation of the profession in our age. It is time that George N. Barnard step at least part way out of the shadows of historical neglect. We have much to learn from him.

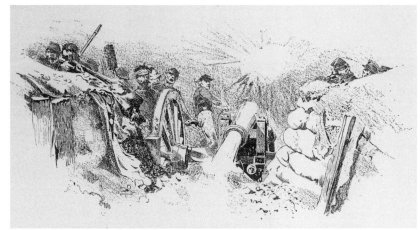

154. **Unknown Artist:** *Defending an Embrasure*, ca. 1880s; engraving; U.S. Army Military History Institute

Appendices and Notes

APPENDICES

Appendix A

Light

"Read before the Second Ordinary meeting of the N.Y.S. Daguerreian Association by G.N. Barnard, Esq." Reprinted from *The Photographic and Fine Art Journal*, May 1855, pp. 143-144.

The Committee who have the honor of an appointment from your body, to prepare for this Association a paper on the subject of Light, conceiving, that, from the magnitude of the subject, and the absence of restriction to any particular points of it, that this body intended, not a discussion of the different theories which have been proposed to account for its nature, properties and effects, and which has so much divided the opinions of savants and philosophers, have felt themselves at liberty to avoid high scientific ground, judging that suggestions and ideas of a more practical character would be equally acceptable. They therefore respectfully beg leave to offer the following pages as the result of their experience and study. They are aware that but little of novelty or of moving interest can be exhibited. Yet they trust that benefit may be derived from a comparison or corroboration of experiences or that something suggestive may be found.

There are few occupations which demand the combination of art and scientific skill in a more intimate manner than that of the Daguerrean, considering the delicacy of his operations and the subtlety of his agents. Not the least in importance is an acquaintance with the management of his Light.

There is a great deal which can only be learned from experience, and the most skilful operators often find themselves baffled by impediments which are unaccountable. Still your Committee are of the opinion that there is but little variation in the chemical qualities of light one day with another, and that much has been charged to this property for which it should not be accountable, but that the difficulty should be sought for in the fluctuations of chemicals and processes.

In the arrangements for light, the skylight is now generally used and preferred although excellent pictures have been and can be made with a side light with proper precaution.

In using the side light, the lower half of the window should be darkened, and a white screen provided, to be used on the opposite side of the sitter, for reducing shades and throwing in reflected lights.

A white screen over-head, not too high is also useful in concentrating light on the sitter.

A sky light, when possible, should always face the North, and should dip at an angle of 45 degrees, or about five feet in ten.

One facing the East is next desirable, but one facing South or West should not be used.

A sky-light should neither be too high, or too low, a suitable medium in our judgement would be about eight feet from the floor.

A frequent source of complaint in the use of the sky-light is the difficulty in preventing it from leaking — this can be entirely obviated by having the glass laid in putty composed of pure white lead and oil, and in having the inside of the sash puttied. The laps of the glass should be puttied to prevent the entrance of dust; or of water by capilliary attraction between the panes.

The walls of an operating room should be of white or pale blue, and in case of a too strong light an absorbing screen may be used in place of a reflecting one.

The glass used for the skylight or operating window should be achromatic or colorless; a very good quality of white glass is now made in Boston at a cost very little above the ordinary green tinged glass.

We are satisfied that the color in this glass has considerable effect in making pictures, for in the experiments we have made, we have found that in the same degree of light — about mid-day, pictures taken through a white medium were taken in 35 seconds, with a blue 60 seconds, with pink, the same, with yellow 120 seconds, light green required 145 seconds and dark green 2½ minutes.

These experiments are perhaps not as delicate as some that have been made, yet we are convinced that a green medium is almost as retarding as yellow. We would therefore recommend that green tinged glass should be avoided in a sky-light or operating window.

Dust, smoke and gas in the room also delay a picture. It would be well if the laboratory were furnished with an artificial draft by means of a funnel or chimney under which to place the vaporizing chemicals as Iodine, Bromine and Mercury.

This would serve to carry off all dust, gas or vapor and prevent the disagreeable odor perceived by visitors, besides keeping the new plates from being affected.

No rule of universal application can be given for placing sitters under a sky-light as much depends upon the discrimination of the operator. They should however be placed nearly under one edge of the sky-light and the degree of light brought to fall upon them must be regulated by circumstances such as the complexion, strength of the light, &c., but always in such a manner as to preserve clearly defined and transparent shadows, and no artist should so trifle with his own reputation, as to be prevailed upon to let a picture go forth from his hands with no shades. This quality is frequently desired by sitters, but in a picture composed entirely of light and shadow — of what value is it, if it contains little or no shadows.

In developing a picture over the Mercury, it is desirable that is should not be

examined, but that operators should learn by experience the time necessary.

If absolutely necessary to examine the picture in this stage, it should be done by the aid of a small taper only, as the least day light, or too strong artificial light at this time materially impairs its proper development.

As our pictures are taken through the operation of light on sensitive surfaces, those circumstances which affect it in the least merit the constant study and attentiveness of the Daguerrean. Anything in the least affecting it should be observed and recorded.

Matters of so much delicacy cannot be provided for by set rules, and it is only by close attention to minute matters that he can be able to account for the erratic performances and difficulties in obtaining good results at all times.

Should such variations and effects be carefully noted and brought to the notice of this Association at its meetings much good might result — in comparison of observation and experience, and thus one of the principal ends of our organization be advanced.

Appendix B
Taste

"Read before the Third Ordinary meeting of the N.Y.S. Daguerreian Association by G.N. Barnard, Esq." Reprinted from *The Photographic and Fine Art Journal*, May 1855, pp. 158-159.

GENTLEMEN: — It was with a degree of surprise and regret that I observed about a fortnight since in the Photographic Art Journal that I had been named to prepare a paper to be offered to this Honorable body.

Regret that in the formation of your committee you had not substituted some abler person in conjunction with my worthy coadjutors in the consideration and preparation of a document on a subject of so much importance. I therefore throw myself upon your indulgence while I offer some remarks not so much on the detail of the subject as views of a general character.

Realising as I do the necessity of elevating the standard of our profession — that Photography has passed the first blush of novelty, and has taken its rank among the necessary arts — as much so as painting and sculpture, I deem that the time has arrived when it should be rescued from the hands of quacks and charlatans, and made to stand upon its intrinsic merits, when instead of novices from all sides rushing into the ranks of Daguerreans — urged thither by curiosity or the desire of gain by peddling it as a novelty in art — it has become firmly established as a philosophic and scientific pursuit, ministering to the necessities of mankind and that none but the really learned and enlightened in its ranks will or can command attention.

To be a true Daguerreotypist requires talents of no ordinary character — he should unite virtues and gifts, seldom attainable in their highest rank in the same person, he should be a skilful chemist, profound in natural philosophy, at least that portion embracing the laws of light and the theory of color, and last but not least he should be a cultivated artist. All and each qualities of a high order and requiring a peculiar mental composition.

From the time of the discovery of the art until a later period the attention of all talented and educated Daguerreans has been almost exclusively engaged in pushing the invention to perfection, and comparatively little attention has been paid to the consideration of Photography in the higher lights of artistic merit. And well has the assiduity of our Photographist been rewarded. The art owes scarcely less to the artists of America than to the inventors Messrs. Daguerre and Niepce; for what they conceived in the incipient germ has been cultivated and perfected in America, until American pictures have obtained renown as far as any knowledge of the art extends. Something may be claimed for the natural advantages of our country but their chief excellence must be attributed to the perfection attained by the high skill and superior knowledge of American genius.

And with what brighter rays will American genius emblazon the hallo of glory which surrounds the genius of Daguerre, when the sun gilded pictures, glowing in all the tints and hues of nature, are exhibited to the world; caught living from the sunbeam, and fastened in immoveable loveliness upon the artist's plate.

This perfection of manipulatory skill being attained, it is time that Photographists should turn their attention to the knowledge and cultivation of the principles of artistic science, and thus elevate their profession above the merely chemical or philosophical art.

And it is here that I have reason to regret the selection of your reader on this subject, for, while, as in the case of your other committees on Light and Chemistry, the investigators are subject to and controlled by, certain philosophical or natural circumscription which are attainable by study or acquirable by experiment, your committee of which I have the honor to form a part of are thrust forth upon the boundless regions of Taste.

After distinctness or clearness the chief beauty of a picture depends upon the skilful arrangement of the drapery, the tasteful introduction of adjuncts, or the artistic disposition of the sitter, or the grouping. And these additional charms are not the production of accident, but the result of the application of fixed principles; and the attainment of a knowledge of these principles on which are founded a correct taste and artistic skill.

Nor would I have an artist undervalue the amount of study necessary to this end. It requires as much patient investigation, study, and experience as the more fully developed laws of Chemistry or Natural Philosophy.

Without the attainment of this knowledge the Photographist is left to the guidance of his own uncultivated, or perhaps perverted ideas, or falls a victim to

the Juggernaut of vitiated public taste.

"Public Taste," says Ruskin "as far as it is the encourager and supporter of Art has been the same in all ages. A fitful and vascilating current of vague impression, perpetually liable to change, subject to epidemic desires and agitated by infectious passion, the slave of fashion and the fool of fancy, but yet always distinguishing with singular clear sightedness between that which is best, and that which is worst of the particular class of food which its morbid appetite may call for; never failing to distinguish that which is produced by *intellect* and that which *is not*, though it may be intellect degraded by administering to its misguided will."

Still fluctuating as taste is, varied though it may be by national education, physical inequalities or in different ages there are certain well defined laws which, if correctly understood and strictly adhered to, give to the work an intrinsic excellence recognized in all ages, and the violation of which sink the high minded artist into the mere mechanical slave.

And it is these laws which I would have the Photographist make his unceasing care and study; the practice of them lie all along his path, and in every picture evidence may be given of something nobler than the mere copyist of the intellectual, cultivated, artistic operator.

Nor do I mention the consideration of these duties to discourage the zealous, energetic operator, who may perhaps have already to complain that his struggle has been sufficiently arduous, but would encourage him in view of the difficulties already surmounted to persevere and place our art upon that high and ennobling position, when a true Daguerreotypist shall be considered by the world — not as he now is, merely the mechanical operator with the camera — but the talented artist and educated and devoted man of science.

How little, alas! does the world know of the toil, the study, the self devotion, the high scientific attainments already expended and now enlisted in the ranks of the Daguerreans. The patient investigation, the devotion, the tireless energy which in any other profession would have made the name of the zealot world renowned, is as it were buried from public appreciation by its very utility to the same public; by rendering the results of its labors so cheap and accessible, nor will it be revealed until some champions step forward and asserts their claims, and demands the exalted meed of praise so justly their due.

What immense aid has not the art of painting and engraving received from the Daguerrean process? How has the multiplication of pictures among the people increased owing to its intervention?

What life-like, striking views of the Crystal Palace and its contents — which otherwise could not have been taken, are exhibited to the world. No human patience or skill could have produced such pictures, and stamped as they are, by its name, pass current in the world as the very embodiment of truthfulness, carrying on their face the impress of faith and confidence.

How much does the multiplication of pictures tend to enlighten and unite the Human family! Read and understood by the infant and the aged; scattered from the hovel of the poor to the palace of the great, it extends a humanizing influence wherever it goes.

And how much of that influence is due to the perfectors of the process, for without its perfection it was of little worth, and how much of credit is due to those noble souls who in devoting their lives and energies have succeeded so perfectly in their undertaking.

Still the Daguerrean must not be satisfied while it yet remains to him to perfect himself in the acquisition of a correct standard of Taste. The acquisition of the graces which unite the True with the Harmonious and Beautiful. And which final acquisition will raise him to the position to which he is so equitably entitled.

It is true that the field for the exhibition of this developed taste in portraiture of the smaller sizes is difficult, and that often the operator is debarred from the exercise of his own judgement in the position, arrangement or details, of a picture by the waywardness or the headstrong perverseness of his client; still occasions like these furnish him with examples of comparison by which he can examine and instruct himself, by judging of the improvement which would have been made had he pursued the dictates of his own taste.

Yet the introduction of larger plates now affords "ample scope and verge enough" in which to show himself and the metal he is made of. All desirable pictures are now made on the larger sized plates and these are those which are mostly valued and preserved and by which the merit of the operator is judged. Here he can show something more than the trick of making a clear and well defined picture; he can exhibit indications of a good judgement and cultivated taste combined with scientific knowledge.

Pictures of this kind have an intrinsic value even after the name and history is lost. There is a portrait of Martin Engelbrecht, by Van Dyck in the Dresden gallery, of whose history and character everything is lost, and as the beholder stands and admires that noble and almost breathing face he sighs to learn that all that is known is the name upon the back and the signature of the artist. Why is that picture so valuable, so much admired, deprived as it is of all collateral subjects of interest? Solely on account of its own merits; by the soul of intellect stamped upon the canvass by the genius of the Master.

Such genius would I introduce into the art of photography; a genius which discriminates to the mind of the observer between the cultivated and the uncultivated Daguerrean.

In portraiture this cultivation is shewn in the depth and power of light and shade; in placing the sitter in the most judicious position, relieving sharp features, emboldening round ones, revealing with exquisite grace the beauties of the elegant form, hiding with adroit skill the inelegancies of the clumsier; varying the light with various complexions, subduing, emboldening, changeful as the sunbeams, but as beautiful in all.

Are these results attainable by every vulgar mind, or does not the art of the Daguerrean receive an additional lustre from the skill and cultivation which enables him to produce such pleasing pictures at will. Some one remarked to Gilbert Stuart that he thought the prices for his portraits enormous, considering the limited time it took to make them. "Consider my dear sir," said the artist, "that I have been thirty years in learning how to do it."

Such is the spirit I would hope to see diffused among our artists; the desire not only of grasping the great truths of science and by their agency fastening the shadows as they fall upon the polished plate. But I would see science wedded to Art, with Truth and Beauty as their Handmaids and our profession soaring above the merely mechanical position which it now holds, aspire to a place among the higher branches of employment and the Daguerrean ranked as he deserves among the noble, intellectual and humanizing employments of the age.

Appendix C

Views in Cuba

Stereograph series photographed by Barnard in the spring of 1860 and published by the Anthony Company. This checklist is compiled from Anthony catalogs of October 1862 and ca. 1865, the examination of original stereographs, and information provided by Mr. A. Verner Conover.

1, 2, 146, 147. The Plaza de Armes, Havana.

3. Palace of the Capt. General, Havana.

4. View on the Plaza, Havana.

5, 180. View of the Cabana from Calle de Tacon, Havana.

6. View of the Treasury Building, from the Plaza, with the church of San Domingo in the distance. Havana.

7. View in the Calle de Tacon, the widest street inside the walls of Havana.

8, 165. The Grecian Temple, built on the spot where Columbus first said Mass.

9. The Calle de Oreilly from the Plaza, Havana.

10, 141, 142, 143, 144. The Puerta de Monserrata, with the Tacon Theater in the background, Havana.

11. View on the Plaza, looking towards the Cabana. Havana.

12, 167. The Castello de la Fuerza, from the Calle de Tacon. The Statue on the top of the Castello is that of Habana, the Indian, whom, as the legend goes, was the first to meet Columbus on his landing.

13, 185. The Dominica, Havana. This is the fashionable place of resort in the city.

14, 150, 151. The Ruins of the Bishop's Palace, Havana.

15, 164. Cocoanut Trees in the Bishop's Garden, Havana.

16, 17, 156. View at the Bishop's Garden, Havana.

18. The large Cactus in the Bishop's Garden, Havana.

19. The Avenue of Royal Palms, Bishop's Garden, Havana.

20. An Instantaneous View. The Harbor of Havana from Tacon prison. In the background the Moro Castle and Light house. In the foreground the spot where Lopez was garrotted.

21, 135, 136, 137, 138. An Instantaneous View. The Harbor of Havana with Castle of the Point in the foreground. The Moro Castle in the background.

22. An Instantaneous View. The Steamer De Soto leaving the Harbor of Havana.

23. An Instantaneous View. The Harbor of Havana with ship under full sail passing Moro Castle.

24, 134, 184. Panoramic View of Havana, from Tacon prison, looking West.

25, 26, 28, 29, 30, 148, 149. Bird's Eye View of the harbor and city of Havana, from the Castle Cabana.

27. Bird's Eye View of the Harbor and City of Havana from the Castle Cabana, looking towards Tacon prison.

31, 32. The Moro Castle and the Entrance to the Harbor of Havana from the Cabana.

33. View of the Ramparts of the Cabana, Havana.

34, 35. Tacon Prison from the Cabana, Havana.

36. The Marquis El Brigadier Altaraz, the Governor of the Cabana, Havana.

37, 186. The Calle de Oreilly, one of the principal business streets of Havana.

38. An Instantaneous View. Looking towards the Plaza from the Dominica, Havana.

39. A Street View, from the Dominica. A company of Spanish troops returning from Mass.

40. The Tacon Theatre, Havana.

41, 42. The Avenue of Royal Palms on the Paseo, with the Indian Statue in the centre.

43. The Indian Statue on the Paseo, Havana.

44. An Instantaneous View of the Dashing Spray, harbor of Havana, with Moro Castle in the background.

45. An Instantaneous View. The harbor of Havana, with the dashing spray in the foreground, with a full rigged brigantine passing the Moro Castle.

46. An Instantaneous View of the dashing spray in the harbor of Havana — the Moro Castle in the distance.

47. An Instantaneous View. The harbor of Havana with the Cabana in the distance.

48, 139. An Instantaneous View. The waves of the sea at the entrance of the harbor of Havana.

49. An Instantaneous View. The Surf, coast of Cuba.

50. An Instantaneous View. The harbor of Havana with an English yacht running out past the Moro Castle.

51. An Instantaneous View. A Ship under full sail passing the Moro castle, Havana.

52. An Instantaneous View. Schooner passing the Moro castle, harbor of Havana.

Appendix D

Instantaneous Photography

Summary of May 1860 meeting of the American Photographical Society at which Barnard's Cuban views provided a major topic of discussion. Reprinted from *The Photographic and Fine Art Journal*, May 1860, pp. 144-145.

Mr. Seeley submitted some specimens of instantaneous photography negatived by Mr. Barnard, printed by Mr. Kuhns. He considered them as perfect as any that had been exhibited. The gentlemen would perhaps explain the process.

Mr. Kuhns stated that some time ago when some specimens were exhibited here by Mr. Black, of Boston, he remarked that, he had made some instantaneous photographs on the Hudson River, and that he would bring them at the next meeting. Unfortunately the negatives were sold, and he could not get a copy of them. Mr. Barnard had now produced some that were better than those taken of the Hudson River, and as soon as the negatives were copyrighted they would be the property of the Society. Mr. Barnard would perhaps have something to say about them.

Mr. Barnard said that they were simply samples of the work he was engaged in. They were water views taken at Havana, where the light was a little stronger than here, and as a general thing worked a little quicker the collodion used was perhaps a little different from that ordinarily used, not so much more sensitive, but a little more, and that little was very important. He used the wet process.

Mr. Kuhns thought the little gain in time was all important. He found no trouble in getting an instantaneous picture with any collodion as to whites and blacks, but as to the intermediate shadows it was different. In these specimens the stones on Moreau [sic] Castle could be distinguished even in the shade. These specimens were really as fine as any stopped off pictures he had even [sic] seen.

Mr. Barnard in reply to a question stated that the time occupied in taking them was about the 40th part of a second.

Mr. Rutherford had often heard of exposure by drops estimated at about 1-20th or 1-40th part of a second, but he was perfectly convinced that it was four or five times as long. In the drop as ordinarily used in the cameras sold by Anthony, and such as he had seen in Mr. Barnard's possession, he did not think that the exposure was less than a fifth of a second, and that was a long time when you came to appreciate it though short if you have to do anything with it. (Laughter.) From his experiments in astronomical clocks and chronometers, and in estimating time by the chronograph he had no doubt that the ordinary drops gave an exposure of a fifth to a sixth of a second. That of course depended on the width of the cut in the drop.

Mr. Seeley said that there was collodion sold as instantaneous collodion, and there were processes talked about as instantaneous processes. In his opinion there was no virtue in any process or formula for collodion as regarded any specific result. In his opinion there were so many little conditions that determined the sensitiveness, intensity and other qualities of collodion that the formulas could not be relied upon. Ether and alcohol to-day might be very different from what they were last week. A man however skillful could not make gun cotton twice the same. There might be a uniformity in the iodides and bromides, but there was complication when you came to mix them with the unknown ether and unknown gun cotton and put them in the ever-changing bath. Materials produced in different places would produce collodion that would not be at all alike. There were many mistaken notions about recipes for collodion. Every practical photographer seemed to have what he called a system of his own — a secret discovered by himself. He rose chiefly to suggest that we should not seek to advance by means of any particular formula but rather by a change in the apparatus — use quicker working cameras, lenses of larger aperture, or shorter focus which was the same thing.

Mr. Rutherford did not agree with Seeley in regard to collodion. He had samples — some of them quick others slow some intense others feeble. With the average material an average result could be obtained. Not that you could get any great advantage in the collodion itself but the little you did get was all important. He had several specimens of collodion made by those who were employed for that purpose, much better than he could buy. The next important thing was to have a camera which, with a large aperture gave a reasonable degree of distinctness in the different parts of the field. Here was required a reconciliation of contradictions, because depth of focus really meant no focus at all. A camera which was microscopically sharp in any one point could not be so in regard to objects on any other plane. It was then by sacrificing a little of this sharpness in all parts of the picture yet still retaining sharpness enough on the whole, that the best result was obtained. A third requisite was a good process of making the picture strong enough after you had got it. Mr. Barnard would no doubt tell them that none of these pictures when he first obtained them were fit to print from until they were re-developed.

Mr. Barnard — One or two of them were.

Mr. Rutherford — He had then been more successful than in any cases that he had yet known. As a general thing instantaneous pictures were scarcely more than positives at first and required to be brought up.

Mr. Seeley did not intend to be understood as saying there was no difference in regard to sensitiveness in collodion. There was a great deal. The manufacture of that article would be a subject worthy of study. There was certainly some law of nature which determined all the various results, and that law might be found out. At present nothing was so certain in producing quickness as a quick working camera — more certain than any chemical process.

Appendix E

Barnard views listed in Alexander Gardner's <u>Catalogue of Photographic Incidents of the War</u>, published in September, 1863.

[Negatives by Barnard and Gibson:]

Fortifications at Centreville, March, 1862, Nos. 1-4
Quaker Guns, Centreville, March, 1862
Confederate Encampment, Centreville, March, 1862
Grigsby House, Headquarters Gen. Johnston, Centreville, March, 1862
Stone Church, Centreville, used as a hospital after the battle of 18th July, 1861
Ruins of Stone Bridge, Bull Run, March 1862, Nos. 1, 2
Manassas Junction, March, 1862
Fortifications at Manassas, March, 1862, Nos. 1-3
Ruins at Manassas, March, 1862, Nos. 1-3
Encampment at Manassas, March, 1862

[Negatives by Barnard:]

Harper's Ferry, June, 1861

From series "Illustrations of the War in Virginia"

1. Capitol, Washington
100. Long Bridge across the Potomac
103. Pensacola Steam Frigate off Alexandria
288. Georgetown Aqueduct
289. Georgetown Aqueduct and College

290. Examining Pass at Georgetown Ferry, "All Right!"
291. Georgetown Ferry
300. Forts on Heights of Centreville
302. Stone Church, Centreville, used as a hospital after the battle of the 18th July, 1861
303. Grigsby House, Centreville, Headquartesr of Gen. Johnston
304. Confederate Graves, Centreville
305. Quaker Guns, Centreville
306. Departure from the Old Homestead
307. Cub Run
308. Mrs. Stevens' House, near Centreville
309. Mrs. Spinner's House, near Centreville
310. Ruins of Stone Bridge, Bull Run, looking up stream
311. Ruins of Stone Bridge, Bull Run, looking across
312. Ruins of Stone Bridge, Bull Run
313. Sudley's Ford, Bull Run
314. Sudley's Ford and Church, Bull Run
315. Sudley's Church, Bull Run
316. Hecatomb at Sudley's Church
317. Thorburn's House, Bull Run
318. Matthews' House, Bull Run
319. Robinson's House, Bull Run
320. Ruins of Mrs. Henry's House, Bull Run
321. Soldier's Graves, Bull Run
322. Battle field, Bull Run
323. Fortifications at Manassas
327. Beauregard's Headquarters, Manassas
330. Confederate Encampment, Centreville
331. Winter Quarters Confederate Army, Centreville, March, 1862
332. Winter Quarters Confederate Army, Centreville, south view, March, 1862
333. Principal Fort at Centreville
334. Fort on Heights of Centreville, mounting Quaker Guns, March, 1862
336. Fortifications at Manassas
337. Ruins at Manassas
338. Ruins at Manassas

From series "Illustrations of General McClellan's Campaign on the Peninsula"

447. View of Ravine at Yorktown, where a large number of Confederate magazines were situated
449. Headquarters Gen. Magruder, Yorktown.
450. Confederate Battery, Yorktown, with McClellan's No. 1 Battery in the distance

451. Confederate Fortifications, Yorktown

452. View of Yorktown from Cornwallis' Cave, showing Confederate water batteries, with McClellan's No. 1 Battery in the distance

453. Confederate Fortifications, Yorktown

454. Water Battery, Yorktown

455. Exploded Gun in Confederate Battery, Yorktown

456. Ruins of Hampton Church, Virginia; the oldest Protestant Church in America

457. Fortifications at Gloucester, showing the water battery

458. Magruder Battery at Yorktown

459. Ruins at Hampton, Va., July 2d, 1862

460. Water Battery, Gloucester, mounting fifteen heavy guns

461. Confederate Fortifications, Yorktown, built on the site where Cornwallis delivered up his sword

462. Moore House, Yorktown, where Cornwallis signed the capitulation

463. Naval Battery, Yorktown, with Nelson Church, now used as a hospital; July 1st, 1862

464. Ruins at Hampton, July 2nd, 1862

465. Main Entrance, Hampton Church, Va., July 2d, 1862

466. Ruins of Old Brick Church, Hampton, Va., the oldest Protestant church in America

467. Ruins of Hampton Church, Va., west end; the oldest Protestant church in America

Appendix F

Among the Ruins in Chicago

Stereograph series photographed by Barnard in October 1871. Checklist compiled from the examination of original stereographs.

1. Pacific Hotel, from cor. of Jackson & LaSalle Sts.
2. Pacific Hotel, looking north down LaSalle St.
3. Bryan Block, N.W. cor. Monroe & LaSalle Sts.
4. Bryan Block, N.W. cor. Monroe & LaSalle Sts.
5. Building of the Republic Insurance Co., LaSalle St.
6. Open Board Building, N.S. Washington St. bet. LaSalle St. & Fifth Av.
7. Open Board Building, N.S. Washington St. bet. LaSalle St. & Fifth Av.
8. Chamber of Commerce, from cor. LaSalle & Washington Sts., looking east.
9. Chamber of Commerce, from cor. LaSalle & Washington Sts., looking east.
10. Court House, from the west.
11. Court House, seen through ruins of east side of Clark Street.
12. Court House, seen through ruins of Fifth National Bank.
13. Court House, seen through ruins of Fifth National Bank.
14. View from Court House, looking south-east.
15. View from Court House, looking north-west.
16. View from the Court House steps, looking north up Clark St.
17. View from the Court House steps, looking south down Clark St.
18. Fifth National Bank, N.E. cor. Clark & Washington Sts., looking east.
19. Fifth National Bank, N.E. cor. Clark & Washington Sts., looking north.
20. Interior of Fifth National Bank — Cooling off a Safe.
21. Bigelow Building. Front View.
22. Bigelow Building, looking north to Post Office.
23. Honore Building, Post Office seen through the ruins.
24. Post Office, from corner Monroe and Dearborn Streets.
25. Post Office, Interior View, North end.
26. Washington Street, from cor. LaSalle, looking East.
27. Tribune Building, cor. Madison and Dearborn Sts., looking East.
28. Tribune Building, cor. Madison and Dearborn Sts., looking South.
29. Tribune Building, cor. Madison and Dearborn Sts. (nearer view).
30. View from Tribune Building, looking North-East.
31. View from Tribune Building, looking N.W., Court House in the distance.
32. View from Tribune Building, looking east.
33. Press Room in Tribune Building.
34. General View of the Ruins from Tribune Building, Bookseller's Row in the centre.
35. Bookseller's Row, N.E. cor. Madison and State Sts.
36. Bookseller's Row, State St.
37. First National Bank: S.W. cor. State & Washington Sts.
38. View from First National Bank, looking north-east.
39. Ruins of the Mammoth Store of Field & Leiter, cor. State and Washington Sts.
40. Ruins of Bigelow Building. [*or:* Ruins of Honore's Building]
41. View on Wabash Avenue, looking north.
42. St. Paul's Church (Universalist) Wabash Ave.
43. Clark Street Bridge, looking north across the River.
44. Historical Building, n.w. cor. Dearborn St.
45. St. James (Episcopal) Church, S.E. cor. Dearborn St.
46. St. James (Episcopal) Church, looking north up Dearborn St.
47. Interior View of St. James Church.
48. New England (Congregational) Church, on Washington Park
49. Unity Church (Robert Collyer's) Washington Park.
50. View into the Interior of Unity Church.
51. Lake Side Publishing House.
52. New England & Unity Churches, looking North on Dearborn St.

53. St. Joseph's (German Catholic) Church.
54. Interior of Court House.
55. Clark Street, near Washington.
56. State Street, from First National Bank, looking north.
57. [unidentified]
58. View from cor. Monroe and Dearborn Sts.
59. Van Buren Street Bridge.
60. Safes Taken from Ruins on Dearborn Street.
61. Ruins on Washington Street.
62. [unidentified]
63. Clark Street looking north.

Appendix G

Obituary

Reprinted from *Anthony's Photographic Bulletin*, April 1902, pp. 127-128.

GEORGE N. BARNARD

was born in Connecticut December 23, 1819. Died at Cedarvale, Onondaga County, N.Y., February 4, 1902. His early life was spent in Nashville, Tenn. In 1843 he commenced taking daguerreotypes. His first gallery was in Oswego; his second in Syracuse. He was employed for a number of years taking views by our publishers, E. & H.T. Anthony & Co. Forty-two years ago he went to Cuba, taking views in the islands of sugar and molasses-making. He had the honor of dining with the Governor-General, of whom he made pictures with his wife and family. He also photographed the interior of the palace.

When the war broke out he was in Washington, D.C. News of a prospective encounter at Bull Run was noised about the city. Loads of civilians were carried to the place to witness the engagement. Taking his camera, which weighed something more than the modern instrument, he engaged a seat in a carryall, but he got no pictures that day. On the return he overtook a poor fellow, sorely wounded in the leg, trying to get back to Washington. He stopped and put him in his place, shouldered his heavy instrument, and after weary walking he reached Washington, footsore and tired. So he was in the first battle and with Sherman at the last one.

When Sherman marched to the sea he was appointed Government photographer, and connected with the department of engineers, messing with the general's staff. He was provided with two mules, a covered wagon and negro driver. When out taking views for maps in dangerous localities an armed guard accompanied him. When going from Nashville to the Hermitage he narrowly escaped capture. His reminiscences of Sherman, Hooker, Grant and other prominent men of the times of whom he had made pictures were very interesting.

The great fire in Chicago destroyed his new gallery and some of his most valuable instruments. He and his printer moved and removed the instruments till they reached the lake, finally deserting them as the flames drove them into the lake. Immediately he sent for new instruments and began taking views of Chicago in ruins. After this he went to Charleston, S.C., buying a gallery there, but fire again destroyed his business. Nothing daunted, he started again in the same place. He sold his business before the earthquake visited that place, but he lost considerable in investments there by the earthquake. He later went to Rochester, N.Y., where he was interested in the dry plate business with Mr. Robert Furman and Mr. Eastman, who employed him to introduce his dry plates among his many acquaintances.

NOTES

Introduction

1. See, for example, James A. Hoobler, *Cities Under the Gun: Images of Occupied Nashville and Chattanooga* (Nashville, Tenn.: Rutledge Hill Press, 1986). This volume is a useful compilation of photographs made during the Civil War. Some of these views were unquestionably, or probably, produced by Barnard in 1864. The chapter, "Downtown Nashville" (pp. 81-112), for example, reproduces some of the photographs Barnard may have made for the city's Quartermaster's Department. In general, however, Hoobler seems much too casual in his attribution of images to Barnard's hand and presents little data on the other photographers who worked in these areas.

 Increasing the accuracy of such attributions is difficult, but sources of information exist. For example, no one to this writer's knowledge has hitherto noted an important advertisement in the *Chattanooga Daily Gazette* (July 12, 1864, p. 4) providing titles and print sizes of views of Chattanooga and vicinity by "Cressey, Adams & Co." This pair may have been R.M. Cressey, a civilian from Chicago, and David O. Adams, an army photographer who subsequently worked as Barnard's assistant. In 1863-64 Cressey made views for William E. Merrill, of the Chattanooga office of the Engineer's Department. Another civilian, H. Goldsticker, photographed around Chattanooga in the same period and is even credited with one or two views in occupied Atlanta.

 For an early outline of these problems of attribution, see Keith F. Davis, "'The Chattanooga Album' and George N. Barnard," *Image*, December 1980, pp. 20-27.

2. The following overview of developments in nineteenth-century American society is drawn from a wide variety of sources, including: George Rogers Taylor, *The Transportation Revolution 1815-1860* (New York: Holt, Rinehart and Winston, 1951; reprint 1962); Glenn Porter, ed., *Encyclopedia of American Economic History: Studies of Principal Movements and Ideas* (New York: Charles Scribner's Sons, 1980); James M. McPherson, *Battle Cry of Freedom: The Civil War Era* (New York: Oxford University Press, 1988); Daniel J. Boorstin, *The Americans: The National Experience* (New York: Vintage Books, 1965); Jack Larkin, *The Reshaping of Everyday Life 1790-1840* (New York: Harper & Row, 1988); and Neil Harris, *The Artist in American Society: The Formative Years 1790-1860* (Chicago: University of Chicago Press, 1966).

I:1 Early Life: 1819-1846

1. Albert E. Van Dusen, *Connecticut* (New York: Random House, 1961), pp. 123-124.

2. Laura Wood Roper, *FLO: A Biography of Frederick Law Olmsted* (Baltimore: The Johns Hopkins University Press, 1973), p. 3.

3. Albert E. Van Dusen, pp. 188-190.

4. See Stewart H. Holbrook, *The Yankee Exodus: An Account of Migration From New England* (New York: The Macmillan Company, 1950), particularly pp. 10-38.

5. John C. Pease and John M. Niles, *A Gazetteer of the States of Connecticut and Rhode-Island* (Hartford, Conn.: William S. Marsh, 1819), pp. 291-292.

6. For a partial genealogy of Barnard's probable family line, see William Richard Cutter, *Genealogy of Northern New York Vol. 1* (New York: Lewis Historical Publishing Company, 1910), p. 331; and Susan Whitney Dimock, *Births, Marriages, Baptisms and Deaths from the Records of the Town and Churches of Coventry, Conn. 1711-1844* (New York: The Baker and Taylor Co., 1897), pp. 9 and 128. Richard Barnard, born in England, settled in Springfield, Massachusetts, where he died

November 19, 1683. His six children included Benoni Barnard (1683-1750), who lived in Coventry and married Freedom —— on June 13, 1712. Benoni's son, Daniel, was born in Coventry on May 15, 1730, and married Lydia Dodge on July 12, 1755. The children of Benoni and Daniel are listed in Dimock, p. 9. Daniel's son Joseph was born in Coventry on April 30, 1754 (according to Coventry records; this date is given as 1756 in Cutter), and evidently moved to Pittsford, Vermont, in about 1778 (1784 in Cutter). Norman Barnard may have been the son of Joseph, and born during the latter's residence in Vermont. However, since Norman's birth record has not been found, this relationship is unproven. The fact that Norman died in West Hartford suggests that he may also have been related to the Barnards residing there.

George N. Barnard may have been distantly related to other well-known Barnards of the nineteenth century, but no direct connections have been discovered thus far. For brief biographies of Daniel Dewey Barnard, Edward Emerson Barnard, Henry Barnard, and the brothers Frederick Augustus and John Gross Barnard, see Allen Johnson, ed., *Dictionary of American Biography*, vol. 1 (New York: Charles Scribner's Sons, 1927), pp. 617-627.

7. *Coventry Land Record Index, 1719-1920*, microfilm reel 236, Connecticut State Archives, Hartford, Connecticut.

8. See, for example, John Cogswell Badger, *Giles Badger and his Descendants* (Manchester, N.H.: The John B. Clarke Co., 1909); and *Second Coventry (No. Coventry) Church Records*, Connecticut State Archives, Hartford.

9. In the 1810 Tolland County census (vol. 8, p. 1758) the Norman Barnard household included the following males: two under 10 years of age, one between 10 and 16, and one (Norman himself) between the ages of 26 and 45; and these females: one under 10 years of age (Mary), two between 16 and 26, one between 26 and 45 (Grace), and one over 45. In the 1820 Tolland County census (vol. 8, p. 1467) Norman Barnard's household included these males: two under 10 years of age (one of whom was George N. Barnard), one between 26 and 45, and one over 45 years of age; and the following females: one under 10 (Pauline), one between 10 and 16 (Mary), and three between 26 and 45 years of age.

 It is recorded that one of Norman Barnard's children died, in 1804, just after birth. See *Coventry (No. Coventry) Second Church Records*, vol. 6, page 184; Connecticut State Archives, Hartford.

 According to the *Coventry (No. Coventry) Second Church Records*, vol. 6, p. 15 (film 462) in the Barbour Collection, Connecticut State Archives, Grace Barnard was admitted to the North Coventry church in 1801, and became a church member on March 10, 1819 (as did several others of her family). She was dismissed in 1831 to the Bridgewater (New York) Congregational Church, which she joined as Grace Howland. No record of the marriage of Norman and Grace has been found. George N. Barnard seems to have been the only one of Grace's children to be baptized (or to have that baptism recorded). This may reflect the fact that Grace Barnard became a church member only months before her son's birth in 1819.

 Mary Barnard Hale (who died February 19, 1883, in Chicago) had the following children: George W. Hale (b. 1829 in Bridgewater, New York); Harriet Paulina Hale (b. January 27, 1832, in Paris, New York); and Mary Frances Hale (b. February 16, 1839, in Kenosha, Wisconsin). Pauline Barnard Gaskill died October 2, 1890 in Chicago.

10. *Coventry (No. Coventry) Second Church Records*, vol. 6, page 220; Connecticut State Archives, Hartford.

11. Obituary in the May 19, 1859, *Kenosha Tribune and Telegraph*. Grace Badger Barnard Howland died on May 5, 1859, at the age of 76. She had been living with the family of her daughter, Mrs. David C. Gaskill, in Kenosha.

12. Obituary in the May 23, 1883, *Kenosha Telegraph*.

13. See William Warren Sweet, *Religion on the American Frontier, 1783-1850* (Chicago: University of Chicago Press, 1950), p. 3; and Anson Phelps Stokes, *Church and State in the United States*, vol. 1 (New York: Harper & Brothers, 1950), pp. 753-755.

14. Norman Barnard's death was recorded in the *West Hartford First Congregational Church Records, 1713-1924*, vol. I, p. 237; Connecticut State Archives, Hartford.

15. The family's move to Auburn is suggested by the fact that Pauline Barnard joined the Congregational Church, at age 17 (1828), at Auburn, N.Y. See Pauline Gaskill obituary, *Kenosha* [Wisconsin] *Union*, October 9, 1890.

16. Henry Hall, *The History of Auburn* (Auburn, N.Y.: Dennis Bro's & Co., 1869), p. 156. For

information on the early history of Auburn, see also Joel H. Monroe, *Historical Records of a Hundred and Twenty Years, Auburn, New York* (Geneva, N.Y.: W.F. Humphrey, 1913); Henry M. Allen, *A Chronicle of Auburn from 1793 to 1955* (Auburn, N.Y.: Henry M. Allen, 1955); and Elliott G. Storke, *History of Cayuga County, New York 1789-1879* (Syracuse, N.Y.: D. Mason & Co., 1879).

17. Henry C. Rogers, *History of the Town of Paris and the Valley of the Sauquoit* (Utica: White and Floyd, 1881), p. 369. For information on the businesses in the area, see J.H. French, *Gazetteer of the State of New York* (Syracuse, N.Y.: R.P. Smith, 1860), pp. 462-3, 465-6.

18. *Records of the Paris Religious Society (A Congregational Church) in the Town of Paris, Oneida County, New York.* Transcribed by the New York Genealogical and Biographical Society; ed. Royden Woodward Vosburg (New York, 1921), p. 93. See also Utica city directories for 1843-45. Harvey Barnard owned a paper hanging warehouse and Mrs. Barnard operated a millinery store. The former was the brother of one George Barnard, of West Hartford, Connecticut.

19. See Hale's obituary in the *Chicago Times*, January 27, 1877. In Kenosha (then called Southport), Hale first ran a lumber business. For details on the size of this settlement, see the *Southport Telegraph*, particularly the issues of September 29, 1840 (p. 2), and November 21, 1843 (p. 3).

20. Zimri Howland genealogy; in files of Onondaga Historical Association. Zimri Howland died on January 3, 1840. A year later Grace Howland moved from Bridgewater to Sauquoit to be closer to relatives. In 1842 she followed her elder daughter's family to Kenosha, Wisconsin, where she died seventeen years later on May 5, 1859. See *Kenosha Tribune and Telegraph*, May 19, 1859.

21. This is suggested by the reference in Barnard's obituary (*Anthony's Photographic Bulletin*, April 1902, p. 127) that he spent his "early life" in Nashville.

22. Gaskill was associated, for example, with Joseph Barnard, a Nashville bookbinder who had been born in Connecticut in 1807. A reprint compilation of the first twelve issues of Gaskill's journal *The Southron* lists D.C. Gaskill of Gallatin and J. Barnard of Nashville as publishers. Although proof has not yet been found, Joseph could well have been a brother or cousin of Pauline and George.

23. Walter T. Durham, *Old Sumner: A History of Sumner County, Tennessee from 1805 to 1861* (Gallatin, Tenn.: Sumner County Public Library Board, 1972), pp. 348-350.

24. James D. Hart, *The Popular Book: A History of America's Literary Taste* (Berkeley: University of California Press, 1950), pp. 75-78.

25. Walter T. Durham, pp. 328, 348-350. In 1848 Gaskill and his wife followed the family example and moved to Kenosha, Wisconsin, where he was elected mayor in 1851. *The History of Racine and Kenosha Counties, Wisconsin* (Chicago: Western Historical Company, 1879), p. 508. In 1858 Gaskill served as town Assessor (see p. 510). The 1850 Wisconsin census listed his occupation as Insurance Agent.

26. *The Southron*, September 1841, pp. 326-327.

27. Henry C. Rogers, p. 116.

28. For existing data on Badger, see George W. Croce and David H. Wallace, *The New-York Historical Society's Dictionary of Artists in America 1564-1860* (New Haven: Yale University Press, 1957), p. 19; Mary Bartlett Cowdry, *American Academy of Fine Arts and American Art Union: Exhibition Record 1816-1852* (New York: New-York Historical Society, 1953), p. 13; and Mary Bartlett Cowdry, *National Academy of Design Exhibition Record 1826-1860* (New York: New-York Historical Society, 1943), vol. I, p. 16.

 Badger's activities between the late 1830s and the late 1860s are a mystery. He lived near the Hale family in Chicago after the Civil War. He is listed in the Chicago city directories for 1869-71 and 1874, with his profession given variously as "artist" and "engineer."

29. Henry C. Rogers, pp. 85-86.

30. Pomroy Jones, *Annals and Recollections of Oneida County* (1851), pp. 294-95. The "academy" may not have been in existence when Barnard resided in Sauquoit.

 The *History of Oneida County, New York* (Philadelphia: Everts & Fariss, 1878), states that "from its early settlement [Sauquoit] had been a place of large manufacturing interests." Some of the businesses, including stores, hotels, and fabric mills, are discussed on pp. 503-504. In addition, Daniel E. Wager, *Our County and Its People: A Descriptive Work on Oneida County, New York* (Boston: Boston History Company, 1896), briefly discusses some of the early merchants and

manufacturers of Sauquoit (pp. 489-501). These volumes also provide similar data on the early history of New Hartford, Bridgewater, and Paris.

31. 1842 New York State *Gazetteer*, p. 363.

32. 1836 New York State *Gazetteer*, p. 570; and Henry C. Rogers, pp. 115-122.

33. Jane Loring Gray, ed., *Letters of Asa Gray* (Boston and New York: Houghton Mifflin and Co., 1894), vol. I, p. 11.

34. Jane Loring Gray, p. 127; see also p. 379.

35. The following wedding notice was published in the *Oneida Whig*, January 31, 1843, p. 3.
 Married--
 On the 24th instant, at Sauquoit, by J.M. Gray, Esq., Mr. George N. Barnard, to Miss Sarah J. Hodge [sic], all of Sauquoit.

 J.M. Gray appears to have been James Madison Gray, son of Jordan Gray. Asa Gray's father was Moses Gray. A connection between Jordan and Moses Gray is possible, but thus far unproven.

36. Sarah Jane Hodges was born on December 3, 1823, in Madison County, New York, the daughter of Lyman and Mary Hodges. Lyman Hodges' first wife, Ann (Hubbard) Hodges, died on April 3, 1822, at the age of 21. He remarried in late 1822 or early 1823 and resided in Cazenovia, New York. He died sometime prior to 1837.

 In the Madison County Surrogate file, Estate of Marion Lodge, a letter dated August 27, 1837, details the location of Lyman Hodges's two daughters: "Ann, resides in Cazenovia and Sarah resides in Oneida County with her Divorced [sic] mother who lives at and works in a Factory on the Sauquoit Creek about 1 to 2 or 3 miles up the Creek from the village of New Hartford..." From photocopy in files of Onondaga Historical Association.

37. *D.A.R. Records*, vol. 6, p. 276, New York State Library, Albany. Barnard and his wife were dismissed from the church on November 2, 1845, after their move to Oswego, where they joined a Presbyterian Church (p. 251).

38. Henry C. Rogers, p. 175.

39. Pomroy Jones, *Annals and Recollections of Oneida County* (Rome, N.Y.: 1851), pp. 298-99. See also, Henry C. Rogers, p. 182.

40. See Whitney R. Cross, *The Burned-over District: The Social and Intellectual History of Enthusiastic Religion in Western New York, 1800-1850* (Ithaca: Cornell University Press, 1950); and Michael Barkun, *Crucible of the Millennium: The Burned-over District of New York in the 1840s* (Syracuse: Syracuse University Press, 1986).

41. Henry C. Rogers, p. 178.

42. Philip Greven, *The Protestant Temperament* (New York: Knopf, 1977), pp. 192-198.

43. *Oswego Palladium*, August 31, 1850, p. 2.

44. Charles M. Snyder, *Oswego: From Buckskin to Bustles* (Port Washington, N.Y.: Ira J. Friedman, Inc., 1968), pp. 108-118.

45. See Ralph Volney Harlow, *Gerrit Smith: Philanthropist and Reformer* (New York: Henry Holt and Company, 1939).

46. Ibid., p. 1. In *Man on Fire: John Brown and the Cause of Liberty* (New York: Macmillan Company, 1971), Jules Abels notes that Smith "campaigned not only against alcohol and tobacco, but also against tea, coffee, meat, and, in fact, against almost everything that seemed to afford pleasure. He [also] backed campaigns for Sunday schools, foreign missions, prison reforms, women's rights, abolition of capital punishment, and observance of the Sabbath on the seventh day of the week" (p. 122).

47. For background on this involvement see (in addition to Harlow and Abels) the following: Anthony J. Barker, *Captain Charles Stuart: Anglo-American Abolitionist* (Baton Rouge: Louisiana State University Press, 1986); Laurence J. Friedman, "The Gerrit Smith Circle: Abolitionism in the Burned-over District," *Civil War History*, March 1980, pp. 18-38; and Jeffrey Rossbach, *Ambivalent Conspirators: John Brown, the Secret Six, and a Theory of Slave Violence* (Philadelphia: University of Pennsylvania Press, 1982).

48. Ralph Volney Harlow, p. 69.

49. Ibid., p. 70.

50. Ibid.

51. On April 10, 1844 (p. 2), the *Oswego County Whig* noted that the hotel "has undergone a thorough repair, and will now rank in appearance with any establishment in the country. It is kept by Messrs. Wormer and Lord, both temperance men, who will keep a house on temperance principles."

52. *Oswego Palladium*, August 20, 1845, p. 3. See also the subsequent version of this announcement which ran in the *Oswego Palladium* from August 27, 1845, through October 14, 1845, p. 3.

53. *Oswego Palladium*, April 2, 1846, p. 2.

54. Daniel J. Boorstin, *The Americans: The National Experience* (New York: Vintage Books, 1965); see chapter 18, "Palaces of the Public," pp. 134-147.

55. Ibid., pp. 145-146. "...in Chicago in 1844, of persons listed in the city directory, about one in six was living in a hotel..." See also Edgar W. Martin, *The Standard of Living in 1860: American Consumption Levels on the Eve of the Civil War* (Chicago: University of Chicago Press, 1942), pp. 148-156.

56. Daniel J. Boorstin, p. 137.

57. *D.A.R. Records*, vol. 6, p. 276, New York State Library, Albany. See also *Oswego County Whig*, February 14, 1844, p. 3, for listing of Wormer's name in a notice for a Whig rally for Henry Clay.

58. *Oswego Palladium*, September 3, 1845, p. 3.

59. Joseph R. Gusfield, *Symbolic Crusade: Status Politics and the American Temperance Movement* (Urbana and Chicago: University of Illinois Press, 1986; first published 1963), see particularly pp. 4-9.

60. Ian R. Tyrell, *From Temperance to Prohibition in Antebellum America, 1800-1860* (Westport, Conn.: Greenwood Press, 1979), p. 160.

61. Ibid., p. 170.

62. In the 1855-58 Syracuse city directories Barnard is listed as a boarder at the Onondaga Temperance House.

63. Ralph Volney Harlow, p. 71.

64. Doris Elizabeth King, "The First-Class Hotel and the Age of the Common Man," *The Journal of Southern History*, May 1957, p. 180.

65. Letter from Edwards to Smith, October 9, 1846: "The Oswego Hotel is as you say an unfortunate piece of property..."; Gerrit Smith papers, George Arents Research Library, Syracuse University.

 In 1835 Smith sold the building to Moses P. Hatch for $25,000. The new owner made many improvements on the rundown structure and sold it in 1836 (at the peak of the area's speculative boom in real estate) for $120,000 to a Mr. Baldwin. However, this sale was "not perfected" and ownership reverted to Gerrit Smith. Smith finally sold the building in 1855. The hotel's name was changed to the Fitzhugh House in the 1850s and the structure was demolished in 1887. (John C. Churchill, *Landmarks of Oswego County, New York* [1895], pp. 331-32.)

66. Letter from Edwards to Smith, September 23, 1846; Gerrit Smith papers.

I:2 Oswego: 1846-1853

1. *Oswego County Whig*, June 16, 1841, p. 2.

2. Ibid., p. 3.

3. *Oswego County Whig*, June 15, 1842, p. 2.

4. *Anthony's Photographic Bulletin*, February 1884, p. 73.

5. See notices on Jackson in the *Utica Daily Gazette*: February 3, 1842, p. 3; February 15, 1842, p. 2; March 2, 1842, p. 3; and March 27, 1842, p. 3. The last of these reports Jackson's partnership with a Mr. Hughes.

 For information on E.D. Palmer, see the *Utica Daily Gazette*, August 16, 1842, and August 24, 1842 (p. 3). Palmer's ads ran through at least December 15, 1842.

 The earliest daguerreotypist in Utica may have been "Mr. Young, a late pupil of Professor Morse," who was reported to have taken portraits and landscapes in "three or four minutes." *Utica Observer*, November 10, 1840, and November 17, 1840, p. 2. Young visited Oswego in June 1841.

6. Ads for "Daguerre's Magical Pictures" appeared in the June 11, 1842, and June 18, 1842, issues of the *Utica Daily Gazette*. The paper later reported (February 16, 1843, p. 2), that this traveling spectacle was destroyed by fire on January 30, 1843, in New Orleans.

7. See Henry C. Rogers, pp. 40, 114, and 127.

8. *Utica Daily Gazette*, February 2, 1843, p. 3. Dr. Bishop advertised his services as a daguerreotypist in the January 25, 1843 issue of the *Utica Daily Gazette*. Three days later the announcement of his partnership with Gray was published.

9. *Oswego Palladium*, June 2, 1846, p. 3. This issue also contained a brief editorial endorsing Becker's competence, p. 2.

10. J.F. Ryder, *Voigtlander and I* (Cleveland: The Imperial Press, 1902), p. 14.

11. Ibid., pp. 18-19.

12. *Oswego Palladium*, August 4, 1846, p. 2.

13. Within a year the hotel was being managed by Ira Garrison, Jr.

14. *Oswego Palladium*, September 8, 1846, p. 2.

15. *Oswego Palladium*, March 9, 1847, p. 2.

16. Ironically, Plumbe was bankrupt by the end of 1847 and had sold off his impressive collection of galleries.

17. The newspapers of the era were conscious of their tendency toward excessive praise. The *Oswego Commercial Times* (August 10, 1848, p. 2) noted approvingly the comments of the *Syracuse Journal* regarding

 the practice now extensively prevalent with the newspaper press in this country, of puffing about every thing new or novel, without strict reference to the merits of the object. The *Journal* pledges itself to a thorough reform of this practice in its own case...The habit has grown out of an easy disposition and a desire to oblige on the part of Editors, but without sufficient investigation into the claims of every new thing to merit and commendation."

18. *Oswego Palladium*, August 3, 1847, p. 2.

19. *Oswego Palladium*, August 10, 1847, p. 2. This same ad was run in the *Oswego Commercial Times* through 1848.

20. *Oswego Palladium*, January 16, 1848, p. 3.

21. *Oswego Times*, November 21, 1848, p. 2. This reference to Barnard's "permanent residence" in Oswego is curious since, by this time, he had been in the city for more than three years.

22. *Oswego Commercial Times*, December 21, 1848, p. 3. This ad was submitted for publication on November 21. Twice in the copy of this ad "daguerreotype" is misspelled "daugerotype"; these errors have been corrected here.

23. *Oswego County Whig*, January 11, 1843, p. 1. These are the first and sixth stanzas of a seven-stanza poem. Death and disease were common themes in the newspapers of the period, and poems or essays on death appeared regularly. See, for example, in the *Oswego County Whig*, "The Dead" by Mrs. C.H. Essling (November 9, 1842, p. 1) and "The Dying Boy" (August 2, 1843, p. 1). The deadly threats of infectious disease were also reported regularly. Prior to Barnard's cholera ad, for example, the *Oswego Palladium* ran an article on the "History of Influenza" (July 5, 1845, p. 2), and notices on the outbreaks of yellow fever (September 6, 1843, p. 2) and smallpox (October 28, 1845, p. 2).

24. N.B. Burgess, "The Value of Daguerreotype Likenesses," *The Photographic and Fine Art Journal*, January 1855, p. 19.

25. See Charles E. Rosenberg, *The Cholera Years: The United States in 1832, 1849 and 1866* (Chicago and London: The University of Chicago Press, 1962), particularly pp. 101-120.

26. The July 13, 1850, issue of the *Oswego Palladium*, for example, was still reporting the dire consequences of the disease. For a contemporary summary of the history of the epidemic, see "Asiatic Cholera," *Harper's New Monthly Magazine*, August 1856, pp. 359-367.

27. Oswego 1850 census manuscripts, cited by Judy Gardner, Margaret Adkins, Brian Bay, *Oswego: 1850* (1974), unpublished paper, Special Collections, Penfield Library, State University of New York-Oswego, unpaginated.

28. 1850 Oswego census, taken August 20, 1850, Oswego Fourth Ward, p. 20, dwelling 165. Mary

Hodges, Barnard's mother-in-law, was listed as owning $1500 in real estate.

29. *Oswego Daily Commercial Times*, January 8, 1850, p. 2. This ad also ran in the *Oswego Palladium*.

30. *Oswego Palladium*, January 12, 1850, p. 2.

31. *Oswego Daily Times*, December 31, 1852, p. 2. This building, on the southeast corner of Cayuga and West First Streets, was torn down in 1967 and replaced by a one-story office building.

32. *Oswego Daily Times*, January 7, 1853, p. 2.

33. *Oswego Daily Journal*, November 3, 1853, p. 2.

34. *The Photographic and Fine Art Journal*, January 1853, p. 63.

35. *The Daguerreian Journal*, October 1, 1851, pp. 309-11.

36. This daguerreotype, now in the collection of the Canadian Centre for Architecture, Montreal, was found in 1971 by an Oswego antiques dealer. See *Oswego Palladium-Times*, February 15, 1972.

37. *Oswego Daily Times*, July 5, 1853, p. 2. The area destroyed in this fire was later given as about eight square blocks. Within days it was determined that the fire had not been caused by "friction in a smut machine," but probably by a firecracker or "an incendiary" thrown in the basement of the Fitzhugh mill (passage from *Oswego Times*, reprinted in the July 9, 1853, *Syracuse Standard*.)
 Oswego began rebuilding quickly after the fire. By August 18, 1853, a visitor reported that "The 'Burnt District' is fast rebuilding...and true Yankee prosperity and enterprise seem to prevail on every hand." (Letter from a "Traveler," *Syracuse Standard*, August 24, 1853.)

38. *Oswego Daily Times*, July 12, 1853, p. 2.

39. This ad ran through September 13, 1853.

40. Beaumont Newhall, *The History of Photography* (New York: Museum of Modern Art, 1982), p. 39. See also, *The Oswego Palladium-Times*, February 24, 1962, p. 7, for reproductions of both plates now in the George Eastman House collection under the heading, "First Spot News Pictures Taken in America."

I:3 The Profession Matures: The Daguerreotype in the early 1850s

1. Richard Rudisill, *Mirror Image: The Influence of the Daguerreotype on American Society* (Albuquerque: University of New Mexico Press, 1971), pp. 197-198.

2. *Oswego Palladium*, August 31, 1847, p. 3.

3. For example, see editorial notices of the galleries of Tracy Gray and S.B. Henderson in the *Oswego Palladium*, September 9, 1850, p. 2, and January 31, 1851, p. 2. By May 24, 1851, a Mr. Spencer had taken over Henderson's business.

4. *Oswego Daily Journal*, November 3, 1853, p. 2.

5. *The Daguerreian Journal*, February 1, 1851, p. 181.

6. Donald R. Adams, Jr., "Prices and Wages," in Glenn Porter, ed., *Encyclopedia of American Economic History, Studies of Principal Movements and Ideas* (New York: Charles Scribner's Sons, 1980), p. 237.

7. Ibid. Interpolation of data given in tables on p. 234.

8. Richard Rudisill, p. 198.

9. Edgar W. Martin, *The Standard of Living in 1860: American Consumption on the Eve of the Civil War* (Chicago: University of Chicago Press, 1942), pp. 153, 409, 423. The value of gold ($10 per ounce in 1848) is drawn from William S. McFeely, *Memoirs of General William T. Sherman* (New York: DeCapo Press, 1984; first published 1875), p. 58.

10. *Humphrey's Journal*, vol. 5, 1853, p. 16; reprint of Brady ad from a New York daily newspaper with editorial comment. See also, "How to Take Cheap Ambrotypes," *The Photographic and Fine Art Journal*, November 1858, p. 343.

11. *The Daguerreian Journal*, July 15, 1851, pp. 153-54; and *The Photographic Art-Journal*, August 1851, p. 122.

12. *The Photographic Art-Journal*, September 1851, pp. 169-71.

13. *The Photographic Art-Journal*, November 1851, pp. 298-99.

14. *The Photographic and Fine Art Journal*, May 1855, pp. 143-44.

15. This may be a reference to the 154 photographs by C.M. Ferrier, of Paris, and by Hugh Owen, of Bristol, England, of the Crystal Palace in 1851. This famous exhibition displayed the machinery, manufactures, and art of many nations. The negatives of Ferrier and Owen were printed by Nikolas Henneman, with the resultant salted paper prints tipped onto the pages of the lavish *Reports by the Juries*, issued in an edition of 130.

16. *The Photographic and Fine Art Journal*, May 1855, pp. 158-59.

17. This theme receives extensive treatment in Richard Rudisill's pioneering study, *Mirror Image*; see particularly pp. 175-196.

18. M.A. Root, *The Camera and the Pencil* (Philadelphia: J.B. Lippincott & Co., 1864), p. 27.

19. William James Stillman, review of "Modern Painters V," *Atlantic Monthly*, August 1860, p. 239.

20. For further data on Ruskin's influence in America, see Roger B. Stein, *John Ruskin and Aesthetic Thought in America, 1840-1900* (Cambridge: Harvard University Press, 1967); and Linda S. Ferber and William H. Gerdts, *The New Path: Ruskin and the American Pre-Raphaelites* (Brooklyn: The Brooklyn Museum, 1985).

21. *The Photographic Art-Journal*, May 1852, p. 324.

22. *The Photographic Art-Journal*, June 1852, p. 380.

23. *The Photographic Art-Journal*, April 1853, p. 251.

24. Barnard used the elaborate frame in his gallery where, as he noted, "it forms a handsome though costly ornament." Letter of August 1, 1853 printed in the *Photographic Art-Journal*, September 1853, pp. 149-150.

25. In a letter to *The Photographic and Fine Art Journal* (September 1856, p. 276), dated August 20, 1856, D.D.T. Davie recalled the pleasures of the association,

 when in healthy and flourishing state...The free communication of sentiments amongst a set of ingenious and speculative friends, such as those were, throws the mind into the most advantageous exercises. *In union there is strength*. Association gives strength to our reason, unanimity of feeling, character to our profession.

Davie attributed the failure of the group to the indifference of the leading galleries in Boston, New York, and Philadelphia. Davie futilely called on these large operators "to go forward in this work, and we in the interior are ready to put our shoulders to the wheel as soon as the word of command is given."
 An equally short-lived organization, established at the same time as the New York State Daguerreian Association, was the American Daguerre Association (originally called the American Heliographic Association). This latter group was composed of an "elected" membership, and was thus quickly accused of secrecy and elitism.

26. *The Philadelphia Photographer*, September .1884, p. 270.

27. *The Photographic Art-Journal*, September 1852, pp. 151-52.

28. *The Photographic Art-Journal*, May 1853, p. 319.

29. Edward Anthony had studied engineering with Renwick at Columbia University, and learned the daguerreotype process from Morse.

30. Harrison's background in the theater is reviewed in Richard Rudisill, p. 127.

31. All information on the Anthony Prize is from *The Photographic and Fine Art Journal*, January 1854, pp. 6-9.

32. Richard Rudisill, p. 12.

33. Elizabeth Johns, "The Farmer in the Works of William Sidney Mount," *Art and History: Images and Their Meaning*, ed. Robert I. Rotberg and Theodore K. Rabb (Cambridge: Cambridge University Press, 1986), p. 266.

34. Review of 1851; cited in Bartlett Cowdrey and Hermann Warner Williams, Jr., *William Sidney Mount 1807-1868; The American Painter* (New York: Columbia University Press, 1944), p. 17.

35. Ibid., p. 264.

36. Henry C. Rogers, pp. 90-93.

37. William Cronon, *Changes in the Land: Indians, Colonists and the Ecology of New England* (New York: Hill and Wang, 1983); see particularly pp. 108-126.

38. Thomas Cole, "Lecture on American Scenery," *The Northern Light*, May 1841, p. 25.

39. See Nicolai Cikovsky, Jr., "The Ravages of the Axe: The Meaning of the Tree Stump in Nineteenth Century American Art," *The Art Bulletin*, December 1979, pp. 611-626.

40. *The Photographic and Fine Art Journal*, September 1856, pp. 287-88.

41. *The Philadelphia Photographer*, May 1866, p. 129.

42. *The Photographic and Fine Art Journal*, October 1855, p. 319. See also an earlier notice for the club in the August 1855 issue, p. 255.

I:4 Syracuse: 1854-1859

1. *Humphrey's Journal*, February 1, 1854, p. 320.

2. This gallery had previously been managed by J.M. Clark, who had also been a member of the New York Daguerreian Association. It appears that this was the same J.M. Clark who had operated a daguerreotype studio in New York City in the early 1850s. In 1851 he was appointed president of the American Photographic Institute, an organization of thirty-seven New York City daguerreotypists (*The Photographic Art Journal*, October 1851, p. 250). Clark had also been an early partner of Edward Anthony's in the mid-1840s.

3. *The Photographic and Fine Art Journal*, April 1854, p. 128; May 1854, p. 160; June 1854, p. 192.

4. *Oswego Times and Journal*, June 24, 1854, p. 2. In the editorial pages of this same issue, the paper affirmed that "Mr. Barnard has recovered from a severe sickness, and is again on hand, as will be seen, at his rooms over the City Bank, making his unrivaled pictures, true to life."

5. Photocopy of the original manuscript text, Onondaga Historical Association.

6. *Oswego Times and Journal*, October 12, 1854, p. 2.

7. On the issue of fading, see *The Photographic and Fine Art Journal*, August 1855, pp. 249-51.

8. Their gallery space over the City Bank was subsequently occupied by John Austen.

9. The first of these plates appears to be 6½x8½ inches in size. The second measures about 4¼x5½ inches. While neither plate bears Barnard's identifying imprint, "G.N. Barnard" appears to be scratched on the back of the larger plate. The date of June 1, 1854, has been given by the Onondaga Historical Association. Both plates read correctly, indicating either that Barnard used a reversing lens in making them, or that they were copied from original (reversed) plates. The larger of these views may have been made from the building to which Barnard moved in May 1856, just around the corner from his gallery in the Franklin Block.

10. *Syracuse Standard*, June 2, 1854, p. 3; June 3, 1854, p. 2.

11. *Syracuse Daily Standard*, March 4, 1854, p. 2.

12. *Syracuse Daily Standard*, September 22, 1854, p. 2.

13. *Syracuse Daily Standard*, December 27, 1854. The first reference to stereoscopic photographs in Syracuse seems to have been in the December 6, 1853 *Syracuse Daily Standard* (p. 2). In describing the scenes of Paris at Mr. Benedict's gallery, the newspaper noted that "those we saw were made on glass, but metallic plates are also used. Their beauty is almost ravishing..."

14. *Syracuse Daily Standard*, December 6, 1853, p. 2.

15. *Syracuse Daily Standard*, December 15, 1854.

16. *The Syracusean*, April 28, 1855, p. 2.

17. *Syracuse Standard*, January 26, 1855, p. 2; January 27, 1855, p. 2; and January 29, 1855, p. 2.

18. *Syracuse Journal*, January 24, 1855, p. 2.

19. *Syracuse Journal*, January 29, 1855, p. 2.

20. *Syracuse Standard*, January 29, 1855, p. 2.

21. *Syracuse Standard*, January 30, 1855, p. 2. The firm of McDougall & Fenton produced shoes.

22. *Syracuse Standard*, March 19, 1855, p. 2.

23. *The Photographic and Fine Art Journal*, July 1855, p. 224. See N.G. Burgess, "Taking Portraits After Death," in the March 1856 issue, p. 95.

24. See, Phoebe Lloyd, "Posthumous Mourning Portraiture," in Martha V. Pike and Janice Gray Armstrong, *A Time to Mourn: Expressions of Grief in Nineteenth Century America* (Stony Brook, N.Y.: The Museums at Stony Brook, 1980), pp. 71-89.

25. In 1853 Whipple received first prize for his paper photographs exhibited at the World's Fair in New York. The great majority of his competitors showed only daguerreotypes. One of the first crystalotype prints made by Whipple for inclusion in the *Photographic Art-Journal* (April 1853) was a portrait of Edward Anthony, copied from a daguerreotype. See Robert Taft, *Photography and the American Scene: A Social History, 1839-1889* (New York: Dover Publications, 1964; first published 1938), pp. 114-122.

26. William Welling, p. 111.

27. Letter from Marcus A. Root, dated June 20, 1855, printed in the July 1855 issue of *The Photographic and Fine Art Journal*, p. 221.

28. *The Photographic and Fine Art Journal*, November 1856, p. 351.

29. William Welling, p. 107.

30. Ibid., p. 97.

31. *The Photographic and Fine Art Journal*, July 1855, p. 223.

32. Ibid., p. 221.

33. *The Photographic and Fine Art Journal*, August 1855, pp. 255-256.

34. Ambrotypes by Barnard in the collections of the Getty Museum, Malibu, California, and the author, are thus stamped on the mat.

35. *The Photographic and Fine Art Journal*, December 1855, p. 356.

36. *The Photographic and Fine Art Journal*, May 1854, p. 160.

37. *Syracuse Standard*, August 28, 1855, p. 2.

38. *Syracuse Standard*, December 12, 1855. Barnard and Nichols won a silver medal for the "best daguerreotypes." (Ibid., March 3, 1856, p. 2.)

39. *Syracuse Journal*, December 28, 1855.

40. *Syracuse Standard*, December 19, 1855.

41. *The Photographic and Fine Art Journal*, March 1856, p. 95.

42. *Syracuse Standard*, January 8, 1856, p. 2.

43. *Syracuse Standard*, March 17, 1855: "A Nuisance — We hear many complaints about the fish market established in front of the Franklin Buildings. The effluvia is unsavory and the appearance anything but attractive."

44. *Bellows Pictorial Drawing Room Companion*, August 2, 1856 (clipping in files of Onondaga Historical Association).

45. *Syracuse Standard*, December 8, 1856.

46. *Syracuse Standard*, April 16, 1856.

47. *Syracuse Standard*, April 30, 1856.

48. *Syracuse Standard*, May 14, 1856.

49. *Syracuse Standard*, May 17, 1856.

50. *The Photographic ana Fine Art Journal*, July 1856, p. 224.

51. The notice of dissolution was dated October 2, 1856, and published in the *Syracuse Standard* in succeeding days.

52. See advertisement in the *Syracuse Standard*, September 19, 1856, p. 2. Mrs. E.T. Crocker announced "to the Ladies of Syracuse" that she was qualified to give instructions in the "useful art" of "Potichomanie," by which "the most common glass vessel" could be changed "into a most splendid Chinese, Dresden or Japanese Vase..." From her room in Barnard & Nichols Daguerrean Gallery she sold all the materials necessary for this work.

53. *Syracuse Standard*, February 7, 1857.

54. *The Photographic and Fine Art Journal*, November 1856, p. 351.

55. *Syracuse Standard*, April 11, 1857.

56. *Syracuse Journal*, March 23, 1857, p. 3.

57. J.F. Coonley, "Pages from a Veteran's Notebook," *Wilson's Photographic Magazine*, March 1907, p. 99.

58. From the *Fulton Patriot*, reprinted in the *Syracuse Standard*, July 27, 1857.

59. *The Photographic and Fine Art Journal*, July 1857, p. 224.

60. *Syracuse Journal*, August 3, 1857, p. 2.

61. *The Photographic and Fine Art Journal*, December 1857, p. 382.

62. James L. Huston, *The Panic of 1857 and the Coming of the Civil War* (Baton Rouge: Louisiana State University Press, 1987), p. 12.

63. *The Photographic and Fine Art Journal*, August 1858, p. 255.

64. *Syracuse Journal*, August 3, 1857, p. 2. As early as July 1854 "25 Cent Daguerreotypes" were being advertised in Syracuse; see *Syracuse Daily Standard*, July 11, 1854, p. 2 (found in advertisement for "Carpenter & Co.").

65. For a review of this process, see *Harper's New Monthly Magazine*, December 1865, pp. 10-11.

66. *The Photographic and Fine Art Journal*, October 1857, p. 319. Mr. Lazier (or Laziere) was evidently a relatively skilled photographer; see Ibid., July 1858, p. 223, and the *Syracuse Standard*, February 22, 1859, p. 3.

67. *The Photographic and Fine Art Journal*, December 1855, p. 384.

68. The variety of photographic processes exhibited at this fair was extraordinary. In addition to daguerreotypes and paper prints, medals were given for "instantaneous" daguerreotypes, life-size "photographs in oil," crayon photographs, photographs in aquarelle, photographic copies of prints, solar-camera enlargements, and stereoscopic "panoramas." This technical emphasis displeased H.H. Snelling. He noted beneath a summary of the photographic premiums that "we think that nothing shows the imbecility of the American Institute to greater advantage, than this whole list of awards." (*The Photographic and Fine Art Journal*, December 1857, p. 383.)

69. *The Photographic and Fine Art Journal*, November 1857, p. 347.

70. See Walter W. Ristow, *American Maps and Mapmakers: Commercial Cartography in the Nineteenth Century* (Detroit: Wayne State University Press, 1985), pp. 355-378.

71. J.H. French, *Gazetteer of the State of New York...* (Syracuse: R.P. Smith, 1859), p. 2.

72. Ibid., pp. 401, 481, and 529.

73. Isaac was listed in the family bible; photocopy in files of Onondaga Historical Association.

74. *Syracuse Standard*, November 18, 1856, p. 3. Unlike other temperance hotels of the period, the Onondaga Temperance House appears to have been a first-class and relatively profitable enterprise. See Ibid., May 18, 1854, p. 2; and November 18, 1856, p. 3.

75. Reminiscence of Grace Lasher, interviewed by the staff of the Onondaga Historical Association in 1963.

76. Voltaire Combe's original name was Captain Combs. Born in Jordan, New York, Combe was a portrait and landscape painter who produced work for the firm of Currier and Ives. See Constance Rourke, "Voltaire Combe," in *The Roots of American Culture and Other Essays* (New York: Harcourt, Brace and Company, 1942), pp. 251-261. This piece first appeared in *The Nation* in 1939. Unfortunately, Rourke's essay is inadequately documented.

There is evidence that Barnard and his wife maintained contact with one another during the war years. In early 1862 Barnard's wife learned that her cousin "had been confined in Irons for some days without just cause or provocation." She immediately wrote the photographer, then at Brady's Gallery in Washington, requesting that he use his contacts in the city to have the matter investigated. On April 18 Barnard wrote to General Lorenzo Thomas to request that this "severe and humiliating punishment" be reviewed. (Letter of April 18, 1862; Combe file in National Archives)

77. In 1875 Sarah was listed as residing in Brooklyn with her widowed mother, Mary A. Hodges, who died in 1880.

II:1 New York and Washington: 1860-1863

1. For background on the firm, see William and Estelle Marder, *Anthony: The Man, The Company, The Cameras* (Plantation, Fl.: Pine Ridge Publishing Company, 1982); and Reese V. Jenkins, *Images and Enterprise: Technology and the American Photographic Industry 1839 to 1925* (Baltimore: Johns Hopkins University Press, 1975). For a brief contemporary description of the Anthonys' facilities, see Oliver Wendell Holmes, "Doings of the Sunbeam," *The Atlantic Monthly*, July 1863, pp. 1-2.

2. Reese V. Jenkins, p. 50.

3. J.F. Coonley, "Pages from a Veteran's Notebook", *Wilson's Photographic Magazine*, March, 1907, p. 105. In this reminiscence Coonley gives the date of his start with Anthony as 1858. However, Coonley was still advertising his Ambrotype, Photograph and Daguerreotype business in Syracuse (No. 6 Franklin Buildings) in January 1859. See the *Syracuse Standard*, January 11, 1859, p. 1.

4. William C. Darrah, *The World of Stereographs* (Gettysburg, Pa.: W.C. Darrah, 1977), pp. 1-7.

5. Oliver Wendell Holmes, "The Stereoscope and Stereograph," *The Atlantic Monthly*, June 1859, p. 744. See also Edward W. Earle, "The Stereograph in America: Pictorial Antecedents and Cultural Perspectives," in *Points of View: The Stereograph in America — A Cultural History* (Rochester, N.Y.: Visual Studies Workshop, 1979), pp. 9-21.

6. *The Journal of the Birmingham Photographic Society*; reprinted in E. Anthony's *New Catalogue of Stereoscopes and Views*, October 1862.

7. Oliver Wendell Holmes, "Sun-Painting and Sun-Sculpture," *The Atlantic Monthly*, July 1861, pp. 17-18.

8. N.G. Burgess, *The Photograph Manual* (New York: D. Appleton & Co., 1863), p. 78.

9. William C. Darrah, p. 3.

10. This concept receives extensive treatment in Thomas Southall, "White Mountain Stereographs and the Development of a Collective Vision," *Points of View: the Stereograph in America — A Cultural History*, pp. 97-108.

11. The first 134 titles of this series were registered for copyright by the Anthony firm between June 25 and July 17, 1860. (See Copyright Records for the District Court of the Southern District of New York, Library of Congress, volume 189.) The Anthonys must have held this series in unusually high regard, since it appears that no previous stereograph series had been copyrighted in its entirety. Only the most unusual images, such as instantaneous views, were typically registered for copyright.

12. *Syracuse Standard*, September 26, 1854, p. 2; and October 7, 1854, p. 2.

13. Robert E. May, *The Southern Dream of a Caribbean Empire, 1854-1862* (Baton Rouge: Louisiana State University Press, 1973), p. 174.

14. For example, see "A Trip to Cuba," *The Atlantic Monthly*, May 1859, pp. 601-608, and June 1859, pp. 686-92. This article emphasizes the negative aspects of a tourist's visit, perhaps in reaction to the period's generally idealized description of the island.

15. *Anthony's Photographic Bulletin*, April 1902, p. 127.

16. For example, see "Three Weeks in Cuba," *Harper's New Monthly Magazine*, January 1853, pp. 161-175; and "Sugar-Making in Cuba," *Harper's New Monthly Magazine*, March 1865, pp. 440-453.

17. The movement of shadows strongly suggests that series number 127 was taken approximately twenty minutes before series number 39. This in turn suggests that the numbers etched into each negative bear little correspondence to the sequence of their actual production.

18. *American Journal of Photography*, February 15, 1861, p. 281.

19. *The Photographic and Fine Art Journal*, May 1860, pp. 144-145.

20. For data on Gardner's character, see his obituary in *The Philadelphia Photographer*, January 1883, pp. 92-95.

21. Josephine Cobb, "Mathew B. Brady's Photographic Gallery in Washington"; reprinted from *The Columbia Historical Society Records*, vol. 53-56 (Washington, D.C.), pp. 9-18.

22. See William C. Darrah, *Cartes de Visite in Nineteenth Century Photography* (Gettysburg, Penn.: W.C. Darrah, 1981)

23. William Welling, *Photography in America: The Formative Years 1839-1900* (New York: Thomas Y. Crowell, 1978), p. 150.

24. Josephine Cobb, pp. 22-23.

25. The collaboration between Barnard and Coonley on this work has been inferred from two separate accounts by Coonley. In 1882 (*Anthony's Photographic Bulletin*, September, 1882, p. 311) Coonley stated, "at the time of Mr. Lincoln's inauguration I was in New York engaged in photographic work in connection with Mr. G.N. Barnard, which rendered it necessary for us to go to Washington in order to complete it..." In 1907 (*Wilson's Photographic Magazine*, March, 1907, p. 106), Coonley wrote, "...on my return to New York I was sent to Brady's Gallery, Tenth Street and Broadway, to copy in [the carte-de-visite] size all his collection of distinguished people. This being completed, I was sent to his Washington gallery to do some work there...."

26. *Anthony's Photographic Bulletin*, September 1882, p. 311.

27. William S. McFeely, *Memoirs of General William T. Sherman* (New York: DeCapo Press, 1984: reprint of edition of 1875), vol. I, p. 163.

28. John S. Bowman, *The Civil War Almanac* (New York: World Almanac Publications, 1983), p. 48.

29. William Swinton, *History of the Seventh Regiment, National Guard, State of New York, During the War of the Rebellion* (New York: Fields, Osgood & Co., 1870), p. 166.

30. Josephine Cobb, p. 18.

31. My thanks to William Frassanito for his initial information on these photographs. Very little is known about Barnard's apparent collaborator, C.O. Bostwick. It may be that he was Charles Oakley Bostwick (b. September 25, 1842), the son of Samuel Fitch Bostwick (b. 1806) and Lucy R. Bartlett (b. 1809). See Henry Anthon Bostwick, *Genealogy of the Bostwick Family in America; The Descendants of Arthur Bostwick of Stratford, Conn.* (New York, 1901), p. 335. It must be presumed that C.O. Bostwick was a youthful employee of the Anthonys who accompanied Barnard as an assistant.

It is uncertain if Charles B.[yron] Bostwick, a First Lieutenant in the Seventh New York Regiment, was related to Barnard's collaborator. See Ibid., p. 578 and Frederick Phisterer, *New York in the War of the Rebellion 1861 to 1865* (Albany: J.R. Lyon Company, 1912), p. 549.

32. W. Fletcher Thompson, Jr., *The Image of War: The Pictorial Reporting of the American Civil War* (New York: Thomas Yoseloff, 1959), pp. 28-29.

33. Colonel Emmons Clark, *History of the Seventh Regiment of New York 1806-1889*, vol. II (New York: Seventh Regiment, 1890), pp. 1-5.

34. William Swinton, pp. 164, 178. The population of the Seventh apparently ranged between 1156 and a high of 1270.

35. Colonel Emmons Clark, pp. 1, 6, 15, 18.

36. Ibid., pp. 16-19; William Swinton, p. 173.

37. Colonel Emmons Clark, p. 23.

38. *Memoirs of General William T. Sherman*, vol. I, p. 176.

39. W. Fletcher Thompson, p. 36.

40. *Memoirs of General William T. Sherman*, vol. I, pp. 178, 181.

41. The hazy and romantic mood of Camp Cameron is suggested in this contemporary description, from "Washington As A Camp," *Atlantic Monthly*, July 1861, p. 113.

It is monotonous, it is not monotonous, it is laborious, it is lazy, it is a bore, it is a lark, it is half war, half peace, and totally attractive, and not to be dispensed with from one's experience in the nineteenth century.

The June 1861 (pp. 744-756) and July 1861 (pp. 105-118) issues of the *Atlantic Monthly* included lengthy first-person descriptions of the Seventh Regiment's march to Washington and activities at Camp Cameron. See also, "The New York Seventh," *Scribner's Monthly*, May 1880, pp. 63-80; William J. Roehrenbeck, *The Regiment that Saved the Capital* (New York: Thomas Yoseloff, 1961); and Margaret Leech, *Reveille in Washington 1860-1865* (New York: Grosset & Dunlap, 1941), pp. 66-86. Leech describes the Seventh as "the kid-glove militia corps..."

42. *New Catalog of Stereoscopes and Views* (New York: E. & H.T. Anthony and Company, n.d. [ca. 1865], p. 26.

43. William A. Frassanito, in letter to the author, May 3, 1989.

44. The Seventh Militia was "in Capital Buildings at Washington April 25 - May 2"; on "duty at Camp Cameron, Meridian Hill, May 2-23"; in "occupation of Arlington Heights, Va., May 24-26"; and back at Camp Cameron on May 26. They were mustered out in New York City on June 3, 1861. Frederick H. Dyer, *A Compendium of the War of the Rebellion, vol. III: Regimental Histories* (New York: Thomas Yoseloff, 1959), p. 1408.

45. William C. Davis, *Battle at Bull Run: A History of the First Major Campaign of the Civil War* (Garden City, N.Y.: Doubleday & Co., 1977), p. 78.

46. Brady reminiscence, published in the *New York World* (1891); cited in *Mathew Brady and his World* (Alexandria, Va.: Time-Life Books, 1977), p. 56.

47. It would have been characteristic of Brady to mention only his more prestigious companions on that day, and not his own employees. It is also obvious that these surviving accounts are blurred by time and distance: Brady's reminiscence of that day was recorded in 1891, while Barnard's was provided second-hand by an Anthony acquaintance or family member (probably his daughter) in 1902.

48. *Anthony's Photographic Bulletin*, April 1902, p. 127.

49. William C. Davis, p. 245.

50. Letter from George B. McClellan to E.M. Stanton, March 11, 1862, describing a forty-mile inspection ride through the area of "Centreville, Union Mills, Blackburn's Ford &c...." McClellan observed that the Confederates' "movement from here was very sudden. They left many wagons, some caissons, clothing, ammunition, personal baggage, &c. Their winter quarters were admirably constructed, many not yet finished. The works at Centreville are formidable; more so than Manassas. Except the turnpike, the roads are terrible..." *The War of the Rebellion: A Compilation of the Official Records of the Union and Confederate Armies*, 128 volumes (Washington: Government Printing Office: 1880-1901), Series I, vol. IV, p. 742.

51. For a brief biographical sketch of Gibson, see: Thomas Waldsmith, "James F. Gibson: Out from the Shadows," *Stereo World*, January-February, 1976, pp. 4-5, 20. See also, William A. Frassanito, *Antietam* (New York: Charles Scribner's Sons, 1978), pp. 33-34.

52. William C. Davis, pp. 204-05.

53. The scope of these ruins attracted other picture makers. See, for example, Alfred R. Waud's sketch (*Harper's Weekly*, March 29, 1862, p. 204) which looks back toward the vantage point used by Barnard in figure 40.

54. Barnard was identified as the maker of these views by Coleman Seller in a letter of December 22, 1862, to the *British Journal of Photography*, January 15, 1863, p. 42.

The date of Barnard's Niagara views is uncertain. The most obvious assumption, based on the date of Sellers' first letter, would be that Barnard produced these negatives in February or March 1862. This period is suspect, however, for several reasons. As Sellers made no mention of snow or ice views, the Anthony series of "Niagara in Winter" was probably not by Barnard. However, the Anthony series that seem most likely to have been described by Sellers — "The Majesty and Beauty of Niagara," or "The Scenery of Niagara," for example — show far more foliage than the area would have had in March. This suggests that Barnard's Niagara series might have been taken in August or September 1861, after the debacle at Bull Run slowed the pace of the war, and produced the following spring. However, it seems a bit unusual for Anthony to have waited this long to release any series of views.

55. *British Journal of Photography*, May 1, 1862, p. 177.

56. William C. Darrah, p. 70. See also Anthony Bannon, *The Taking of Niagara: A History of the Falls in Photography* (Buffalo, N.Y.: Media Study, 1982).

57. *British Journal of Photography*, January 15, 1863, p. 42.

58. The first of these illustrations were published in the May 3, 1862, issue of *Harper's Weekly*, pp. 280-81.

59. As listed in Alexander Gardner's catalog of *Photographic Incidents of the War*, September 1863, pp. 11-13.

60. *Harper's Weekly*, July 12, 1862, p. 438.

61. *Oswego Commercial Times*, September 23, 1862, p. 1.

62. *Oswego Commercial Times*, March 10, 1863, p. 1.

II:2 Nashville: 1864

1. Poe Collection, Library of Congress; in a letter to his wife (March 11, 1864), Poe wrote, "I send you a photograph of myself....The picture was taken by the same man that took that good one of me in New York."

2. See letter from Barnard to General Lorenzo Thomas regarding Combe, dated April 18, 1862, in Combe's service file, National Archives; in this letter Thomas states that he knew Barnard "very well." For Thomas's connection with Secretary of War Cameron, see *Memoirs of General William T. Sherman,* vol. I, p. 201.

3. See *Philadelphia Photographer,* July 1866, p. 214, and January 1869, p. 5; and *British Journal of Photography,* December 15, 1862, p. 475.

4. Eighty-two of these photographs were collated in Herman Haupt, *Photographs Illustrative of Operations in Construction and Transportation...,* accompanied by a 27-page pamphlet of text (Boston: Wright & Potter, 1863). For information on Russell's career, see Charles F. Cooney, "Andrew J. Russell: The Union Army's Forgotten Photographer," *Civil War Times Illustrated,* April 1982, pp. 32-35; and Joe Buberger and Matthew Isenberg, *Russell's Civil War Photographs* (New York: Dover Publications, 1982).

5. *British Journal of Photography,* July 15, 1862, p. 281, and November 15, 1862, p. 438.

6. Colonel R. Delafield, *Report on the Art of War in Europe in 1854, 1855 and 1856* (Washington: George R. Bowman, 1861), p. v.

7. Margaret Denton Smith and Mary Louise Tucker, *Photography in New Orleans: The Early Years, 1840-1865* (Baton Rouge: Louisiana State University Press, 1982), pp. 123-126.

8. See, for example, the list of photographs forwarded to Delafield from Colonel William E. Merrill on October 20, 1864, from Chattanooga; *Official Records,* Series I, vol. 39, part 3, pp. 380-381.

9. David O. Adams was born in about 1840 in Lockport, New York, and resided in Danville, Indiana. When he enlisted in the 77th (4th Cav.) Indiana Volunteers on July 24, 1862, he listed his occupation as "artist." On about December 1, 1862, he contracted a chronic case of "diarrhea and piles" while stationed near Gallatin, Tennessee. After being sent home for convalescence, Adams was reassigned to lighter duty. On May 15, 1863, he was "detailed as a photographer in the Topographical Engineer Corps, Department of the Cumberland, and served under Capt. Wm. E. Merrill, U.S. Engrs., until January 23, 1864, when I was again detailed in the Topographical Engineer Department of the Military Division of the Mississippi, and served under [Capt.] O.M. Poe, U.S. Engineers, until discharged at Washington City, D.C., June 3, 1865." (Statement in service file National Archives.) Adams was frequently incapacitated by his malady and remained in ill health until his death in 1888.

10. For short biographies of Poe, see *Biographical Register of the Officers and Graduates of the U.S. Military Academy at West Point, N.Y....by Bvt. Maj.-Gen. George W. Cullum,* vol. III, Nos. 1001 to 2000 (Boston and New York: Houghton, Mifflin & Co., 1891), pp. 643-645 and *Library of Congress Acquisitions, Manuscript Division* (Washington, D.C.: Library of Congress, 1982), pp. 16-20.

11. The manuscript of Jenney's autobiography is in his scrapbook, Chicago Microfilm Project, Burnham Library, Chicago. In this manuscript, Jenney notes:

 > On the fall of Vicksburg accompanied Genl. Sherman to Jackson, Mississippi and later to Chattanooga. After the defeat of Bragg and the capture of Mission Ridge we spent the winter in Huntsville, Alabama, and in the spring joined General Sherman in Nashville. During the Atlanta Campaign was in charge of the Engineer Headquarters at Nashville, Tenn. Was employed on the permanent and temporary fortifications at Nashville. During the battle of Franklin was building breast works to which the army might retreat if necessary. Joined Gen. Sherman in Savannah shortly after the capture, and followed up the coast to Goldsboro and rode with Sherman's staff at the Grand Reviews in Washington.

 For details on Jenney's architectural career, see Theodore Turak, "Jenney's Lesser Works: Prelude to the Prairie Style?," *The Prairie School Review,* VII:3, Third Quarter 1970, pp. 5-20; "The Ecole Centrale and Modern Architecture: The Education of William Le Baron

 Jenney," *The Society of Architectural Historians,* XXIX:1, March 1970, pp. 40-47, and *William Le Baron Jenney: A Pioneer of Modern Architecture* (Ann Arbor: UMI Research Press, 1986).

12. Theodore Turak, "The École Centrale...", p. 46, note 11. Jenney's reminiscence of his days in Paris, published as "Whistler and Old Sandy in the Fifties" *(The American Architect and Building News,* January 1, 1898, pp. 4-5) suggests that he was one of a diverse group of American "literary men, artists and students of all kinds" who frequented a cafe on the rue de la Michandiere. Whistler, then a student of "no promise of any particular ability as an artist," was among the *habitués* of this cafe.

13. See Jenney's "With Sherman and Grant from Memphis to Chattanooga — A Reminiscence," *Military Essays and Recollections, Papers Read Before the Commandery of the State of Illinois Military Order of the Loyal Legion of the United States,* vol. IV (Chicago: Cozzens & Beaton Co., 1907), pp. 193-212.

14. Laura Wood Roper, *FLO: A Biography of Frederick Law Olmsted* (Baltimore: Johns Hopkins University Press, 1973), pp. 221-222. For another insight on Jenney's character, see Louis H. Sullivan, *The Autobiography of an Idea* (New York: Dover Publications, 1956; first published 1924), pp. 203-204.

15. See Theodore Turak, "The École Centrale...", p. 46; and Carl W. Condit, *The Chicago School of Architecture* (Chicago: University of Chicago Press, 1964), pp. 28-29.

16. Erna Risch, *Quartermaster Support of the Army: A History of the Corps, 1775-1939* (Washington, D.C.: Quartermaster Historian's Office, 1962), pp. 432-433. See also Charles F. Bryan, Jr., "Nashville Under Federal Occupation," *Civil War Times Illustrated,* January 1975, pp. 43-46.

17. Gen. James F. Rusling, *Men and Things I Saw in Civil War Days* (New York: The Methodist Book Concern, 1914), pp. 185, 322.

18. Erna Risch, pp. 432-433.

19. Ibid., p. 434; and Gen. James F. Rusling, p. 322.

20. Gen. James F. Rusling, p. 331.

21. Captain Duncan R. Major and Captain Roger S. Fitch, *Supply of Sherman's Army During the Atlanta Campaign* (Fort Leavenworth, Kansas, 1911), pp. 7-12.

22. *Memoirs of General William T. Sherman,* vol. II, p. 11.

23. A third method of reproduction involved the sun-printing of maps drawn on translucent paper. In this "fac-simile photo-printing process" maps on thin tissue were put in contact with, and printed directly on, photographic paper. Such negative-image maps (white lines on black ground) were made throughout the war, but the process was crude and inflexible. Captain Margedant, Merrill's chief assistant in Chattanooga, developed such a process. See Richard W. Stephenson, "Mapping the Atlanta Campaign," *Bulletin No. 127, Geography and Map Division, Special Libraries Association,* March 1982, pp. 7-17.

 For an excellent overview of this subject, see Richard W. Stephenson, *Civil War Maps* (Washington: Library of Congress, 1989).

24. Poe Collection, Letter to wife dated February 11, 1864. Poe enclosed a portrait of himself in this letter. In correspondence of the previous day Poe reported that he had been given "quite a number of views of the Peninsular Campaign." He did not mention Barnard by name, but stated that "they are presented to me by the gentleman who photographed them."

25. This medal is now in the Division of Military History, National Museum of American History, Smithsonian Institution. See James G. Barker, *U.S. Grant: The Man and The Image* (Washington, D.C.: National Portrait Gallery, 1985), p. 41.

26. Gen. James F. Rusling, p. 106.

27. Poe Collection, Letterbook, November 25, 1863 - August 5, 1864, p. 101; Poe to Barnard, February 4, 1864.

28. Poe Collection, Letters Received, December 4, 1863 - July 15, 1864, p. 19; Merrill to Poe, February 8, 1864.

29. Gen. James F. Rusling, p. 331.

30. Poe Collection, Letterbook, February 4, 1866 - March 28, 1868; Poe was still trying to clear his wartime accounts a full year after Appomattox. He wrote Barnard asking him to verify that the latter's trip from Nashville to Chattanooga and back, on February 4-12, 1864, had resulted in expenses of $9.50.

31. *Memoirs of General William T. Sherman,* vol. I, p. 385. Jenney had completed this map by December 19, 1863.

32. On February 19, 1864, Poe sent General Thomas a photographic copy (presumably an early version) of his map of the Battle of Chattanooga. Poe noted that "we have not yet succeeded in Photographing [it] to the full scale, but the smaller scale of the map enclosed admits of sufficient distinctness..."

33. Stanley F. Horn, *The Decisive Battle of Nashville* (Knoxville: University of Tennessee Press, 1978), p. 26.

34. Poe Collection, Letterbook, November 25, 1863 - August 5, 1864, p. 176; Poe to Barnard, March 12, 1864.

35. *Official Records,* Series I. vol. XXXI, Part 1, p. 300.

36. Lieut. R.S. Smith, *A Manual of Topographic Drawing* (New York: Wiley and Halsted, 1856), p. 1.

37. *Memoirs of General William T. Sherman,* vol. I, p. 278; volume II, p. 126.

38. *Official Records,* Series I, vol. XXXI, Part 1, pp. 314-315; letter of April 11, 1864.

39. See *The Crayon,* October 1856, p. 311; and October 1858, pp. 295-296.

40. *Official Records,* Series I, vol. XXXII, Part III, p. 434, Meigs to Sherman, April 20, 1864.

41. Ibid., p. 504; Sherman to Meigs, April 26, 1864.

42. Letter in National Archives, RG 92, Records of the Office of the Quartermaster General, Consolidated Correspondence File, "Photographs in Tennessee," Poe to Meigs, April 26, 1864. A slightly different version of this letter is recorded in Poe's Letterbook, November 25, 1863 - August 5, 1864, p. 223.

43. Delafield gave his approval on June 23, 1864, emphasizing to Poe that the Quartermaster's Department be billed for their portion of Barnard's expense. With Delafield's approval in hand Poe, who was then in northern Georgia with Sherman, telegraphed Jenney to facilitate the production of these views. Jenney worked with Colonel James L. Donaldson, who had charge of the Quartermaster's Department in Nashville. Captain James F. Rusling, Donaldson's Assistant Quartermaster, also advised Barnard in the production of these views and passed many of the finished prints back to Washington under his signature. On July 1, 1864, Poe wrote Jenney,

> You can direct Mr. Barnard to make such views for the Quartermaster's Department as Col. Donaldson may wish, holding him subject however to our orders whenever we may require his services. Have Mr. Barnard keep an accurate accounting of the actual cost of these views, in order that the Engineer Department may be reimbursed by the Quartermaster's Dept. in accordance with Gen'l Meigs' letter to me, dated June 18, 1864 and the letter from the Bureau of Engineers to me dated June 23, 1864. See Col. Donaldson concerning the manner in which he wishes the vouchers made out, as I will want to use the money in purchasing Photographic supplies to replace those expended in these views. Have the thing done in such a shape that there will be no difficulty about it, as all my Photographic Expenditures up to this time have been stopped against me in the Auditor's office.

(Poe Collection, Letterbook, November 25, 1863 - August 5, 1864, p. 407; Poe to Jenney, July 1, 1864.)

44. Barnard may not have spent more than four consecutive days on this assignment, since on July 5 he was ordered to Louisville to "procure instruments" and photographic supplies.

45. Poe Collection, Letterbook, November 25, 1863 - August 5, 1864, pp. 290-292; Poe to Richard Delafield, June 18, 1864.

46. Ibid., Letterbook, August 7, 1864 - November 14, 1864, p. 19; Poe to Delafield, August 7, 1864.

47. It is difficult to equate precisely military and civilian pay scales. However at $6.75 per day,

Barnard earned only slightly less than a full Colonel of Engineers. A colonel's daily salary included wages for the officer ($3.67) and one servant (80¢), a clothing allowance for the servant (17¢), and rations for both officer (6) and servant (2) commuted at 30¢ each. The pre-tax daily total then was $7.04. See J. Lowenthal, *Pay Table for the Army* (Washington, D.C.: Blanchard and Mohun, 1865). For a summary of basic monthly pay levels, see Francis A. Lord, *They Fought for the Union* (Harrisburg, Pa.: The Stackpole Company, 1960), p. 123.

48. On July 15 Poe sent Jenney the following checks for services rendered in June by the employees of the Nashville office:

> I send you enclosed, the following checks, viz--
> No. 14 Charles Schott 98.40
> No. 15 James M. Stafford 117.90
> No. 16 Benjamin A. Drayton 98.40
> No. 18 Samuel Geisman 127.21
> No. 23 George N. Barnard 197.92
> Total 639.83
> intended to pay employees above named for their services, respectively, during the month of June.

(Poe Collection, Letterbook, November 25, 1863 - August 5, 1864, p. 440; Poe to Jenney, July 15, 1864.) In July 1864 Barnard was paid a total of $201.29.

49. Ibid., p. 425-28; Poe to Delafield, July 11, 1864.

50. Ibid., p. 494; Poe to Delafield, August 5, 1864.

51. These views, which were received in the Washington office on August 18, were enumerated as follows:

> No. 31. Capitol, Nashville, Tenn.
> No. 32. Fort Negley from the East, Nashville
> No. 33. Fort Negley looking North East
> No. 34. Fort Negley looking North East
> No. 35. Casemate, Fort Negley
> No. 36. From the Capitol: looking S.E.
> No. 37. From the Capitol: looking South
> No. 38. From the Capitol: looking North
> No. 39. From the Capitol: looking North East

(Letter to Jenney from J.L. Woodruff acknowledging receipt of these photographs; "Letters Sent by the Topographical Bureau of the War Department and by Successor Divisions in the Office of the Chief of Engineers," vol. 22-27, National Archives [microfilm M66, roll 25].)

52. Poe Collection, Letterbook, August 7, 1864 - November 14, 1864, pp. 102-103, and 149; Poe to Delafield, September 11 and 12, 1864.

II:3 Atlanta and the March to the Sea

1. Poe Collection, Manuscript Division, Library of Congress; Letterbook, November 25, 1863 August 5, 1864, p. 464; letter from Poe to Barnard, July 28, 1864.

2. About three weeks later, just before the fall of Atlanta, Poe requested that Captain William E. Merrill send his (unfortunately unnamed) photographer from Chattanooga. But confusion reigned and Merrill's photographer never arrived. See Poe Collection, Letterbook, August 7, 1864 - November 14, 1864, p. 64; Poe to Merrill, August 24, 1864:

> The Photographer whom you sent to report to me came as far as the Chattahoochie Railroad Bridge, whence he reported to me by letter. I referred the letter to Lieut. Wharton, and directed him to send after the man and his baggage. Lieut. Wharton did so, and reports to me that the man was not there, and I strongly suspect that he got stampeded and went back to Chattanooga. I report the facts to you, in order that you may do as you please about paying him. I never saw the man and he did not work here.

Merrill had employed photographers by the name of Cressey and Goldsticker, and it is possible that one of them was "stampeded" at the Chattahoochie Bridge.

3. Ibid., p. 78; Poe to Barnard, September 4, 1864. While Barnard was packing his equipment and preparing for the move, Poe wired again on August 7 that the photographer "ought to bring a sufficient mess chest." He also requested that Barnard bring all Poe's clothing remaining in Nashville. (Ibid, p. 87; telegraph from Poe to William Le Baron Jenney, September 7, 1864; and p. 89, Poe to Capt. William Warner, September 7, 1864.)

4. Ibid., pp. 146-47; Poe to Delafield, September 11, 1864.

5. Ibid., pp. 95-98; these orders were directed to Captain C.B. Reese, Captain W.J. Twining, and Lieut. Col. H.C. Wharton.

6. All aspects of Barnard's work in Atlanta depended on good light and weather. In response to a request from Colonel J.S. Fullerton, Poe replied on September 25:

 Your note of this morning is recd. The weather has been so very bad for the last few days that we have not been able to do anything in the way of preparing copies of the map referred to in your note. But the clear sun of today enables us to do something, and I shall endeavor to furnish the copy asked for by tomorrow, if you will send in for it.

 Poe Collection, Letterbook, November 25, 1863 - August 5, 1864, p. 173; Poe to Fullerton, September 25, 1864.

7. For a profile of McPherson, see William H. Hassler, " 'A Sunny Temper and a Warm Heart,' " *Civil War Times Illustrated*, November 1967, pp. 36-44; and Paul E. Steiner, *Medical-Military Portraits of Union and Confederate Generals* (Philadelphia: Whitmore Publishing Co., 1968), pp. 190-214.

8. For an excellent summary of the events of July 22, 1864, see William E. Strong, "The Death of General James B. McPherson," *Military Essays and Recollections* (Chicago: A.C. McClurg and Company, 1891), pp. 311-343. See also, "Another Account of M'Pherson's Death," *Confederate Veteran*, May 1903, p. 221.

9. William E. Strong, p. 337.

10. Ibid., p. 340.

11. See, for example, the reports of McPherson's death and career in the *New York Times*, July 25, 1864, p. 1 and 4; July 26, 1864, p. 1; July 30, 1864, p. 4; and July 31, 1864, p. 4.

12. Reported in the *Nashville Union*, July 26, 1864; reprinted in the *New York Times*, July 31, 1864, p. 4.

13. This action by officers William E. Strong and Andrew Hickenlooper is described by Strong and cited in an unpublished manuscript ("The Reminiscences of Gen. Andrew Hickenlooper 1861-1865," edited by Gordon Hickenlooper, 1984) in the *Civil War Times Illustrated* Collection, U.S. Army Military History Institute, Carlisle Barracks, Pennsylvania.

14. These images were also issued by other publishers, either as pirated versions of Anthony originals, or under license to them.

15. *Harper's Weekly*, February 18, 1865, p. 101.

16. See undated clipping in Sherman file, University of Notre Dame Archives, "Gen. Sherman at an Artist's Studio," from the *New York Sun*. This article describes Sherman's visit sometime after the conclusion of the war to the New York City studio of battle painter James Walker, then working on a large painting of the battle of Lookout Mountain. Mentioned in the article was an unnamed "artist who accompanied the General through nearly all his campaigns, making sketches for several illustrated papers." This may refer to Theo R. Davis, a close friend of Walker's. Later in this account Sherman asks the unnamed artist, "Have you got that photograph you took of me on horseback?" While this photograph was made by Barnard it may have been arranged by Davis for use in *Harper's Weekly*.

 It is also possible, of course, that the unnamed artist was Barnard himself, although Barnard did not accompany Sherman "through nearly all his campaigns," and does not appear to have produced sketches "for several illustrated papers." Still, the reference to the photograph of Sherman on horseback, which was unquestionably by Barnard, is intriguing.

 The group portrait of Sherman and his staff was made in the days preceding September 28, when Poe mailed a copy of this image to his wife. Henry Hitchcock sent a copy to his wife on November 9 from Kingston, Georgia.

17. *Harper's Weekly*, December 17, 1864, pp. 808-809. *Harper's* incorrectly credited this illustration to Brady.

18. *Syracuse Standard*, November 3, 1864, p. 3.

19. *Memoirs of General William T. Sherman*, vol. II, p. 137.

20. Ibid., pp. 148-49.

21. Ibid., p. 150.

22. Ibid., p. 152.

23. It is possible that Barnard personally carried these plates to Nashville in late October or early November, 1864. J.F. Coonley recalled visiting with Barnard in Nashville just "days" before Sherman's march. However, it cannot be determined with certainty whether, in hindsight, Coonley remembered seeing Barnard in early November or in early September when he left for Atlanta on Poe's initial order (*Anthony's Photographic Bulletin*, September 1882, p. 311):

 A few days before Sherman's army left Atlanta "for the sea" I arrived in Nashville for the purpose of making photographs, by order of the Quartermaster's Department, of all bridges, trestles, buildings, boats, etc., that were under its control, built, or operated by the department. The rear guard and engineer corps were still at Nashville, but left for Atlanta the day of my arrival. I there met many former friends and acquaintances, among whom again was Mr. G.N. Barnard, then chief photographer of the topographical engineers. We had but a short time to remain together, as he, with the rear guard, were ordered to report at Atlanta and left immediately. The next news was that the army had left Atlanta marching east, its destination no one then being aware of except the officers in command.

24. Poe Collection, Letterbook, August 7, 1864 - November 14, 1864, p. 306; Poe to Jenney, November 1, 1864.

25. Ibid., p. 303.

26. *Syracuse Daily Standard*, November 18, 1864, p. 3.

27. Henry Hitchcock Collection, Manuscript Division, Library of Congress; Henry Hitchcock letter to wife, January 29, 1865.

28. Poe Collection, Letterbook, August 7, 1864 - November 14, 1864, pp. 352-54; Poe to Delafield.

29. Ibid., pp. 369, 371.

30. Poe Collection, Diary 1864, entry for November 15, 1864.

31. Henry Hitchcock Collection, Diary entry for December 6, 1864.

32. Ibid., entry for November 15, 1864.

33. *Memoirs of General William T. Sherman*, vol. II, p. 178.

34. Poe Collection, Diary, entry for December 2, 1864.

35. Henry Hitchcock Collection, Diary entry for December 6, 1864.

36. *Harper's Weekly*, January 7, 1865, pp. 6, 9, 12, 13.

37. Poe Collection, Letterbook, December 14, 1864 - October 13, 1865, p. 6; "Engineer Order No. 5," December 21, 1864.

38. Ibid., p. 2; Poe to Hazen, December 14, 1864. See "How Fort McAllister Was Taken," *Harper's New Monthly Magazine*, August, 1868, pp. 368-370.

39. *Harper's Weekly*, February 11, 1865, p. 93.

40. *Memoirs of General William T. Sherman*, vol. II, p. 217.

41. The Hitchcock Collection, includes a list, dated January 17, 1865, of 15 stereographic scenes of Atlanta, photographed by Barnard and printed in Savannah.

 In a letter to his wife (January 22, 1865) Hitchcock noted:

 I send you with this two or three photographs — very poor ones, but all I could get. The wretched weather of the last ten days makes it unprofitable to print...I have left word with Mr. Barnard to send you the rest he was to print whenever he could get them done; but now that I am gone [from Savannah], and he is constantly busy otherwise, I confess I doubt if you will get them...

42. Poe Collection, Letterbook, December 14, 1864 - October 13, 1865, p. 72; text of letters from Poe to Edwin M. Stanton, Maj. Gen. J.G. Barnard, and Maj. Gen. Montgomery C. Meigs.

43. Poe Collection, Journal, January 25, 1865 - March 22, 1865; entries for February 17, 1865, and February 19, 1865.

44. Poe Collection, Letterbook, December 14, 1864 - October 13, 1865, pp. 94-96; Poe to Barnard, January 19, 1865.

45. Ibid., p. 113.

46. E. Milby Burton, *The Siege of Charleston 1861-1865* (Columbia: University of South Carolina Press, 1982), p. 321.

47. Sidney Andrews, *"The South Since the War,"* quoted in *Charleston Come Hell or High Water* (Columbia: R.L. Bryan Co., 1975), p. 16.

48. "Charleston As It Is," *Syracuse Standard*, March 14, 1865, p. 3.

49. Changes in various details of the fort itself suggest that Barnard visited this sandbar on trips a few days apart, once in a rowboat and once in a small sailboat. During this time work progressed on the fort's suspension walkway, and the flagstaff was raised to its full height.

50. National Archives, Record Group 393, vol. 20/31, MDM, p. 9, "Records of the U.S. Continental Command, 1821-1890", Military Division of the Mississippi, Engineer Office"; letter from Jenney to Poe, April 26, 1865.

51. Poe Collection, Letterbook, December 14, 1864 - October 13, 1865, pp. 247-248; telegram from Poe to Jenney, April 26, 1865.

52. Ibid., p. 280; Poe to Delafield, June 2, 1865.

53. Ibid., pp. 290, 294; Poe to Delafield, June 6 and June 21, 1865.

54. Ibid., Delafield to Poe, June 22, 1865.

55. Ibid., p. 305, Poe to Delafield, June 27, 1865. The photographic apparatus and negatives in Poe's possession were turned over to Lieut. Colonal J.C. Woodruff, Corps of Engineers.

56. Ibid., p. 316; Poe to Delafield, June 30, 1865.

III:1 Production and Promotion

1. See William C. Davis, ed., *Touched by Fire: A Photographic Portrait of the Civil War*, vol. I (Boston: Little, Brown and Co., 1985), p. 276; and II, p. 301.

2. These articles are collected in John Richard Dennett, *The South As It Is: 1865-1866* (Athens: The University of Georgia Press, 1986; first published 1965), edited by Henry M. Christman.

3. *Harper's New Monthly Magazine*, pp. 396-97; October 1865, pp. 571-589; and December 1865, p. 122.

4. *Harper's New Monthly Magazine*, January 1866, p. 257. In the previous month's issue it was indicated that Nichols' book had gone through thirty editions.

5. Ibid.

6. *Harper's New Monthly Magazine*, February 1866, pp. 366-367. Melville also published poems titled "Chattanooga" and "Gettysburg — July, 1863" in the June 1866 (p. 44) and July 1866 (p. 209) issues.

7. *New York Commercial Advertiser*, December 18, 1866, p. 2.

8. The copy of this album in the Hallmark Photographic Collection is inscribed:
 To Dr. Gray
 From his sincere friend,
 Mrs. Wm. F. Smith
 January 1st 1867

9. *Philadelphia Press*, February 26, 1866; quoted in 4-page prospectus on the album published by Philp & Solomons, ca. March 1866, in National Archives. A reprint edition of Gardner's *Photographic Sketch Book* was published in 1959 by Dover Publications.

10. Poe Collection, Library of Congress Manuscript Division; letter #118, Barnard to Poe, March 7, 1866.

11. Poe Collection, Letterbook, February 4, 1866 - March 28, 1868, p. 68-69; Poe to Barnard, March 10, 1866.

12. Letter from Sherman to Barnard, March 24, 1866; copy in files of Onondaga Historical Association.

13. Sherman Collection, Library of Congress. The copy of this prospectus mailed to Sherman had, in Barnard's hand, "or 789" following the Anthony address, indicating that Barnard could also be reached at 789 Broadway, near Brady's gallery at 785 Broadway.

14. Poe Collection, Barnard to Poe, April 10, 1866.

15. The Chicago Historical Society has in its collection a carte-de-visite of General Grant with the following stamp on the reverse:
 J.W. Campbell
 Army Photographer
 20th Army Corps
 Army of the Cumberland

16. Campbell may have produced work for both the Anthonys and himself. At least fifteen views of Charleston and Fort Sumter were registered for copyright under Campbell's name on May 23, 1865. See Copyright Records for the District Court of the Southern District of New York, vol. 208, Library of Congress. The 1865-66 New York City directory listed Campbell's business address as 575 Broadway. For a review of his series of "about forty" Charleston stereographs, see *American Journal of Photography*, May 15, 1865, p. 525.

17. Fred E. Brown, "The Battle of Allatoona," *Civil War History*, September 1960, pp. 277-297.

18. *Memoirs of General William T. Sherman*, vol. II, p. 53.

19. Ibid., p. 59.

20. My thanks to David Ruth of the National Park Service, Fort Sumter, for this data.

21. *Savannah Daily News and Herald*, June 13, 1866, p. 3. Barnard and Campbell registered at the Marshall House hotel.

22. Eva J. Barrington, "Bonaventure Cemetery, Former Plantation, Possesses Rare Natural Beauty and Charm," *Savannah Morning News*, August 6, 1950, pp. 22-23.

23. *Savannah Daily News and Herald*, June 18, 1866, p. 3.

24. Poe Collection, letter #212, Barnard to Poe, June 22, 1866.

25. Poe Collection, Letterbook, February 4, 1866 - March 28, 1868, p. 286-287; Poe to J.E. Hilgard, July 9, 1866.

26. Sir Leslie Stephen and Sir Sidney Lee, eds., *The Dictionary of National Biography*, vol. 3 (London: Oxford University Press, 1921-22), p. 97.

27. Sherman Collection, Library of Congress, microfilm reel 18; letter from Barnard to Sherman, July 7, 1866.

28. *Chicago Evening Post*, February 11, 1893, p. 5.

29. Poe Collection, Letterbook, February 4, 1866 - March 28, 1868, p. 346; Poe to Barnard, August 31, 1866.

30. For example, on July 20, 1866, Barnard wrote Poe that "Campbell I think has Hooked a big Fish in way of a patent and I am in hopes will make a fortune out of it. I am helping him to get his patent." (Ibid., letter #219, Barnard to Poe, July 20, 1866). Campbell received two patents in 1866: one on August 14 for a vacuum "Photographic Printing Frame," and another on November 20 for a "Machine for Ornamental Printing." (*Annual Report of the Commissioner of Patents*, 1866, pp. 1055, 1451.) It is doubtful that either invention resulted in a financial windfall.

31. Poe Collection, Barnard to Poe, July 20, 1866, July 29, 1866, and August 14, 1866.

32. Ibid., letter #256; Barnard to Poe, September 3, 1866.

33. Ibid., letter #266; Davis to Poe, September 9, 1866.

34. See Eugenia Parry Janis, *The Photography of Gustave LeGray* (Chicago: The Art Institute of Chicago/University of Chicago Press, 1987), pp. 73-75.

35. V. Blanchard, "On the Production and Use of Cloud Negatives," *The Photographic News*, September 4, 1863, pp. 424-425. See also, "Art and Truth *versus* White Skies," *British Journal of Photography*, March 1, 1861, p. 97; and "The Clouds," *Philadelphia Photographer*, January 1867, pp. 11-13.

36. Poe Collection, letter #305; Barnard to Poe, November 4, 1866.

37. *New York Times*, November 30, 1866, p. 2.

38. *Harper's Weekly*, December 8, 1866, p. 771.

39. *Harper's New Monthly Magazine*, January 1867, p. 266.

III:3 Themes and Sources

1. For a review of this exhibition, see Ben Lifson, "Oh What a Lovely War," *Village Voice*, July 18, 1977, pp. 58-59.

2. *Memoirs of William T. Sherman*, vol. I, pp. 324, 364.

3. Ibid., vol. II, p. 56. See also Henry O. Dwight, "How We Fight at Atlanta," *Harper's New Monthly Magazine*, October 1864, pp. 663-666, on the effectiveness of defensive works in this campaign. Dwight's description is, at times, remarkably evocative of the horrors of World War I trench warfare.

4. The similarity of other *Sherman's Campaign* plates to *Harper's Weekly* illustrations reflects Barnard's interest in representing subjects of acknowledged importance. For example, an engraving of Chattanooga in the September 12, 1863, issue of *Harper's* is roughly comparable to plate 8 of Barnard's album. The photograph is the most interesting of the two, however, for its diagonal perspective of the bridge, and the clever formal play between the pair of foreground buildings and the matched masses of Cameron Hill and Lookout Mountain in the distance. Similarly, plate 48 is reminiscent of a stilted engraving published in the December 1, 1860, issue of *Harper's Weekly*. "Relics on a Battlefield," published in the June 9, 1866 issue, is comparable in subject and mood to Barnard's *Scene of General McPherson's Death* (plate 35).

5. See Neil Harris, *The Artist in American Society: The Formative Years 1790-1860* (Chicago: University of Chicago, 1966), pp. 267-268.

6. This enormously complex subject is outlined in such important studies as: Barbara Novak, *Nature and Culture: American Landscape and Painting 1825-1875* (New York: Oxford University Press, 1980); John Wilmerding, et. al., *American Light: The Luminist Movement 1850-1875* (Washington, D.C.: The National Gallery, 1980); John K. Howat, et. al., *American Paradise: The World of the Hudson River School* (New York: Metropolitan Museum of Art, 1987); and Franklin Kelly, *Frederic Edwin Church and the National Landscape* (Washington, D.C.: Smithsonian Institution Press, 1988).

7. The photographers who made significant landscape images prior to about 1859 include Samuel Bemis, Alexander Hesler, James Wallace Black, Samuel Masury, and William J. Stillman.

8. See, for example, Jasper Cropsey, "Up Among the Clouds," *The Crayon*, August 8, 1855, p. 79.

9. See Rose Macaulay, *Pleasure of Ruins* (New York: Thames and Hudson, 1984; reprint of edition of 1953).

10. Prof. Tayler Lewis, *State Rights: A Photograph from the Ruins of Ancient Greece* (Albany: Weed, Parsons and Company, 1865), pp. 5, 20, 28.

11. Martha V. Pike and Janice Gray Armstrong, p. 13.

12. See, for example, Donald E. Simon, "The Worldly Side of Paradise," in Martha V. Pike and Janice Gray Armstrong, pp. 51-66.

13. See "Cemeteries," *Harper's New Monthly Magazine*, August 1863, pp. 330-338; and James F. Rusling, "National Cemeteries," *Harper's New Monthly Magazine*, August 1866, pp. 310-322.

14. See, for example, Ann Uhry Abrams, *The Valiant Hero: Benjamin West and Grand-Style History Painting* (Washington, D.C.: Smithsonian Institution Press, 1985); and William H. Gerdts and Mark Thistlethwaite, *Grand Illusions: History Painting in America* (Fort Worth: Amon Carter Museum, 1988).

15. William H. Gerdts and Mark Thistlethwaite, p. 10.

16. Horace Bushnell, "Our Obligations to the Dead," reprinted in Alan Trachtenberg, ed., *Democratic Vistas: 1860-1880* (New York: George Braziller, 1970), p. 43.

17. "The Condition of Art in America," *North American Review*, January 1866, p. 22.

18. Horace Bushnell, p. 46.

19. William H. Gerdts and Mark Thistlethwaite, pp. 49-50.

20. Horace Bushnell, p. 42.

21. Ibid.

22. For an excellent survey of this theme, see Michael Barkun, "Divided Apocalypse: Thinking About the End in Contemporary America," *Soundings*, Fall 1983, p. 257-280. Barkun notes that, "far from suffering terminal exhaustion, apocalyptic literature is more popular in America now than at any time since the early nineteenth century."

Not unexpectedly, this theme has been enormously prevalent in the art of recent years. See, for example, Eleanor Heartney, "The End of the World," *Arts Magazine*, February 1984, pp. 100-101; and Suzi Gablik, "Art Alarms: Vision of the End," *Art in America*, April 1984, pp. 11-15.

23. Donald Kuspit, "Uncivil War," *Artforum*, April 1983, pp. 34-43.

IV:1 Charleston and Chicago, 1867-1880

1. *The Philadelphia Photographer*, March 1869. This endorsement was also printed in *Anthony's Photographic Bulletin*, April 1878, p. 128.

2. *The Philadelphia Photographer*, August 1871, p. 261. A lengthy summary of Anthony's process is given on pp. 258-261. Charles Wager Hull was a respected authority on photography who wrote for *The Photographic Times* in the early 1870s.

3. George S. Cook, the leading daguerreotypist in Charleston, had briefly managed Brady's New York gallery in 1851. There are numerous other instances of photographers traveling back and forth between New York and Charleston. The career of Albert G. Park may suggest both the mobility of photographers of the period, and the links between the two cities. After learning the daguerreotype process in Mobile, Alabama, in 1844-45, Park practiced in Newark, New Jersey, and Montgomery, Alabama before moving to Charleston. Here he was "employed by his friend, Mr. Geo. S. Cook, who had assisted him in former years." Park later traveled to New York to work for Brady for a year. He then returned to Charleston to open a new daguerreotype gallery, but went back to New York to learn and practice the new ambrotype process. See *The Photographic and Fine Art Journal*, February 1856, p. 59.

4. *Anthony's Photographic Bulletin*, April 1884, p. 15.

5. Quinby had owned a gallery in New York City as early as 1854. The 1854-55 New York City directory listed Quinby's daguerreotype business at "415 Av. 8 & 90 Chatham." The 1856-57 and 1858-59 directories list his business at 385 Broadway. Quinby's gallery received brief notices in *The Photographic and Fine Art Journal* (January 1856, p. 20; and February 1858, p. 64 [here misspelled "Quimby"]).

The partnership of Barnard and Quinby was noted in the record of sale of the Quinby & Co. gallery in 1871, (Volume U 15, p. 51, Charleston Land Records, Charleston City Archives.)

6. Charleston Land Records, Vol. F15, p. 316.

7. Charleston city directory, 1869-70, pp. 87, 172.

8. Charleston Daily Courier, October 25, 1870, p. 1; November 2, 1870, p. 4; November 10, 1870, p. 4.

9. Catharine Esther Beecher and Harriet Beecher Stowe, *The American Woman's Home*; cited in Peter C. Marzio, *The Democratic Art: Chromolithography 1840-1900* (Boston: David R. Godine, 1979), p. 117. Marzio's book provides an excellent overview of the history of chromolithography in America.

10. Typical of these was the editorial notice published in the *Charleston Daily Courier*, May 27, 1870, p. 2:

> CHROMOS — We had the pleasure of inspecting yesterday, one of the finest collections of Chromos that has ever been exhibited in Charleston. In it are comprised selections from the designs of the most famous masters, and the prints are of the best English and German type, framed in black walnut and rosewood. The entire collection will be sold out on Monday, by Messrs. LEITH & BRUNS, without reserve. Catalogues will be ready today. A better opportunity to purchase fine works of art, was never offered the public of Charleston, and we advise everybody, but more particularly the ladies, to call at QUINBY'S Gallery and examine the collection. The fine pictures will repay the trouble of a visit. Go and see them by all means.

On June 24, 1870 (p. 1) the newspaper reported that "crowds flock to QUINBY'S Art Gallery daily to inspect the splendid collection of Chromos that will be disposed of on Monday next."

11. Report of sale held by J.A. Abraham; *Charleston Daily Courier*, June 14, 1870, p. 2.

12. The prints sold through the Quinby gallery were described as "of a class superior to the Chromos now offered" elsewhere. *Charleston Daily Courier*, May 27, 1870, p. 3.

13. *Charleston Daily Courier*, May 30, 1870, p. 1; and June 25, 1870, p. 2.

14. *Charleston Daily Courier*, May 31, 1870, p. 2.; June 21, 1870, p. 1; June 27, 1870, p. 1; July 6, 1870, p. 1; and December 6, 1870, p. 3.

15. *Charleston Daily Courier*, June 21, 1870, p. 1.

16. According to the 1872-73 Charleston city directory, Stephen T. Souder, "photographer and artist," operated a studio at 263 King Street as well as a ferrotype gallery next door at 265 King. He resided at 27 Rutledge Avenue.

17. Charleston Land Records, vol. U 15, pp. 51-52; record of sale of Quinby & Co. gallery to Bertha F. Souder, May 5, 1871.

18. Samuel Hale obituary, *Chicago Times*, January 25, 1877.

19. Matthews genealogy, Onondaga Historical Association.

20. A.T. Andreas, *History of Chicago from the Earliest Period to the Present Time, Volume II, from 1857 until the fire of 1871* (Chicago: A.T. Andreas Company, 1885), pp. 734-735. Matthews' position was subsequently taken by Reverend Lewis H. Reid, of Syracuse, New York.

21. Matthews genealogy, Onondaga Historical Association.

22. Appraisal of the Barnard and Matthews gallery by the R.G. Dun firm; R.G. Dun records, Illinois, vol. 36, p. 249, Baker Library, Harvard University Business School, Boston, Massachusetts. The Dun entry, dated July 7, 1871, concludes by noting that "parties who have known them several years say they are men of good character and likely to succeed."

23. *The Philadelphia Photographer*, December 1871, p. 403.

24. Carl W. Condit, *The Chicago School of Architecture* (Chicago: The University of Chicago Press, 1964), pp. 14-16.

25. Louis H. Sullivan, *The Autobiography of an Idea* (New York: Dover Publications, 1956, first published 1924), p. 201.

26. Carl W. Condit, p. 18; and Paul M. Angle, *The Great Chicago Fire* (Chicago: The Chicago Historical Society, 1971), pp. 1-5.

27. Carl W. Condit, p. 19.

28. *Harper's Weekly*, October 28, 1871, p. 1010.

29. Paul M. Angle, p. 3.

30. *Harper's Weekly*, October 28, 1871, pp. 1010-1011.

31. *Anthony's Photographic Bulletin*, April 1902, p. 128.

32. *Chicago Evening Journal*, October 12, 1871, p. 1.

33. William C. Darrah, *The World of Stereographs* (Gettysburg, Pa.: W.C. Darrah, 1977), p. 161.

34. *The Philadelphia Photographer*, December 1871, p. 407; and January 1872, p. 28.

35. *Anthony's Photographic Bulletin*, April 1882, pp. 122-123.

36. *The Lakeside Memorial of the Burning of Chicago* (Chicago: The University Publishing Company, 1872). While these tipped-in albumen prints are not credited to Barnard, all appear to be extremely close variants of his published stereographs. These half-stereos average about 5½ x 3¾-inches in size, indicating the use of a relatively large format (probably a "whole-plate" 6½ x 8½-inch) camera. These uncut prints provide a considerably wider view (vertically) than Barnard's trimmed stereographs of the same scenes.

 Jenney's architectural firm, "Jenney, Schermerhorn & Bogart," had been located at 73 Clark Street. After the fire Jenney relocated to 708 Wabash Avenue (see *Chicago Tribune*, October 17, 1871, p. 4).

37. *Chicago Evening Journal*, October 20, 1871, p. 4; *Chicago Tribune*, October 26, 1871, p. 2.

38. *The Philadelphia Photographer*, December 1871, pp. 401-402.

39. *Transactions of the American Institute*, 1871, p. 980.

40. *The Philadelphia Photographer*, December 1871, p. 402.

41. *The Philadelphia Photographer*, February 1872, p. 45; *Anthony's Photographic Bulletin*, February 1872, p. 466.

42. *The Philadelphia Photographer*, March 1872, p. 76.

43. *The Philadelphia Photographer*, April 1872, p. 118.

44. *The Philadelphia Photographer*, May 1872, pp. 143-144.

45. For background on White, see: Joseph Logsdon, *Horace White: Nineteenth Century Liberal* (Westport, Conn.: Greenwood Publishing Corporation, 1971).

46. *The Philadelphia Photographer*, May 1872, p. 403.

47. *The Philadelphia Photographer*, June 1872, pp. 239-240.

48. Charleston real estate records for 1871-75 seem to indicate Barnard's stability. In these years his taxable net worth climbed from $1950 to $7000. (By contrast, however, Barnard's fellow studio owner George S. Cook had real estate in this period worth between $13,600 and $18,100.)

 In the same period Barnard's taxable personal property worth was relatively low, generally $200 to $250. In 1874 this figure dropped to $50. This evidence suggests that Barnard reinvested his money in his business and lived rather simply. In 1879 and 1880 Barnard's personal property showed a marked increase in value (to $3250 and $1050 respectively) due to large sums in the category "material, machinery & tools of manufacture."

49. Charleston Land Records, volume L 16, p. 99; July 8, 1873.

50. *Charleston News and Courier*, August 11, 1873, p. 3.

51. "The South Carolina Problem; The Epoch of Transition," *Scribner's Monthly*, June 1874, p. 142.

52. Ibid., p. 145.

53. Ibid., p. 144.

54. Ibid., p. 145.

55. "Up the Ashley and Cooper," *Harper's New Monthly Magazine*, December 1875, pp. 1, 22-23.

56. James M. McPherson, *Battle Cry of Freedom* (New York: Oxford University Press, 1988), pp. 859-861.

57. John P. Radford, *Culture, Economy and Urban Structure in Charleston, South Carolina, 1860-1880*, unpublished dissertation (Clark University, 1974), p. 29.

58. Ibid., p. 36.

59. Ibid., pp. 228, 314.

60. Ibid., p. 50.

61. "Up the Ashley and Cooper", *Harper's New Monthly Magazine*, December 1875, p. 4.

62. Ibid., p. 8.

63. Ibid., p. 13. See also William Oliver Stevens, *Charleston: Historic City of Gardens* (New York: Dodd, Mead & Company, 1939), pp. 194-200.

64. Undated photocopy in the files of the Onondaga Historical Association.

65. *Anthony's Photographic Bulletin*, June 1875, p. 192.

66. Charleston Land Records, Vol. K16, p. 125.

67. For reproductions of J.N. Wilson views, see Mills Lane, *Savannah Revisited: A Pictorial History of Savannah* (Savannah, Ga.: The Beehive Press, 1969), pp. 79, 81, 85, 87, 89. For larger discussions of this topic, see Elwood Parry, *The Image of the Indian and Black Man in American Art, 1590-1900* (New York: Braziller, 1974); Peter H. Wood and Karen C.C. Dalton, *Winslow Homer's Images of Blacks* (Austin: Menil Collection/University of Texas Press, 1988); and Hugh Honour, *The Image of the Black in Western Art, Vol. V*; Part 1: *Slaves and Liberators*; and Part 2: *Black Models and White Myths* (Menil Foundation/Harvard University Press, 1989).

68. A grand procession was held in Charleston on May 2, 1870, to celebrate the ratification of the 15th Amendment. *Charleston News and Courier*, May 2, 1870, p. 1.

69. *Charleston News and Courier*, July 7, 1873, p. 2.

70. *Charleston News and Courier*, March 11, 1874, p. 4.

71. *The Photographic Times*, April 1871, pp. 49-50.

72. *Charleston News and Courier*, November 16, 1875, p. 4. Barnard notified his acquaintances in New York of the fire; see *Anthony's Photographic Bulletin*, December 1875, p. 368.

73. *Charleston News and Courier*, November 29, 1875, p. 2.

74. *Charleston News and Courier*, November 24, 1875, p. 4.

75. *Charleston News and Courier*, April 11, 1876, p. 4.

76. *Charleston News and Courier*, April 12, 1876, pp. 2, 4.

77. The frescoes were by an artist named T.R. Celli. See Robert P. Stockton, "249 King St. Endured Changes," *Charleston News and Courier*, June 14, 1982.

78. Record of sale of Barnard's gallery to Frank A. Nowell; Charleston Land Records, vol. D 18, p. 292; May 12, 1880.

79. *Charleston News and Courier*, August 16, 1876, p. 3.

80. See, in particular, *Scribner's Monthly*: May 1874, p. 7; June 1874, pp. 129, 130, 131, 139, 141, 148, 151, 155; August 1874, pp. 387, 393, 408.

81. *The South Carolina State Gazetteer for 1880-81*, pp. 187, 192.

82. *Humphrey's Journal*, January 1, 1868, pp. 259-260; cited in William Welling, *Photography in America* (New York: Thomas Y. Crowell, 1978), p. 191.

83. *Photographic News*, December 7, 1877, pp. 579-580; cited in William Welling, p. 249. Hesler spoke from experience. In about 1877 or 1878 he produced good quality cabinet-size portraits in carbon. It is not known if these pre- or postdate his stated disinterest in the process.

84. William Welling, p. 247; see *Anthony's Photographic Bulletin*, January 1877, pp. 20-21.

85. *Charleston News and Courier*, November 9, 1877, p. 3.

86. *Charleston News and Courier*, November 21, 1878, p. 3.

87. *Anthony's Photographic Bulletin*, February 1878, pp. 60-61.

88. *Anthony's Photographic Bulletin*, May 1880, pp. 148-149.

89. *Charleston News and Courier*, December 12, 1877, p. 3.

90. *Frank Leslie's Illustrated Newspaper*, July 19, 1879, p. 337.

91. William Gilmore Simms, *Views and Reviews in American Literature, History and Fiction*, C. Hugh Holman, ed. (Cambridge, Mass.: Belknap Press of Harvard University Press, 1962), p. vii.

92. Jon L. Wakelyn, *The Politics of a Literary Man: William Gilmore Simms* (Westport, Conn.: Greenwood Press, Inc., 1973), pp. 263-264. See also J.V. Ridgely, *William Gilmore Simms* (New York: Twayne Publishers, Inc., 1962).

93. Earlier, for example, the Quinby gallery had donated money to assist the relocation of Confederate war dead from cemeteries in the north to Charleston's Magnolia Cemetery. *Charleston News and Courier*, February 15, 1871, p. 1.

94. *Charleston News and Courier*, August 16, 1876, p. 3.

95. *Charleston News and Courier*, November 21, 1878, p. 3.

96. *The South Carolina State Gazetteer and Business Directory for 1880-81*, compiled by R.A. Smith, p. 2. This advertisement must have been submitted for publication in mid- to late 1879.

97. *Painesville Telegraph*, May 15, 1884.

98. *Charleston News and Courier*, May 11, 1880, p. 2.

99. Charleston Land Records, vol. D 18, pp. 292-94; see entries dated January 14, 1889 and January 21, 1889 written across original bill of sale (May 12, 1880). The sale of the gallery's equipment and fixtures is noted in a bill of sale dated January 16, 1890, vol. X 20, p. 585.

IV: 2 Late Work: 1880-1902

1. 1880 census for Monroe County, New York, Town of Henrietta, microfilm roll 861, p. 18/197

2. No record of a divorce has been found, but, given Barnard's character, he must have legalized the break with his first wife before remarrying.

3. 1880 census for Monroe County, New York, Town of Henrietta, microfilm roll 861, p. 163/166. Emma Chapin Gilbert Barnard was born June 16, 1816 or 1817 (there is some disagreement between sources)

4. *Anthony's Photographic Bulletin*, June 1881, p. 183.

5. Ibid., pp. 182-183.

6. *Anthony's Photographic Bulletin*, November 1881, pp. 342-343.

7. Ibid., p. 344. A dozen 3¼x4¼" plates sold for 65 cents. In the 20x24" size plates sold for $24.00 per dozen.

8. Ibid., April 1902, p. 128.

9. Eastman Dry Plate Company, Ledger 000.01, p. 24; Journal, Eastman Dry Plate Company, January 1881-May 1885, p. 4, 6, 11, 16, 20-21, 36-37; both in archives of Eastman Kodak Company, Rochester, New York.

10. Typewritten manuscript, "Story of Kodak", p. 8; Library, Eastman Kodak Company, Rochester, New York.

11. *Anthony's Photographic Bulletin*, March 1881, p. 86.

12. Ibid., p. 86.

13. Ibid., p. 90.

14. *Anthony's Photographic Bulletin*, April 1881, p. 117.

15. *The Philadelphia Photographer*, December 1882, p. 383.

16. For data on Furman, see: *Photographic and Fine Art Journal*, April 1860, p. 115; *Anthony's Photographic Bulletin*, September 1877, p. 288; and James D. Furman, *The Furman Legend* (Greenville, S.C.: Keys Printing Co., 1978).

17. *Anthony's Photographic Bulletin*, September 1883.

18. *Anthony's Photographic Bulletin*, February 1884, pp. 70-72.

19. Ibid., pp. 72-74. A slightly different version of this letter was also published in the *Philadelphia Photographer*, March 1884, pp. 83-84.

20. See *Anthony's Photographic Bulletin*, June 1884, p. 260, for a description of Painesville by a traveling photographer. Painesville's population in 1880 was 3,841; in 1890 it numbered 4,612.
 There is some likelihood that the Barnard or Gilbert families had friends or relatives in Painesville. It is interesting to note that Samuel Huntington, a Painesville resident and second Governor of Ohio, had grown up in Coventry, Connecticut. He left Connecticut for Ohio in 1800. See Steward H. Holbrook, *The Yankee Exodus: An Account of Migration from New England* (New York: The MacMillan Company, 1950), p. 31.

21. *The Painesville Telegraph*, March 20, 1884.

22. *The Painesville Telegraph*, June 19, 1884.

23. *The Painesville Telegraph*, May 15, 1884.

24. *The Painesville Telegraph*, January 15, 1885, p. 1.

25. *The Painesville Telegraph*, November 20, 1884.

26. Henry Howe, *Historical Collections of Ohio, vol. II* (Cincinnati: C.J. Krehbiel & Co., 1888), pp. 39, 44, 47.

27. *The Painesville Telegraph*, March 29, 1888, p. 2.

28. It is not known who operated the gallery after Barnard's departure. On January 10, 1889 an unsigned notice in the newspaper announced the close of the Old Tibbals' Gallery on April 1; persons desiring prints from its stock of negatives were advised to "attend to it at once." Although Barnard was the last recorded owner of the gallery, this unsigned notice provides no clue as to his involvement in it in early 1889. According to Painesville city records Barnard paid personal property tax from 1885 to 1888, but his name does not appear after that date.

29. Etowah County Deed Records: Vol. N, pp. 396, 633-634. Gilbert paid $500 for his land. Barnard paid $3650 for his purchase of October 1, 1888.

30. Typescript copy of Mary Grace Barnard Gilbert's diary from April to August 1892, in the files of the Onondaga Historical Association.

31. *Gadsden Times-News*, April 10, 1890, p. 6; and July 31, 1890, p. 4.

32. Typescript of interview with Edward J. Speich, May 1964, in files of the Onondaga Historical Association.

33. Dick Wright, "Last Years of a Pioneer Cameraman", *Syracuse Post-Standard Magazine*, May 24, 1964, pp. 4-7.

34. Ibid., p. 4.

35. *Marcellus Observer*, November 22, 1901, p. 5.

36. *Syracuse Evening Telegram*, Feb. 3, 1902, p. 6.

37. Robert Taft, *Photography and the American Scene: A Social History, 1839-1889* (New York: Dover Publications, 1964; reprint of 1938 edition), p. 230.

38. Richard G. Case, "Photo Pioneer Remembered in Death," *Syracuse Herald-World*, June 4, 1964, p. 2.

IV:3 Conclusion

1. J. Wells Champney, "Fifty Years of Photography," *Harper's New Monthly Magazine*, August 1889, p. 357.

2. Ibid., pp. 360-365.

3. William Welling, *Photography in America: The Formative Years 1839-1900* (New York: Thomas Y. Crowell, 1978), p. 321.

4. J. Wells Champney, p. 366.

**George N. Barnard
Photographer of Sherman's Campaign**

was produced in a first edition of
twenty-five hundred hardbound and
three thousand paperbound copies.

The photographs are reproduced in
200-line screen, with varnish, on 100 lb. Karma Natural text.

The typeface is Baskerville Old Style.

Beckett Cambric 80 lb. cover Birch was used for endsheets,
and Holliston Payko for the cloth cover.

Separations were done by Art Lithocraft, Kansas City, Missouri,
presswork by Commercial Lithographing Co., Kansas City, Missouri,
and binding by Nicholstone Book Bindery, Nashville, Tennessee.